BRANDT

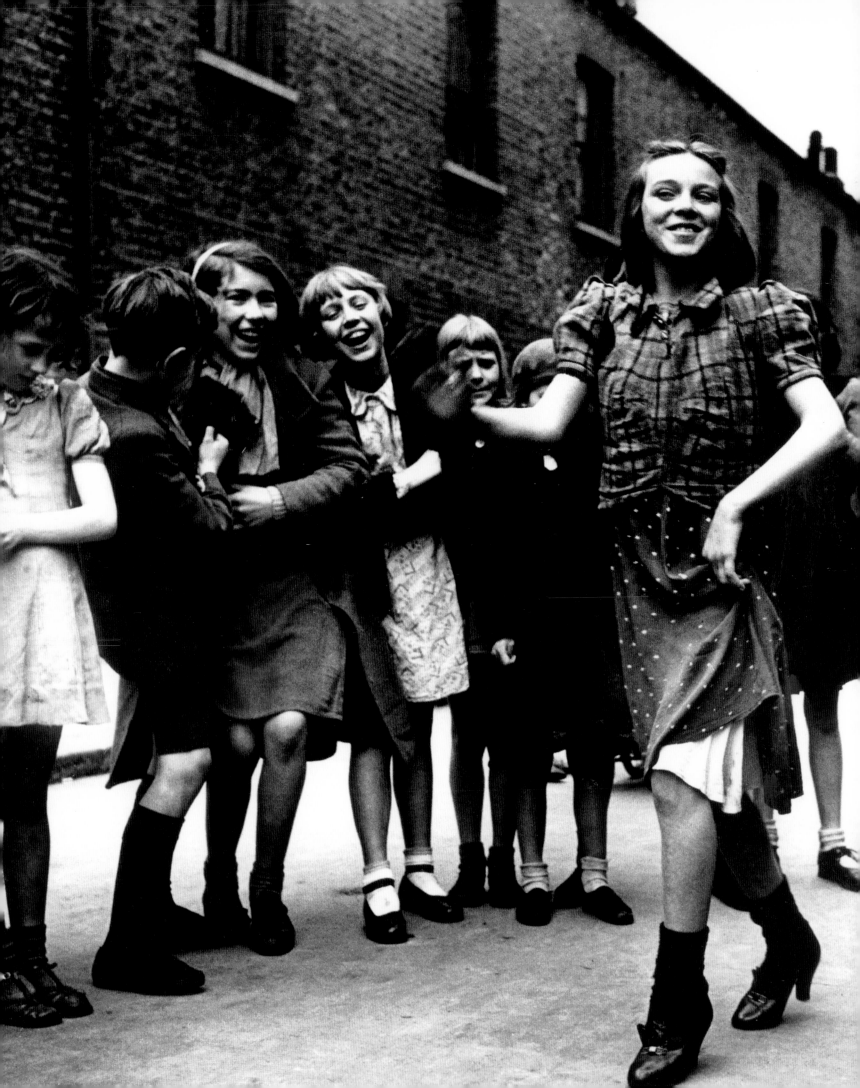

BRANDT

THE PHOTOGRAPHY OF BILL BRANDT

Foreword by David Hockney
Introductory Essay by Bill Jay
The Career by Nigel Warburton

Harry N. Abrams Inc., Publishers

FOR NOYA BRANDT

Acknowledgements

For their encouragement in the preparation of this work I am indebted to Dorothy Bohm, Mark Hayworth-Booth,
John Szarkowski and Edwynn Houk. For the design and layout my thanks go to Roger Sears,
Martin Tilley and David Pocknell.

For their invaluable assistance in research I thank Stella Angelaki and David Allison of The Hulton Getty
Picture Library, Jacklyn Burns and Gordon Baldwin of the J Paul Getty Museum, Los Angeles, Pierre Richard
Bernier of the CCA Toronto, The Museum of London and The National Newspaper Archives.

My thanks also go to Bill Jay, Nigel Warburton, David Hockney and Paul Delany for their contributions.
And finally, I would like to thank David Scheinmann, Giles Sarson, Caspar Luard, Susan Towers and Jane Edden
for being there when they were needed most.

This book has been produced as a catalogue to accompany a new international travelling exhibition
'Bill Brandt: A Retrospective' which is circulated with the collaboration of Curatorial Assistance Inc, Los Angeles.

John-Paul Kernot, Bill Brandt Archive Ltd.
www.billbrandt.com

Photographic credits:
Page 60 courtesy The J Paul Getty Museum, Los Angeles
Page 77 courtesy Edwynn Houk Gallery, New York
Page 285 © Arnold Newman
Page 286 courtesy Laelia Goehr
Page 293 top left, courtesy Collection Centre Canadien d'Architecture / Canadian Centre
for Architecture, Montréal
The following are courtesy The Hulton Getty Picture Collection
Page 113, page 295 bottom right, page 298 top right, page 298 bottom left,
page 300 top right, page 305 top right, page 307 bottom left, page 308 top left

A Sears Pocknell book

Editorial Direction	Roger Sears
Art Direction	David Pocknell
Editor	Michael Leitch
Designer	Martin Tilley

Library of Congress Catalog Card Number: 99–73657
ISBN 0–8109–4109–0

Printed and bound in Germany

Harry N Abrams, Inc
100 Fifth Avenue
New York, N.Y. 10011
www.abramsbooks.com

1 East End, **1939** (previous page)

CONTENTS

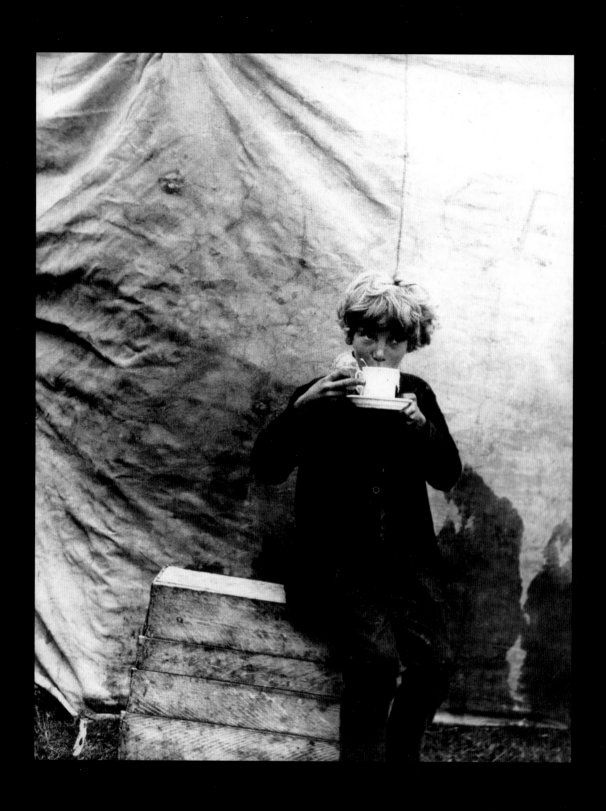

2 England, **1933**

"Bill Brandt made pictures of the North of England around the time I was born. They are carefully composed and seem to me very real. I say he made pictures (rather than take them) because he regarded the image as the important thing, rather than the purity of execution.
 His techniques understand the power of images. It's this that, for me, gives them their strength in a time when the photograph as documentary evidence is fading fast. They survive and enter the memory because they were constructed by an artist."

David Hockney

"The photographer must first have seen his subject, or some aspect of his subject as something transcending the ordinary. It is part of the photographer's job to see more intensely than most people do. He must have and keep in him something of the receptiveness of the child who looks at the world for the first time or of the traveller who enters a strange country... they carried within them a sense of wonder..."

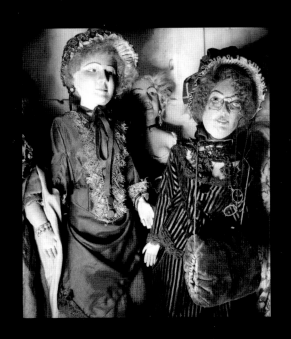

A CABINET OF WONDERS

A CABINET OF WONDERS BILL JAY

During the past couple of decades there have been many occasions when my student groups have asked me a similar question, the main thrust of which is this: if you had to select just one name from the whole history of photography as representative of all that is wonderful about the medium, who would it be? I do not need time for contemplation. I simply say: Bill Brandt. Trepidation accompanies this answer because I know what happens next - the students ask why. My stock response has been to point out the visual potency of his images, his readiness to explore new directions, his individuality bordering on eccentricity.

All those characteristics are true, but I am aware of their inadequacies. There are many other photographers to whom they could refer. I am tempted to add that the real reason for my love of Brandt's work is rooted in my sense of wonder, and that it continues unabated and undiminished after more than thirty years of looking at his images. I do not say this to the students, mainly because it is too abstract. The most important aspect of Brandt's work - its ineffable mystery - thus remains unstated. Mystery might seem an odd choice of a word to the first-time viewer of these pictures, when the photographs are clearly and unmysteriously of something identifiable, but I believe a full appreciation of them is not possible without the willingness to wonder.

Inherent in Brandt's oeuvre, viewed in its totality, is just that element of wonder that

inspired the *Kunst- und Wunderkammern*, or Art and Wonder Cabinets, which were rampant throughout Europe around the beginning of the seventeenth century. These cabinets of curiosities, the first museums, contained anything that was startling, different, new, unlikely, amazing or odd. Francis Bacon wrote in 1594 that the 'compleat' learned gentleman should compile:

'a goodly, huge cabinet, wherein whatsoever the hand of man by exquisite art or engine has made rare in stuff, form or motion; whatsoever singularity, chance and the shuffle of things hath produced; whatsoever Nature has wrought in things that want life and may be kept; shall be sorted and included.'

The 'wonder' of these cabinets referred not only to the objects displayed but also to the state of mind of their viewers. And it is the latter which is in danger of being swamped by the specialisations and determinism of the modern world. Today, eclecticism is out and museums have been broken up into specialised interests: natural history, art, technology, freak shows, photography...

The history of photography, itself a specialisation, has not been immune from further categorisations. We only have to read contemporaneous accounts following the invention of the medium in 1839 to discover wonder bordering on ecstasy; we only have to look at the state of the medium today to know

that its products are divided into neat but artificial categories, such as fashion, industrial, advertising, wildlife, photojournalism, portraiture, fine art, and many others. Micro-divisions proliferate within each category, so much so that no photographic museum I can think of would collect or even exhibit images which depart too widely from its own notions of micro-speciality.

Bill Brandt's body of work defies such fragmentation, rejects certainties, and returns us to the rich eclecticism of the Cabinet of Wonder. His images are eclectic, not easily categorised, contain strange juxtapositions, instill doubt and confound prejudice with its attendant assurances.

This book and its images hold part of the *Kunst- und Wunderkammern* which Brandt collected assiduously during his lifelong obsession with life's marvels. When you gaze at its pages, contained in the cabinet of its edges, you have left behind the raucous intrusions of the everyday. Your first sight confirms what is already known: that is what a miner, a street, a bird's nest, Stonehenge, a parlour-maid, a pub interior, a house by moonlight, Peter Sellers, looks like. But not quite. Reality has been shifted, manipulated, dislocated into something else. The photographer has dared to tamper with what we think of as truth. Doubt at authenticity - the end of assurance - begins to oscillate towards the beginning of knowing new, potentially more important truths. We wonder if Brandt is recording things as they are or wonder at the image disconnected from what it represents. 'Wonder' has two meanings: the 'I wonder...' of self-inquiry and the passive acceptance of a marvel.

I remember my first meeting with Bill Brandt, at which I tried to interview him and elicit some clarification of disputed facts in his biography. I itemised these contradictions and stated that they had been variously reported. 'Yes,' said Brandt. He was merely agreeing that contradictory facts had indeed been written about him. I waited for him to clarify. I would have to wait for ever. 'Will you tell me the truth?' I asked. In his slow, carefully modulated manner, he said 'No.' 'Why not?' I blurted. I wanted to know. 'It is not important,' he said firmly, 'just look at the pictures.' Dead-pan.

Brandt, I realised later, wished to shift me away from the quest for 'facts' and to divert me towards the inner qualities of his photographs. Let me quote from just one of his writings:

'The photographer must first have seen his subject, or some aspect of his subject as something transcending the ordinary. It is part of the photographer's job to see more intensely than most people do. He must have and keep in him something of the receptiveness of the child who looks at the world for the first time or of the traveller who enters a strange country... they carried within them a sense of wonder...

I believe this power of seeing the world as fresh and strange lies hidden in every human being. In most of us it is dormant. Yet it is there, even if it is no more than a vague desire, an unsatisfied appetite that cannot discover its own nourishment. I believe it is this that makes the public so eager for pictures. Its conscious wish may be simply to get information. But I think the matter goes deeper than that. Vicariously, through another person's eyes, men and women can see the world anew. It is shown to them as something interesting and exciting. There is given to them again a sense of wonder...

We are most of us too busy, too worried, too

intent on proving ourselves right, too obsessed with ideas, to stand and stare. We look at a thing and believe we have seen it. And yet what we see is often only what our prejudices tell us to expect to see, or what our past experiences tell us should be seen, or what our desires want to see. Very rarely are we able to free our minds of thoughts and emotions and just see for the simple pleasure of seeing. And so long as we fail to do this, so long will the essence of things be hidden from us.[1]

In my opinion these words contain the truest and most beautiful ideas in the whole literature of photography.

The degree to which Brandt has been misunderstood can be assessed by a simple experiment which I often conduct. I trawl through a written article and jot down the prevalence of key words. From the essay by Bill Brandt quoted above, I jotted down words like: magic, spell, fantasy, weird, excitement, discovery, emotional response, interesting, pleasure, curiosity, awareness, drama, atmosphere, fresh, strange, exciting and wonder. Many of these words occurred several times.

A similar trawl for words through my file of articles about Brandt by critics produced a vastly different sense. Predominant words included: melancholy, angst, wariness, joyless, stricken, far from benign, harsh, dark, ominous, brooding, dour, forlorn, haunted, claustrophobic, desperation, lugubrious, terror, terrible, morbid, Poe-like. Critics waxed lyrical in their description of Brandt's work of 'places of desperation and meagre pleasures', 'heavy with age and darkness',

'haunted by the ghosts of slaughtered Picts', coated with coal dust and the grime of history'.

These typical reactions to Bill Brandt's images, and their vastly different tone from Brandt's own stated intent, may come as a surprise to contemporary viewers, who have assumed his greatness and therefore presumed the reason for his genius has always been recognised by critics. Unfortunately such presumption would not be accurate, and it is relevant to ask the reason.

In the early 1960s, Brandt was still regarded as the 'English hermit', closeted in his private world producing the occasional disturbing image. The photographic world was a vastly different place; it was a narrow peninsula with only one road - stray from the straight and narrow conventions of what constituted a 'good' photograph and you were lost.

Now, pluralism is the rule, a *laissez-faire* acceptance of a bewildering variety of styles, processes, presentations and intents, all of which co-exist in a state of equality and equanimity. It is difficult to comprehend the state of serious photography in Britain a mere thirty-plus years ago: no exhibition galleries willing to show photographic prints with any regularity; few art colleges suffusing the students with art ideas; no art museums collecting the best of the medium; very few magazines or books devoted to the art of the camera; no grants or awards for the photographer. The outlets for serious photography did not exist and the future looked bleak - except in one public arena: illustrations for newspapers and magazines. And that implied a social conscience and that the camera should be aimed at the poor, dispossessed, alienated and forgotten. Producing a social record was

[1] Quoted from Bill Brandt's introduction to his book *Camera in London* (Focal Press, London, 1948).

presumed to be the one true function of the medium. The only option for the photographer was one of style, within very narrow limits: the cool formalism of Henri Cartier-Bresson or the hot drama of W Eugene Smith. These two photographers set the acceptable range of permitted photographic responses, and even then debate raged over the permissibility of Smith's penchant for rearranging the scene, introducing artificial illumination and fussing with the print in the darkroom.

When I was picture editor of the *Daily Telegraph Magazine* in the late 1960s, it needed a new portrait of J B Priestley. I suggested we used Bill Brandt as the photographer. Brandt's reaction was warm and quick. He rushed down to Priestley's home and within a couple of days had delivered a magnificent portrait. The reaction from the *Telegraph* darkroom staff was equally quick but not as warm: 'bloody awful picture, a travesty of printing, too contrasty, give me the neg and I'll show you how it should be printed'. Verbal battles were fought. I lost, and the editor told me to contact Brandt and get him to make a softer print! He generously agreed - on one condition: his name must not be attached to the print in any way. The second print arrived, and it was a terrible travesty. Eventually the *Telegraph* agreed to use the original print - but only as a tiny single-column image swamped by a sea of text.

Meanwhile Brandt was having his own problems with the same portrait. He had sent a print to J B Priestley, a personal friend until that point. Priestley wrote back.

'Thank you for sending me a print of my portrait. It is quite horrible. It makes me look like a Chinese murderer in a UFA film of the early 1920s. It might be called "The Photograher's [sic] Revenge", though from what injury I cannot imagine. In your conscious mind I may figure as a fairly nice chap, but from the evidence here your unconscious hates my guts.'

I was involved in a similar fight over Brandt's work on publication of *Perspective of Nudes* in 1961, when I was a junior member of the staff of a photography magazine.

A review copy arrived in the office. The editors were unanimous that the pictures were so awful that the photographer must be perpetrating a confidence trick on the medium. I fought hard to get it into the magazine - and only managed to include two images, and then only because the editors saw the merit of free reproductions. But their reaction was not atypical. The editors of *Popular Photography* in the USA produced a symposium review. The first of these was by Les Barry, who believed that the whole thing was a 'gag' and found it 'impossible to accept the concept that this collection of poorly printed, ineptly cropped photographs of badly posed, unattractive women is his idea of a serious work'. He facetiously ended his review by stating that 'Brandt is to be commended for his sense of humour, and complimented for successfully putting over this hoax.'

Oh, how pure we were! How rigid, how inflexible in our tenets of correctness. Bill Brandt would have none of those rules and regulations. There are no rules, he said, photography is not a sport. 'Photographers should follow their own judgment, and not the fads and distastes of others,' he wrote. 'Photography is still a very new medium and everything is allowed and everything should be tried.'

No wonder he was misunderstood: he would not conform.[2]

Bill Brandt's images could only belong to the mainstream, albeit tentatively and with reservations, if the viewer was selective. Yes, his early pictures of the class system of England were acceptable, and perhaps the pictures of the Northern towns during the Depression could be considered as documents, if we viewed them through a narrow slit which masked out what is different about them. But the nudes?

Yet it is Brandt's differences which now distinguish him as one of the greatest artists the medium of photography has yet produced. He must have possessed great moral courage and single-minded conviction to continue pursuing his unique vision in the face of such blinkered and myopic stereotyping.

The sources of his convictions remain a mystery; the sources for his photographic distinction can be seen. Imagine a typical Brandt image resting on the platform of a tripod, each leg of which is firmly planted in a separate and seemingly contradictory approach to the medium. Brandt's genius, and the source of his uniqueness, is that he combined the three main trends of photography of his age into a symbiotic fusion. Yes, he was a documentary photographer, but he was also a pictorialist and a surrealist, and it is worth discussing these three attitudes to photography and how they were employed by him.

The term 'documentary' is a contentious one because its meaning to photographers has changed quite drastically. In the nineteenth century, for example, it would have denoted someone who photographed documents, sheets of paper, portfolio pages and manuscripts. It was not until the 1930s that it was used for photographers who took pictures of real life - and even then it was specifically applied to photographers who approached their subject matter with a subjective, personalised passion; it implied advocacy, even propaganda (if the word is shorn of its derogatory connotations).[3] By the 1950s, the term 'document' acquired its present meaning of an objective, even bland, record in which the subject has such primacy that the person who made the picture is to all intents and purposes irrelevant. It is this objectification of the subject, however, which is at the root of photography's origins.

The idea of photography (as opposed to its invention) arose during the Renaissance. It was in Italy during the fifteenth century that a massive shift in consciousness took place with immense ramifications for the remainder of history until the present day. This cannot be exaggerated. For the very first time the purpose of two-dimensional representations suddenly changed from symbolism to mimesis; art underwent a profound change from ritualised images to those that mimicked the vision of the human eye. The aim of art was now the duplication of the appearance of reality.

[2] When other writers have quoted this sentence, the word 'distastes' has invariably changed to 'dictates'. Perhaps correctly. However, when Bill Brandt sent me his original manuscript, he had made several corrections by hand to grammar and spelling - but 'distastes' had been left intact.

[3] The term 'documentary' was first used in this sense by the film-maker John Grierson, who soon led a team of committed cinematographers to produce some of the most compelling propaganda films on behalf of the Allies during the Second World War.

As Leonardo da Vinci proclaimed:

'The most excellent painting is that which imitates nature best and produces pictures which conform most closely to the object portrayed.'

Erwin Panofsky, the renowned art historian, wrote:

'...the Renaissance established and unanimously accepted what seems to be the most trivial and actually is the most problematic dogma of aesthetic theory: the dogma that a work of art is the direct and faithful representation of a natural object.'

The culmination of this quest for faithful representation of reality in two dimensions was the invention of photography in 1839. No other invention in the history of science prompted such excitement. At last, here were depictions of the real world which were trustworthy and could be used as evidence, and the veracity of which was unquestionably superior to any representation which relied on the skill of the maker with an unknown agenda. Allied to the later ability of newspapers and journals to reproduce photographs alongside text, beginning in the waning years of the nineteenth century, this veracity created a powerful new weapon of persuasion, for good and ill. Social problems, made emotionally potent through the pictures, were brought to the attention of millions. As picture-journals flourished, they became the single most reliable source of income for serious photographers.

Bill Brandt earned his living as a professional photographer from such periodicals. His photographs of coal-miners, maids, working-class children, bookies, society matrons, *et al*, were all commissioned for and/or used in periodicals such as *Picture Post*. In this context the photographs were intended to depict the reality of the subjects' lives, not the creative abilities of the photographer. Indeed, *Picture Post* did not even provide the photographer's name alongside the image. The subject was not only important, it was paramount; the photographer was invisible, a mere ambulatory camera-carrier.

In recent decades the word 'pictorialism', the second leg of our tripod, has become associated with attendant adjectives such as 'trite', 'banal' or 'sentimental', and with cliché-ridden subject matter such as sunsets, big-eyed children, fluffy animals, wrinkled-skin character studies and idyllic landscapes composed with conformity and predictability. With justification. But it is worth bearing in mind that during Brandt's formative years of the 1920s, pictorialism was a relatively new idea which seemed charged with potential.

Since the invention of dry-plates, photography had been dominated by high-street portrait studios and hordes of indiscriminate snap-shooters. Photographers who were serious about their medium as a means of personal expression were anxious to disassociate themselves from both camps. They began to explore alternative processes, producing prints which looked as different as possible from both the professional 'glossies' and the small, badly-crafted images of the amateur. They wanted to be taken seriously as artists. Although both craft and process were important ingredients in this quest, the most important idea of the pictorialist was that the primary purpose of the image was to reveal strongly felt emotion, by any means available. Above all, mood became the subject

matter, irrespective of the object portrayed, whether it was a church or a nude. In their zeal for feeling, content was often diminished to the point of non-existence, a classic example of throwing out the baby with the bath-water. But the goal was laudable (after all, photography is a picture-making medium) even if the means were sometimes suspect.

Bill Brandt was breathing this air of pictorialism while working as a documentary photographer. His photographs are not only records of people and places but are also suffused with the emotional content of pictorialism, or, as Brandt himself affirmed, with 'atmosphere'.

'...I found atmosphere [Brandt's emphasis] to be the spell that charged the commonplace with beauty... it is a combination of elements... which reveals the subject as familiar and yet strange.'

As the following text makes clear, 'atmosphere' for Brandt was synonymous with drama and emotion - ideas at the heart of pictorialism. This too was Brandt's goal, so to intensify the atmosphere that 'I can thus most effectively arrest the spectator's attention and induce in him an emotional response to the atmosphere I have tried to convey.'[4]

The difference between Brandt and most pictorialists of the day is not in the emphasis on mood or emotion but in the origin of the 'atmosphere'. For the pure pictorialist it resided in rules of composition, an emphasis on prescribed lighting and formulaic processes, on rough papers and muddy printing, on marks of the human hand. For Brandt the atmosphere was embedded in, for example, a room's past association with the humans who lived in it, instancing the almost mystical belief that traces of human emotions linger in objects which can be augmented by the photographer until they burst through the surface of the picture. These traces are the picture, Brandt wished us to believe, and they lie dormant everywhere, ready to be discovered beyond and below surface appearance. In other words, Brandt was also toying with surrealism, the third leg of our tripod.

Ask half a dozen art historians for a description or definition of surrealism, particularly as regards photography, and you are likely to receive as many different answers. The exact nature of this movement is unclear even today - and this should be expected, emphasising as it does the irrational. The catalogues of the two major exhibitions of surrealism in photography of recent decades pointedly declined to include any clear definitions.[5]

But what is clear is that surrealism suffused the world of art (and photography) during the late 1920s, just at the time when Brandt was most susceptible to influence and just in the place, Paris, where surrealism was most strongly felt. Although the origins of the movement are open to conjecture, they were given substance in Andre Breton's 'First Surrealist

[4] Interestingly, Brandt goes on to differentiate between subjects which hold atmosphere (such as a room interior) and those that do not. In the latter case he singles out 'a close-up of the heart of a cabbage'. This is such a specific example that I have often wondered if he was referring to Edward Weston and his series of vegetables, which included a halved cabbage.

[5] See *Photographic Surrealism* (New Gallery of Contemporary Art, Cleveland, Ohio, 1980); *L'Amour Fou: Photography - Surrealism* (The Corcoran Gallery of Art, Washington, DC, 1985-6).

Manifesto' in 1924. When most lay people today think of surrealism, the images which the mind perceives include strange juxtapositions of found objects colliding in photographic montages and collages or as bizarre effects created by optical/chemical manipulations. And such works exist in enough quantity and with enough distinction in appearance to be instantly tagged 'surreal'. More problematic for the critics and historians is the fact that the primary interest of the surrealists was the veracity of the straight document. Art historians, bemused by this fact, have declared that surrealism 'challenged matter-of-fact realism' or asked how 'surrealist effects can be obtained in a medium devoted to the real'. They miss the point. Assumption of the real is essential to surrealism: it harnessed the veracity of the document in order to point to the strangeness of reality itself. Old subjects became surreal when seen as symbolic of a new, more intense, reality lurking below the surface appearance. Tristan Tzara, one of the founders of the surrealist movement, talked of the juxtaposition of 'everyday reality with spiritual reality', a notion which Bill Brandt recognised so clearly. And no statement of the aims of the movement could be more lucid, or succinct, than Breton's own remark that 'surrealism is contained in reality itself'. This, indeed, is why the surrealists could embrace such an unassuming document-maker, Eugène Atget - the least 'artistic' of Paris photographers - as a kindred spirit.

Bill Brandt was not only well aware of the surrealists, and of Atget, through his contacts at Man Ray's studio but also was living and breathing in a time when the very air was permeated with the spores of surrealism. He was, inevitably, infected by the mind-stuff of those times.

Brandt was certainly familiar with the surrealist publications, *Bifur*, *Variétés*, *Minotaure* and others, and with surrealist films such as Buñuel's notorious *Un Chien Andalou* and *L'Age d'Or*, 'which had a strong effect on photography', as Brandt noted. And not only on photography. Surrealism spread wildly and widely into the culture through mass-media outlets; contrary to popular notions, surrealism was not the prerogative of a handful of quirky artists in Paris. Its ideas quickly invaded the non-art fields of fashion, photojournalism, advertising, design and typography. It is ironic that Brandt's nudes have been used in advertising in recent years (for Levi jeans, 1993) because, when alive, he was scornful of fashion photographers who mimicked and appropriated his distortions for their own purposes so shamelessly.

When Bill Brandt writes about seeing the world 'as familiar yet strange' or marvelling at the 'spell that charged the commonplace', he is revelling in the surrealism of photography. This is particularly true of his nudes, photographed with an old wide-angle camera. 'I let myself be guided by this camera,' Brandt wrote, 'and instead of photographing what I saw, I photographed what the camera was seeing. I interfered very little, and the lens produced anatomical images and shapes which my eyes had never observed.' He then continues: 'I felt that I understood what Orson Welles[6] meant when he said "the camera is much more than a recording apparatus. It is a medium via which messages reach us from another world.'[6]

[6] Earlier in the same article, Brandt wrote about Welles's film *Citizen Kane*: 'The technique of this film had a definite influence on my work at the time when I was starting to photograph nudes.' Published in *Album* (No2, 1970).

Bill Brandt's tripod of influence is firmly rooted in the three major picture ideas of the age - documents, pictorialism and surrealism - all charging his work with potent and seemingly contradictory energies. Let it be admitted too that other photographers of Brandt's generation were not immune to these same influences.

Frederick Sommer, a photographer from Arizona and a friend of Max Ernst, was invited to exhibit at the International Surrealist Exhibition of 1947; Edward Weston's 1942 image of a woman lounging on a couch wearing nothing but a gas-mask is archetypically surrealist in effect; and so are many of the photographs by such disparate workers as Manuel Alvarez Bravo, Henri Cartier-Bresson and Cecil Beaton.

Pictorialism was also affecting non-art photographers with its emphasis on mood. W. Eugene Smith, for example, spent an inordinate amount of time in the darkroom in an attempt to imbue his prints with dramatic atmosphere. Indeed, it could be claimed with justification that every photographer of the 1930s and 1940s combined elements of the prevailing *Zeitgeist*. No-one - least of all image-makers - exists in a vacuum of ideas. Brandt was not unique in the fact of his influences; he was unique in that he utilised those influences so consistently to produce a potent amalgam of opposing forces.

No wonder Brandt's images confuse the critics and leave them baffled. How can you conveniently label a photographer whose work is an amalgam of such diverse influences? The very purpose of naming movements is to create divisions, to separate intents, to provide groupings with photographers of like minds. What do you do with a photographer who disrupts such conveniences and refuses to be boxed and filed with others? You declare him an eccentric, an anomaly. He is just too damned odd and difficult because he confounds expectations. He is the ultimate photographic Outsider, which is also precisely the reason why his work repays continual study, as many other photographers have discovered.

Bill Brandt may often have been misunderstood by the critics, but he was always deeply respected by other photographers. I might cite examples of his influence on the subsequent generation of British photographers, but two problems immediately surface: a list of names with commentary would be superfluous without accompanying images and, more significantly, the list would be longer than this Introduction.

The inescapable fact is that it would be difficult to find examples of photographers who were not influenced by Brandt.[7] Suffice to say, in the words of Owen Edwards:

'Ironically, Brandt is considered by many, myself included, as the quintessential British photographer of modern times. He influenced all but a few in the subsequent generations of English photographers, and his stamp rests indelibly on the imagery of his time and place.'

[7] For example, take a look at the excellent book *Young Meteors: British Photojournalism 1957-1965*, by Martin Harrison (Jonathan Cape, in association with the National Museum of Photography, Film and Television, London, 1998). The images by Graham Finlayson, John Bulmer, Philip Jones Griffiths, Don McCullin, Roger Mayne, Terence Donovan and Robert Freeman reek of Brandt's influence.

I cannot resist commentating on that opening word: 'ironically', because the remainder of Owen's piece is not at all complimentary. He states, for example, that 'Brandt's dark, manipulated prints were almost unrelievedly morose and finally downright morbid'.[8] The misunderstanding of Brandt continues. In Mr Brandt's Cabinet of Wonder, expectations are not confirmed; instead the real slips into the surreal and is charged by atmosphere, matters of surface fact blossom into fictions which turn again into truths. Wander around in his world for a while and reality will never again appear so obvious, or as comfortable, or so sure.

And that is why I trust Bill Brandt as a visionary - and why I believe his images, so redolent with the whiff of subversion and magic, hold secrets which can transform all our lives.

[8] Owen Edwards, normally one of the more astute and readable of American critics, wrote his review of Bill Brandt's exhibition at the Museum of Fine Art, Philadelphia, for *American Photographer* (November 1985).

"I had the good fortune to start my career in Paris in 1929. For any young photographer at that time, Paris was the centre of the world. Those were the exciting early days when the French poets and surrealists recognised the possibilities of photography. One could say that it was now that modern photography was born. Atget's work was at last being published, he had died almost unrecognised, two years before."

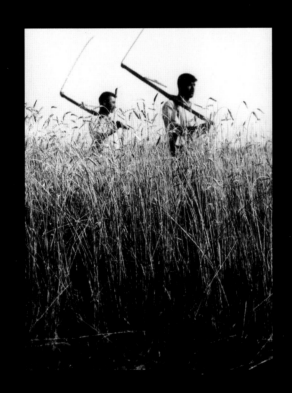

A EUROPEAN APPRENTICE

4 Hungary, **1933**

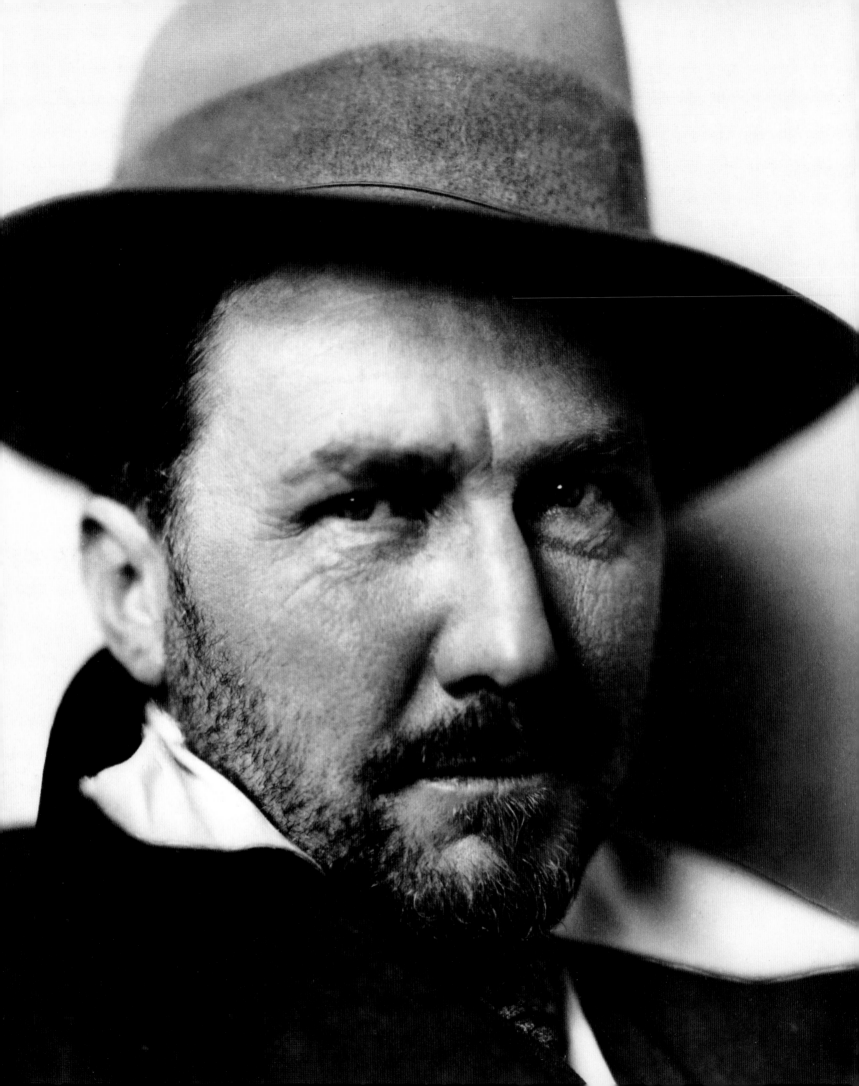

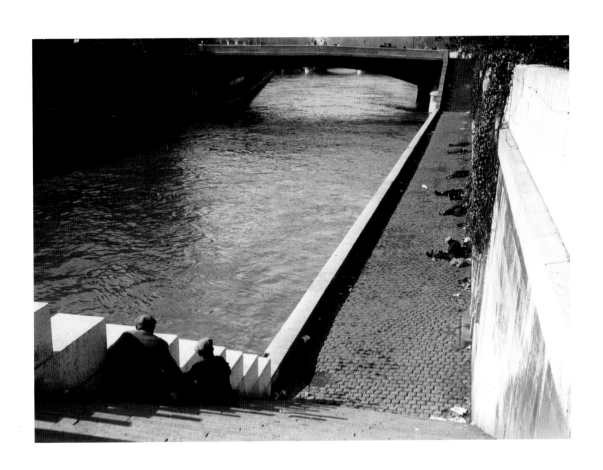

5 Ezra Pound, 1928 6 Paris, 1928

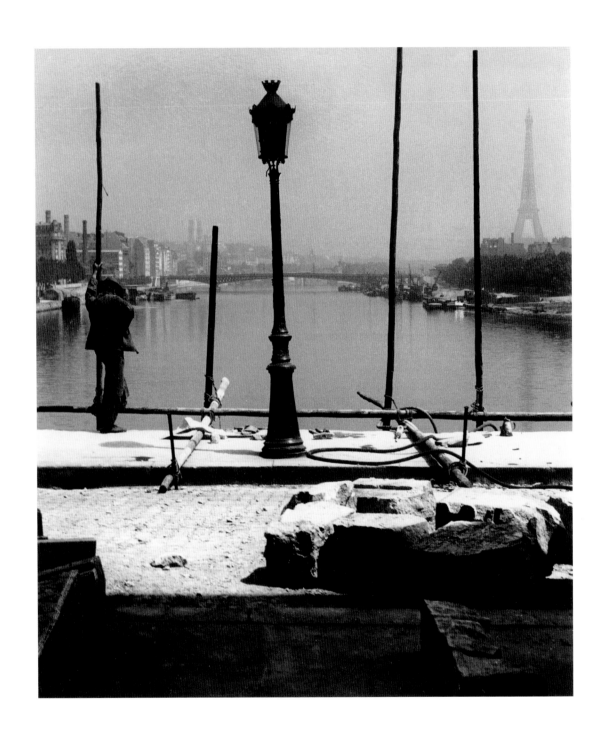

7 Paris, **1929**

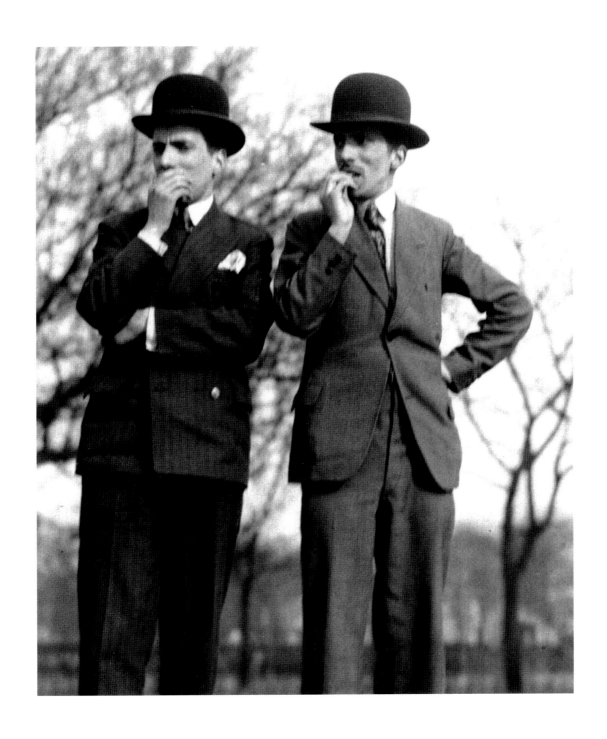

8 Paris, 1931

9 Hamburg, c 1930 10 unknown location, 1930's

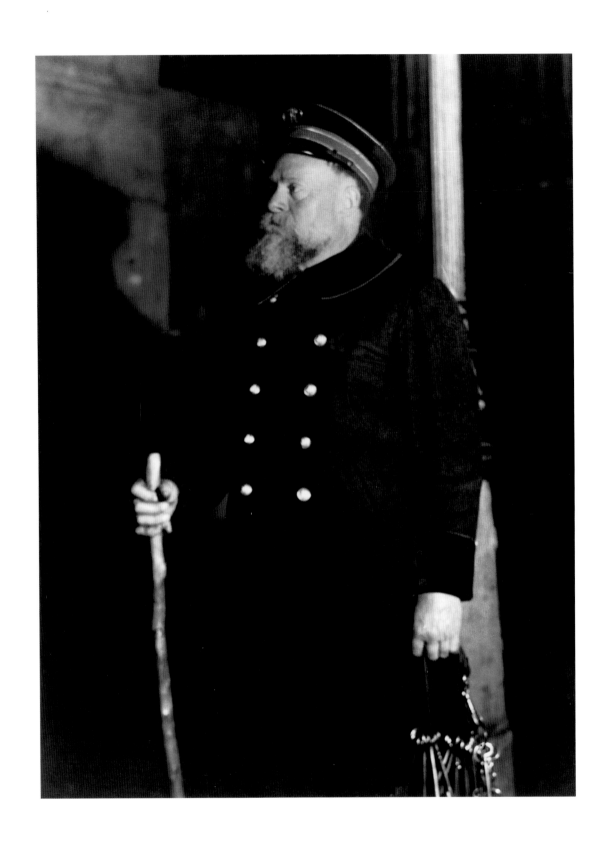

11 Barcelona, **1932** 12 Paris, **1928**

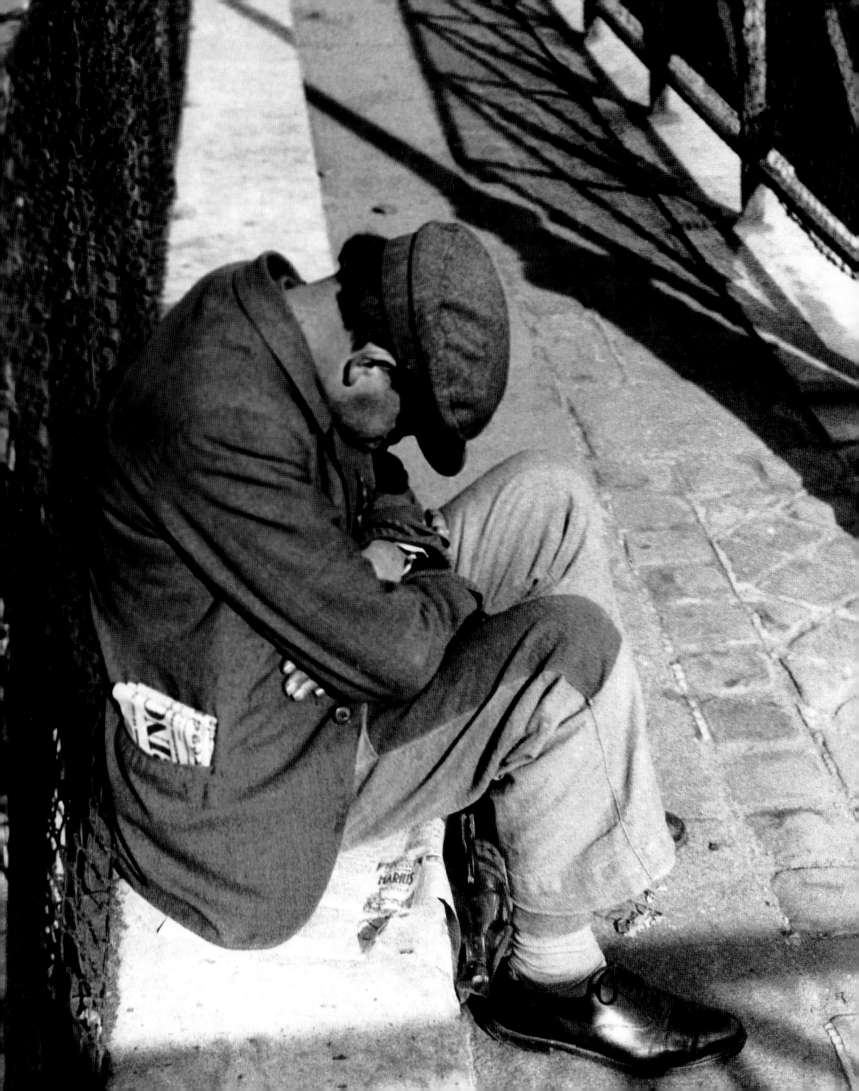

"A feeling for composition is a great asset. I think it is very much a matter of instinct. It can perhaps be developed, but I doubt it can be learned. To achieve his best work, the young photographer must discover what really excites him visually. He must discover his own world."

14 Seville, **1932** 15 Barcelona, **1932**

16 Hungary, **1933**

18 Barcelona, **1932** 19 Barcelona, **1932**

20 Hungary, **1933** 21 Hungary, **1933**

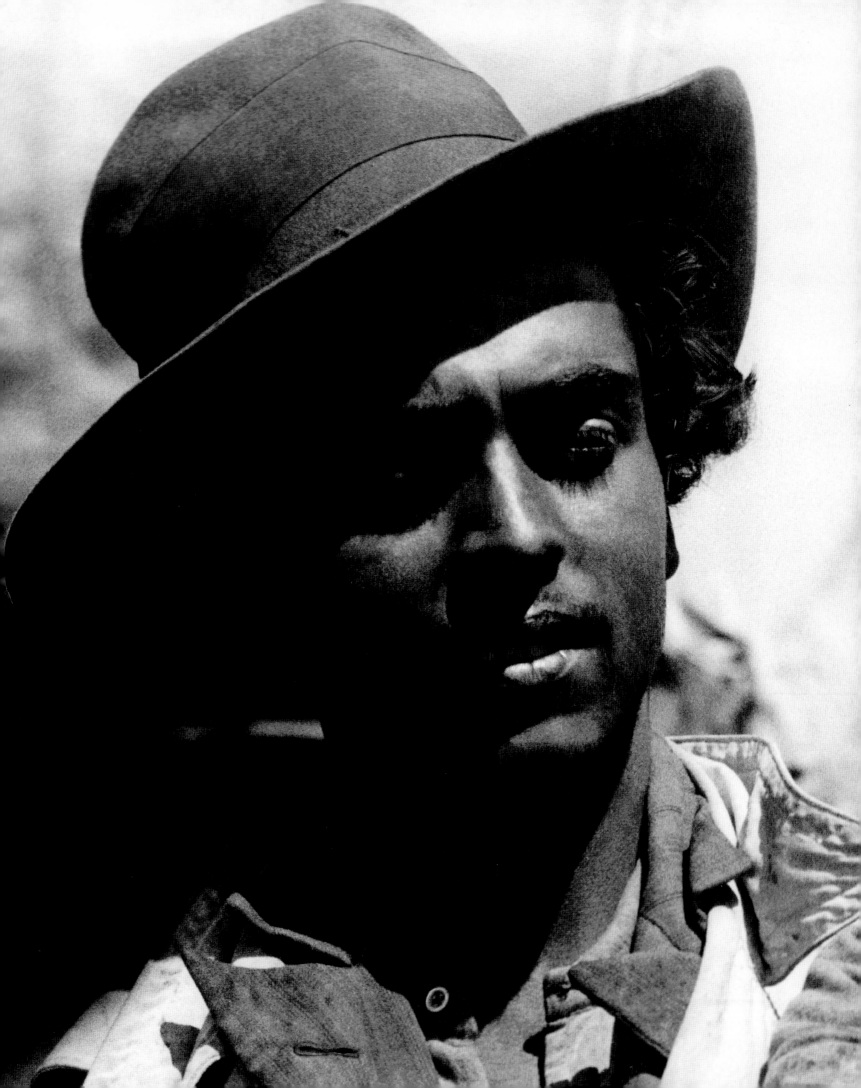

"The extreme social contrast, during those years before the war, was, visually, very inspiring for me. I started by photographing in London, the West End, the suburbs, the slums. I photographed everything that went on inside the large houses of wealthy families, the servants in the kitchen, formidable parlourmaids laying elaborate dinner tables, and preparing baths for the family; cocktail-parties in the garden and guests talking and playing bridge in the drawing rooms: a working-class family's home, with several children asleep in one bed, and the mother knitting in a corner of the room. I photographed pubs, common lodging-houses at night, theatres, Turkish baths, prisons and people in their bedrooms. London has changed so much that some of these pictures have now the period charm almost of another century."

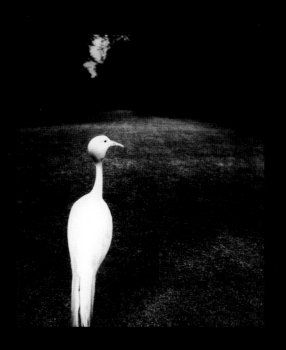

OBSERVING THE ENGLISH

22 Kew Gardens, **1930s**

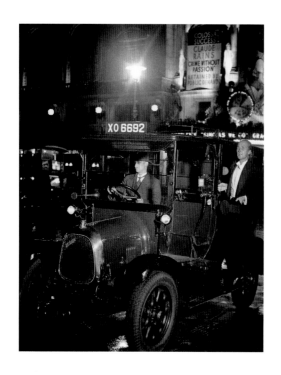 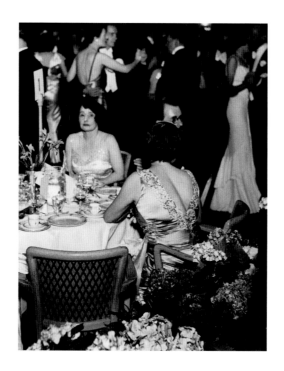

23 West End, **1934** 24 Mayfair, **1938** 25 London, **1934**

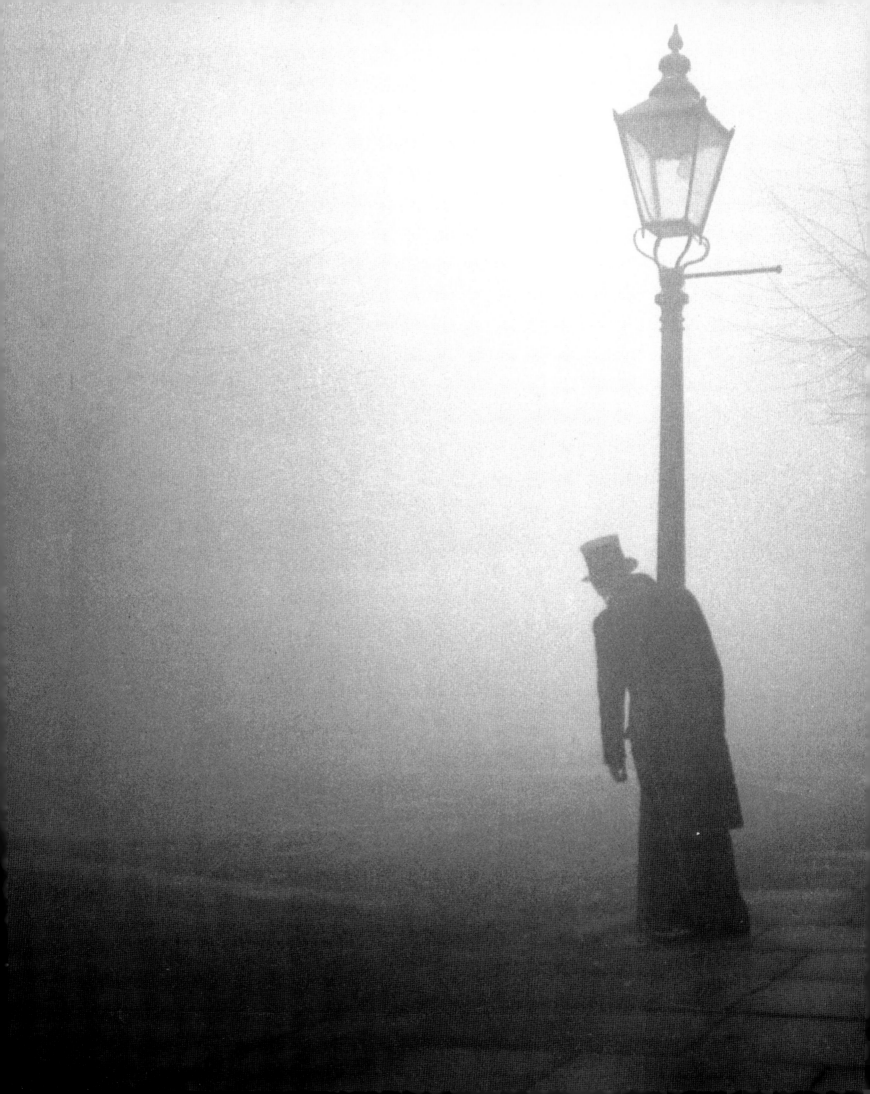

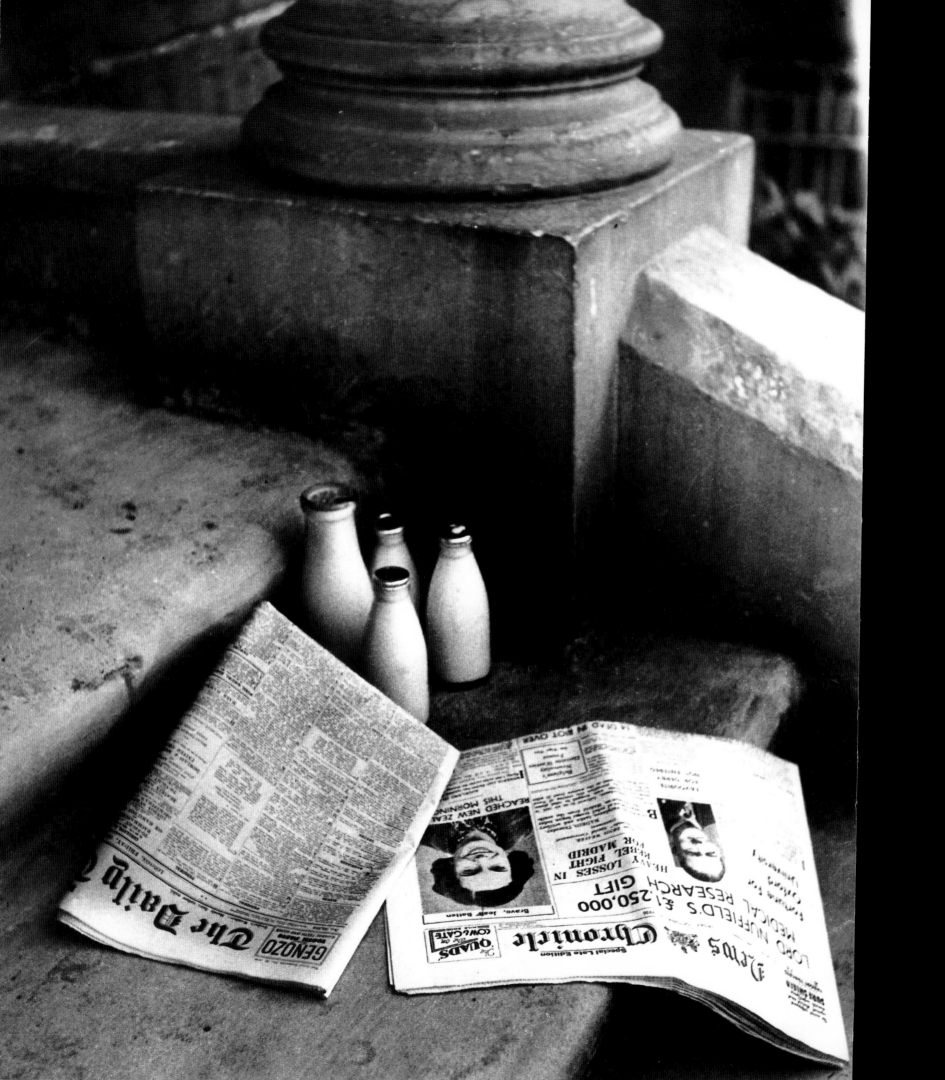

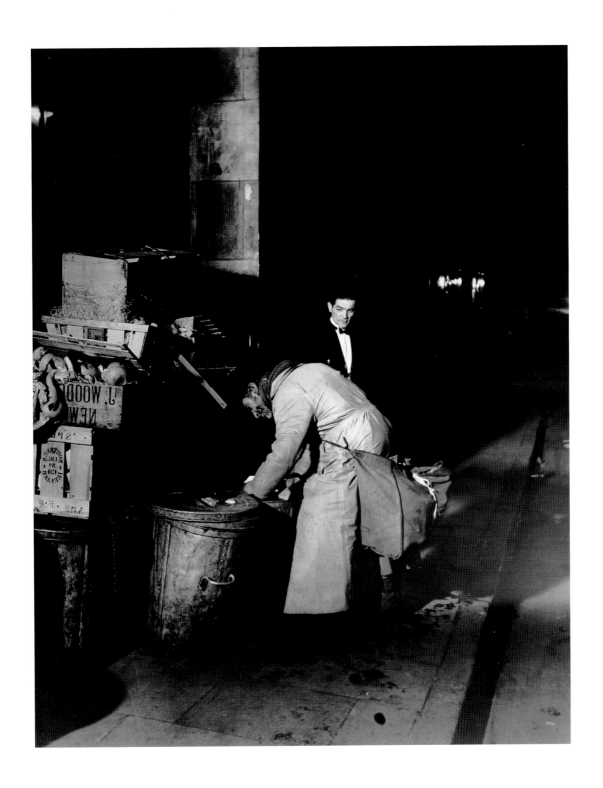

26 London, 1936 27 London, c 1937

28 Stepney, **1939** 29 East End, **1937**

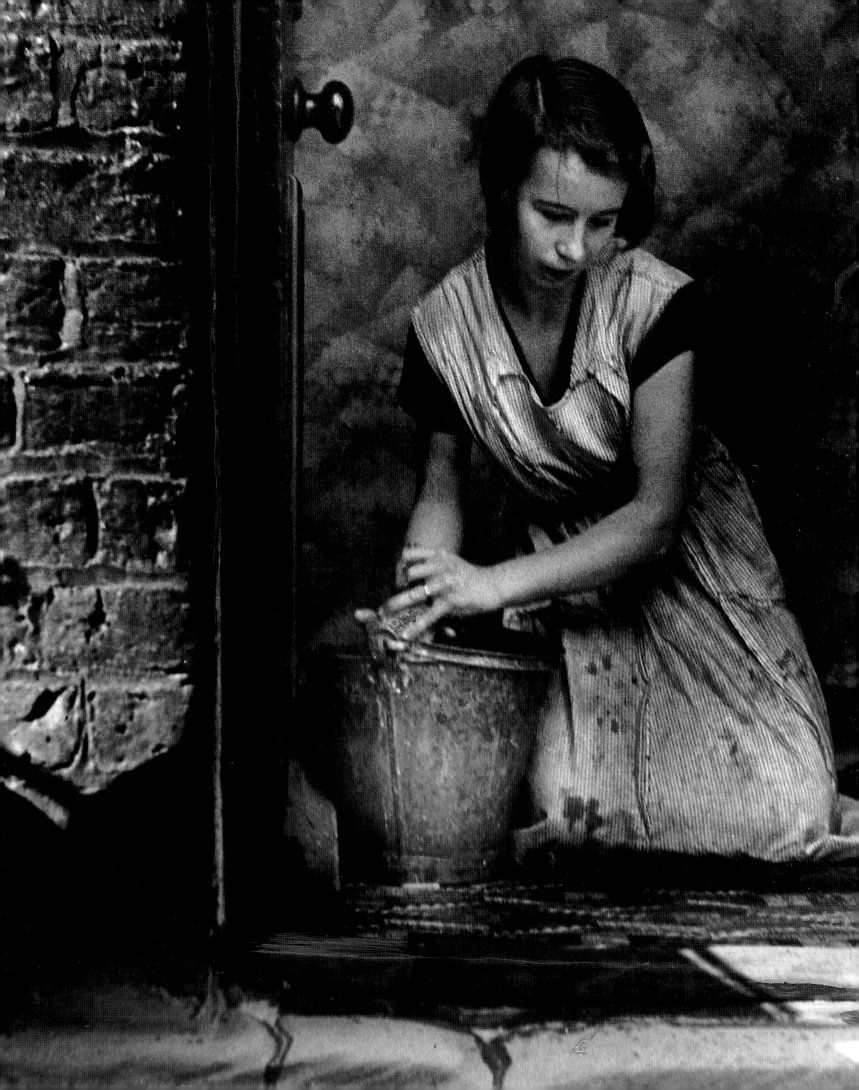

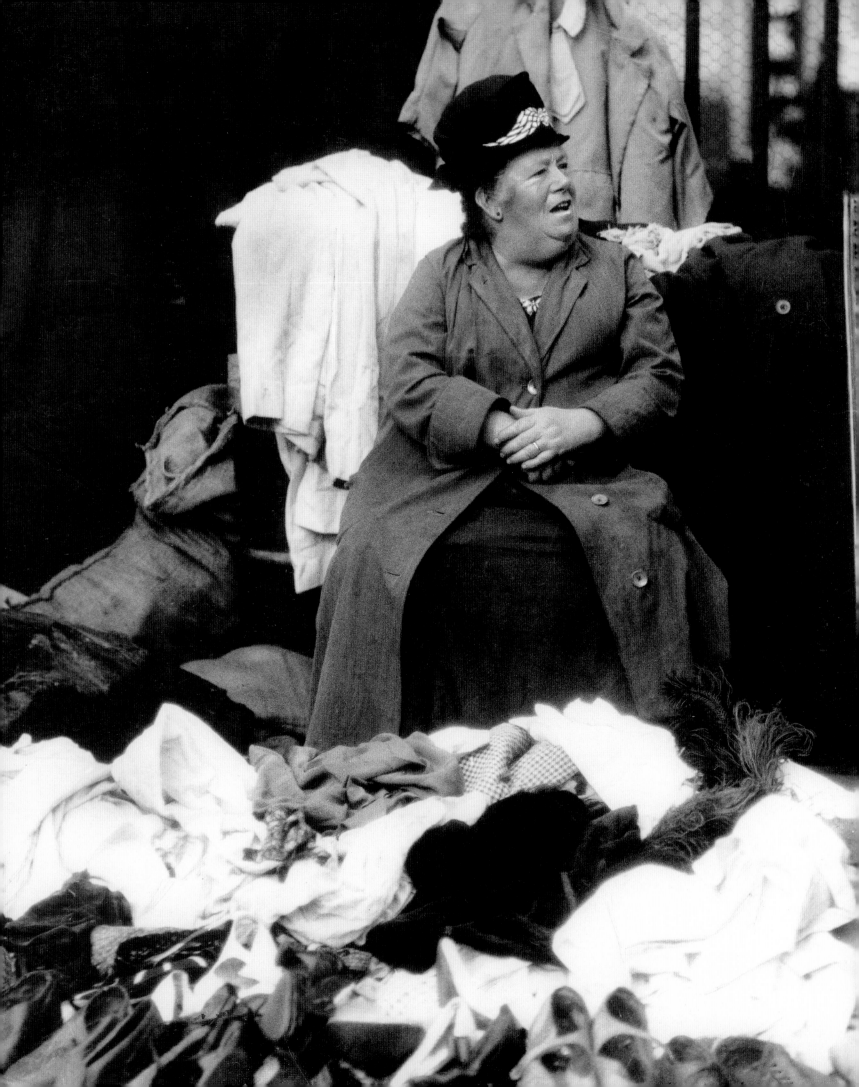

"Looking back now, one can see that already two trends were emerging: the poetic school, of which Man Ray and Edward Weston were the leaders, and the documentary moment-of-truth school. I was attracted by both, but when I returned to England in 1931, and for over ten years thereafter, I concentrated entirely on documentary work."

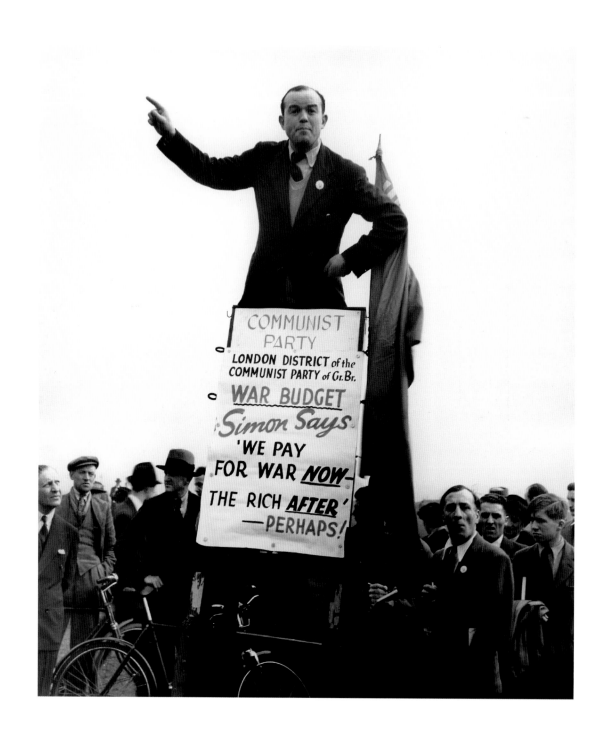

31 Hyde Park Corner, c 1940

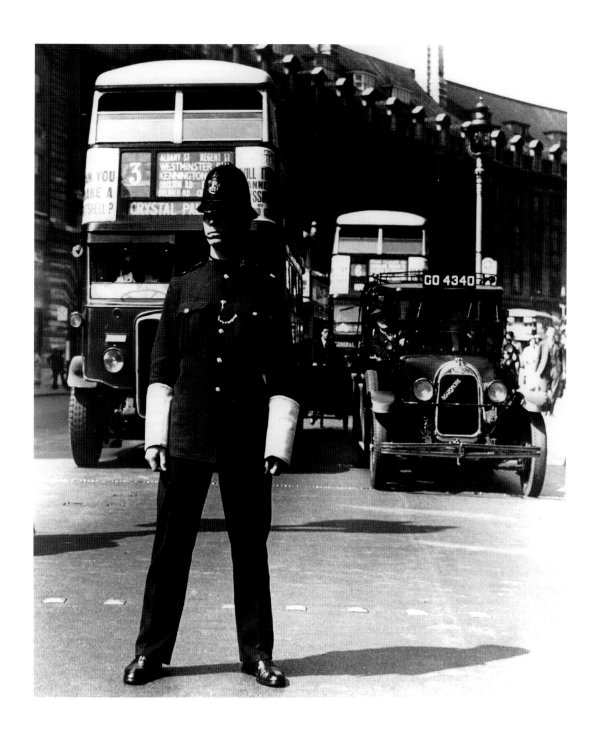

32 Piccadilly Circus, 1939

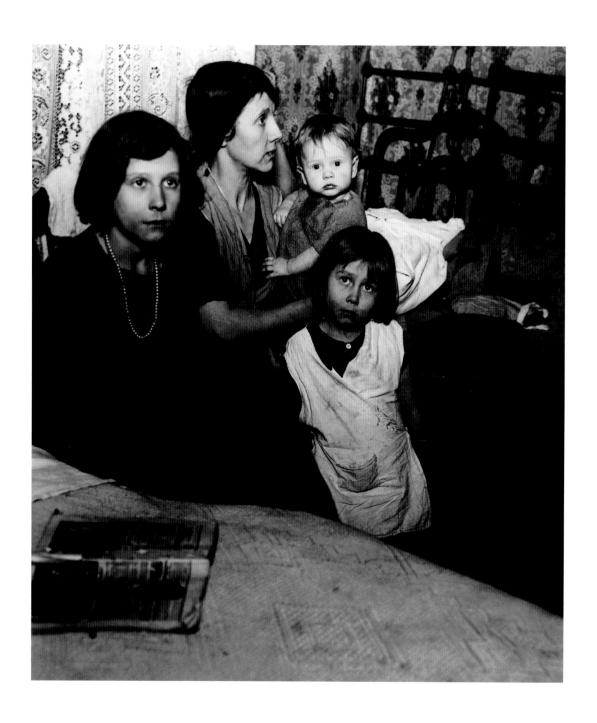

33 London, **1930s**

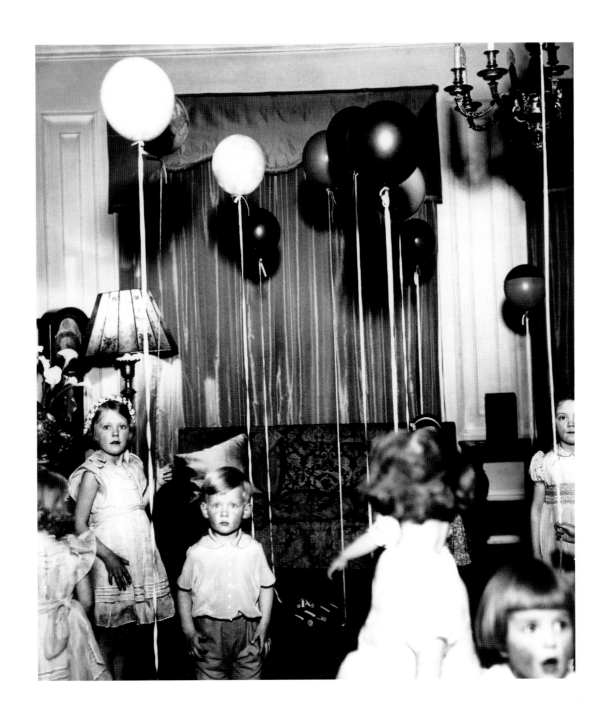

34 Kensington, c 1935

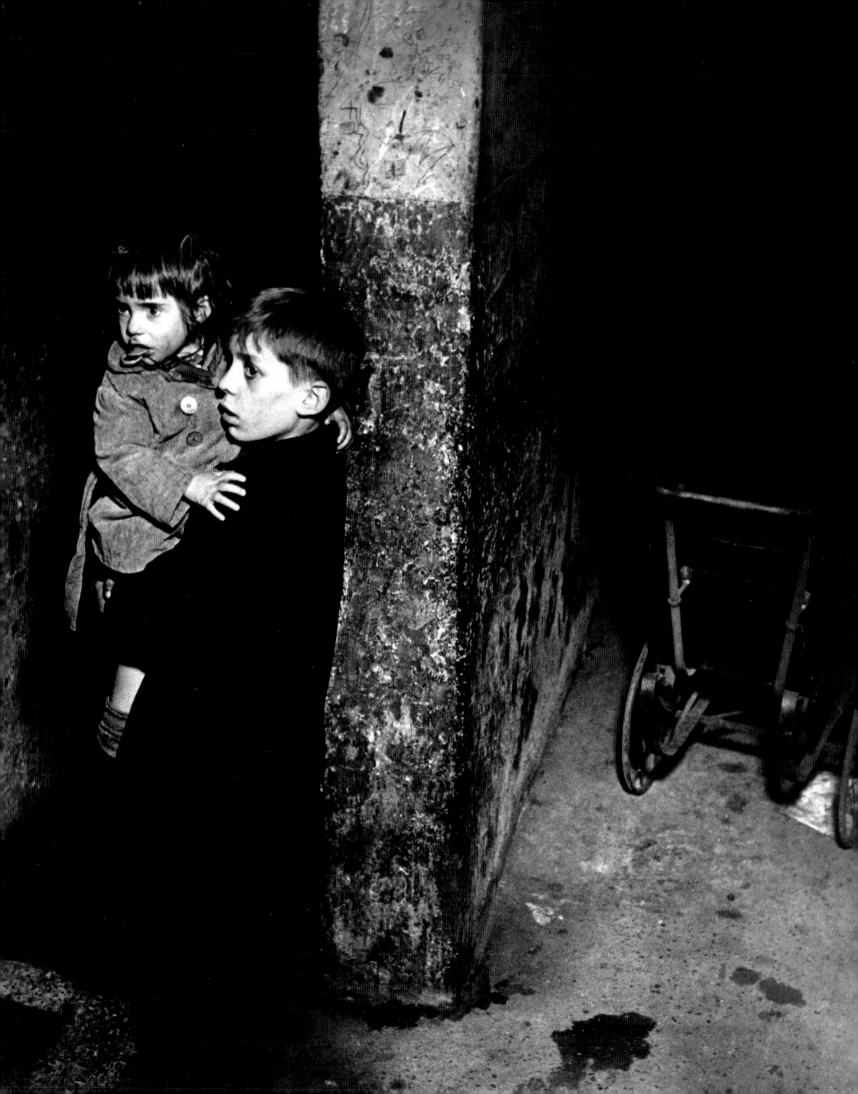

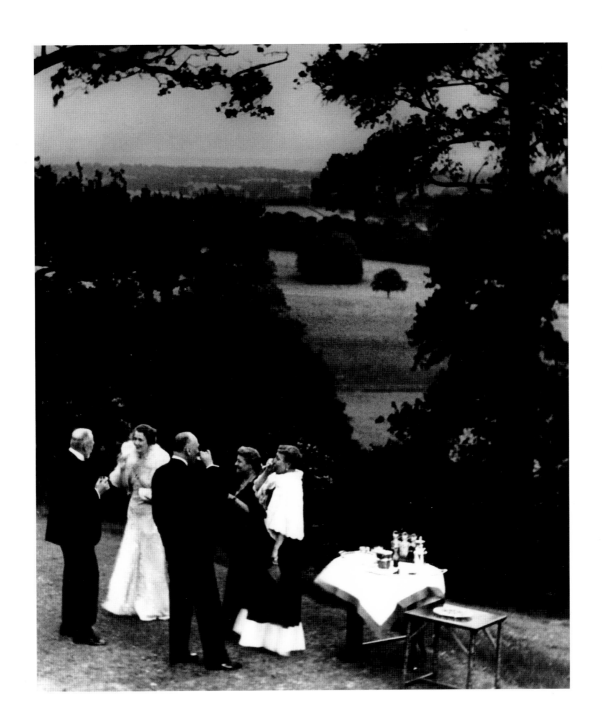

35 London, **1939** 36 Surrey, *c* 1938

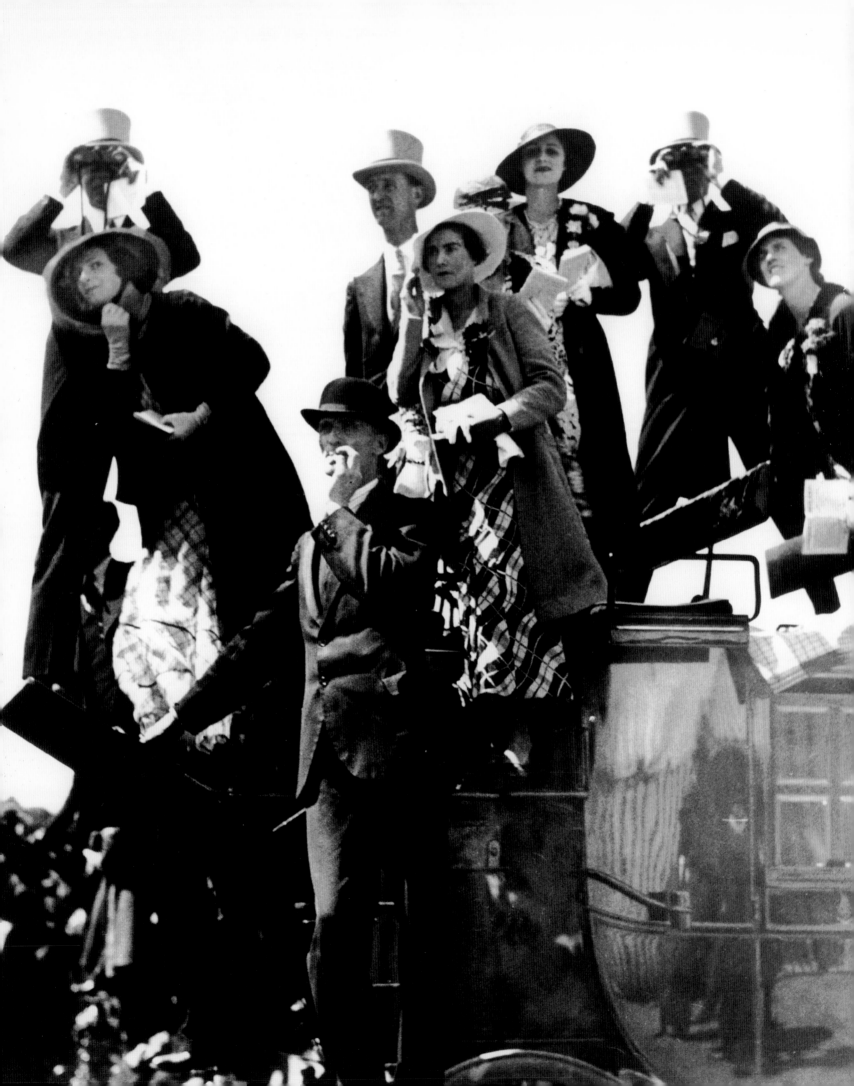

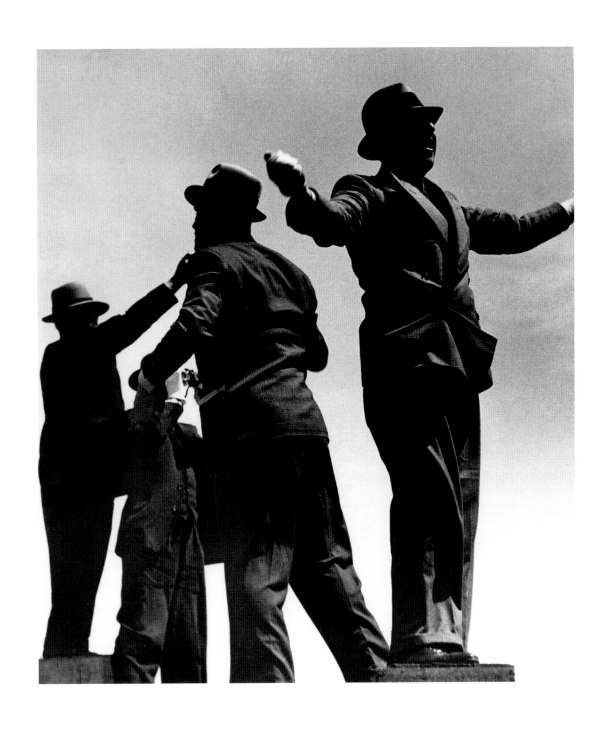

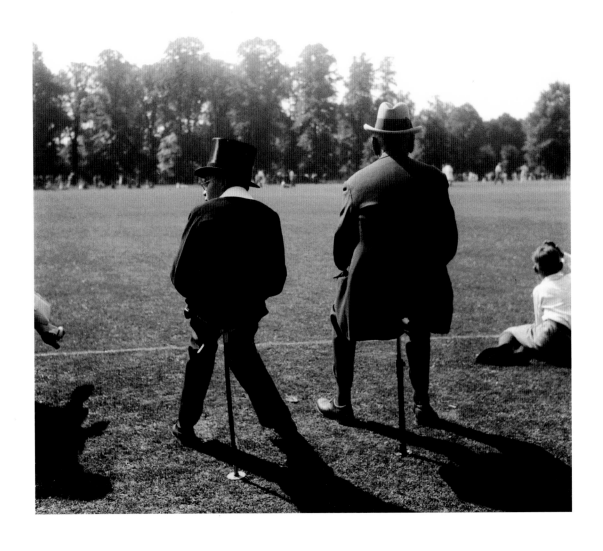

39 Eton, c 1935

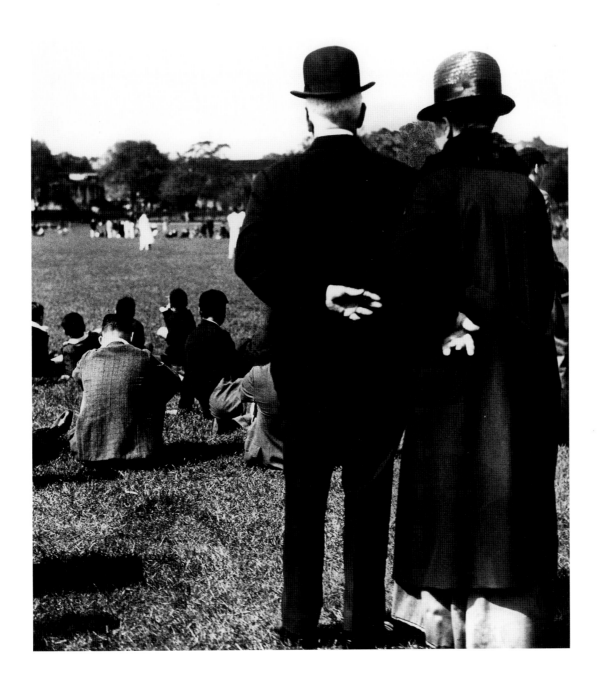

40 Regent's Park, **1936**

41 The *Queen Elizabeth*, **1946** 42 London, **1930s**

SAILOR

COX

LONDON

MEMBER OF
NATIONAL
B.P.A.
ALL THE NICE
GIRLS
BET WITH
SAILOR

COX

SAILOR

SA

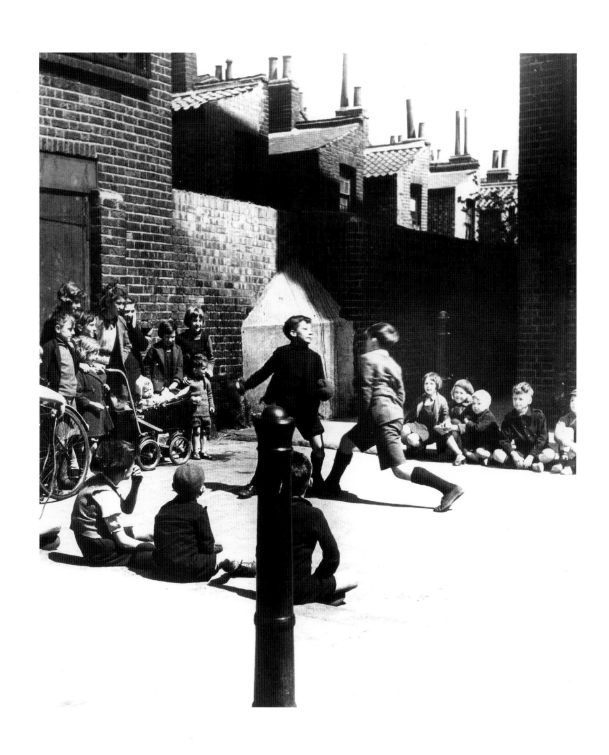

45 Bethnal Green, **1939** 46 Blackfriars, c **1937**

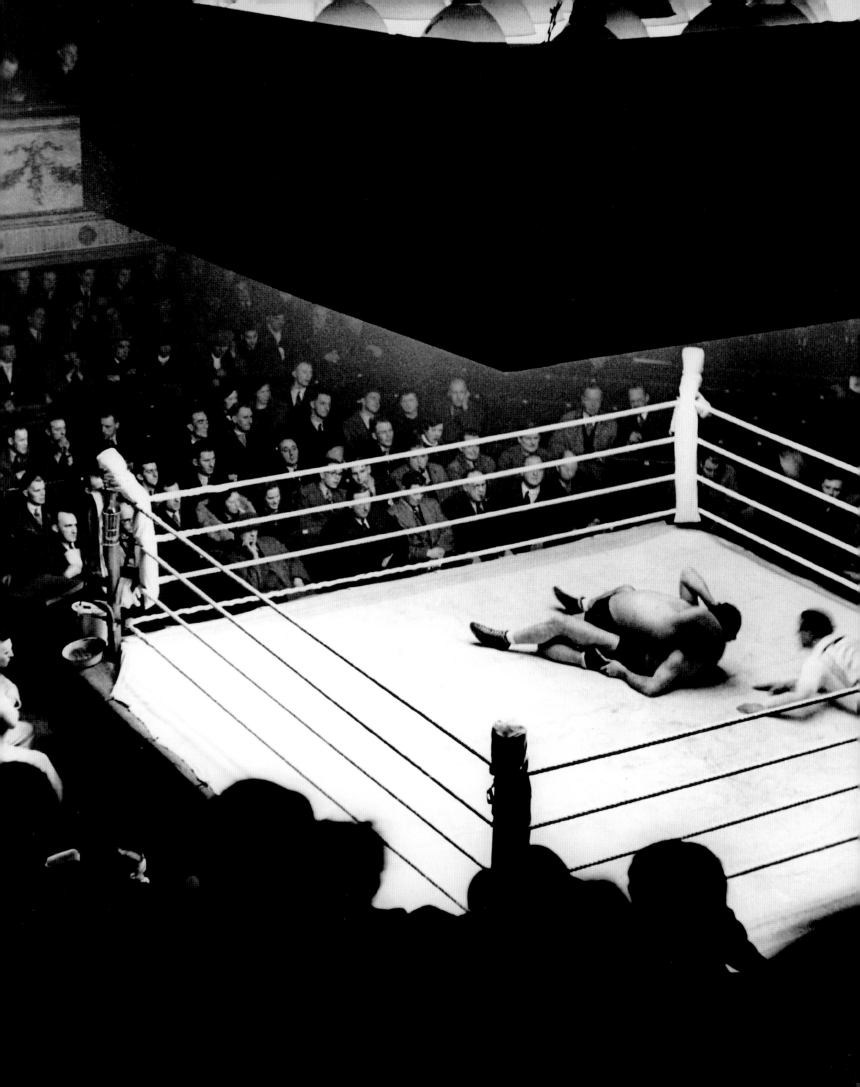

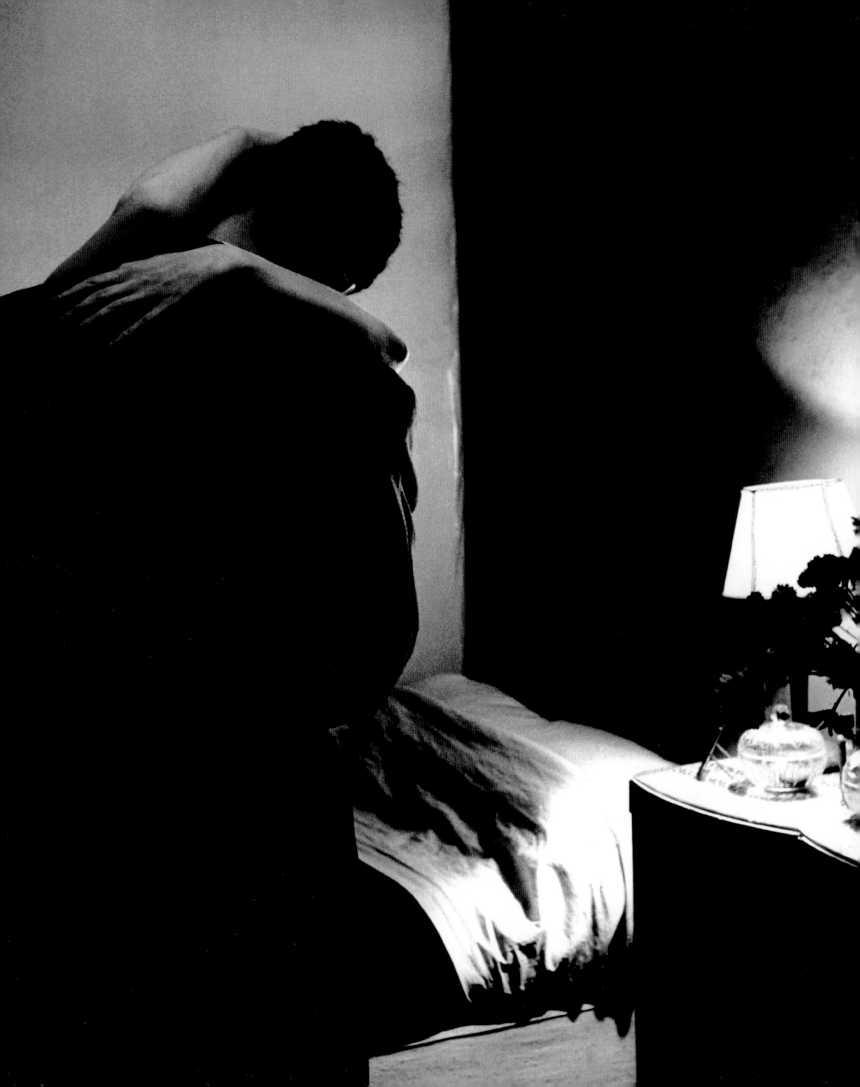

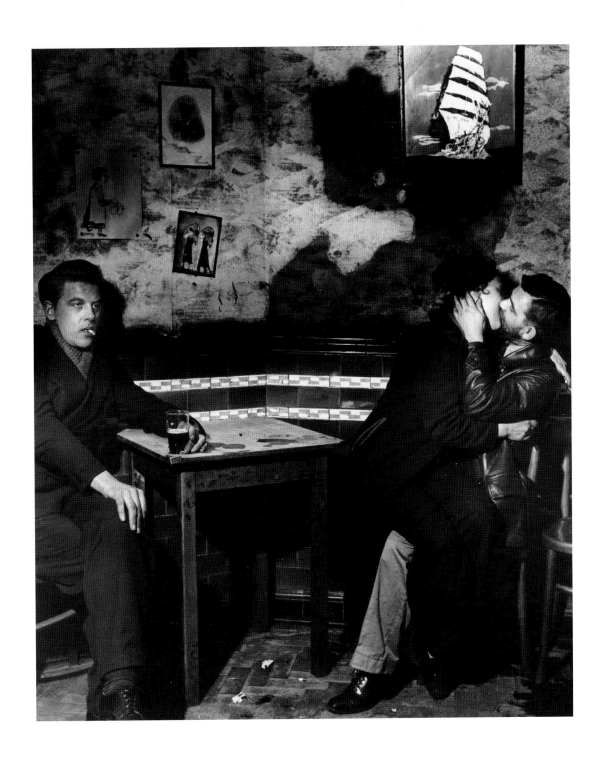

47 Soho, **1934** 48 Limehouse, **1945**

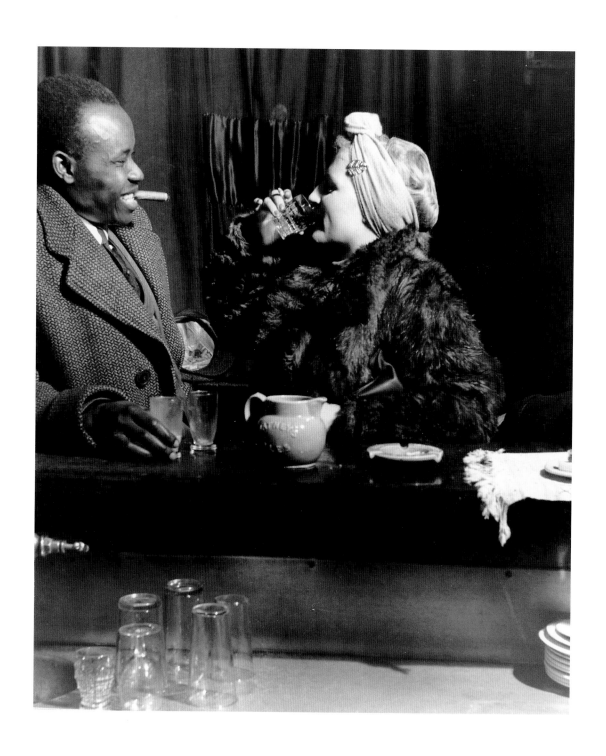

49 Soho, **1942**

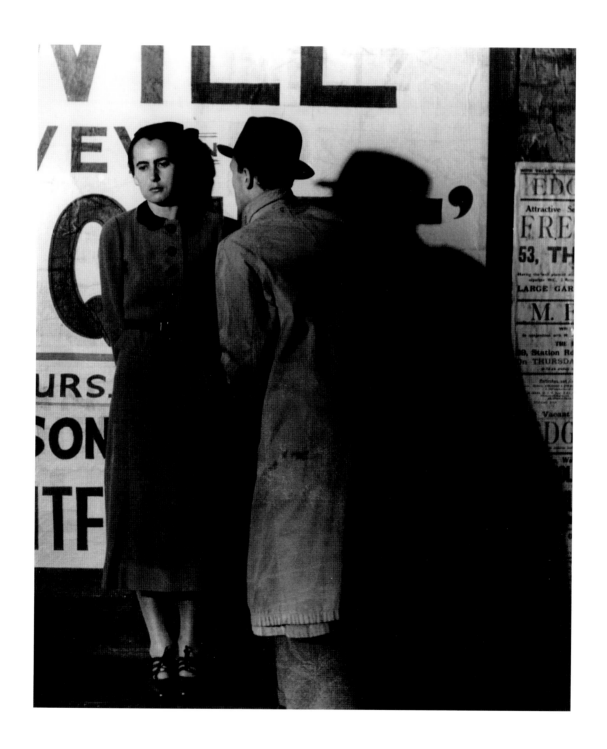

50 Peckham, 1936

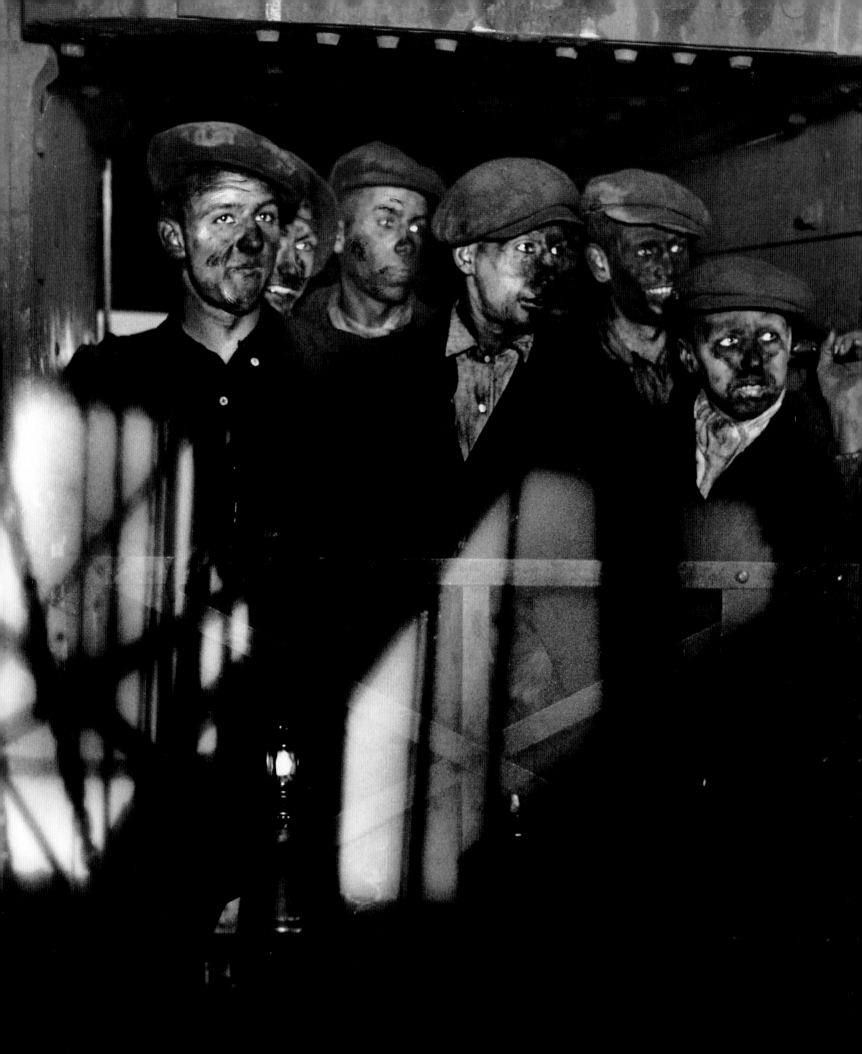

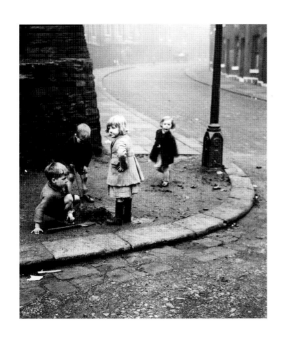 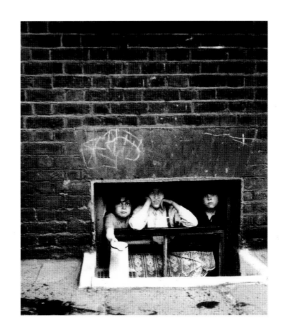

51 South Wales, c **1935** 52 South London, **1930s** 53 Stepney, c **1935** 71

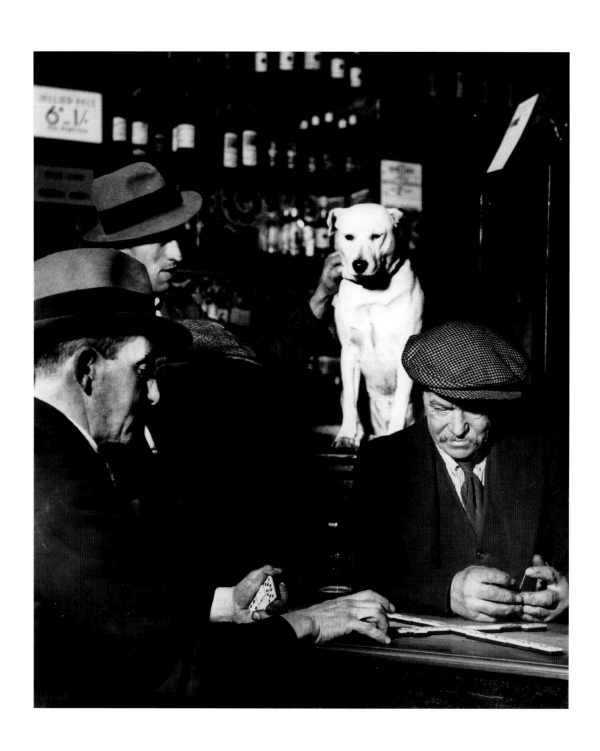

54 North London, c 1935 55 Bond Street, c 1935

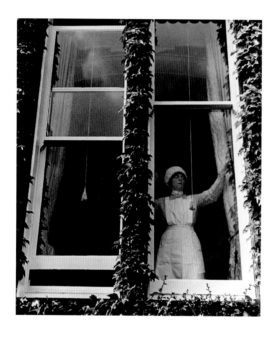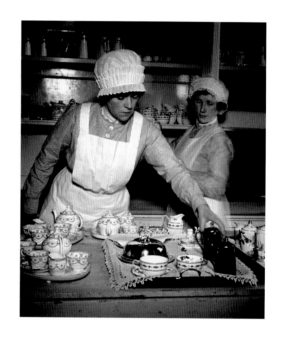

56,57,58,59 Mayfair, **1936**

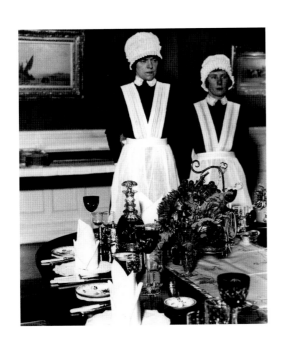

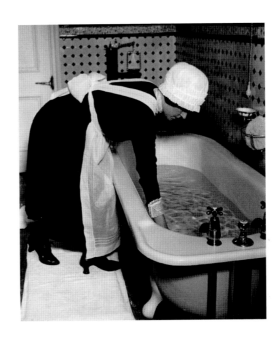

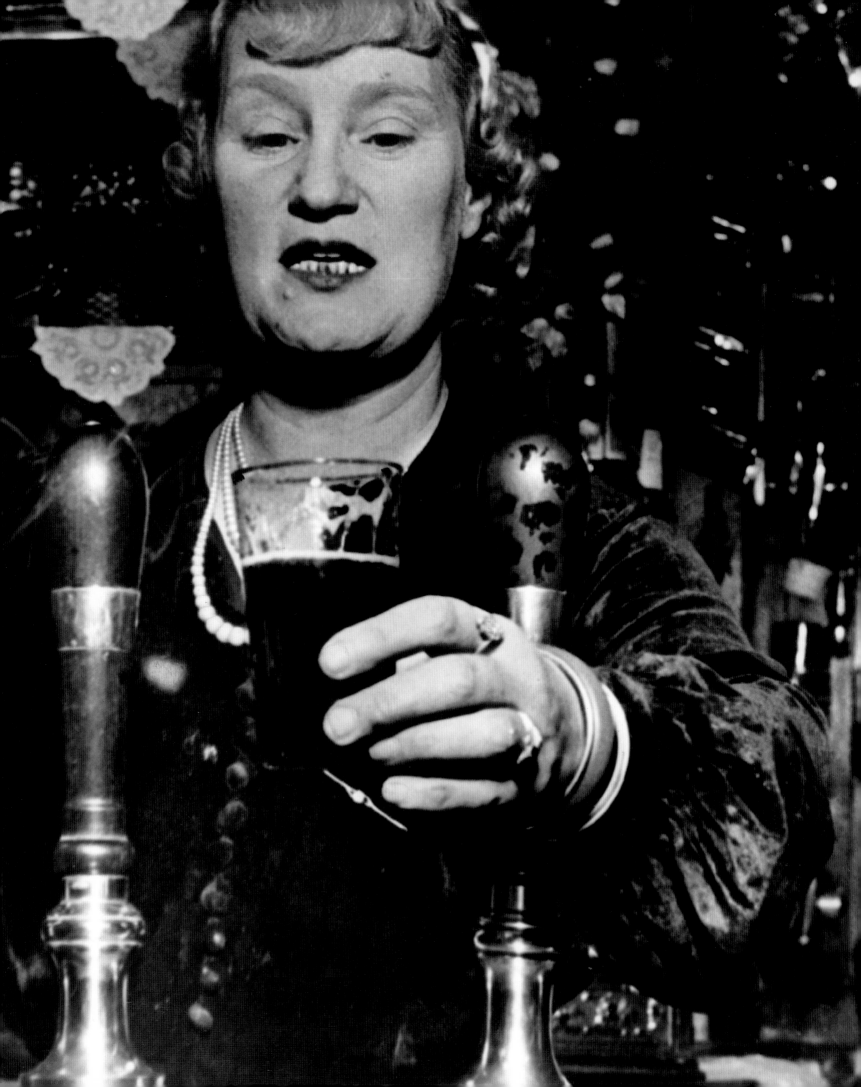

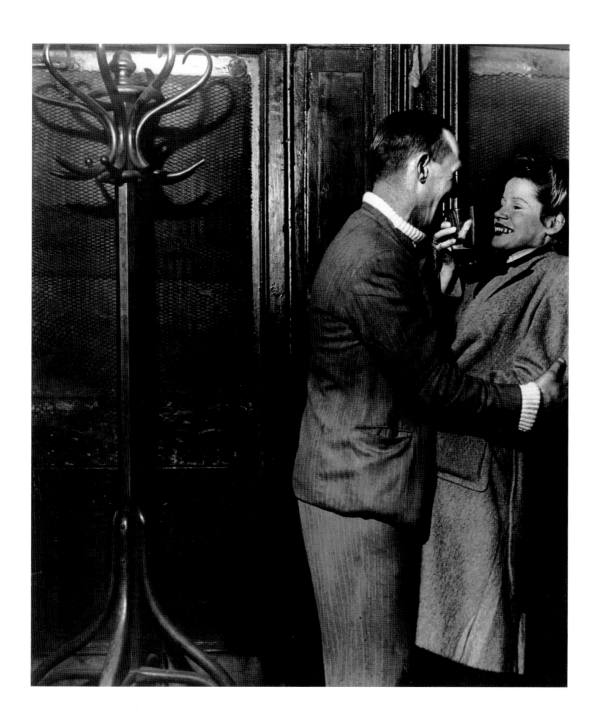

60 Stepney, c 1939 61 Stepney, c 1939

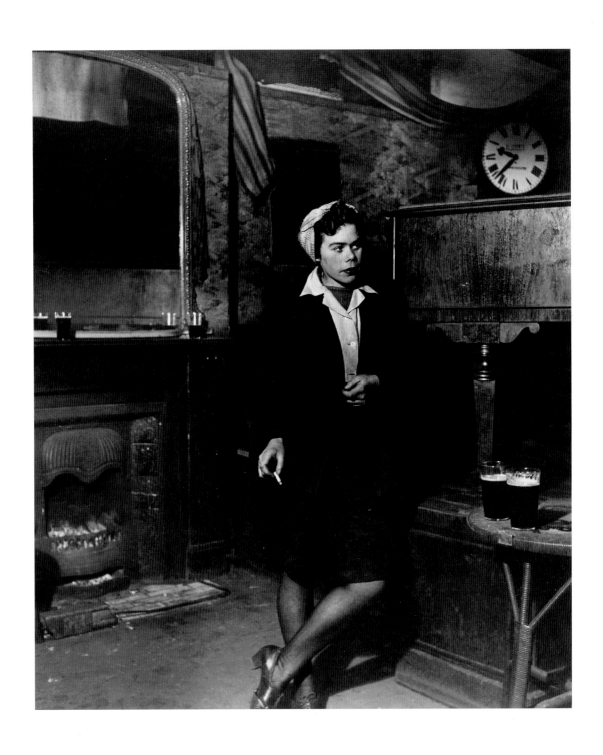

62 Limehouse, **1930s** 63 Mayfair, **1938**

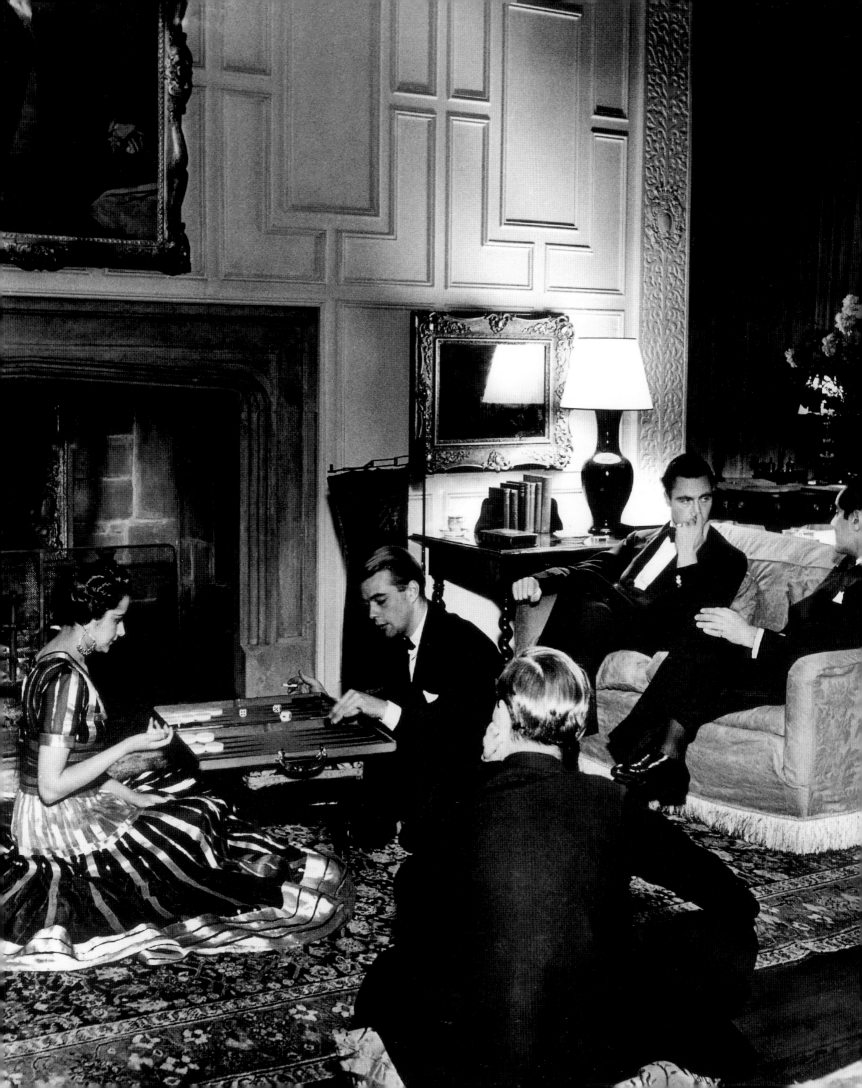

"Man Ray, the most original photographer of them all, had just invented the new techniques of rayographs and solarisation. I was a pupil in his studio, and learned much from his experiments. There were the surrealist publications, *Bifur, Variétés, Minotaure* and others, the first magazines to choose photographs for their poetic quality; there were the surrealist films such as Bunuel's notorious *Un Chien Andalou* and *L'Age d'Or*, which had a strong effect on photography."

COURTING THE SURREAL

64 Garsington Manor, **1943**

65 Barcelona, 1932

66 Billingsgate, c 1935

67 Chiswick House, **1944** 68 Northern France, **1930s**

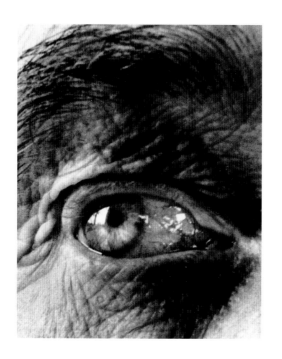 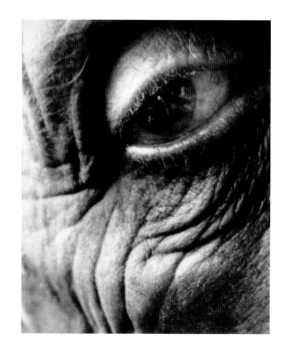

69 Henry Moore, **1972** 70 Jean Arp, **1960**

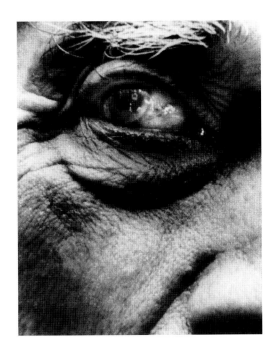 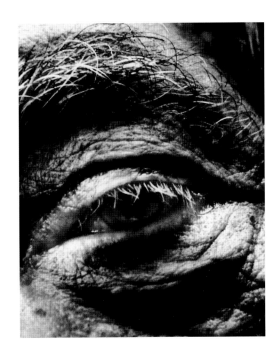

71 Georges Braque, **1960s** 72 Alberto Giacometti, **1963**

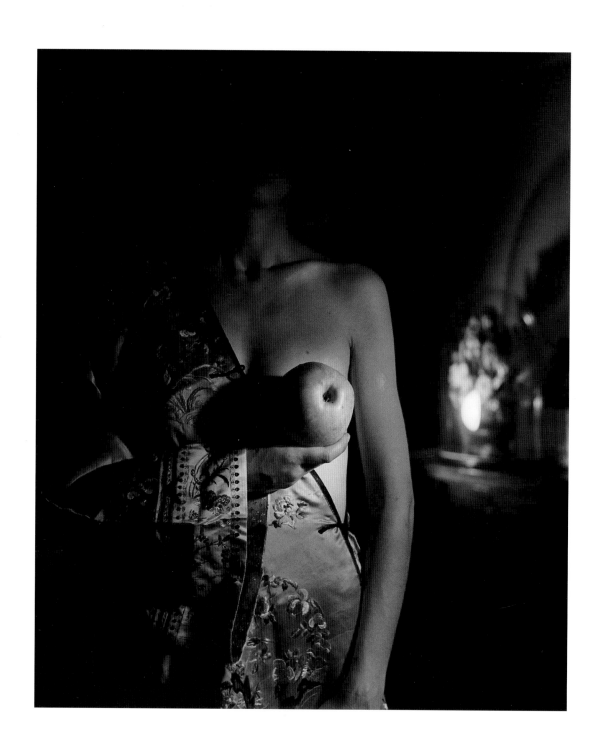

73 London, **1940s**

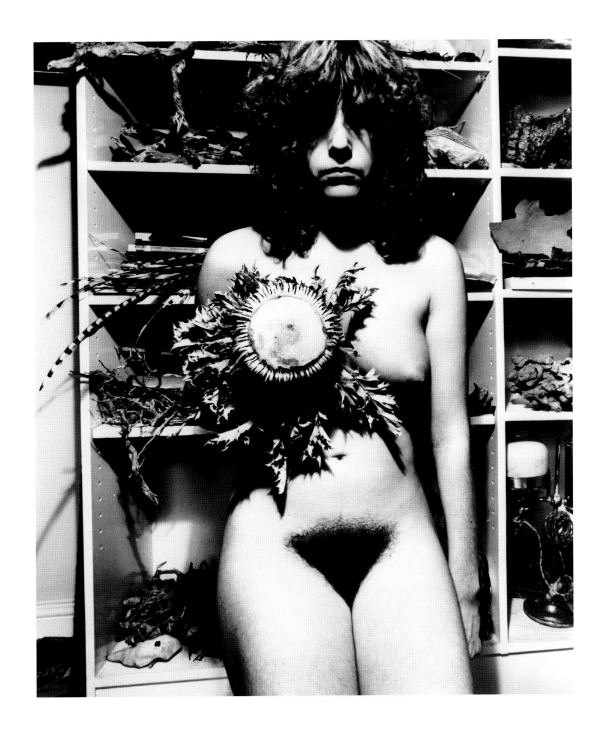

74 Campden Hill, 1978

"It is part of the photographer's job to see more intensely than most people do. He must have and keep in him something of the receptiveness of the child who looks at the world for the first time or of the traveller who enters a strange country. Most photographers would feel a certain embarrassment in admitting publicly that they carried within them a sense of wonder, yet without it they would not produce the work they do, whatever their particular field. It is the gift of seeing the life around them clearly and vividly, as something that is exciting in its own right. It is an innate gift, varying in intensity with the individual's temperament and environment."

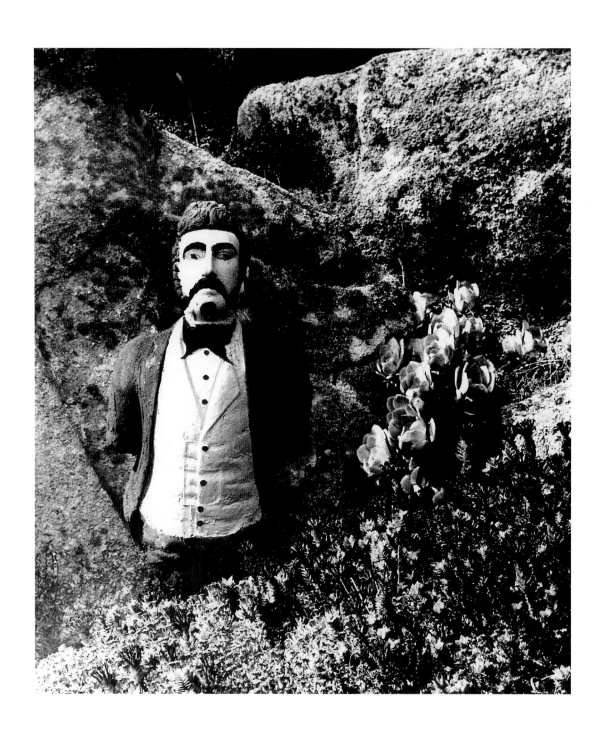

76 Scilly Isles, **1934**

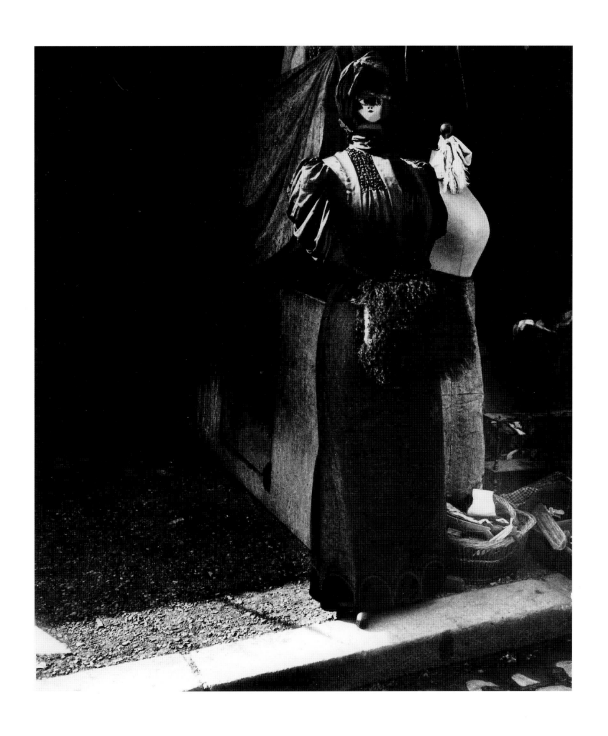

77 Paris, 1929

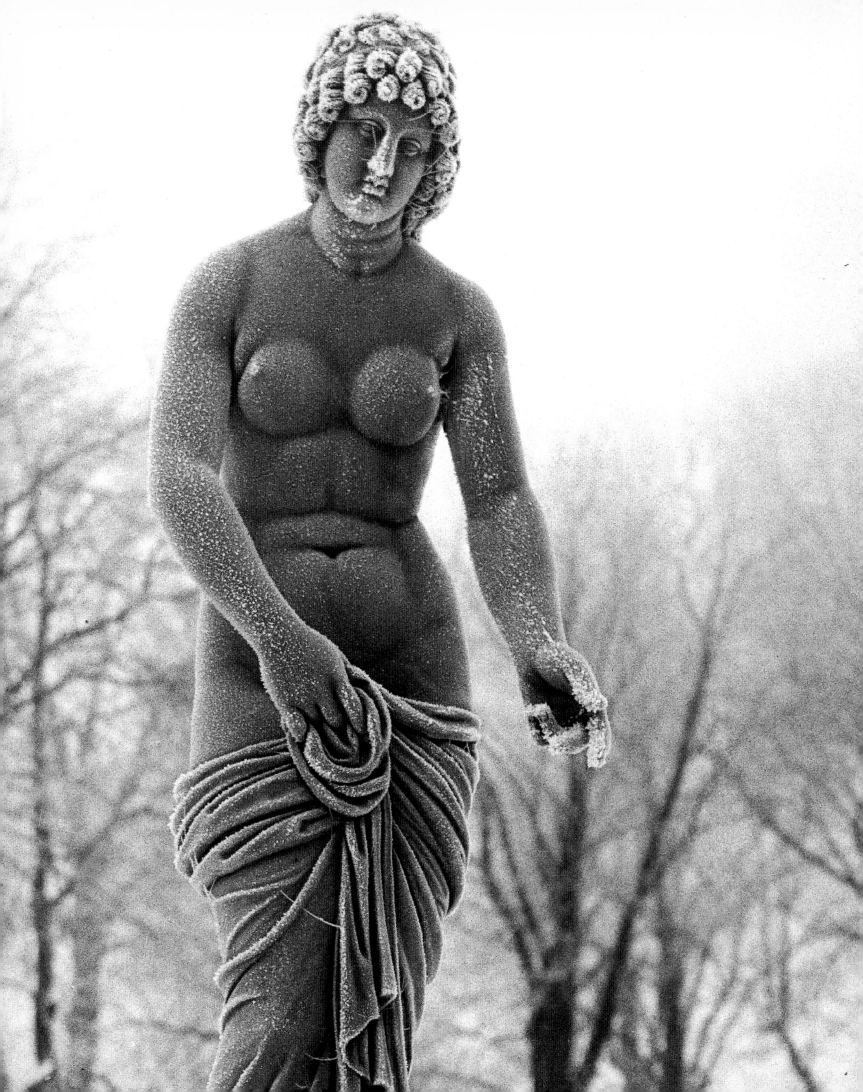

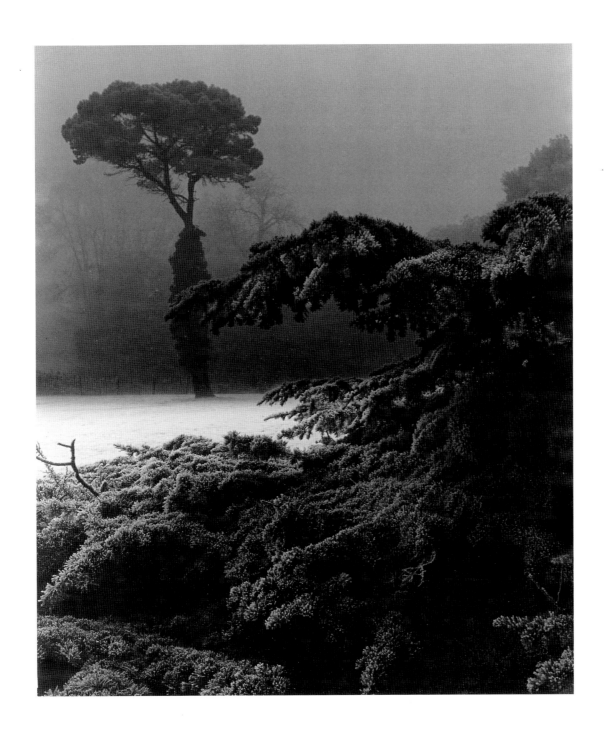

78 Crystal Palace, **1938** 79 Chiswick House, **1944**

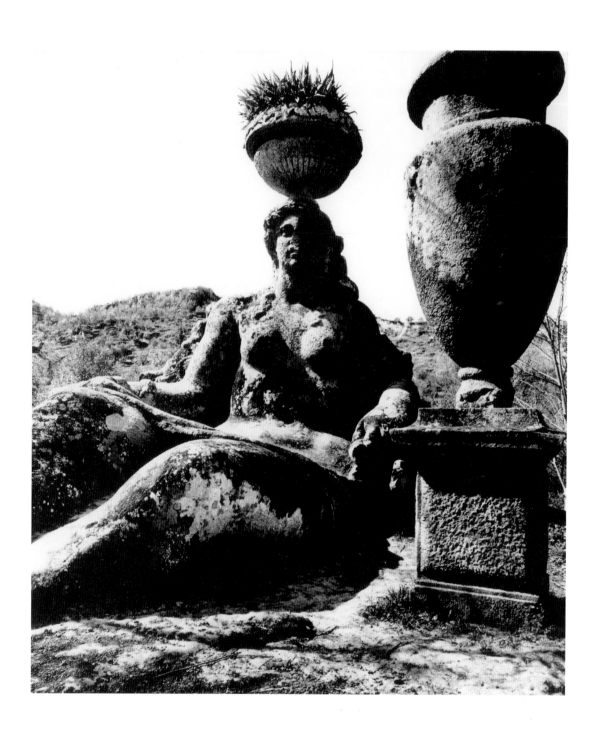

80 Italy, **1965** 81 Eaton Place, **1955**

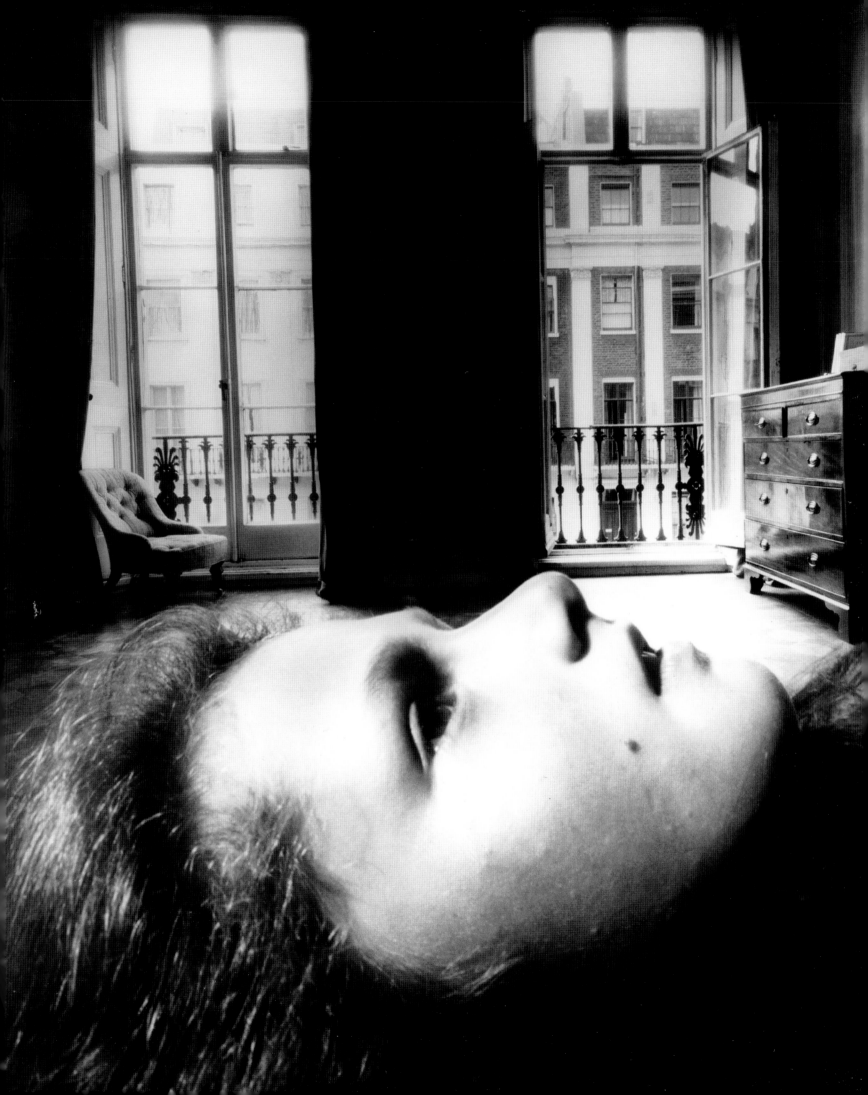

"After several years of working in London, I went to the north of England and photographed the coal-miners during the industrial depression. My most successful picture of the series, probably because it was symbolical of this time of mass unemployment, was a loose-coal searcher in East Durham, going home in the evening. He was pushing his bicycle along a footpath through a desolate waste-land between Hebburn and Jarrow. Loaded on the crossbar was a sack of small coal, all that he had found after a day's search on the slag-heaps. I also photographed the Northern towns and interiors of miners' cottages, with families having their evening meal, or the miners washing themselves in tin baths, in front of their kitchen fires."

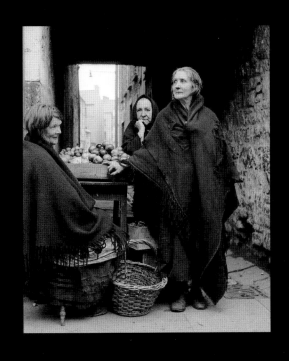

JOURNEYS NORTH

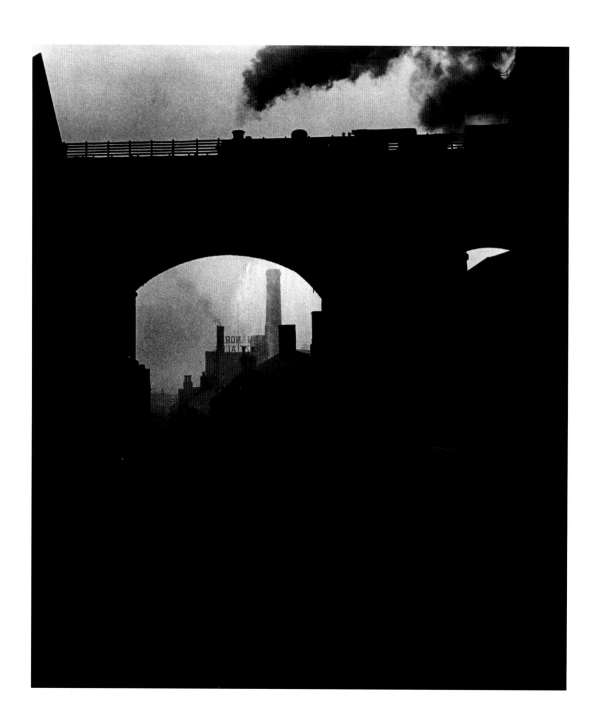

83 Newcastle, **1937** 84 Halifax, **1937**

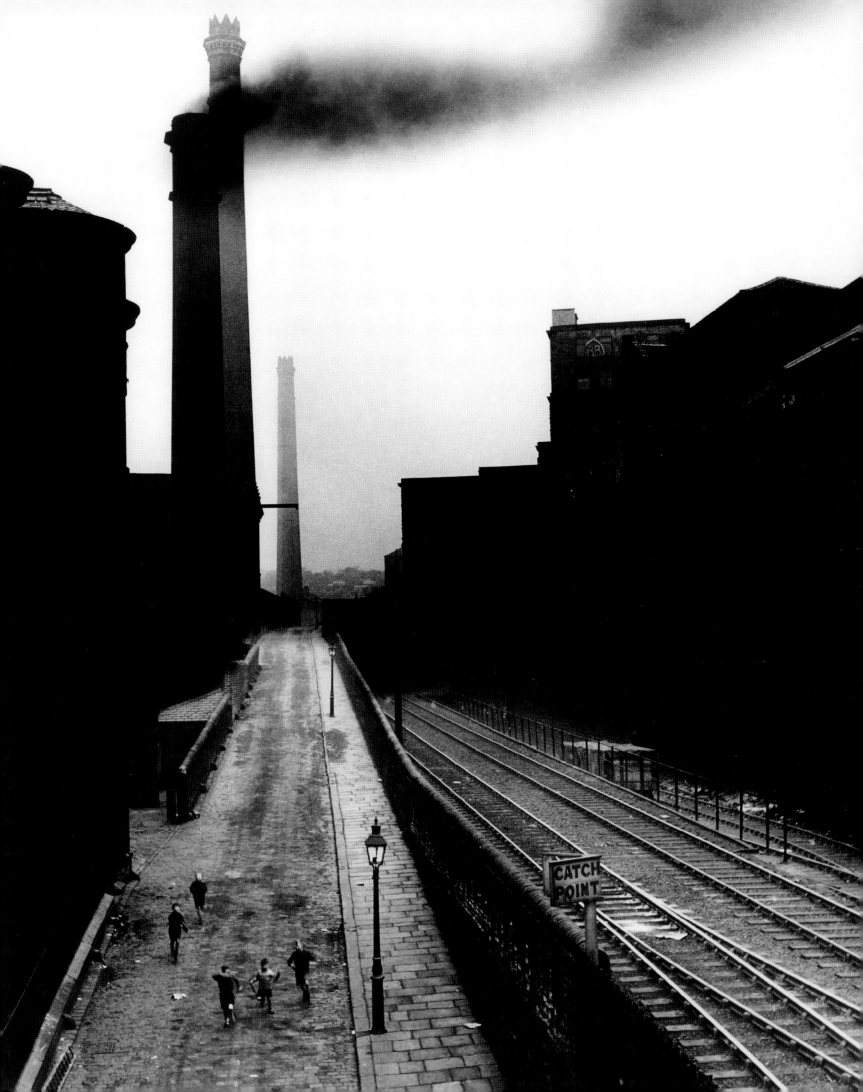

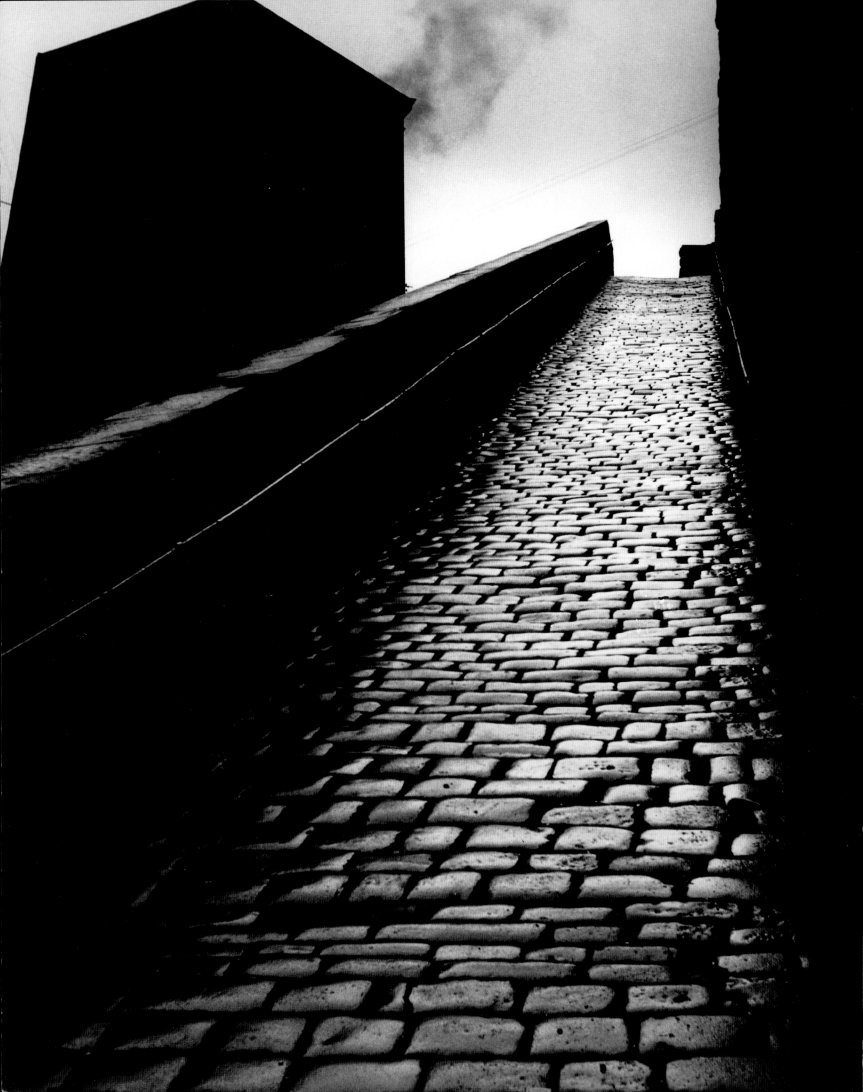

"Thus it was I found *atmosphere* to be the spell that charged the commonplace with beauty. And still I am not sure what atmosphere is. I should be hard put to define it. I only know it is a combination of elements, perhaps most simply and yet most inadequately described in technical terms of lighting and viewpoint, which reveals the subject as familiar and yet strange. I doubt whether atmosphere, in the meaning it has for me, can be conveyed by a picture of something which is quite unfamiliar to the beholder."

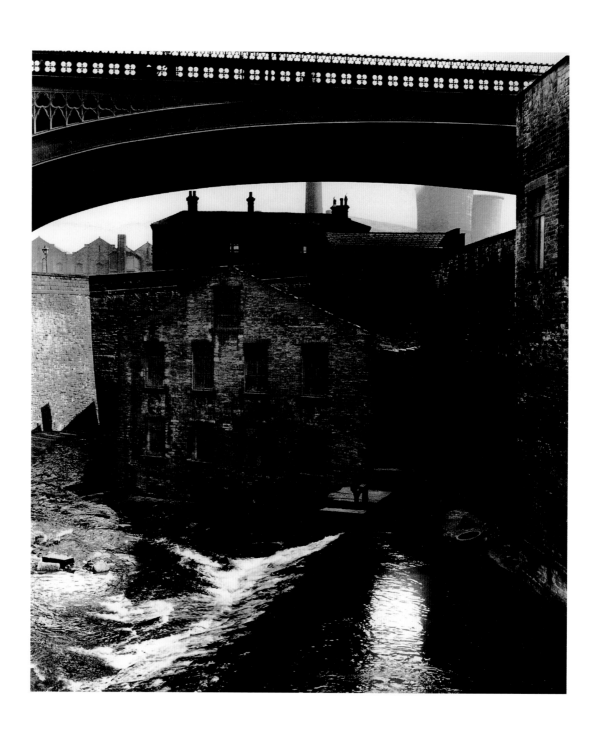

86 Halifax, **1937**

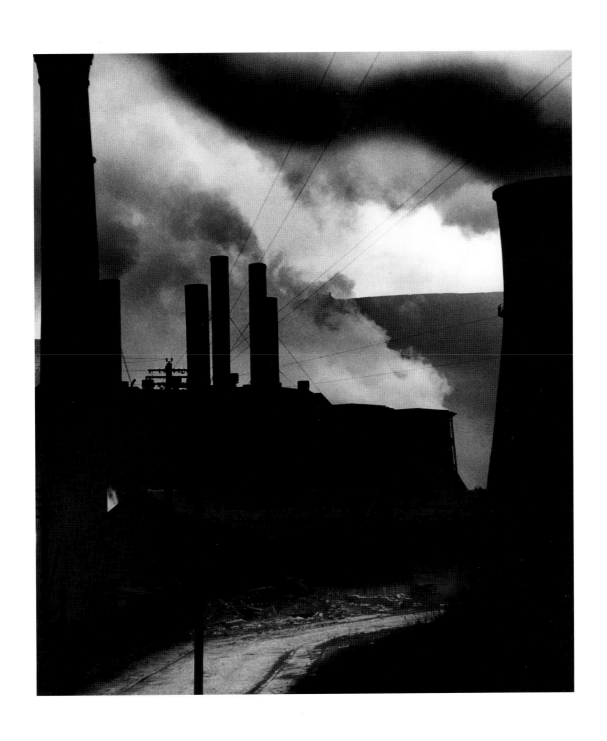

87 Halifax, **1937**

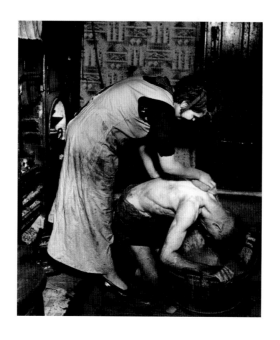 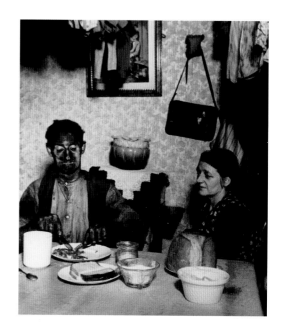

88 County Durham, c 1937 89 Northumberland, c 1937 90 Jarrow, c 1937

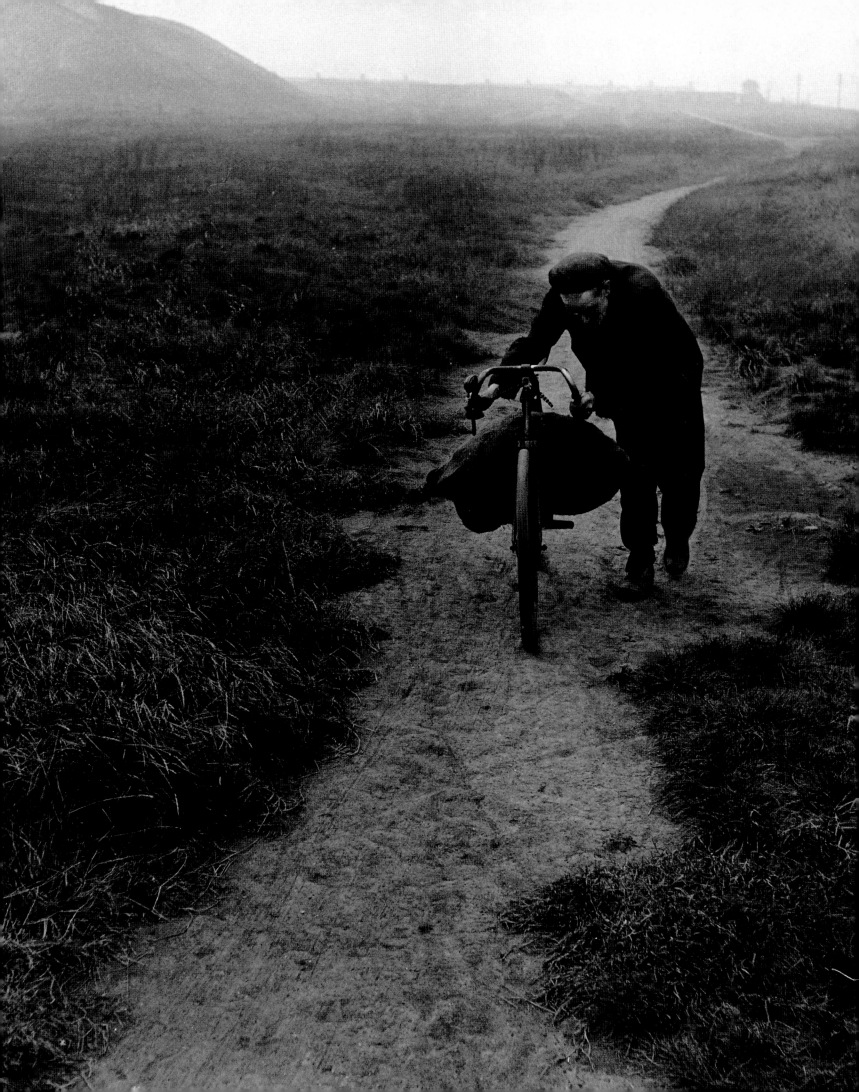

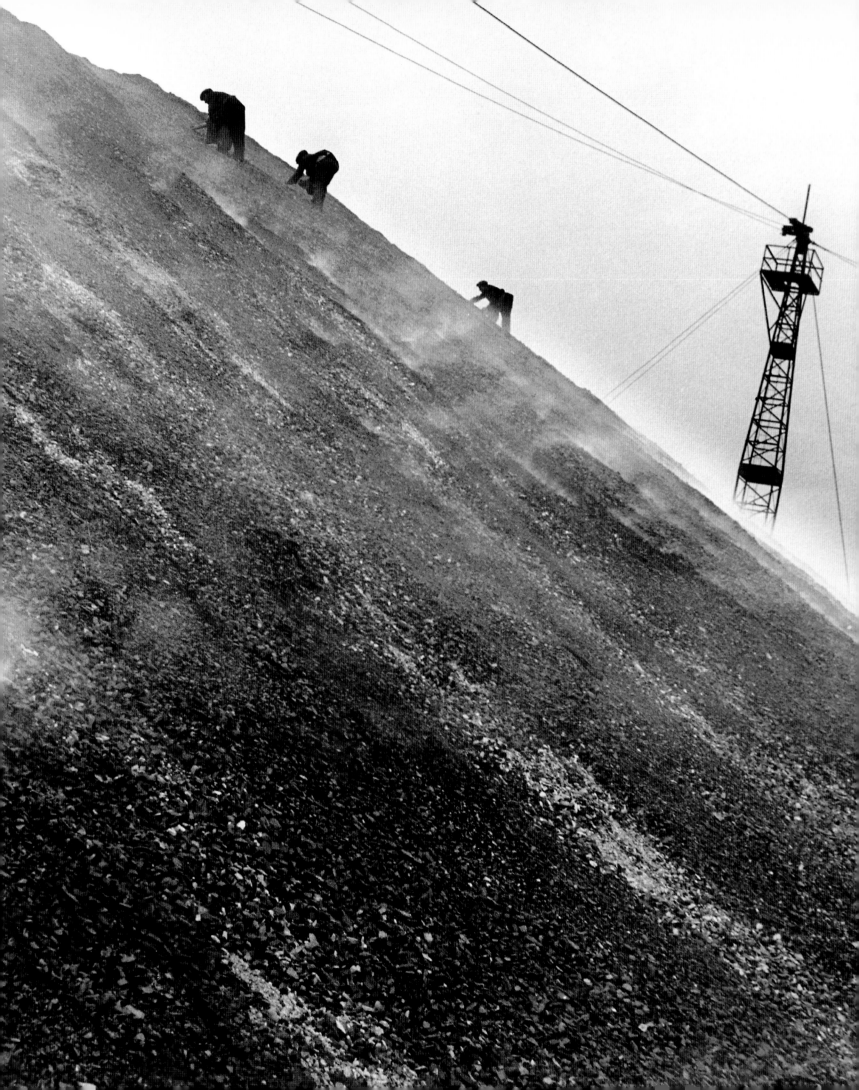

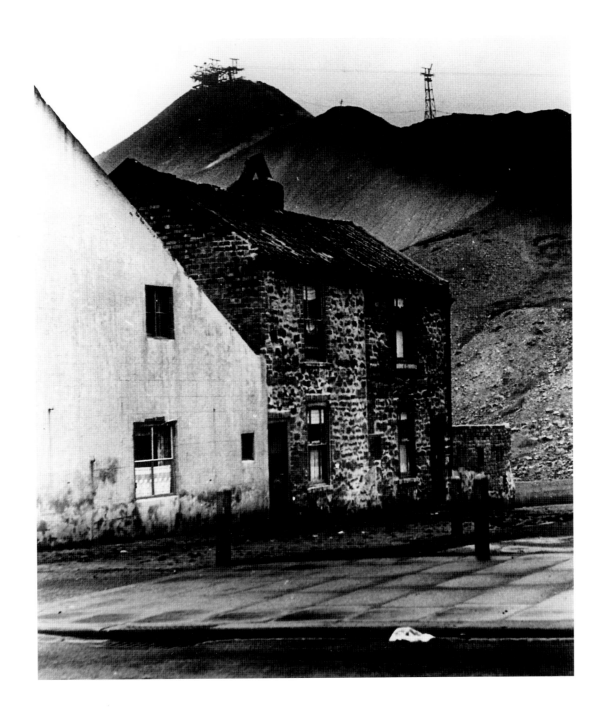

91 East Durham, c 1937 92 East Durham, c 1937

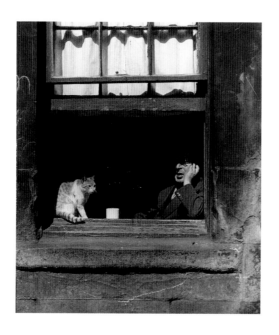

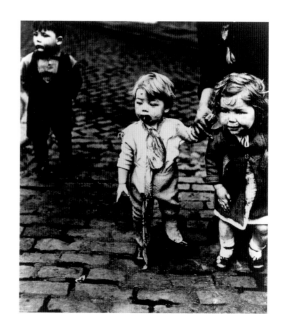

93 The Gorbals, **1948** 94 Sheffield, **1937** 95 Jarrow, **1937**

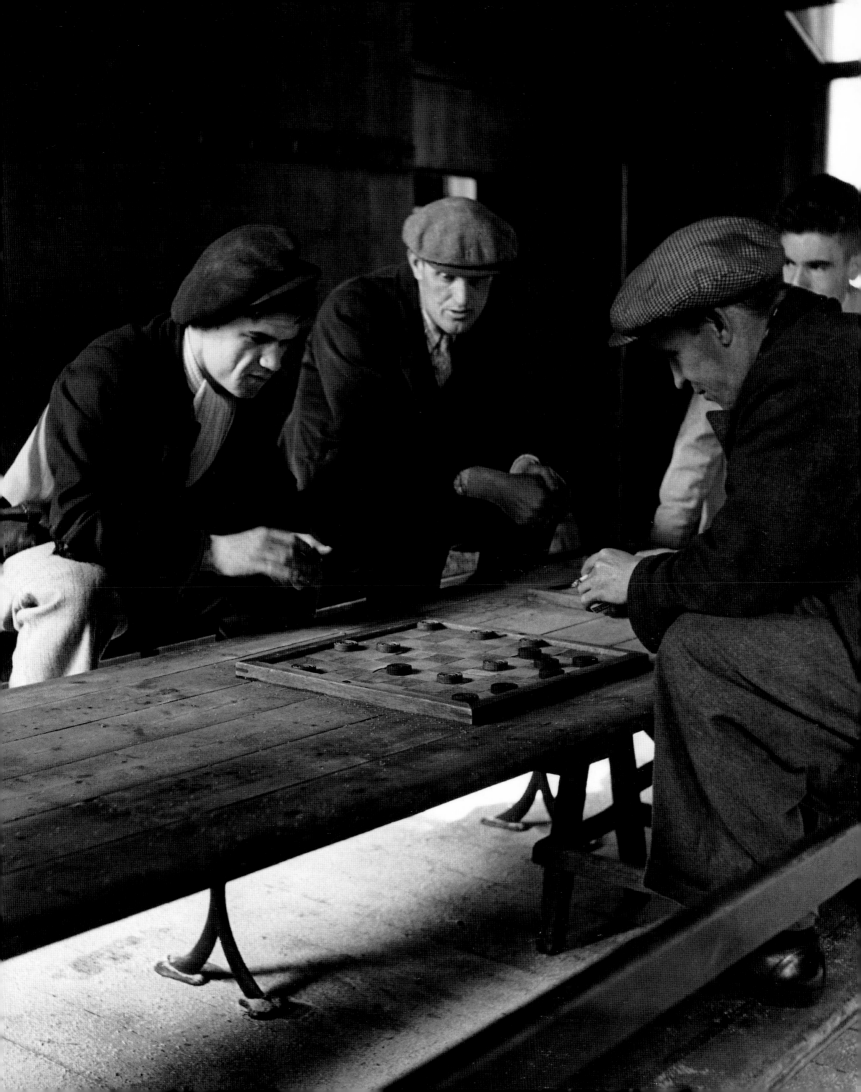

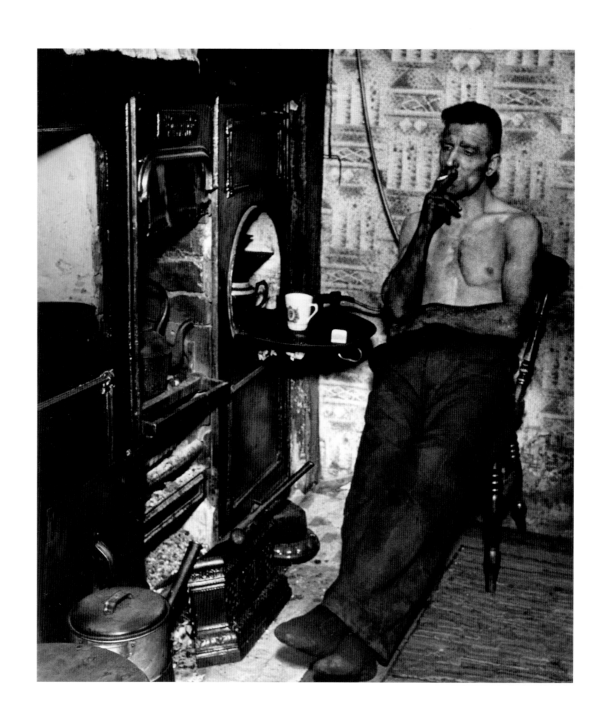

96 East Durham, **1937** 97 Gorbals, **1948**

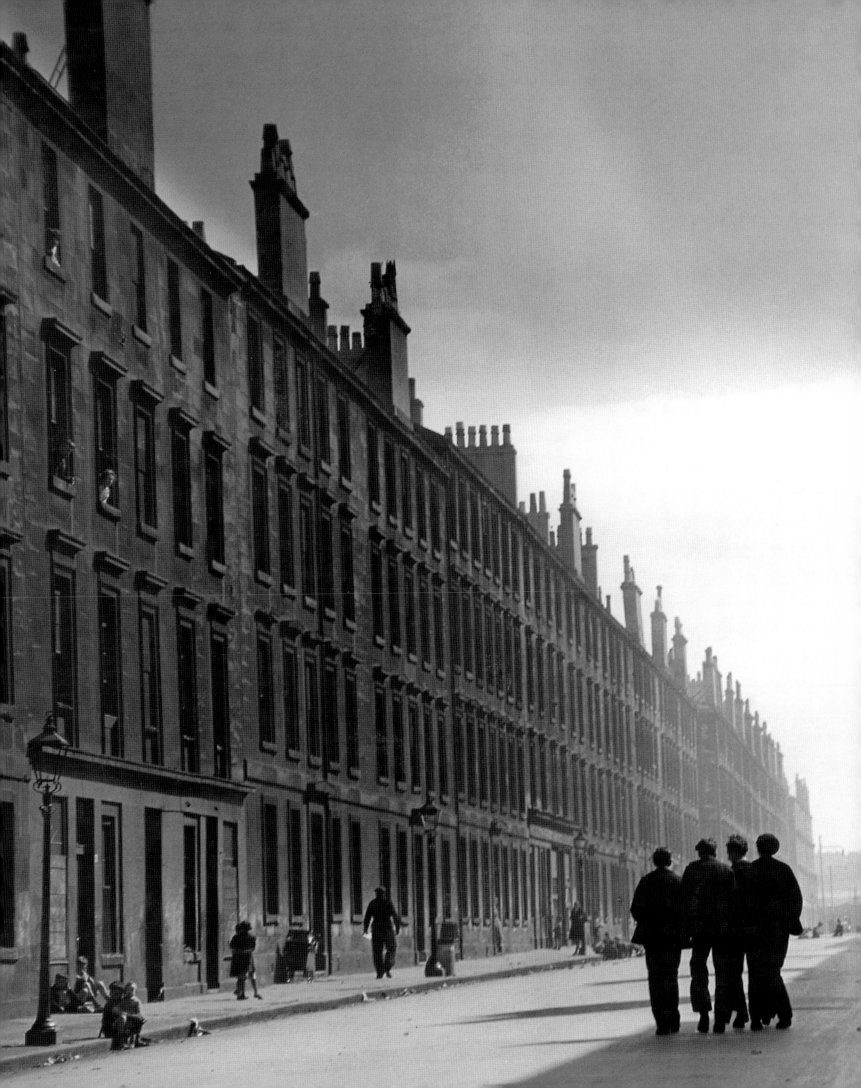

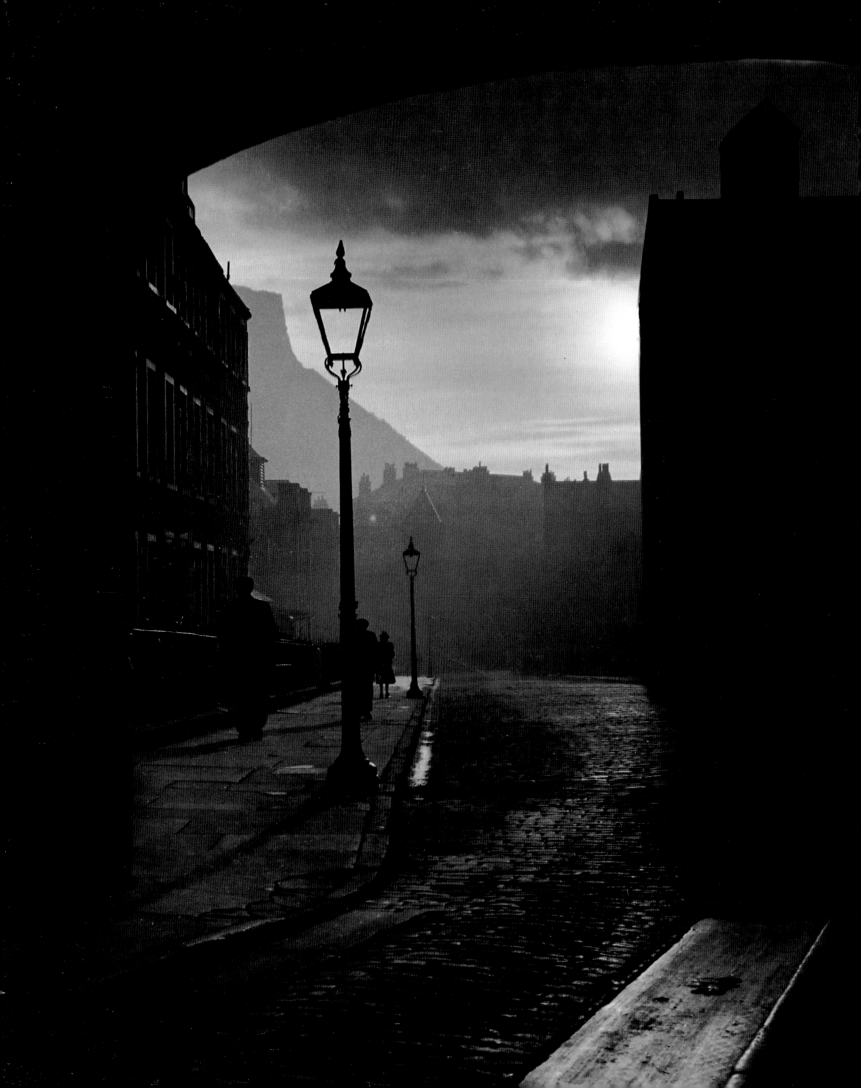

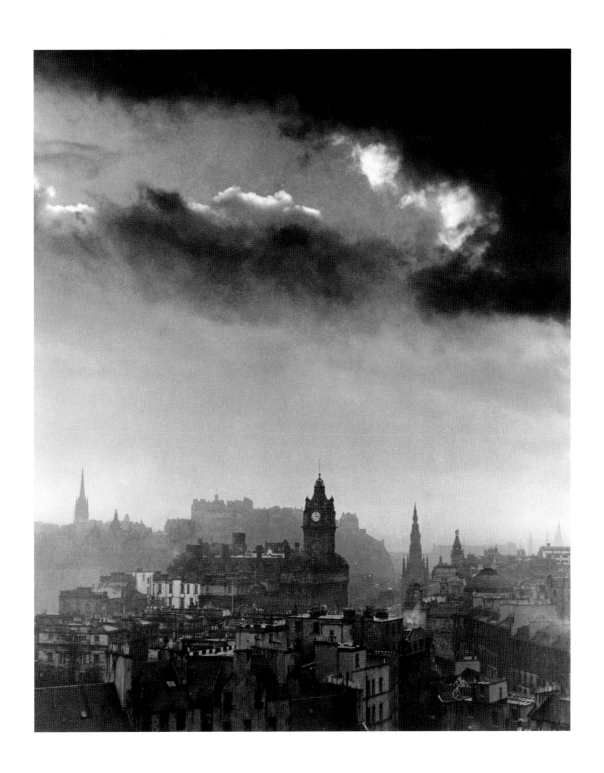

98 Edinburgh, **1942** 99 Edinburgh, **1942**

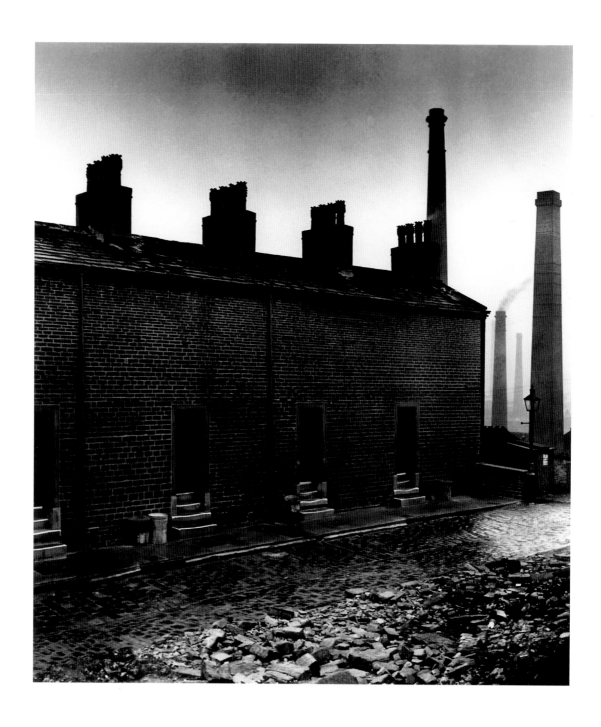

100 East Durham, c **1937**

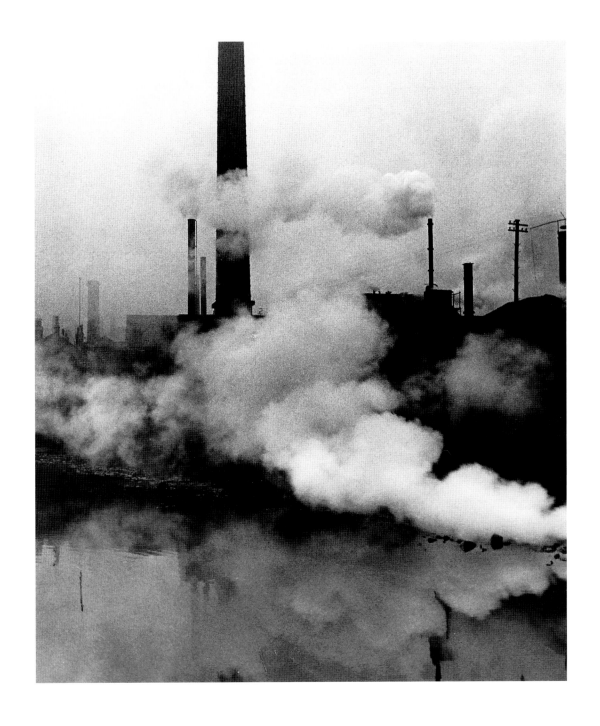

101 Sheffield, **1937**

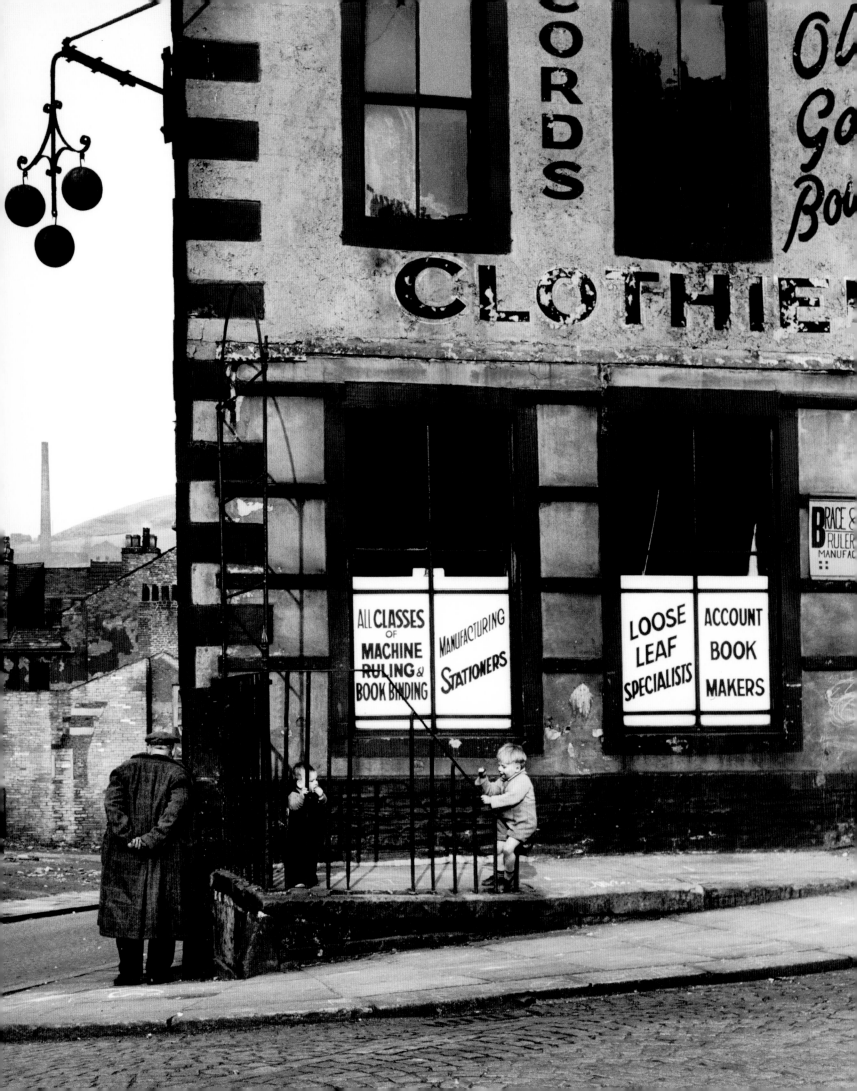

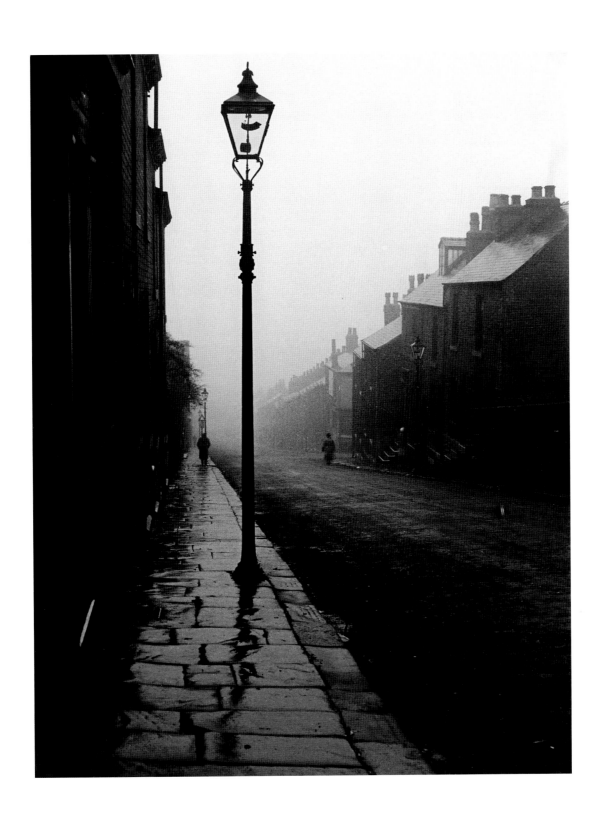

102 Halifax, **1937** 103 Unidentified location, **1940s**

"In 1939, at the beginning of the war, I was back in London photographing the black-out. The darkened town, lit only by moonlight, looked more beautiful than before or since. It was fascinating to walk through the deserted streets and to photograph houses which I knew well, and which no longer looked three-dimensional, but flat like painted stage scenery. When the bombing started I was commissioned to take pictures of Londoners in their improvised air-raid shelters in unused Tube tunnels, East-end wine cellars, church crypts and the basements of large houses. These pictures were taken for the Ministry of Information, and kept for the Home Office records. A selection of them were later published in *Lilliput* magazine, opposite Henry Moore's Shelter drawings."

104 Kensington, **1930**

THE DARK CITY

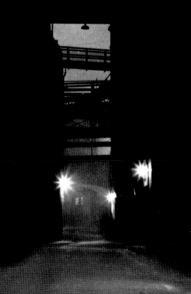

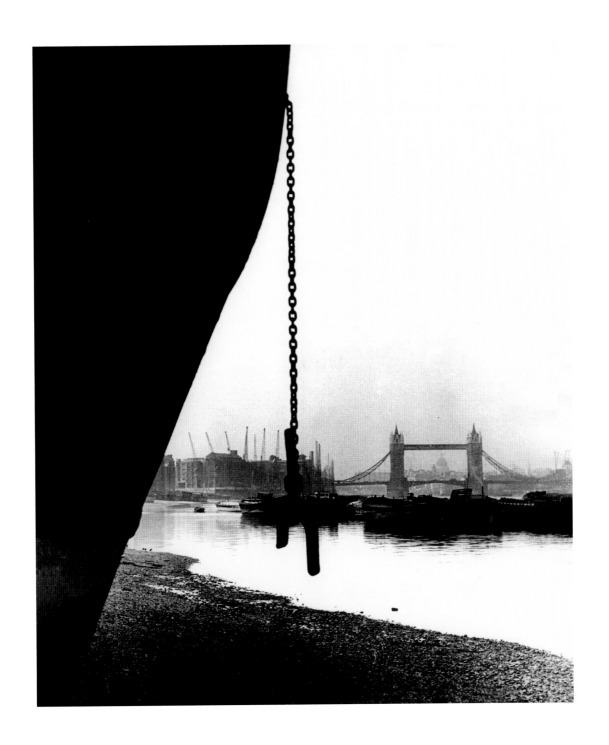

105 Shad Thames, **1939** 106 Bermondsey, **1945**

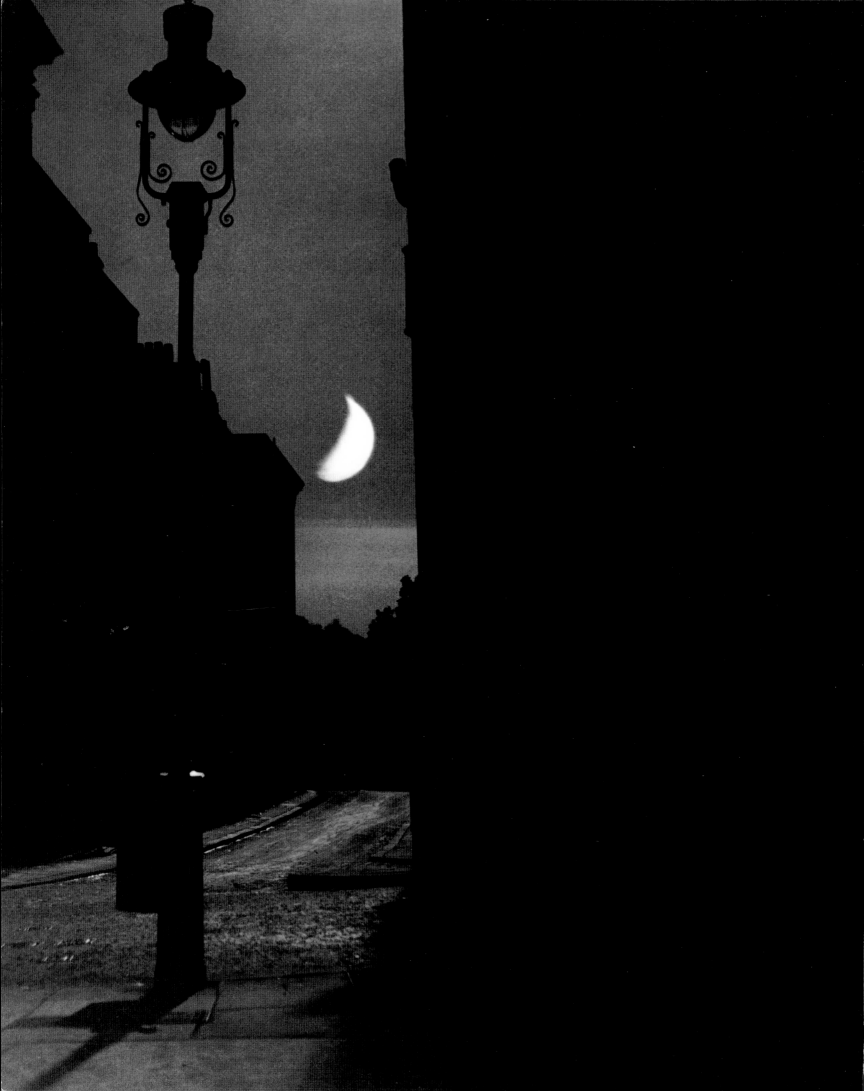

"The London of the last war was a different place from the London of 1938. The glamorous make-up of the world's largest city faded with the lights. Under the soft light of the moon the blacked-out town had a new beauty. The houses looked flat like painted scenery and the bombed ruins made strangely shaped silhouettes. Through the gaps new vistas were opened and for the first time the Londoner caught the full view of St Paul's Cathedral."

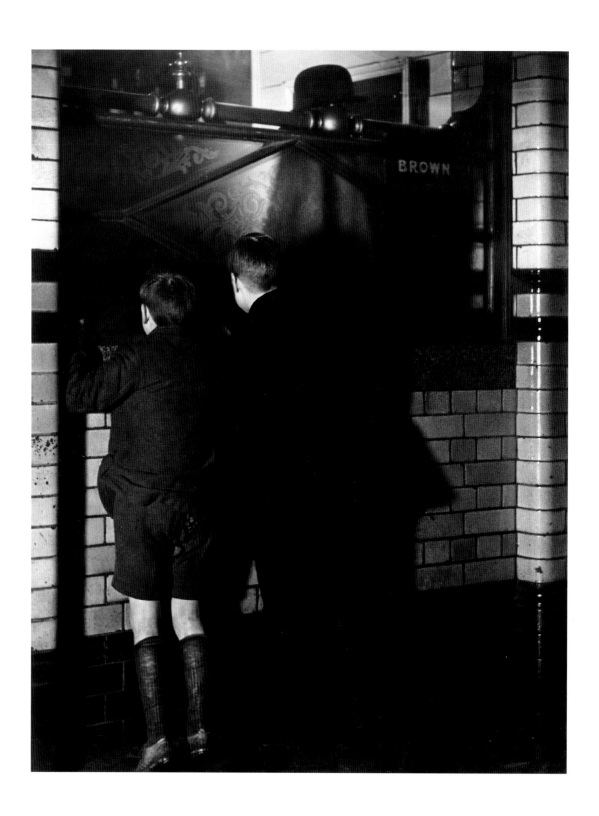

108 London, c 1937

109 London, **1938**

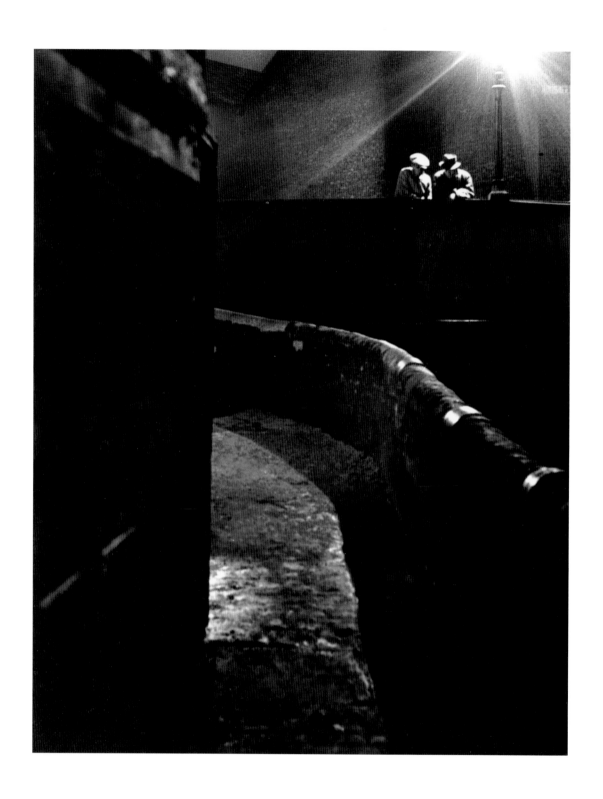

110 Limehouse, c 1937

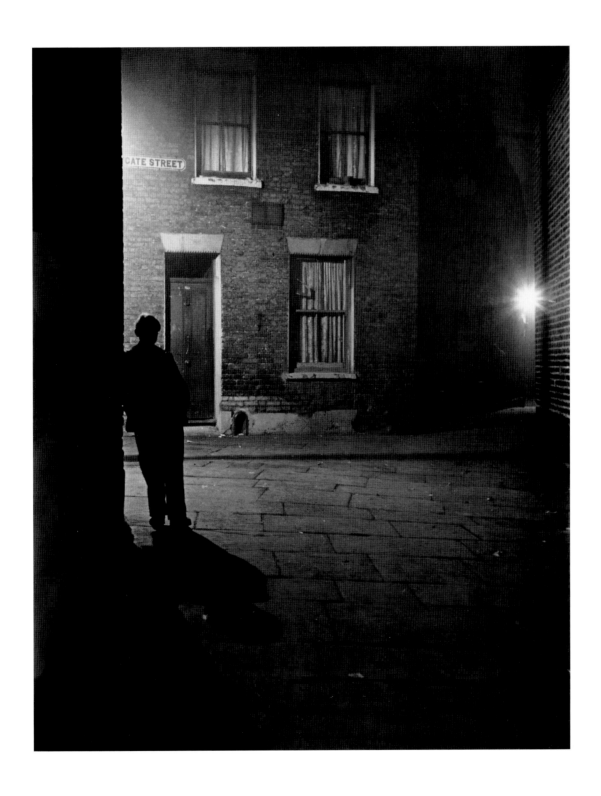

111 London, c 1937

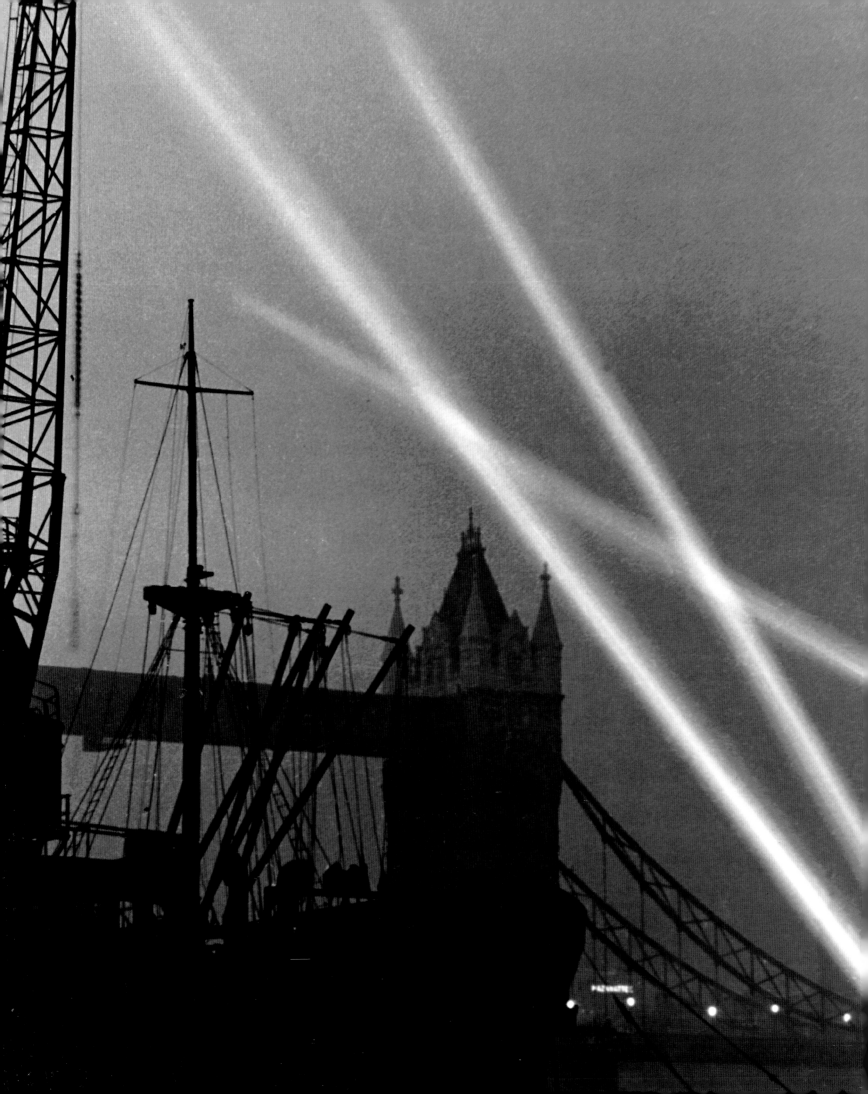

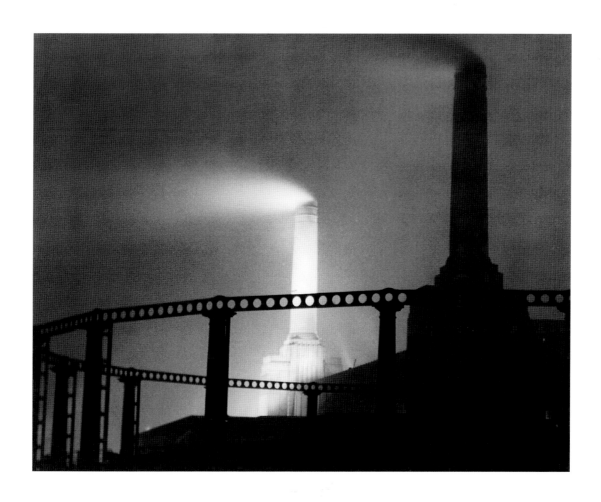

112 Bermondsey, **1945** 113 Battersea, c **1935**

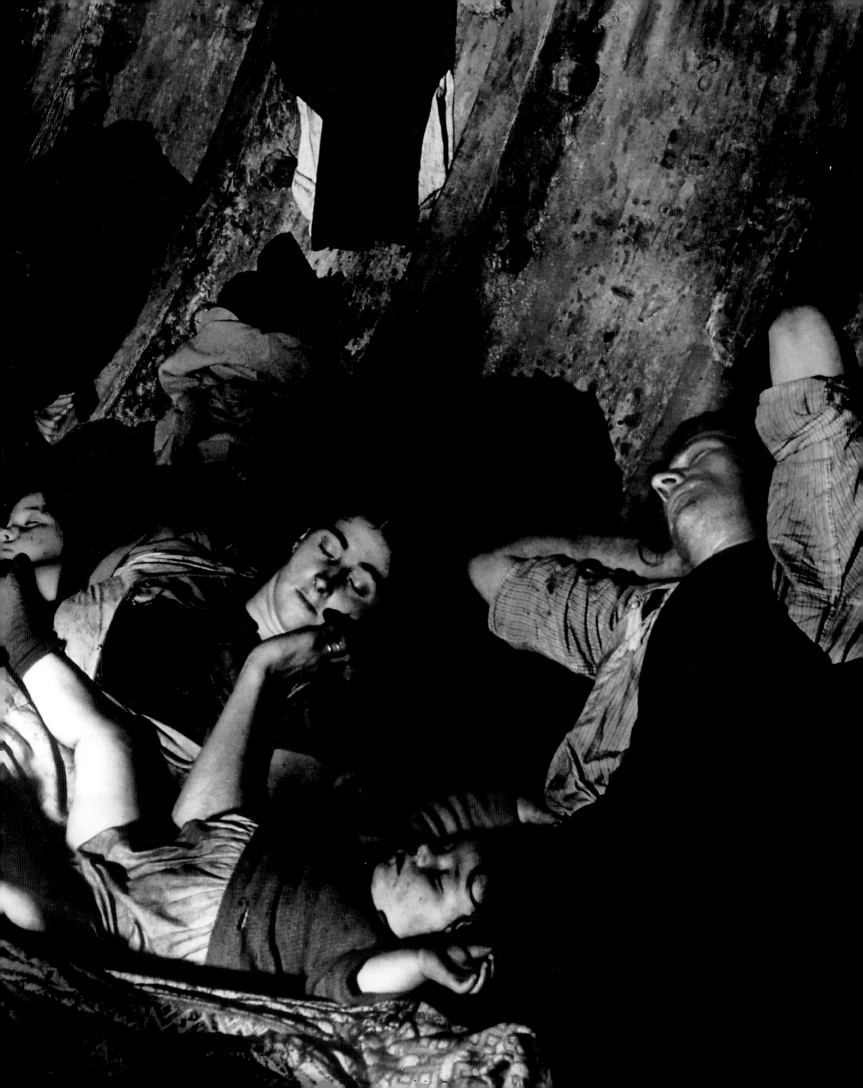

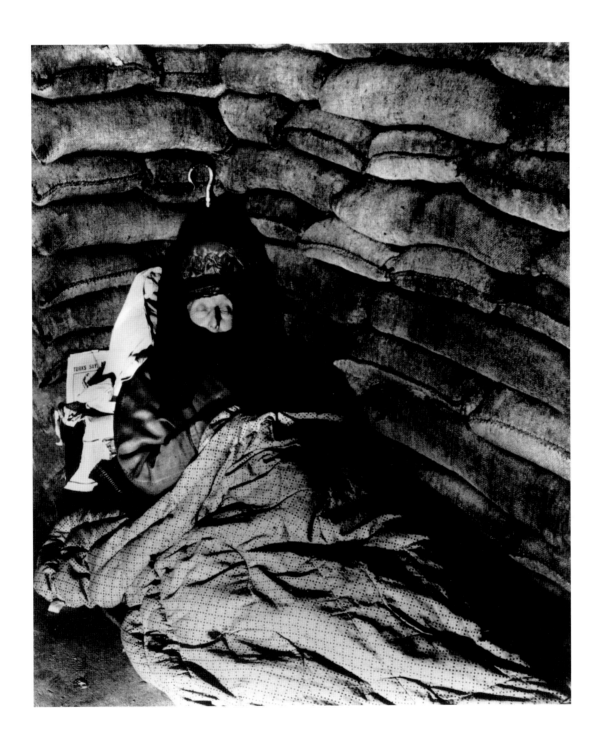

114 Liverpool Street, **1940** 115 Pimlico, **1940**

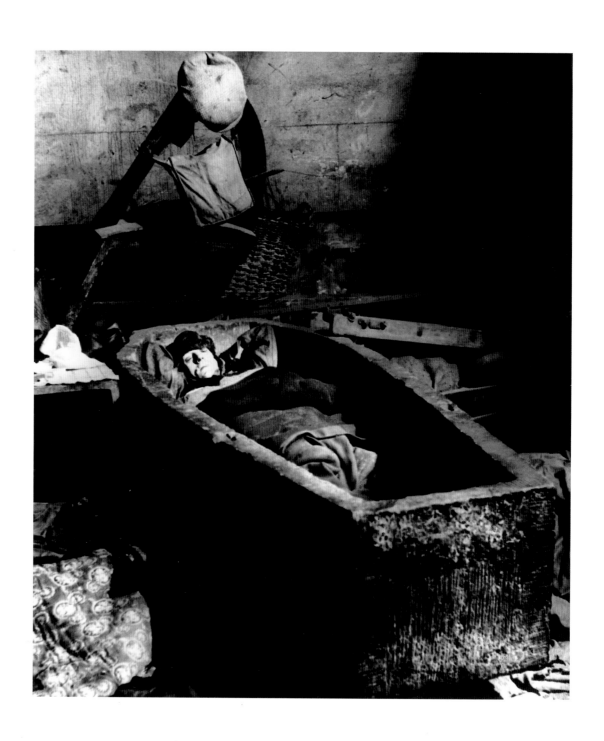

116 Spitalfields, **1940** 117 Elephant & Castle, **1940**

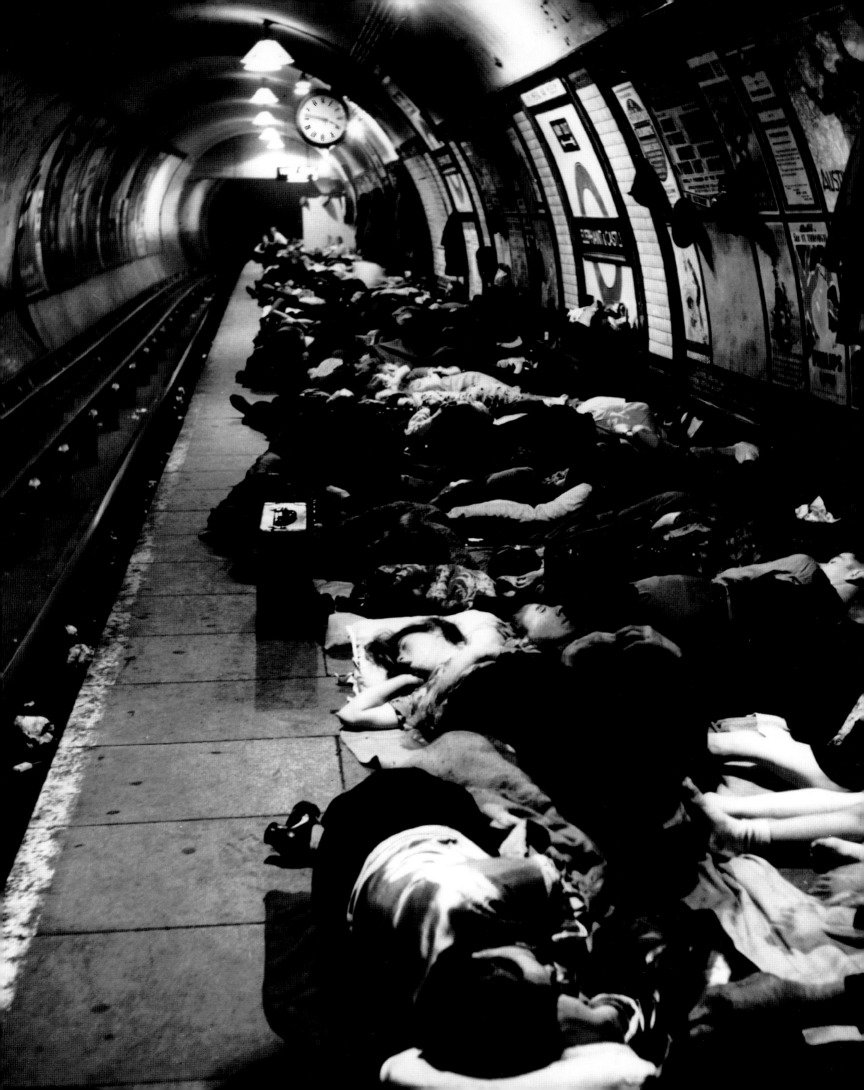

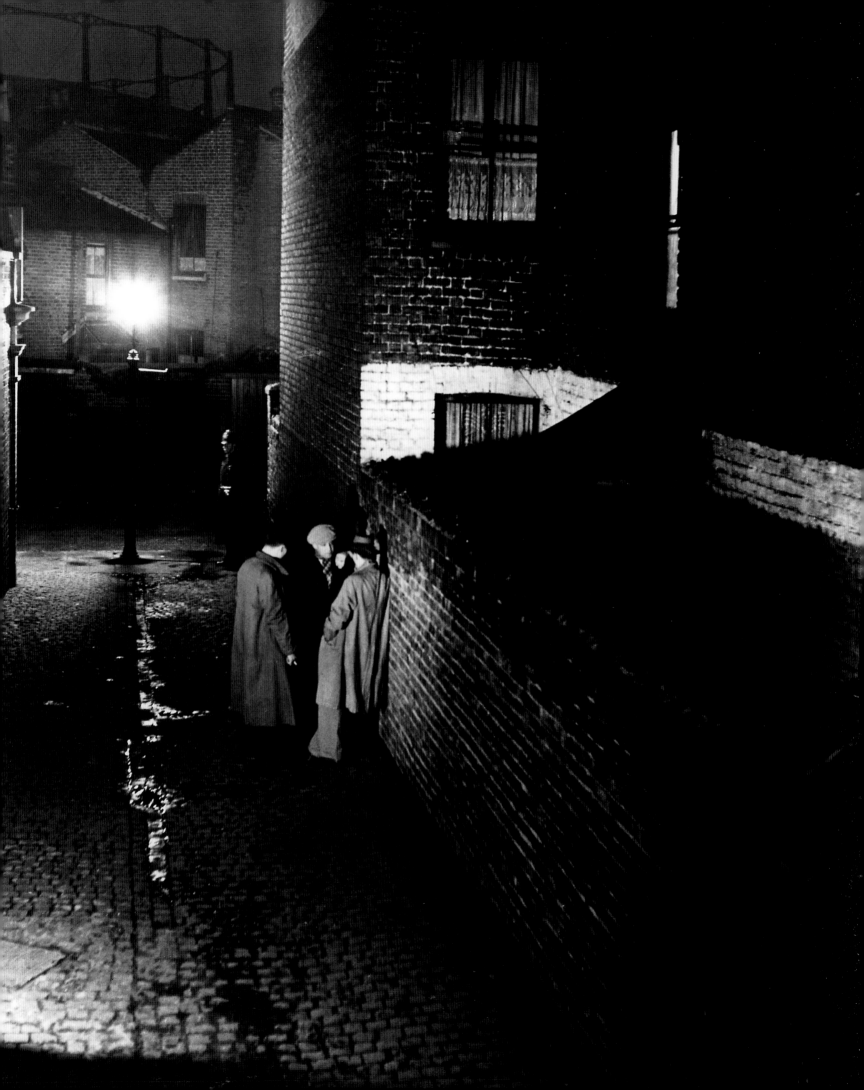

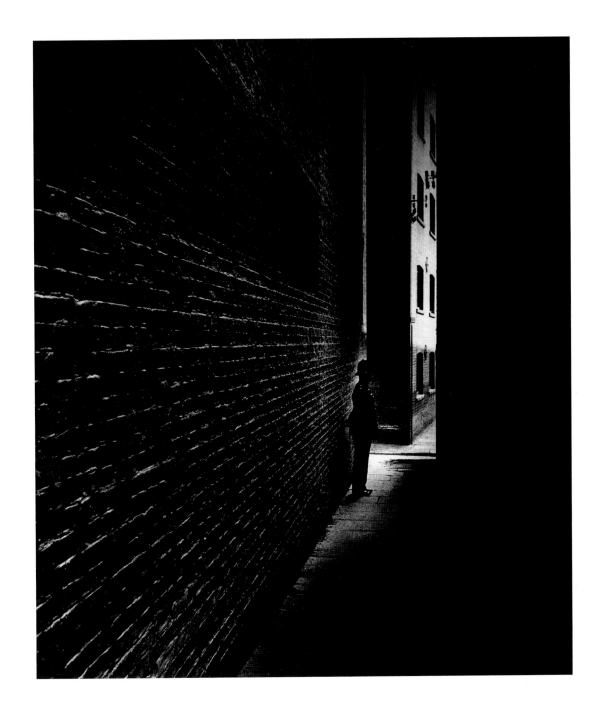

118 East India Docks Road, **1938** 119 Bermondsey, **1938**

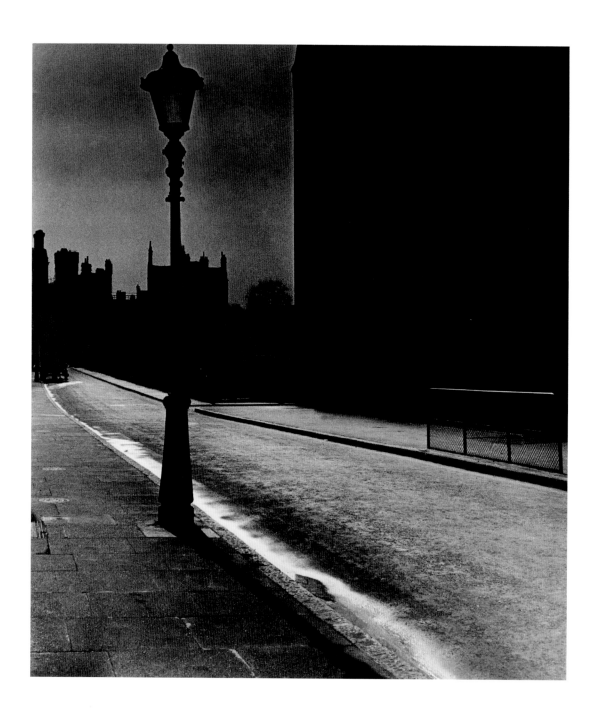

120 Bloomsbury, **1942**

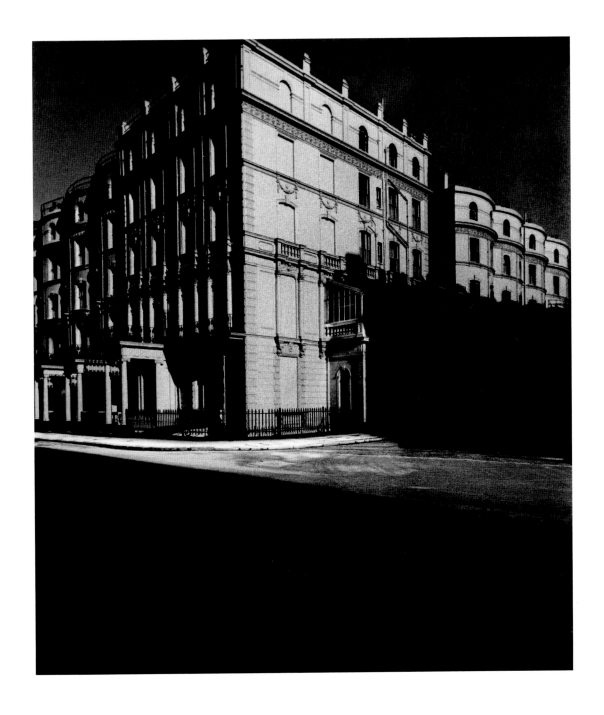

121 Bayswater, **1933**

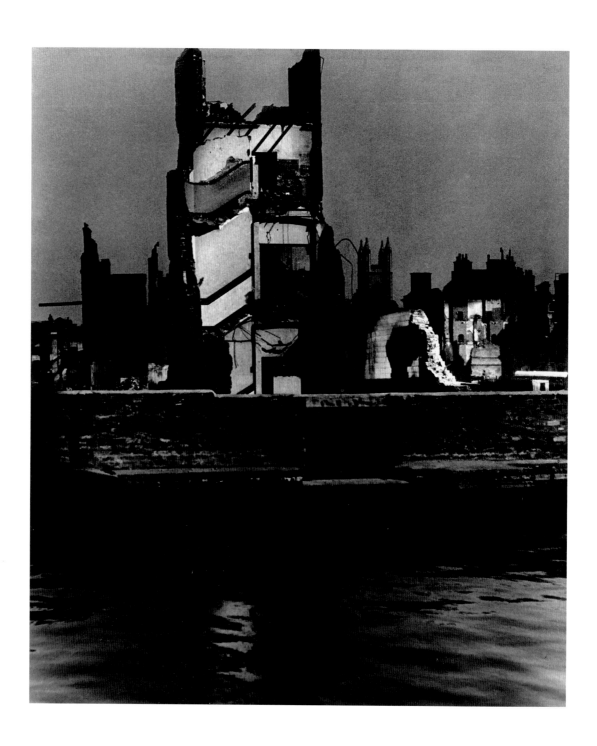

122 City of London, **1942** 123 Saint Paul's, **1942**

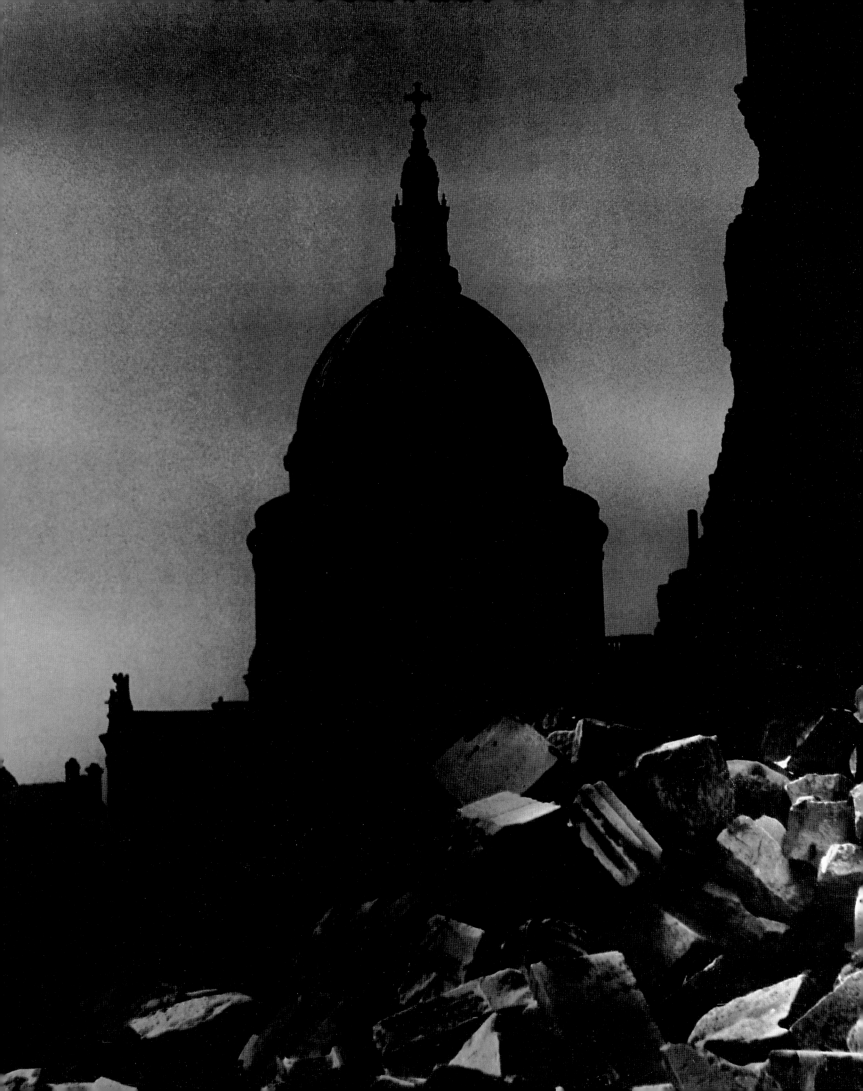

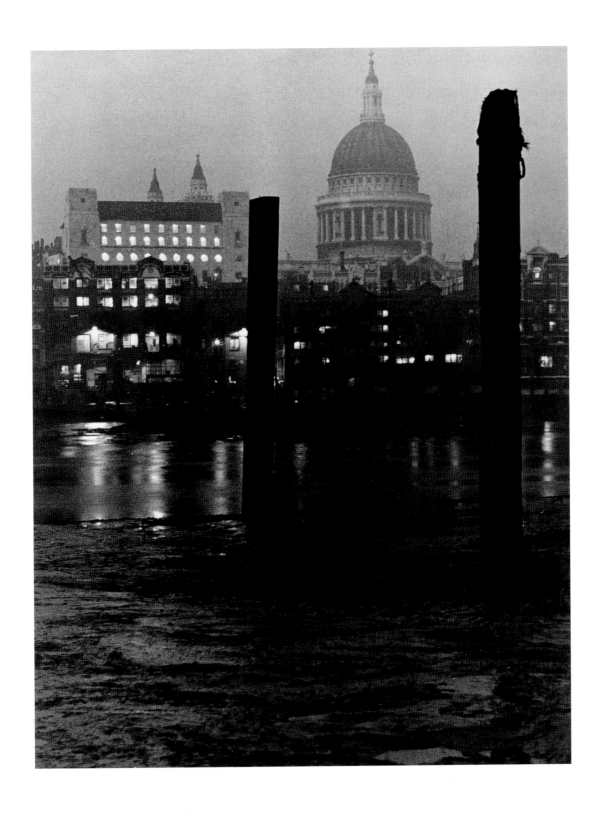

124 Bermondsey, **1945** 125 St Paul's, **1930s**

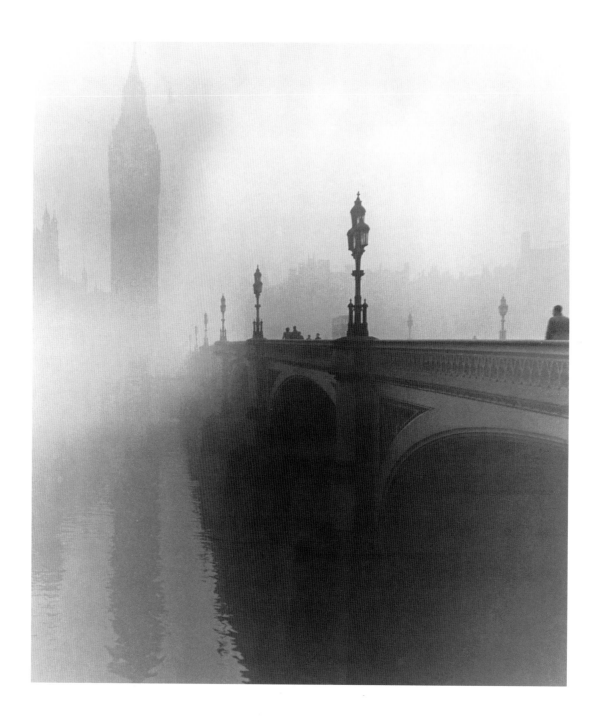

126 Wesminster, **1946** 127 Westminster, c **1938**

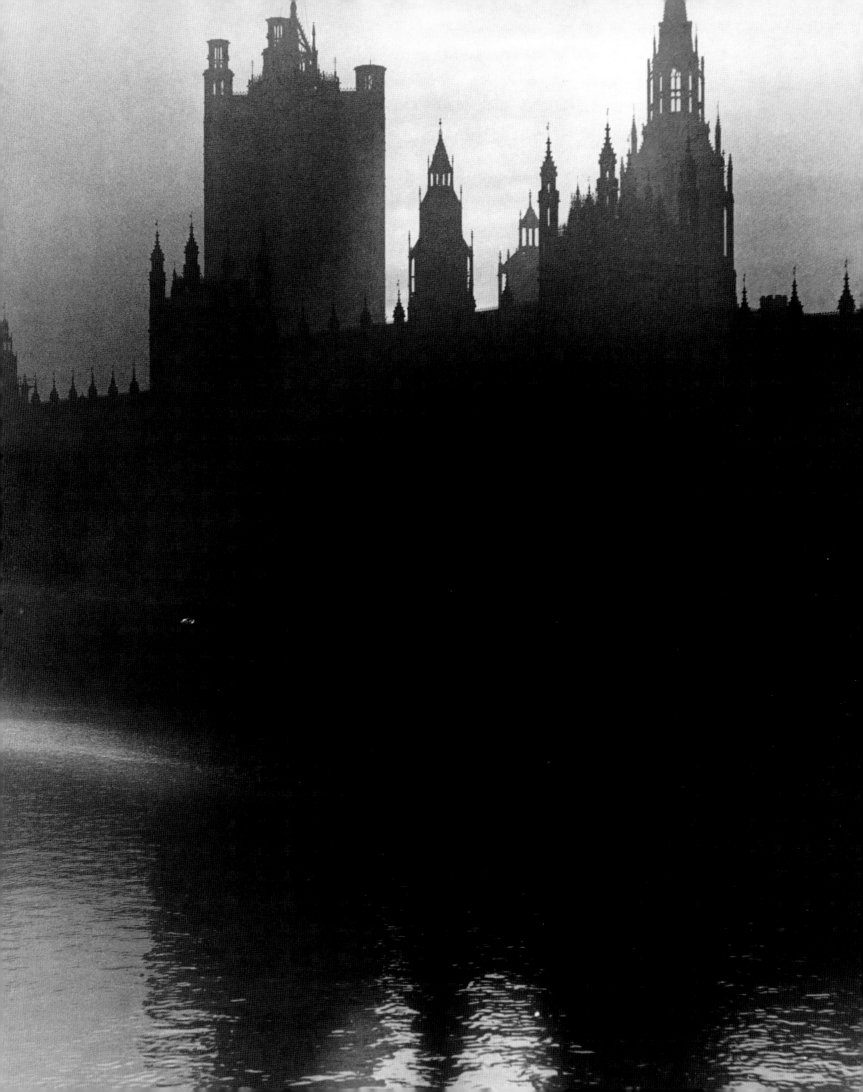

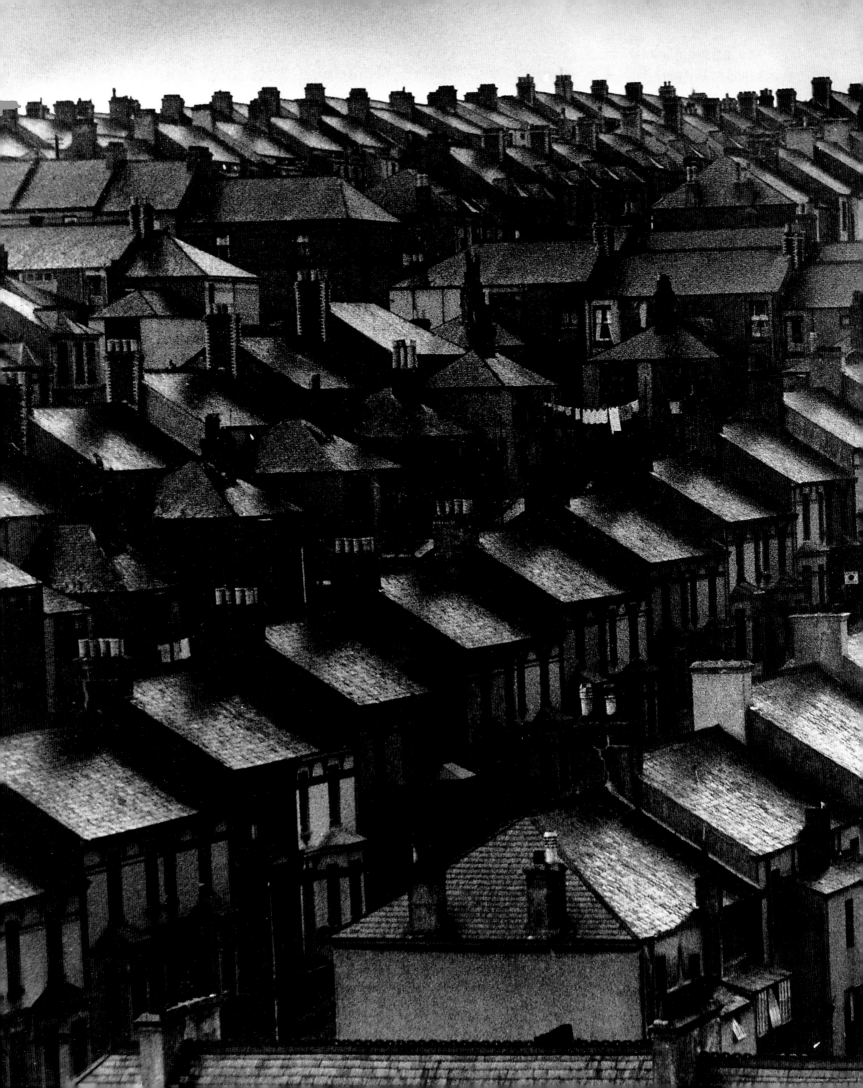

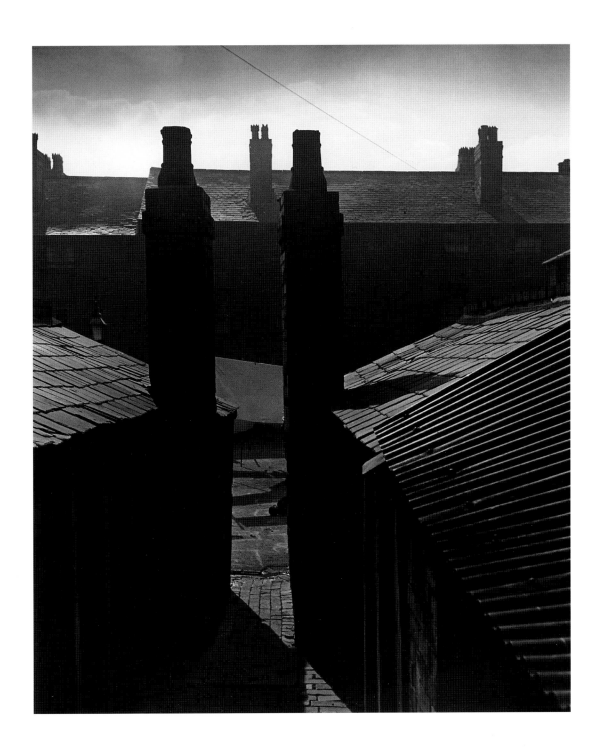

128 South London, **1933** 129 Unidentified location, **1940s**

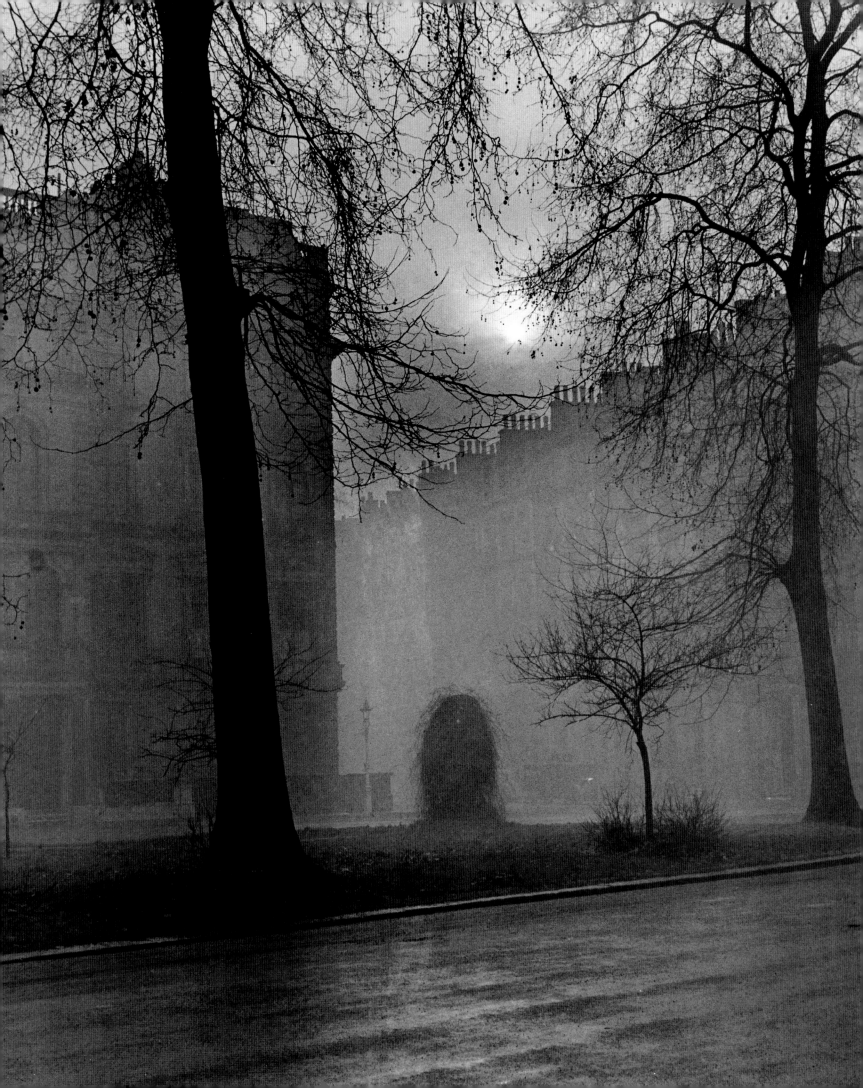

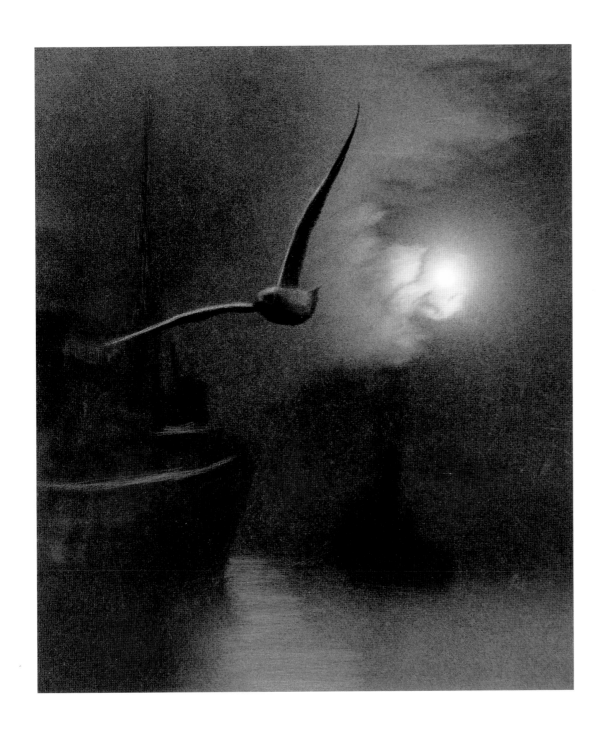

130 Bayswater, **1946** 131 London Bridge, **1939**

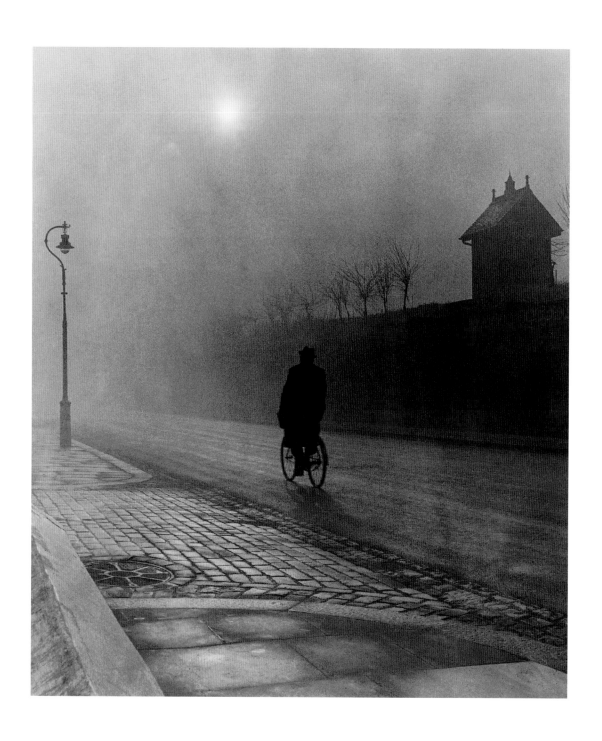

132 Campden Hill, **1946**

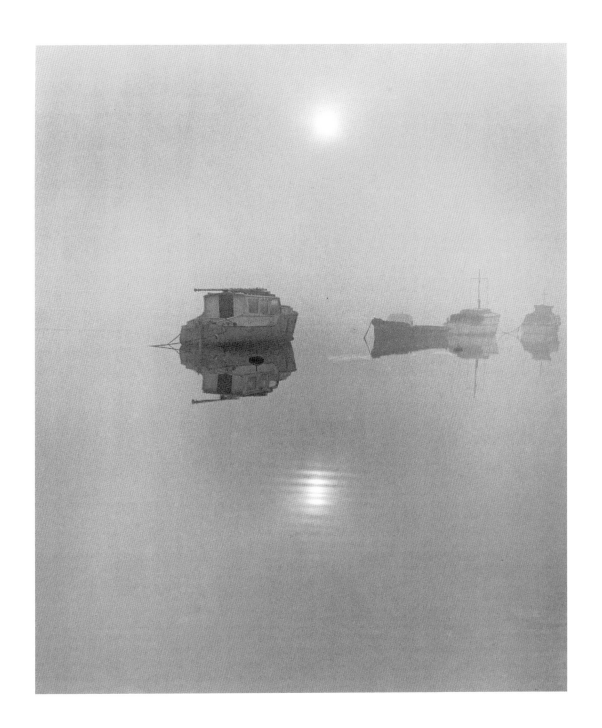

133 Chelsea, **1946**

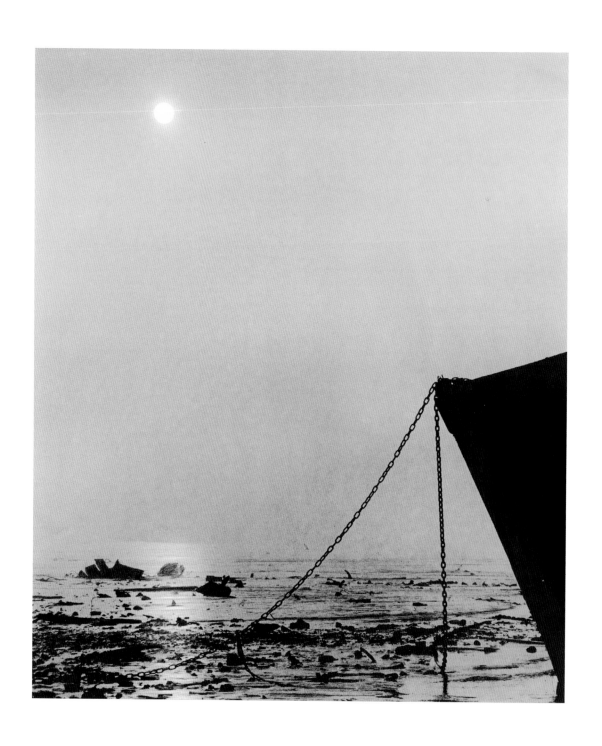

134 Wapping, c 1947 135 Paddington, c 1938

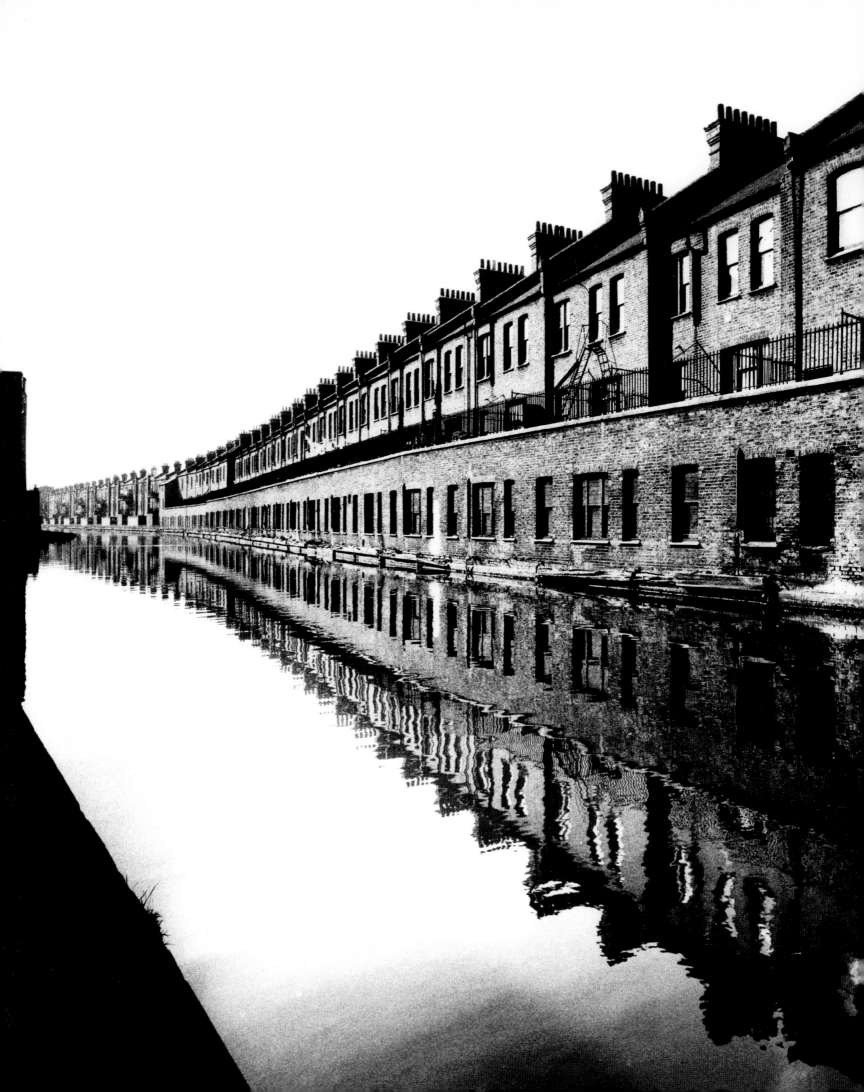

"Whatever the reason, the poetic trend of photography, which had already excited me in my early Paris days, began to fascinate me again. It seemed to me that there were wide fields still unexplored. I began to photograph nudes, portraits, and landscapes.

　　　To be able to take pictures of landscape, I have to become obsessed with a particular scene. Sometimes I feel that I have been to a place long ago, and must try to recapture what I remember. When I have found a landscape which I want to photograph, I wait for the right season, the right weather, and right time of day or night, to get the picture which I know to be there."

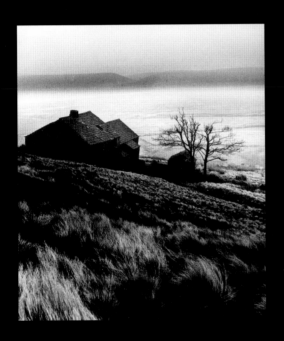

A RETURN TO POETRY

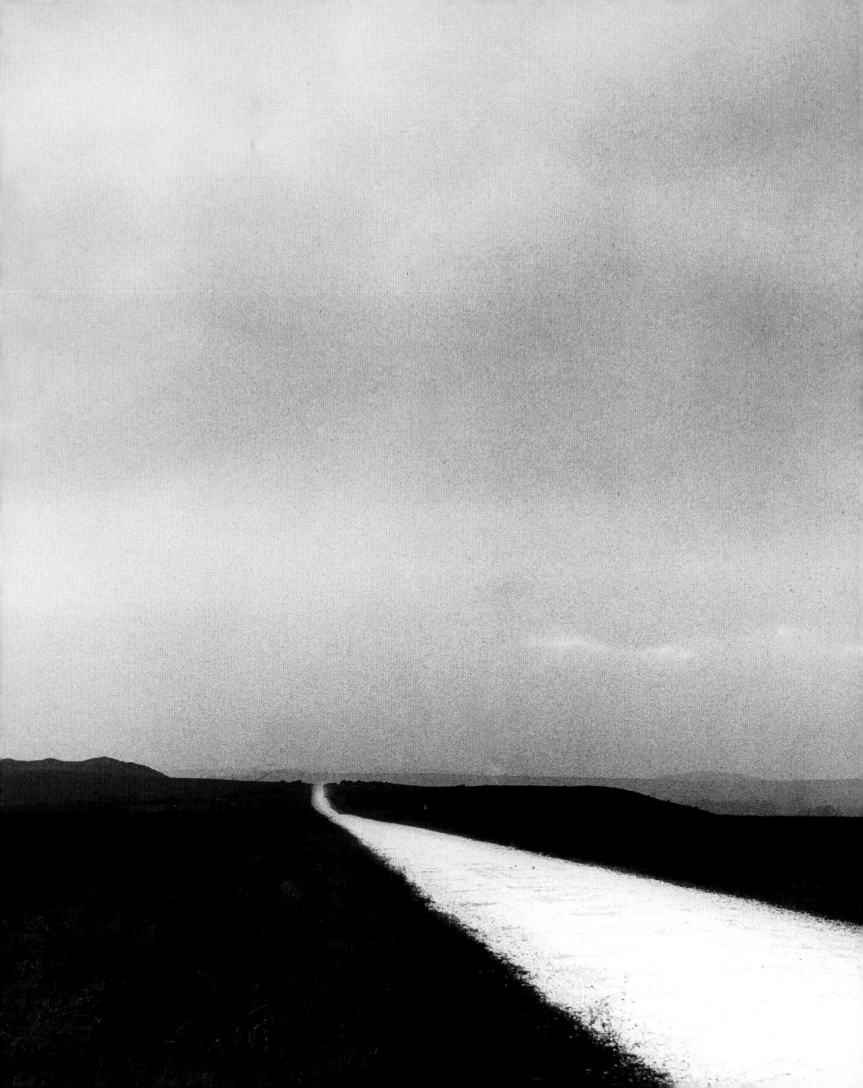

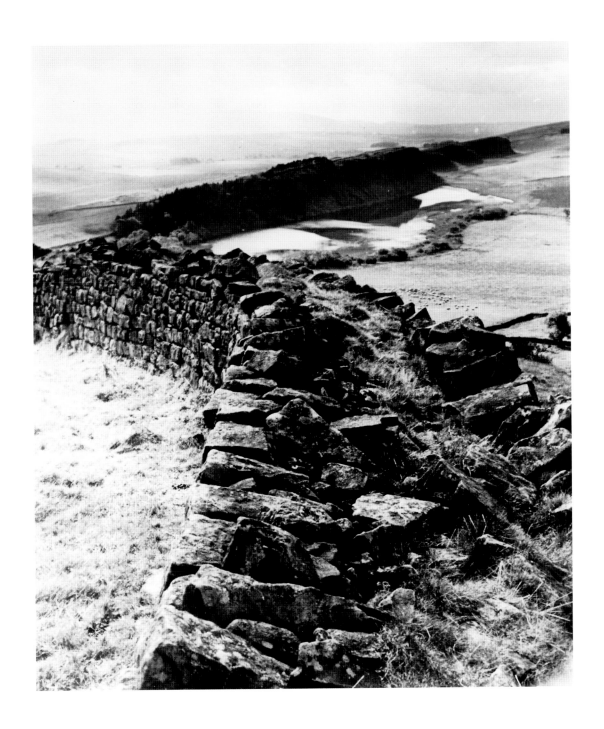

137 Unknown location, **1940s** 138 Hadrian's Wall, **1943**

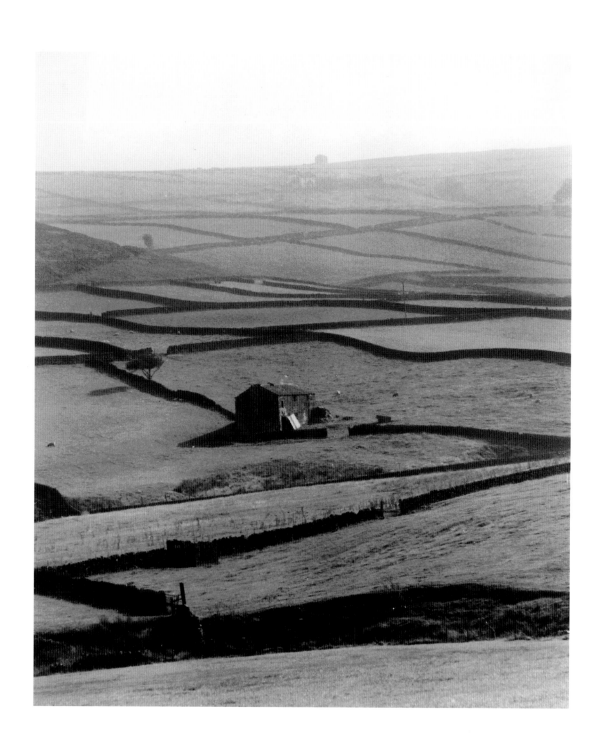

139 Yorkshire, **1940s** 140 Marlborough Downs, **1948**

160 141 Maiden Castle, **1940** 142 Avebury, **1940**

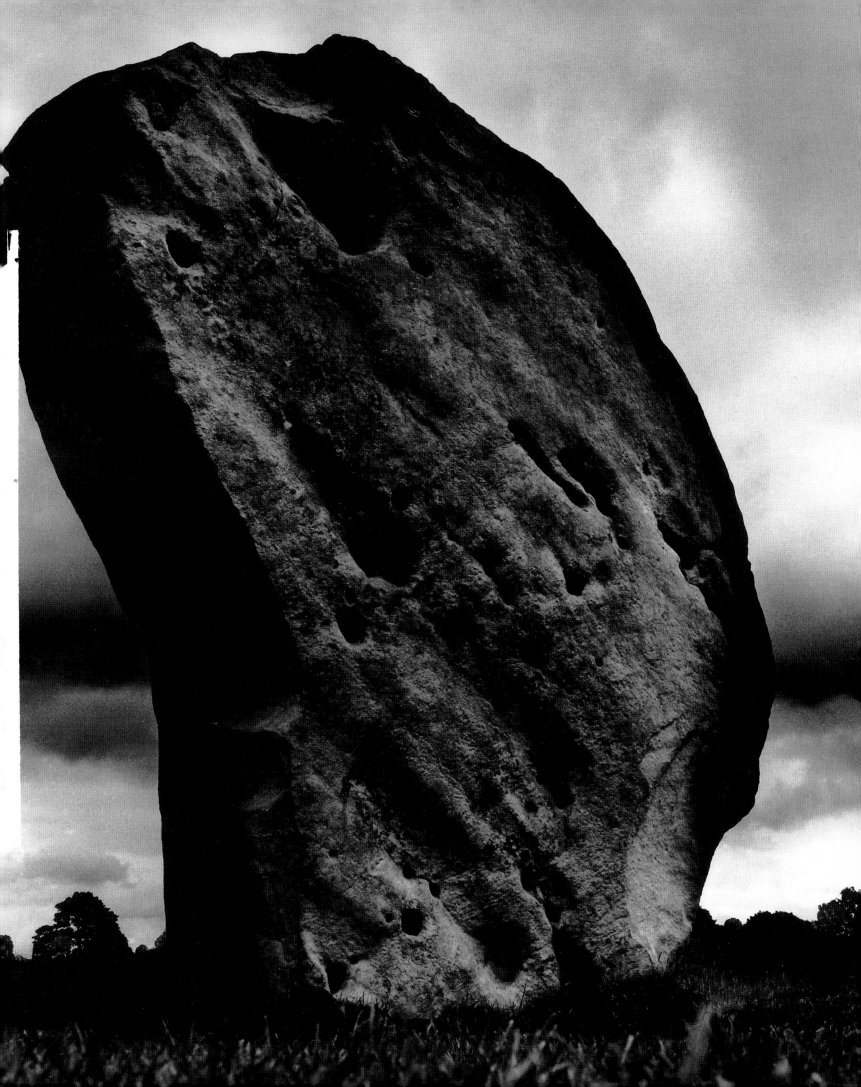

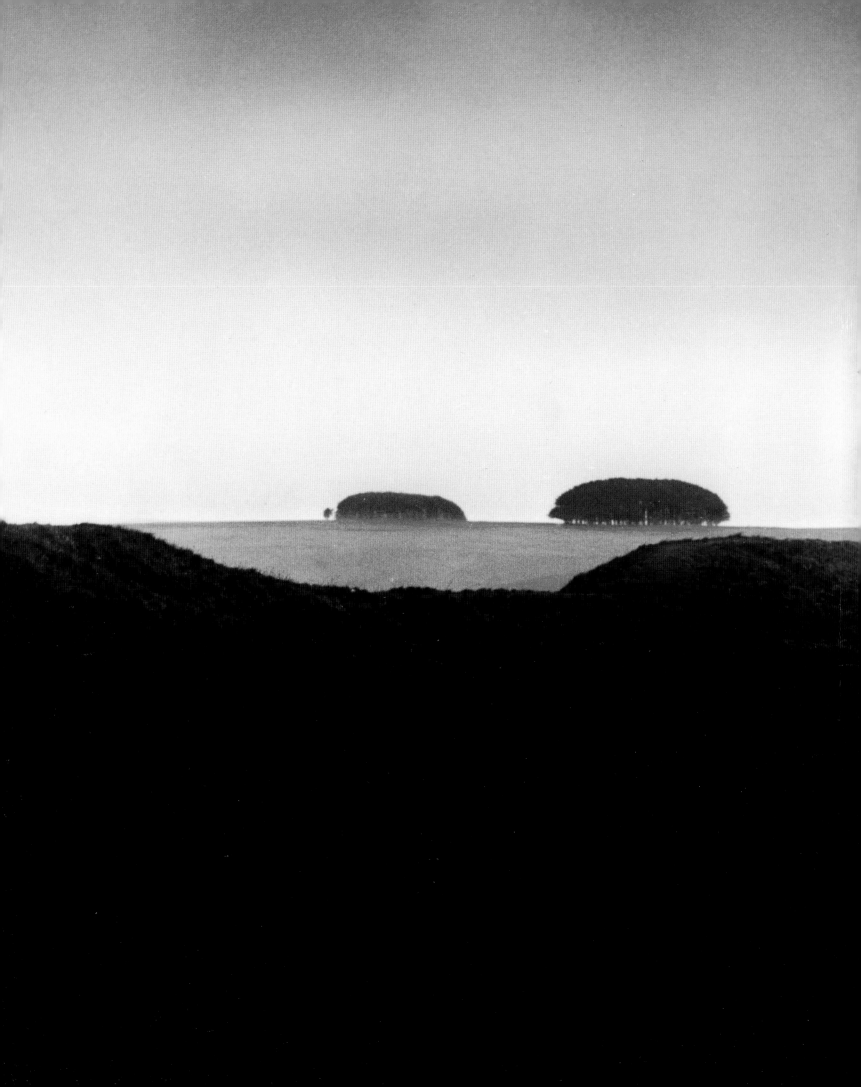

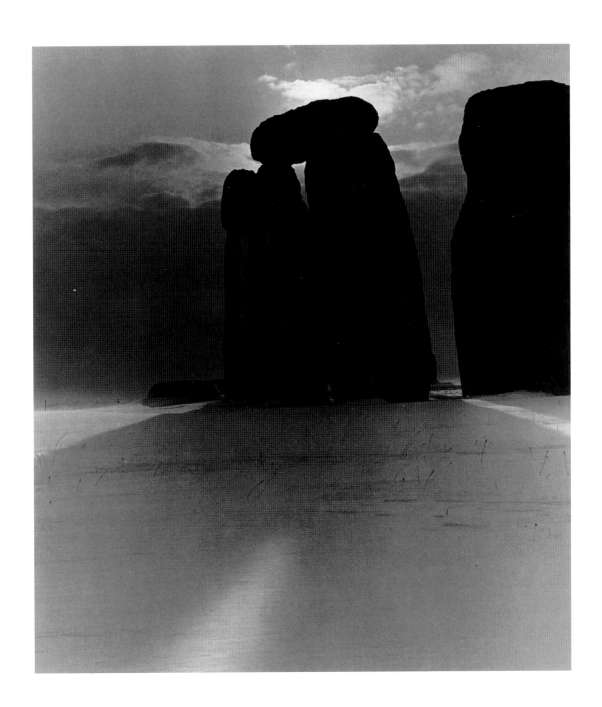

143 Barbary Castle, **1948** 144 Stonehenge, **1947**

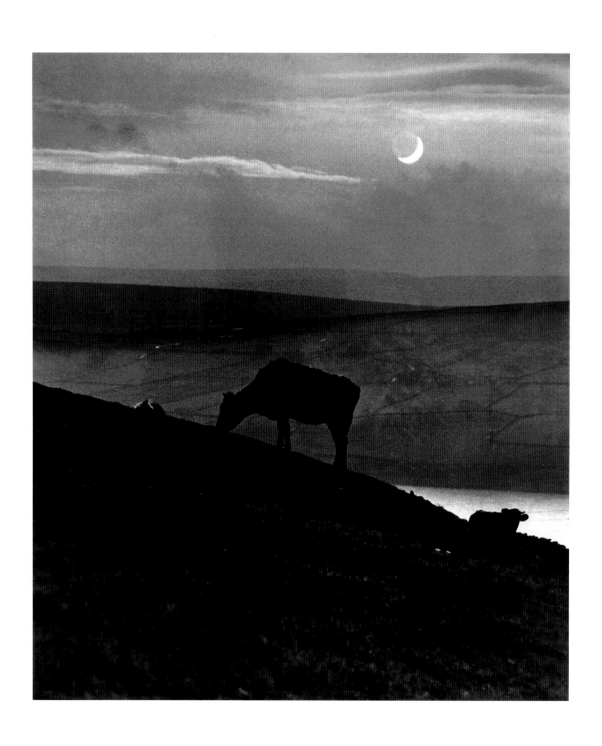

145 Yorkshire, **1944**

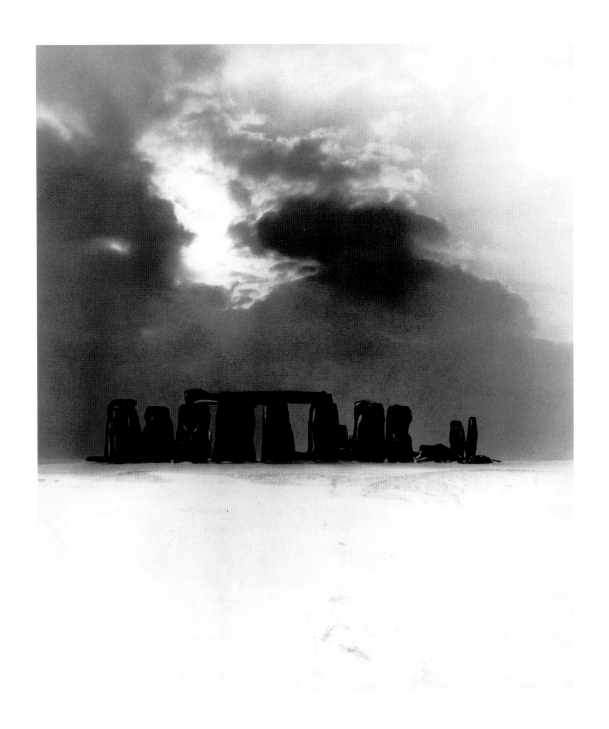

146 Stonehenge, **1947**

165

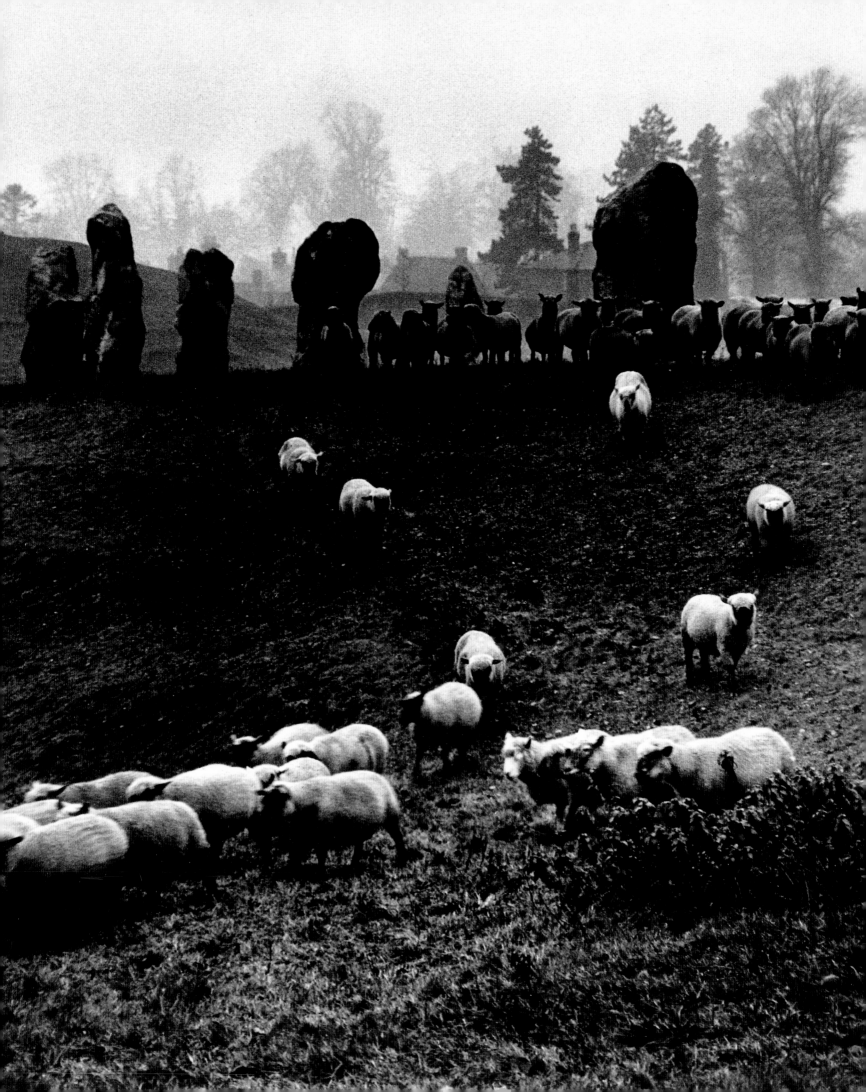

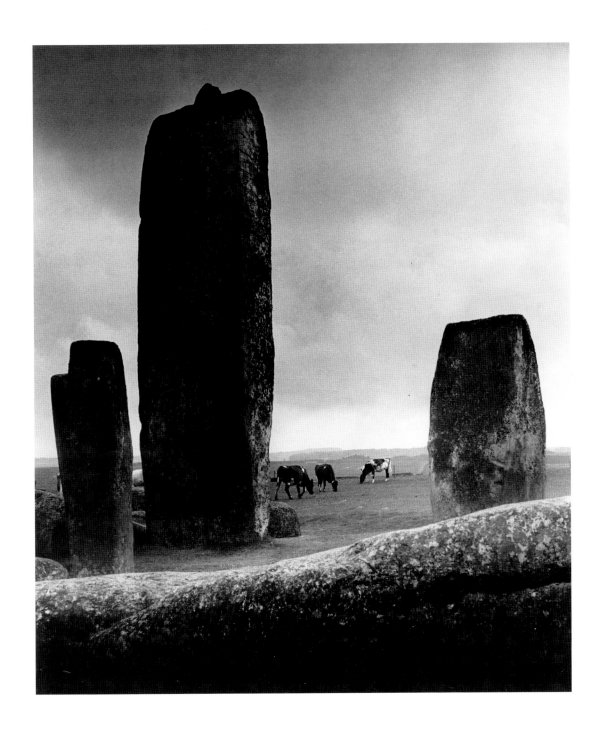

147 Avebury, **1945** 148 Stonehenge, *c* **1946**

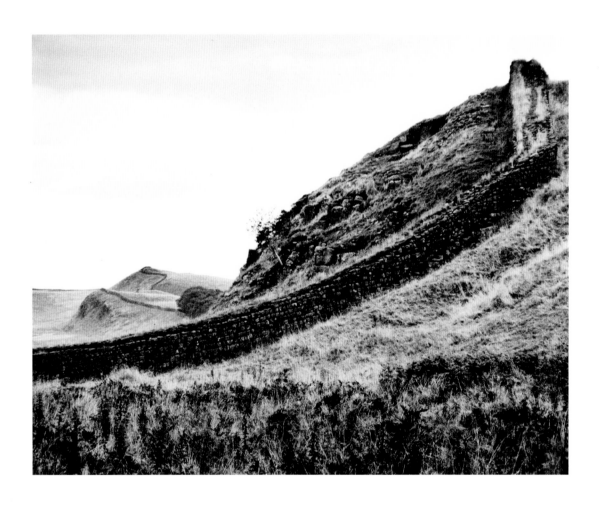

149 Hadrian's Wall, **1941**

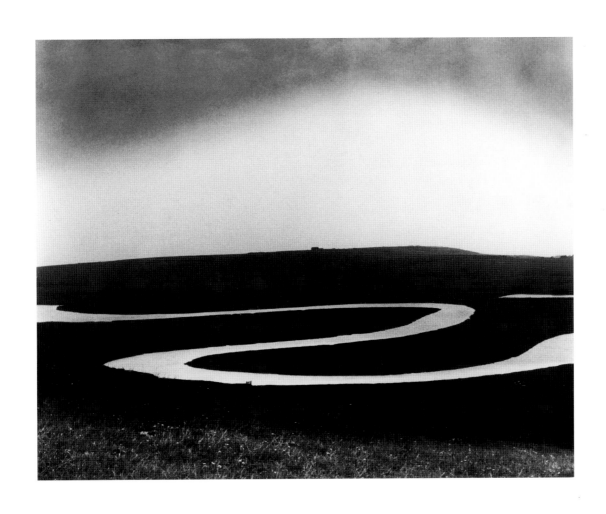

150 Cuckmere River, Sussex **1963**

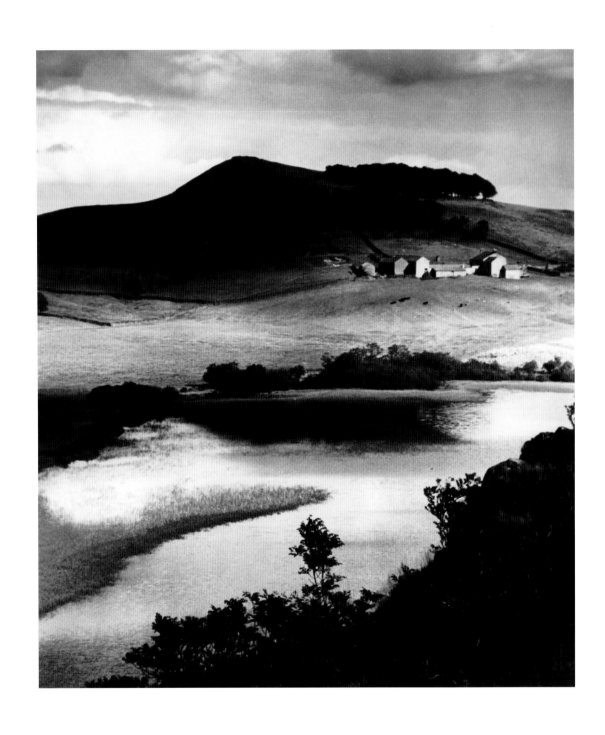

151 Isle of Skye, **1947**

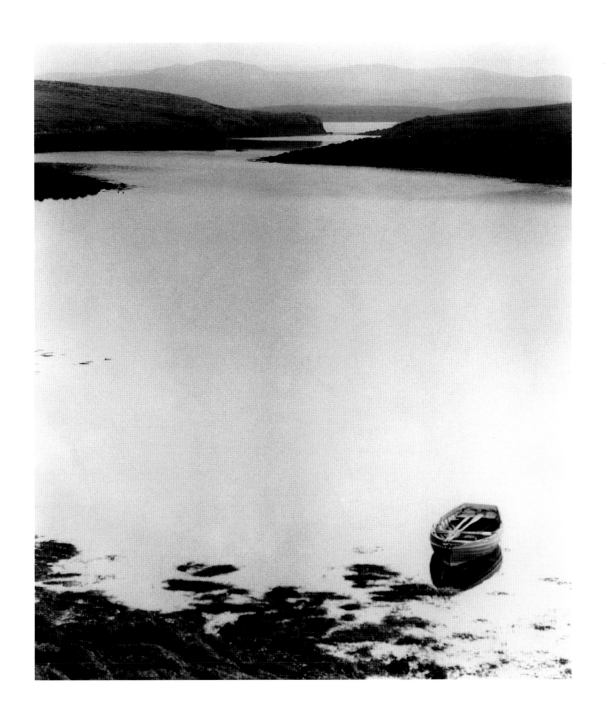

152 Outer Hebrides, **1947**

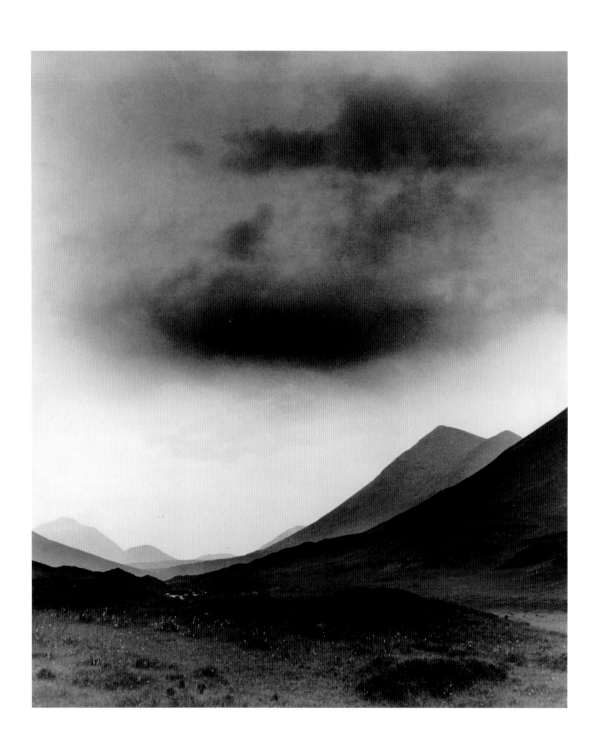

153 Isle of Skye, **1947** 154 Isle of Skye, **1947**

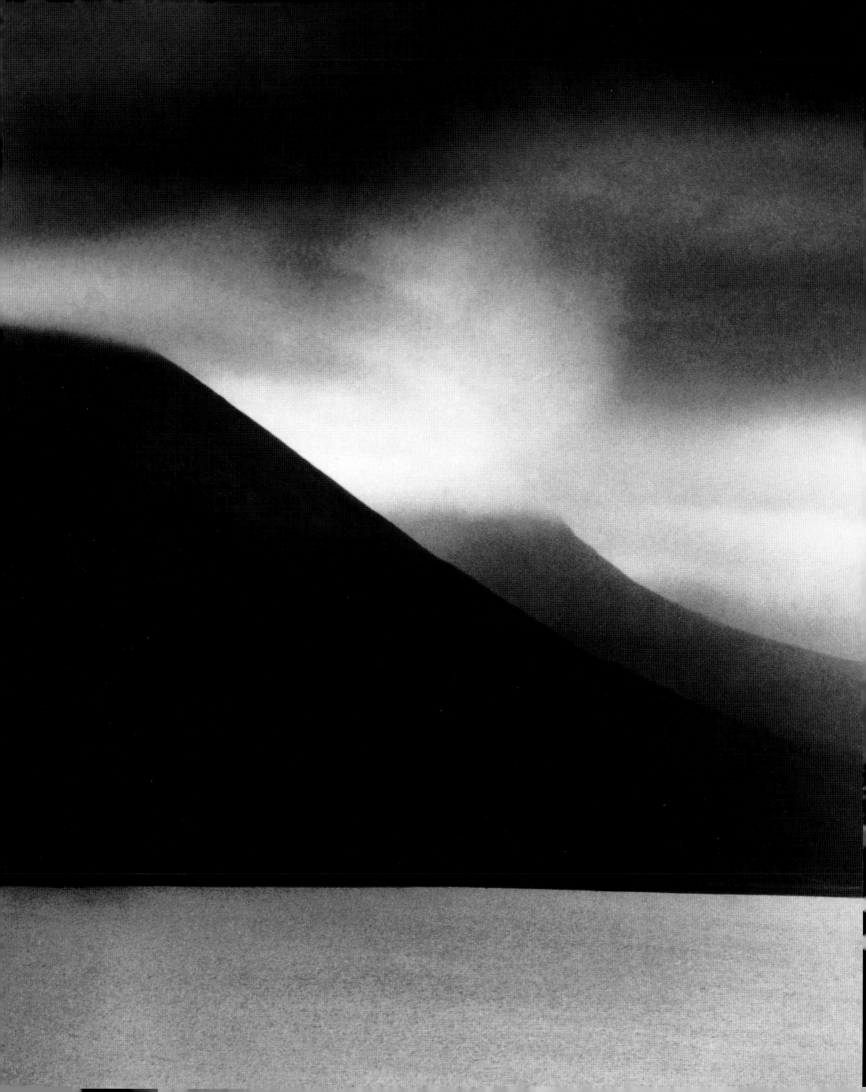

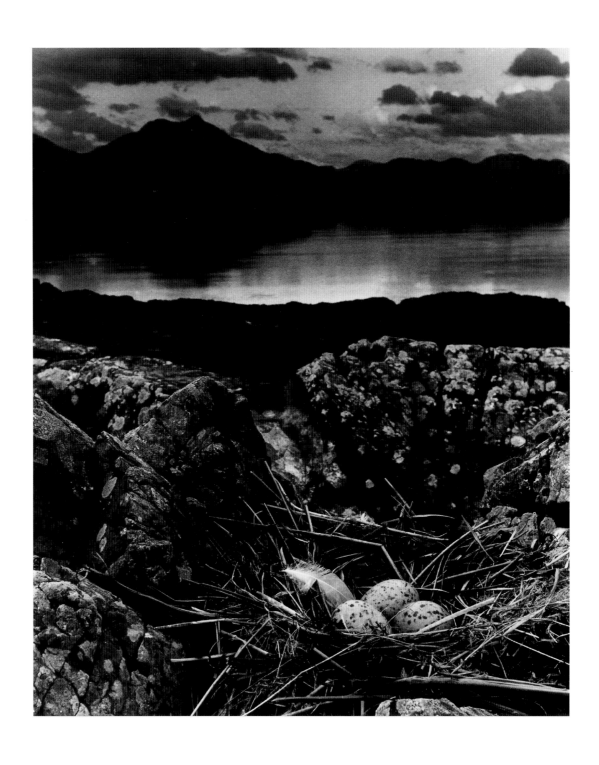

155 Isle of Skye, **1947**

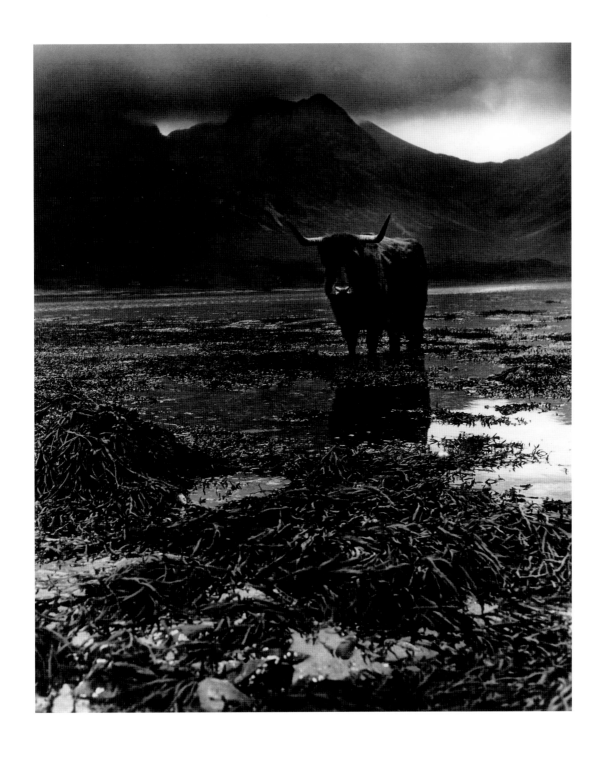

156 Isle of Skye, **1947**

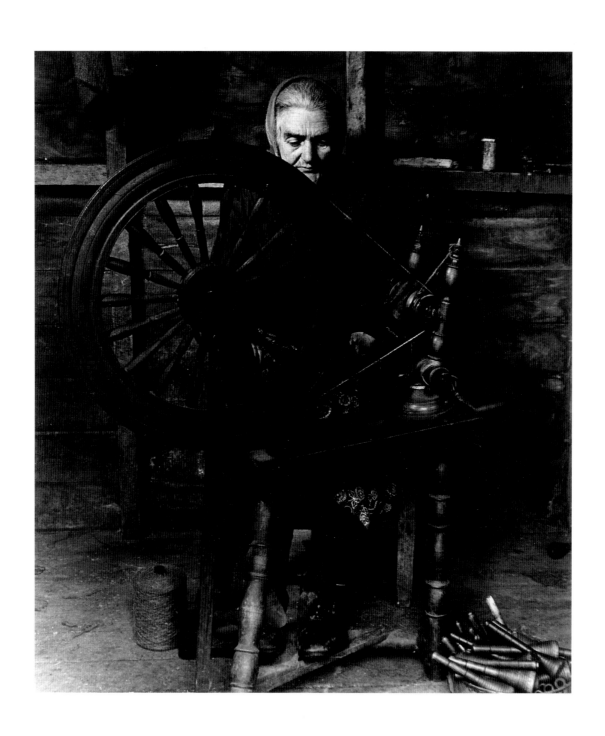

157 Isle of Skye, **1947** 158 Isle of Skye, **1947**

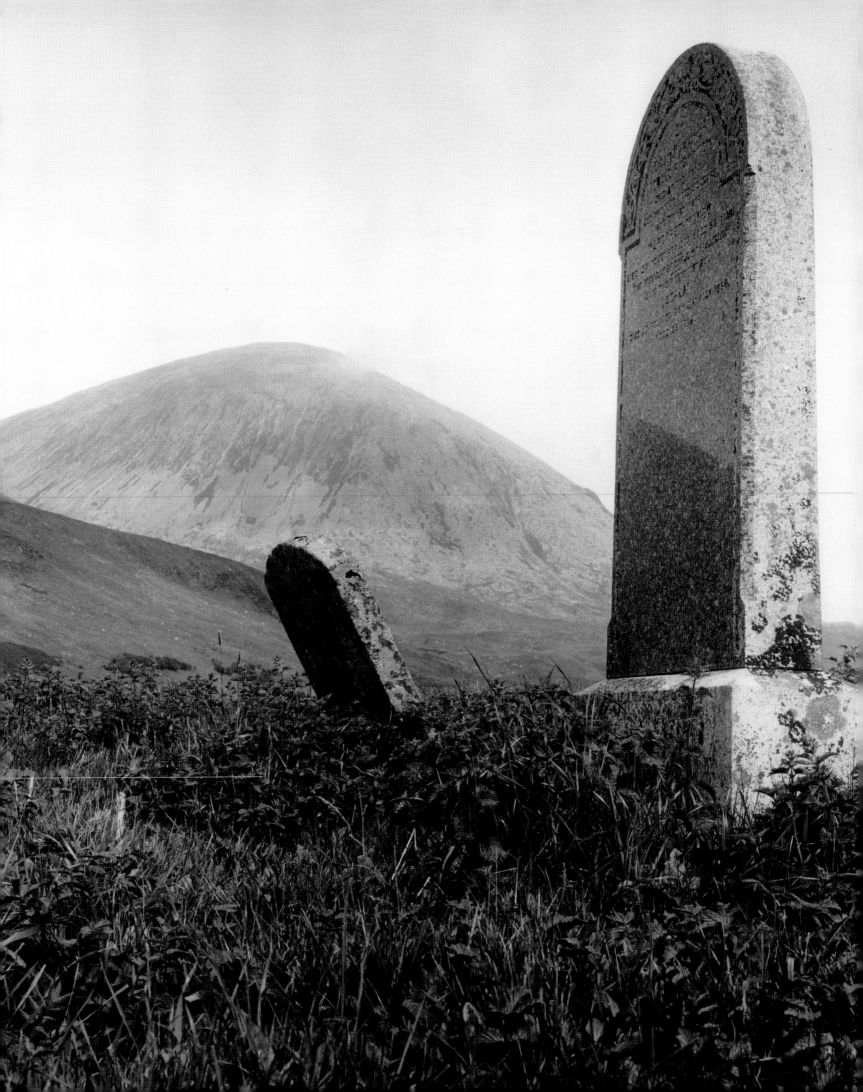

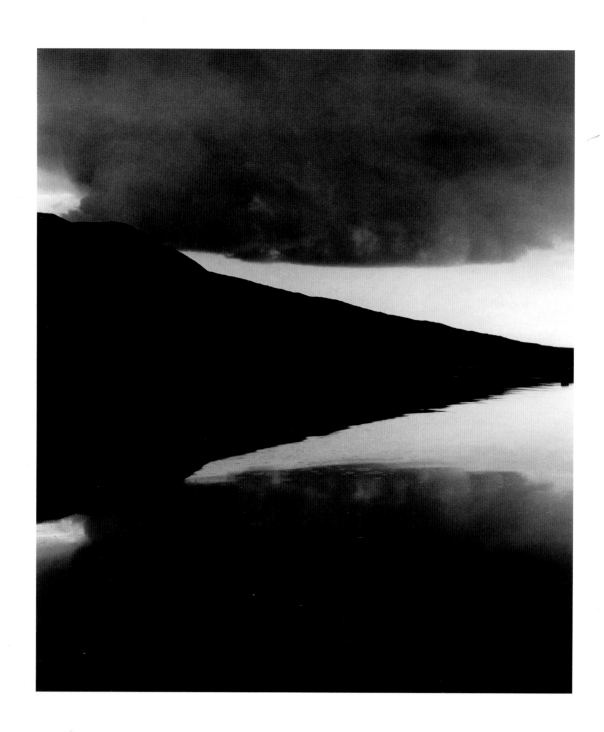

159 The Western Isles, **1947** 160 Gordale Scar, **1947**

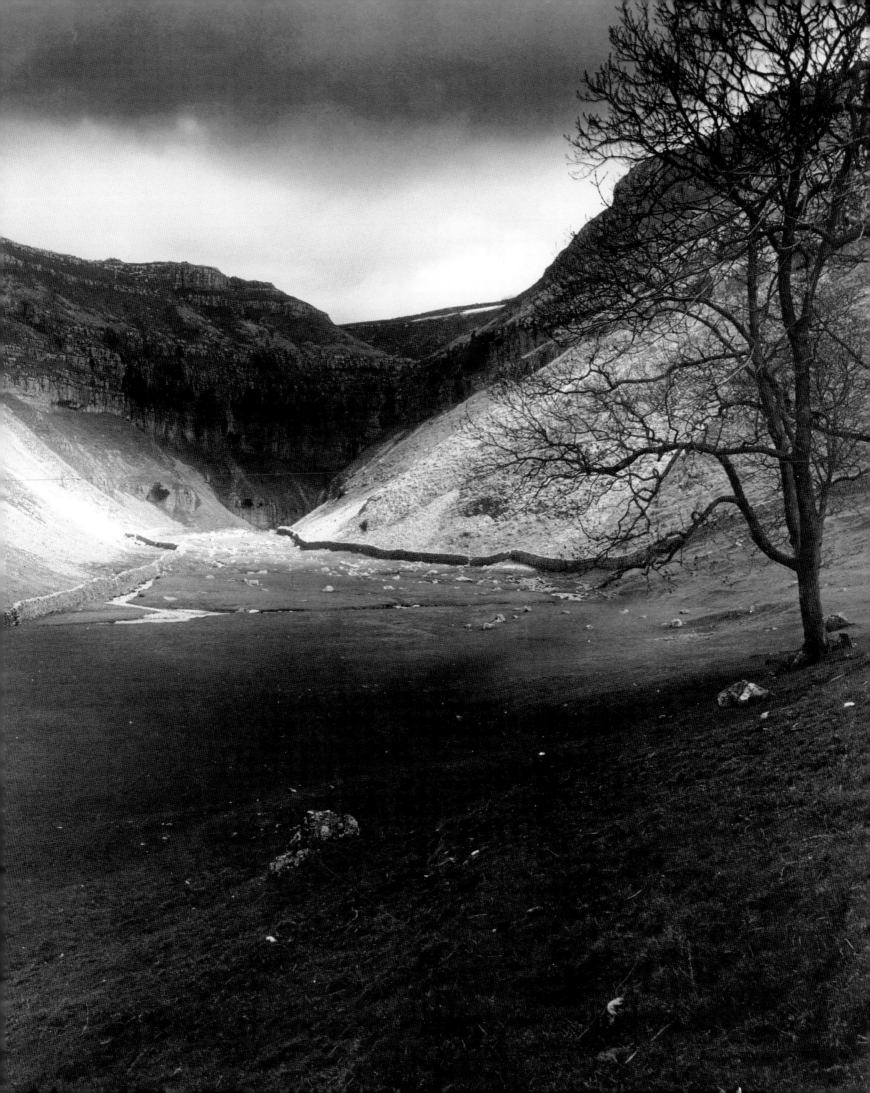

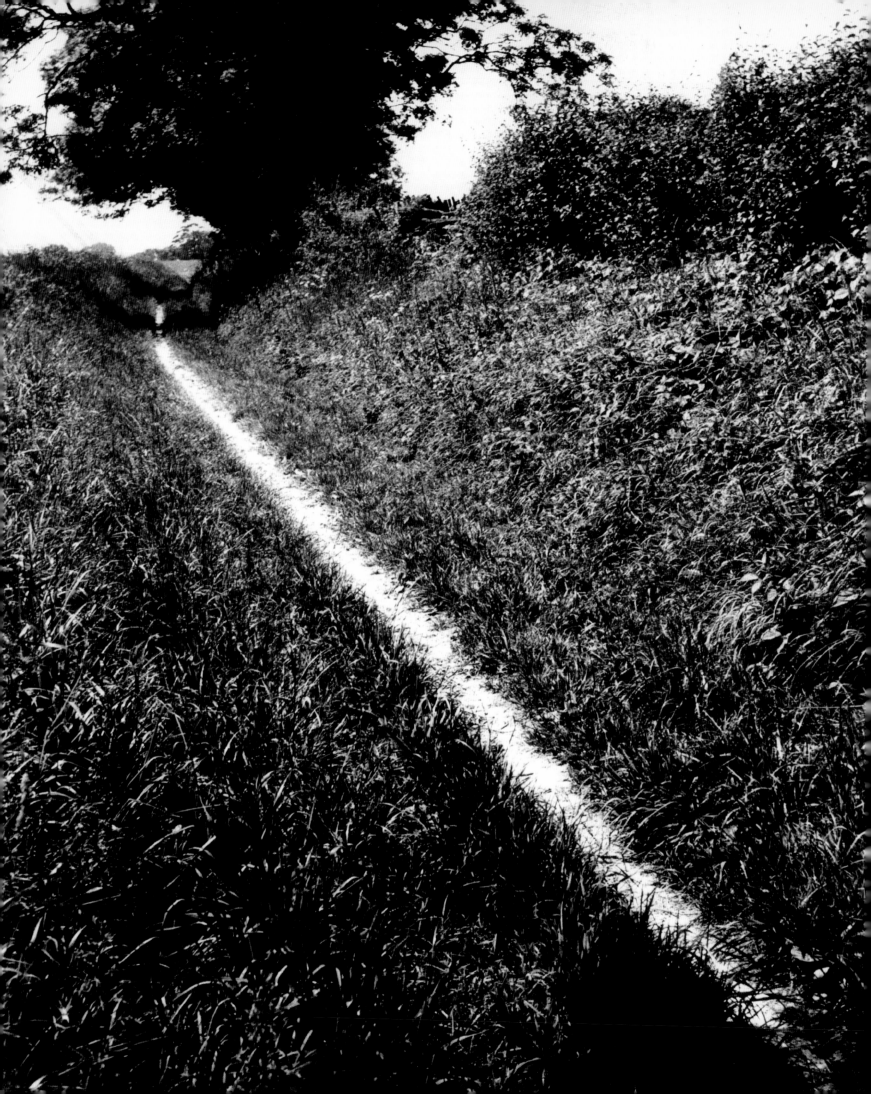

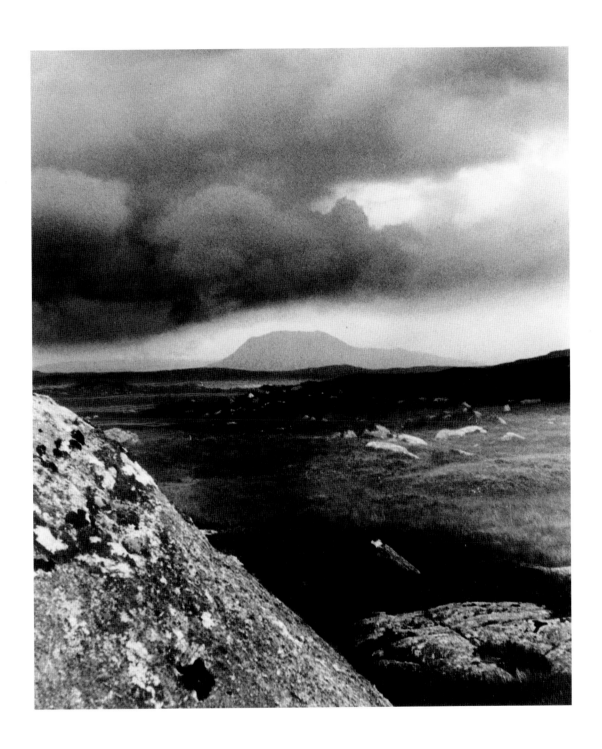

161 Pilgrim's Way, Kent, 1950 162 Perthshire, 1940

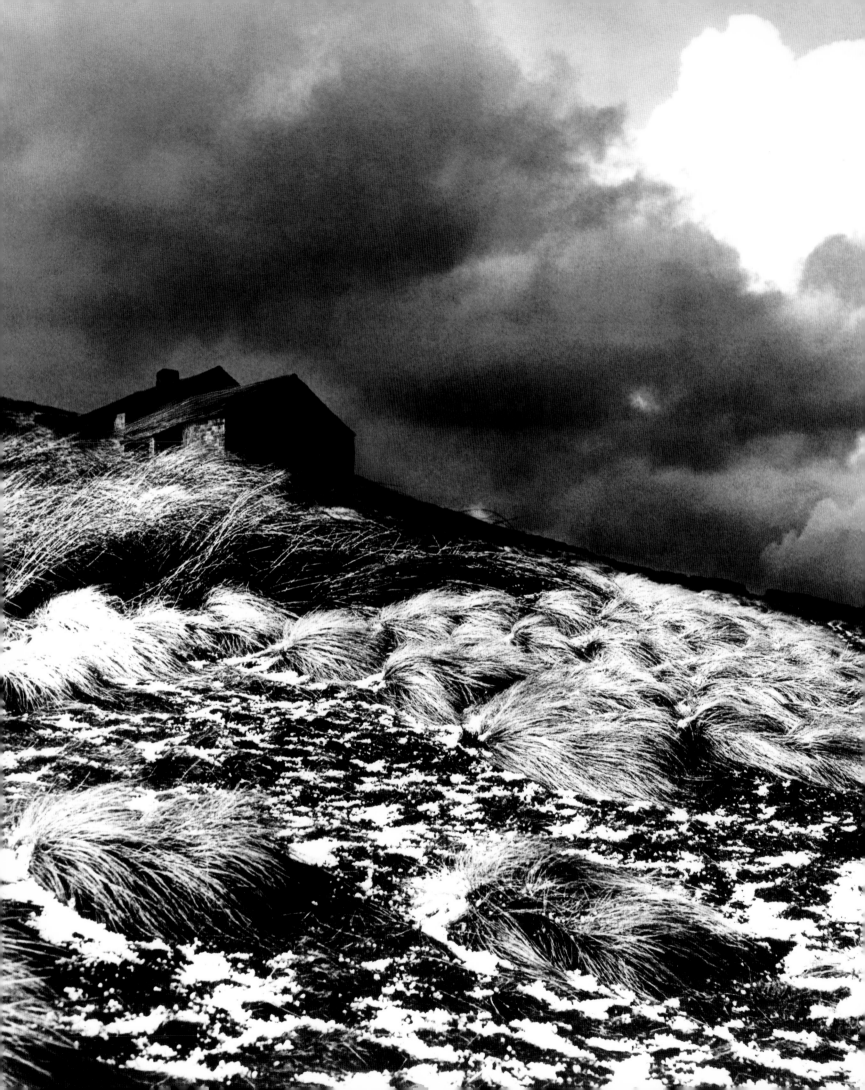

"One of my favourite pictures of this time is 'Top Withens' on the Yorkshire moors. I was then trying to photograph the country which had inspired Emily Brontë. I went to the West Riding in summer, but there were tourists and it seemed quite the wrong time of the year. I liked it better misty, rainy and lonely in November. But I was not satisfied until I saw it again in February. I took the picture just after a hailstorm when a high wind was blowing over the moors."

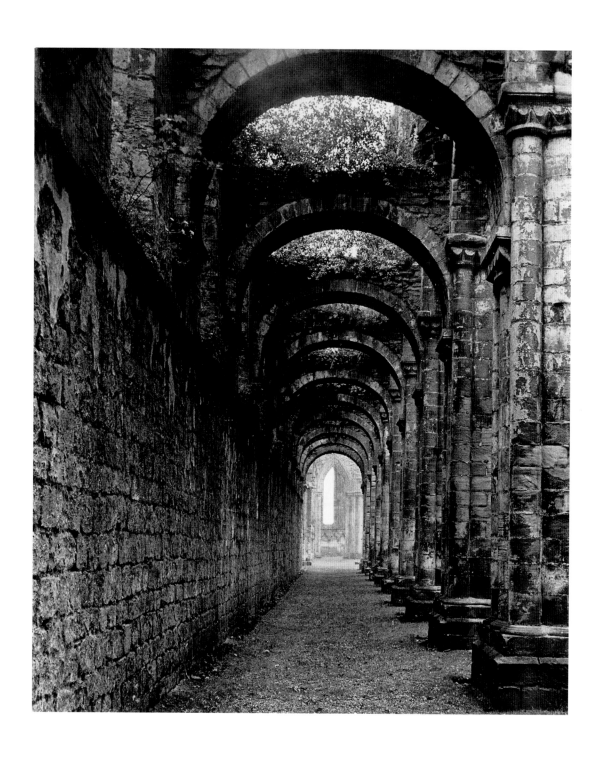

164 Fountains Abbey, **1946**

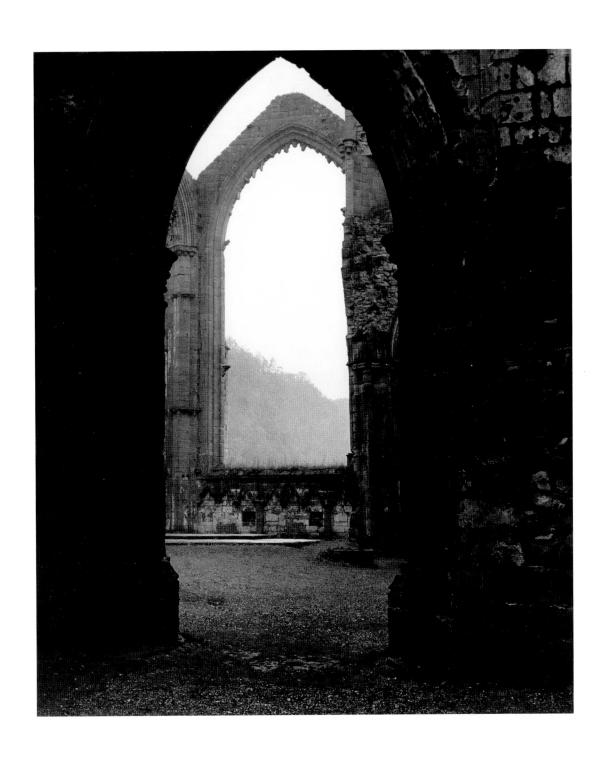

165 Fountains Abbey, **1946**

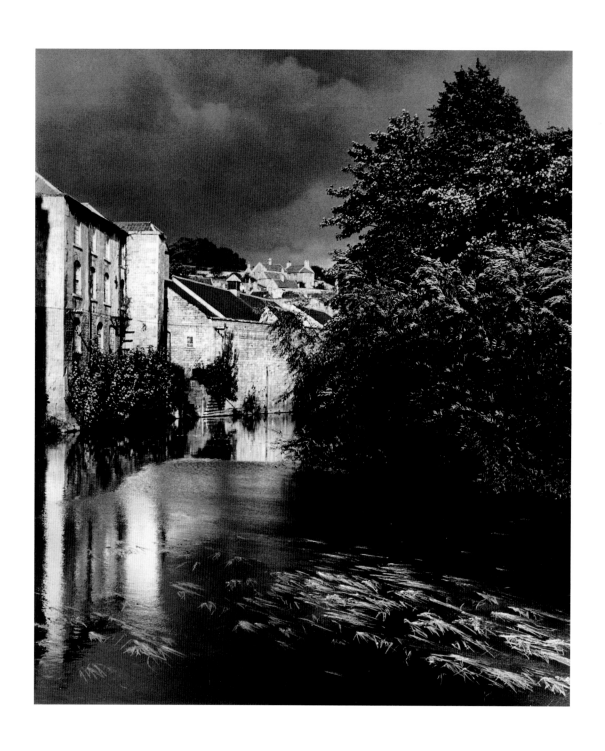

186 Bradford-on-Avon, **1944** 167 Bradford-on-Avon, **1944**

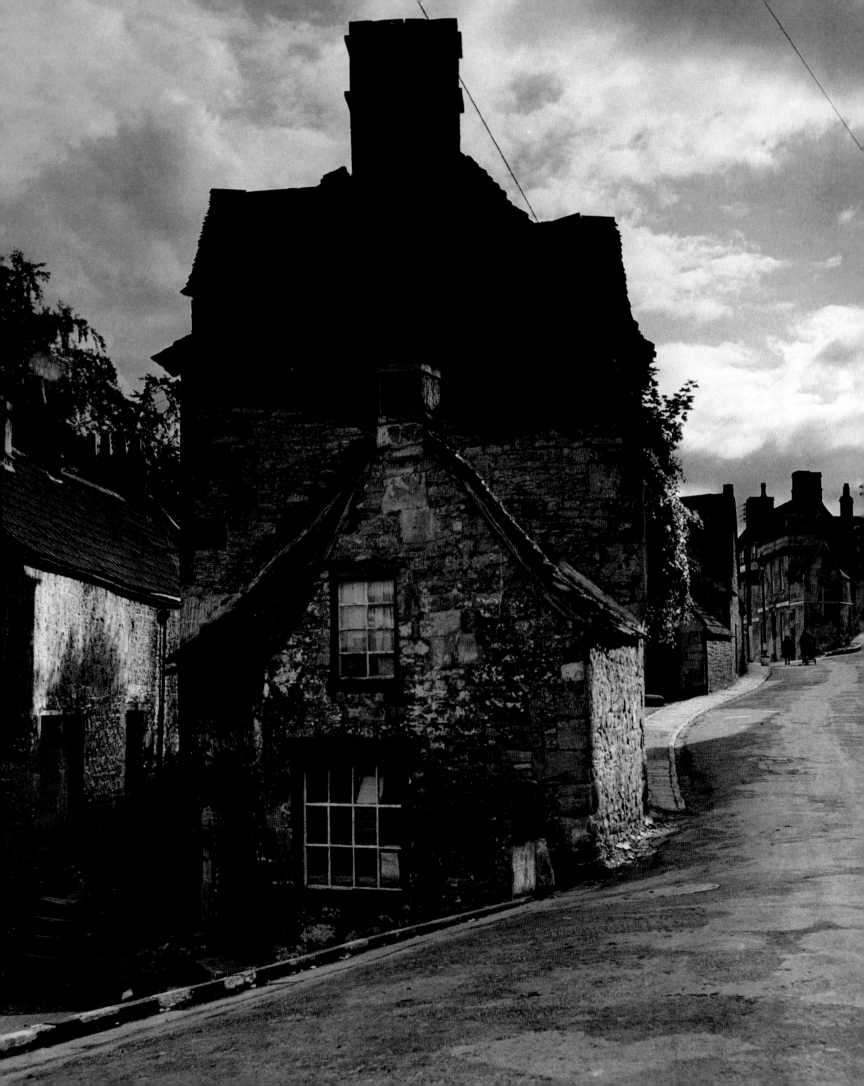

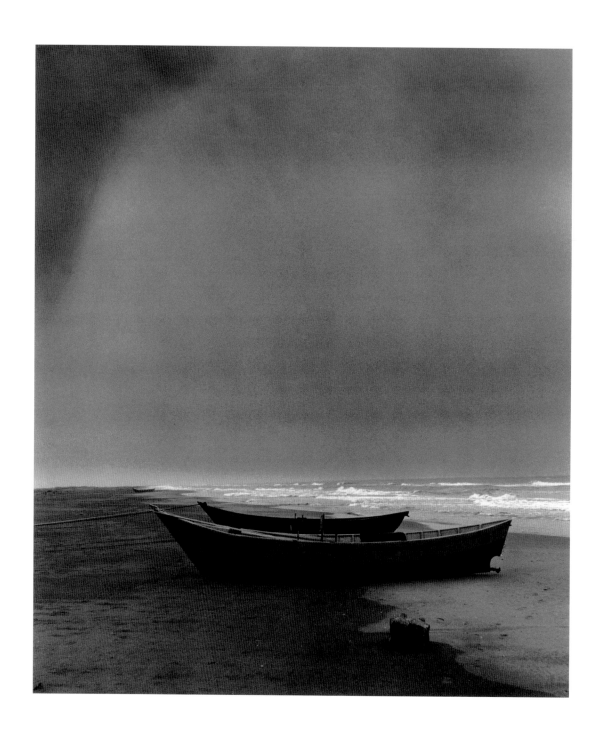

168 Saintes-Maries-de-la-Mer, **1948** 169 Dover Beach, *c* **1940**

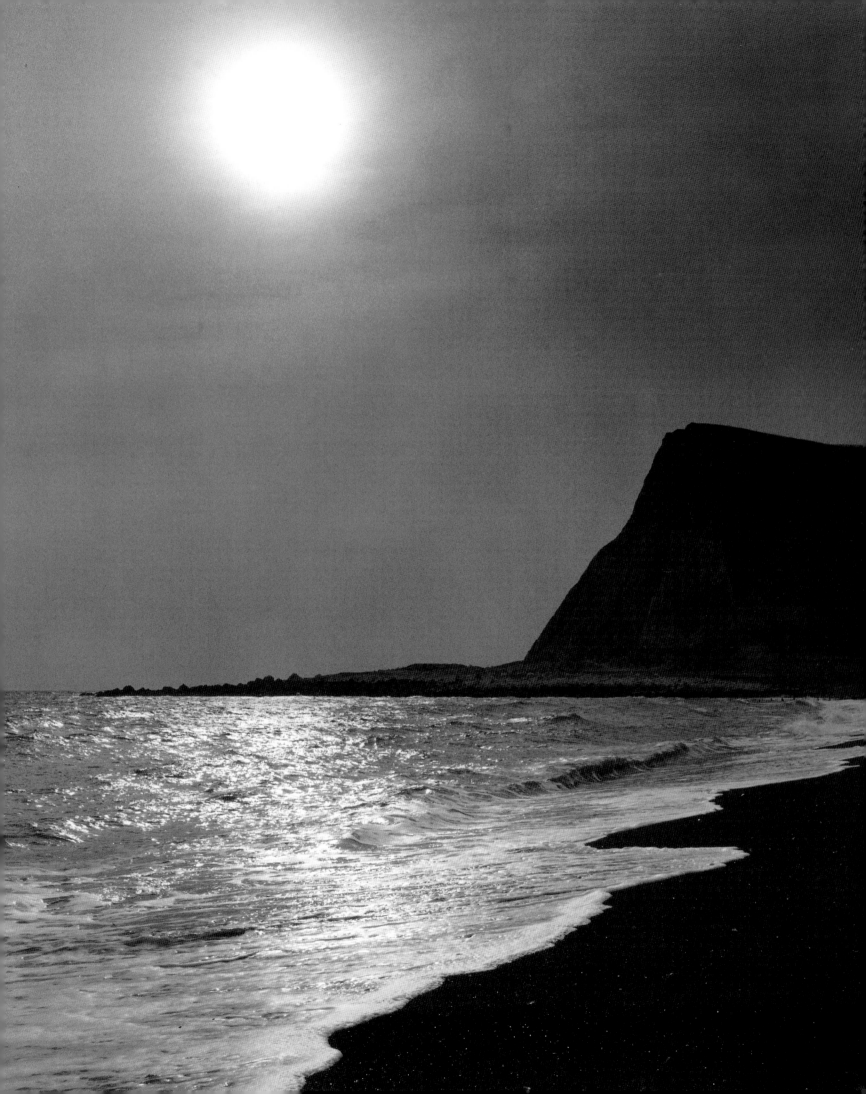

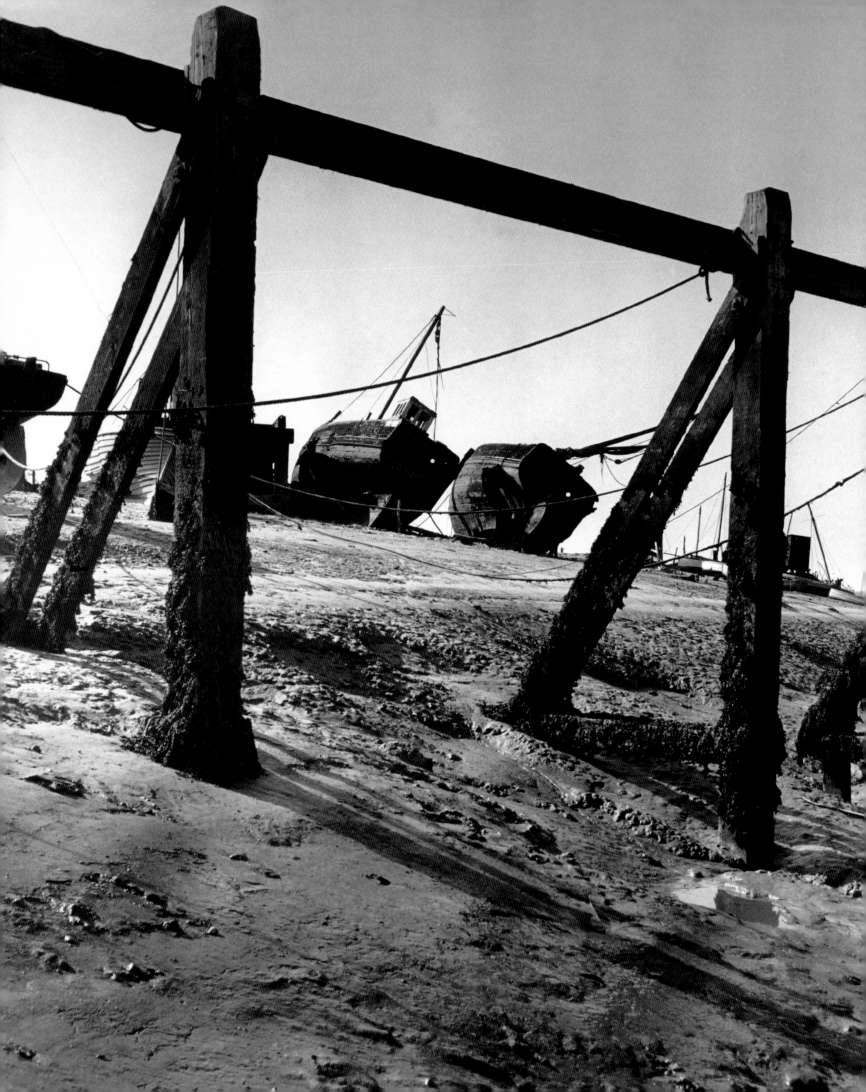

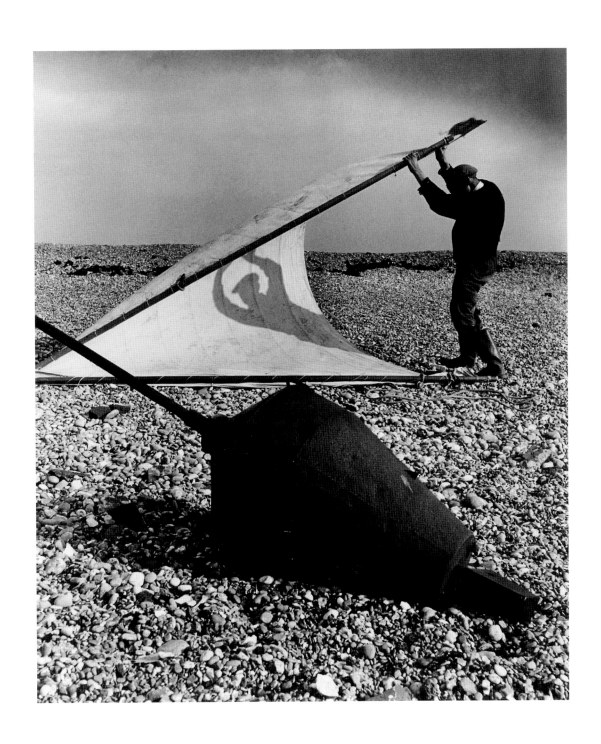

170 Unknown location, **1940s** 171 Aldeburgh, **1948**

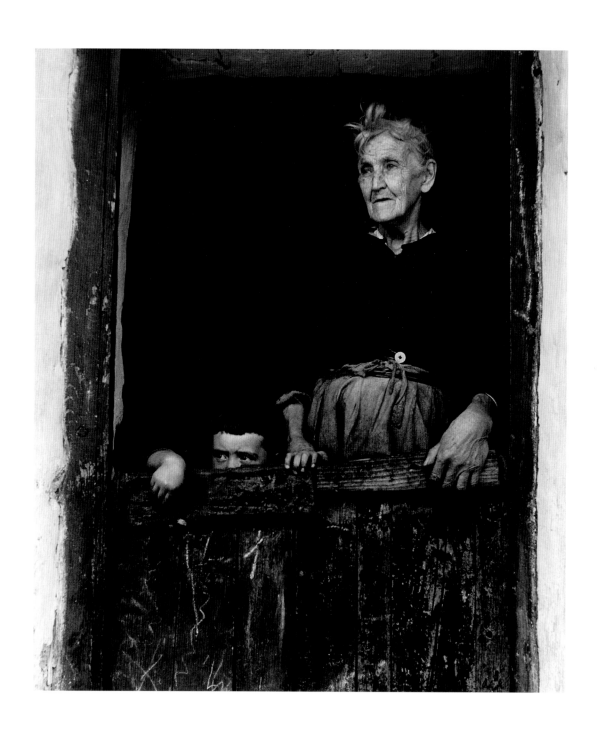

172 Connemara, 1946

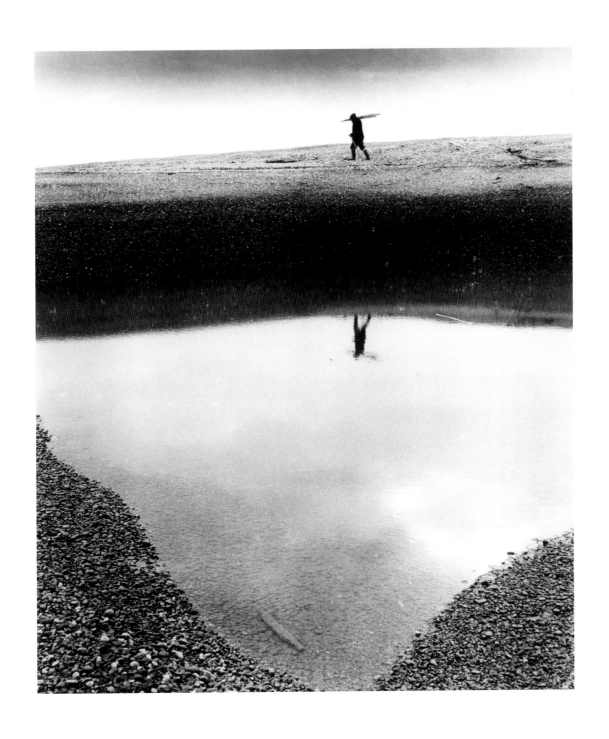

173 Aldeburgh, **1948**

174 Scilly Isles, c **1935** 175 Unknown location, c **1949**

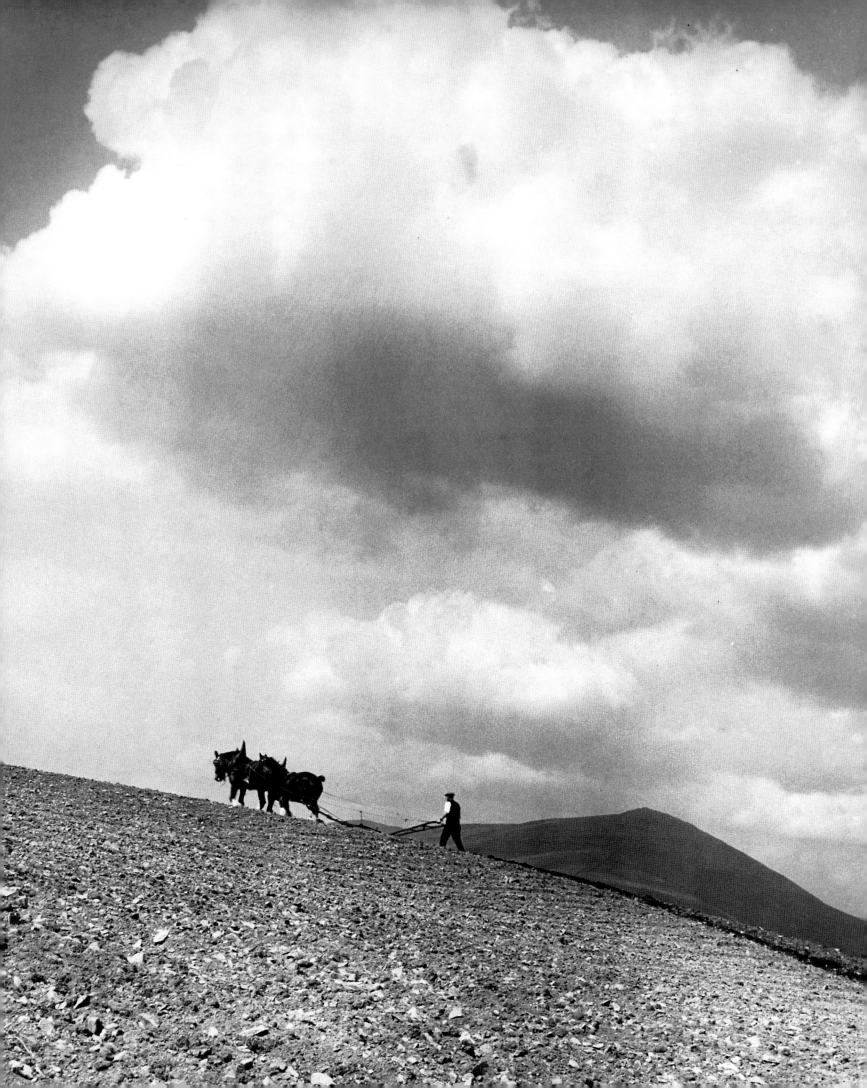

"I always take portraits in my sitter's own surroundings. I concentrate very much on the picture as a whole and leave the sitter rather to himself. I hardly talk and barely look at him. This often seems to make people forget what is going on and any affected or self-conscious expression usually disappears. I try to avoid the fleeting expression and vivacity of a snapshot. A composed expression seems to have a more profound likeness. I think a good portrait ought to tell something of the subject's past and suggest something of his future."

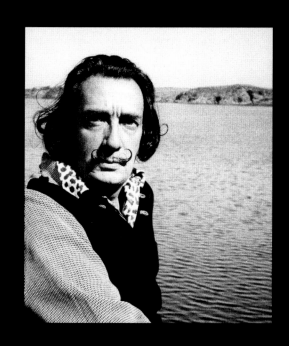

PORTRAYING THE ARTIST

176 Salvador Dali, **1957**

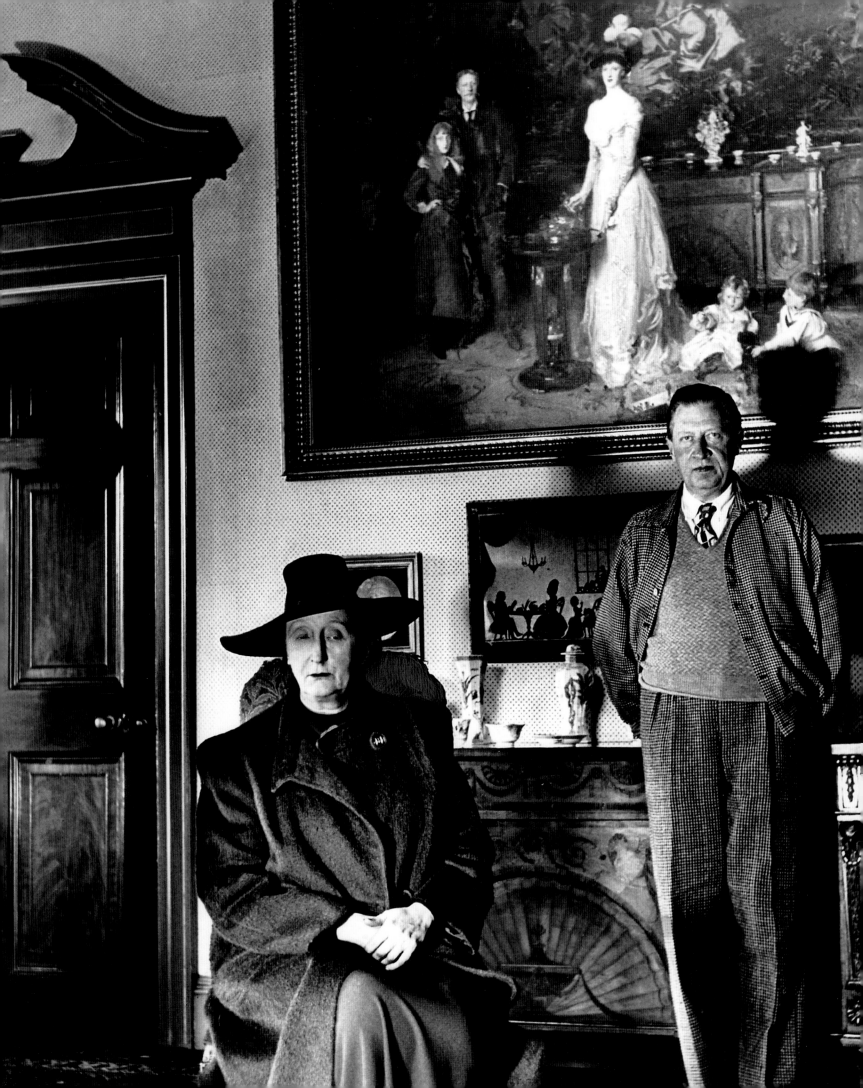

177 Edith and Osbert Sitwell, **1945** 178 Cecil Day Lewis, **1941**

179 Jack Yeats, **1946** 180 Dylan Thomas, **1941**

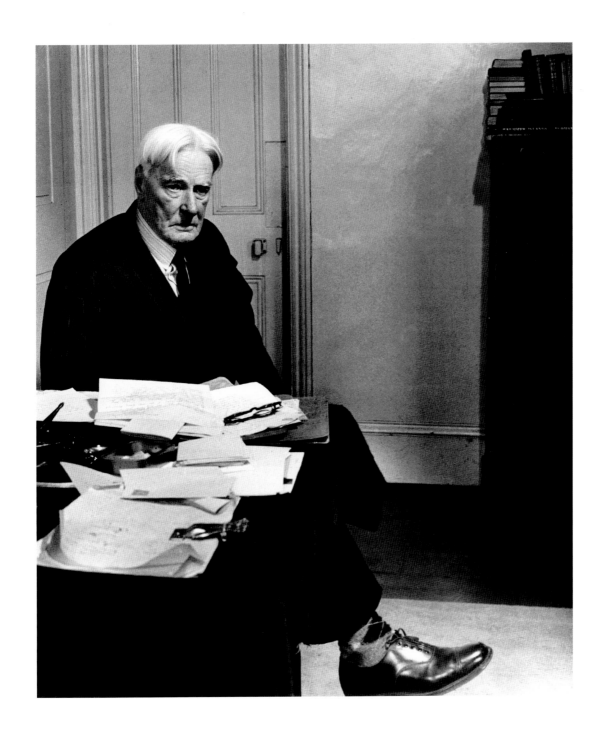

181 John Paul Getty, **1960** 182 Norman Douglas, **1946** 203

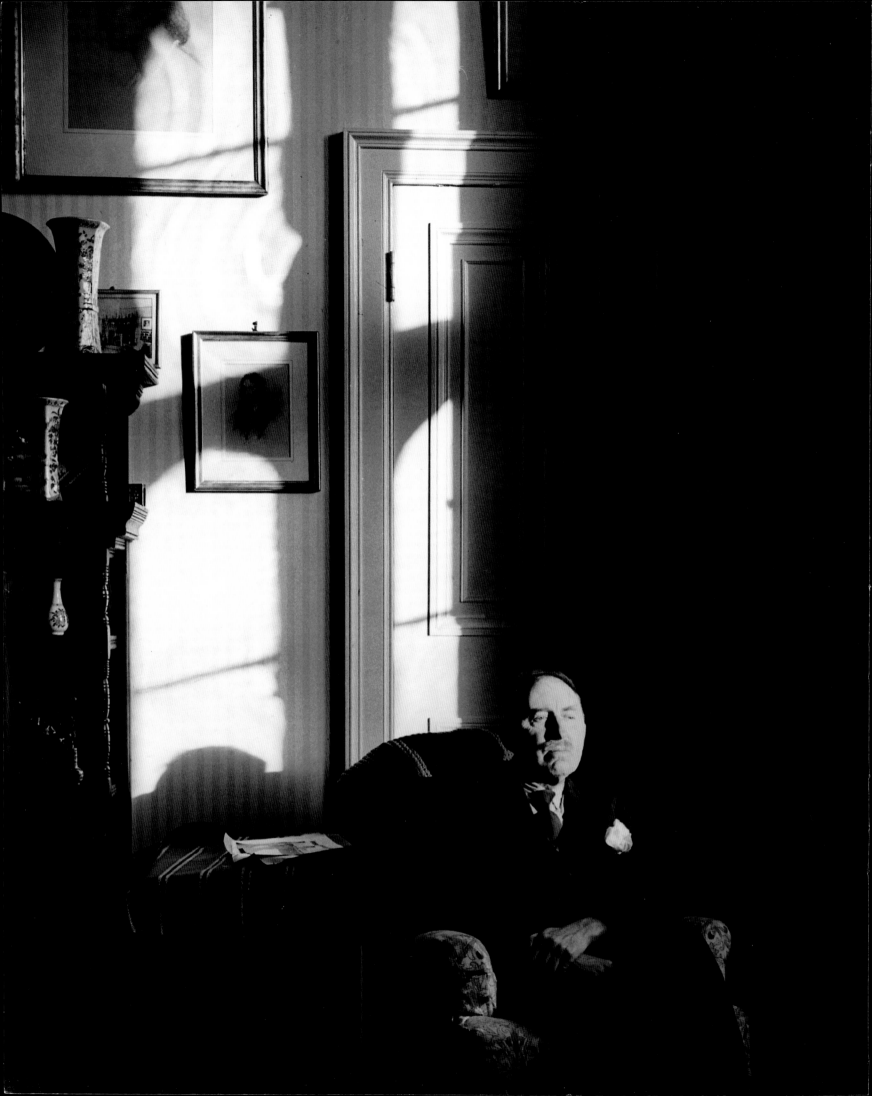

"When photographing a writer, I was forcibly impressed by the Victorian character of the room in which he sat. A hard print brought out this impression. Details were lost as they were in early Victorian photographs. My print did not imitate those old photographs; the method of printing simply formed a link of association between the two, adding its reminiscent effect to the Victorian setting."

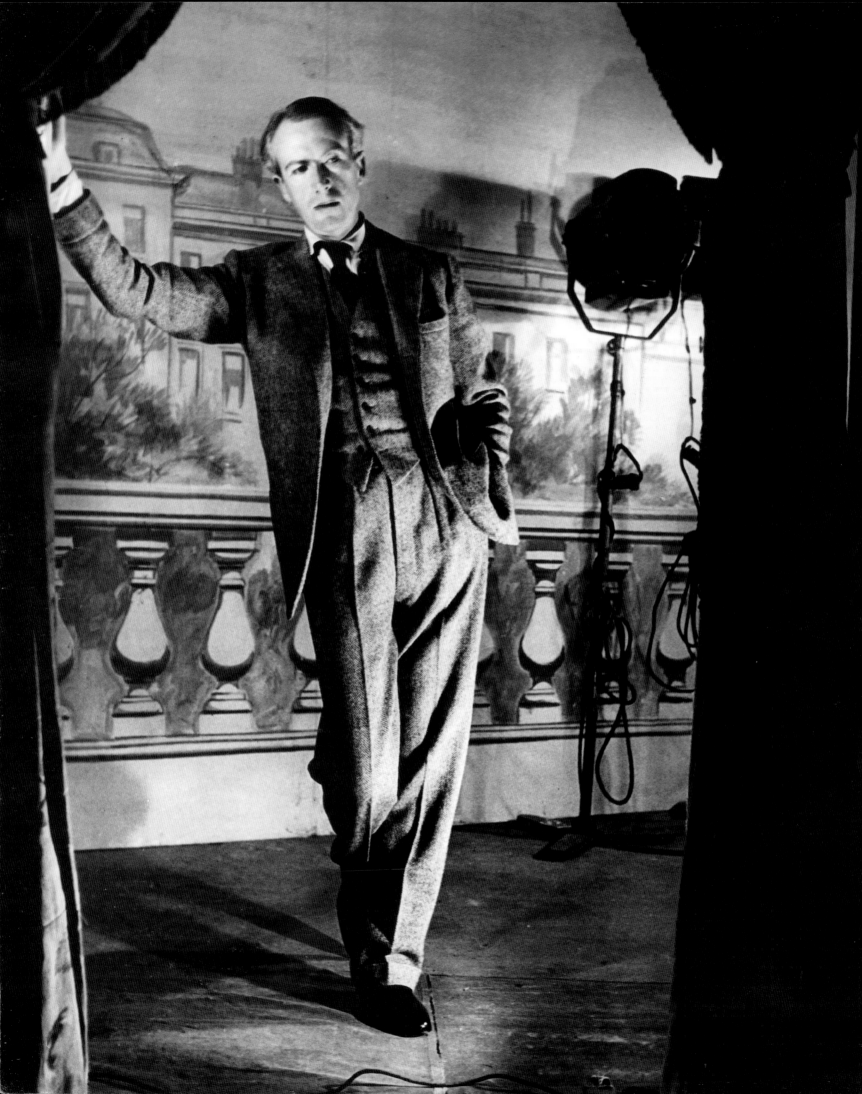

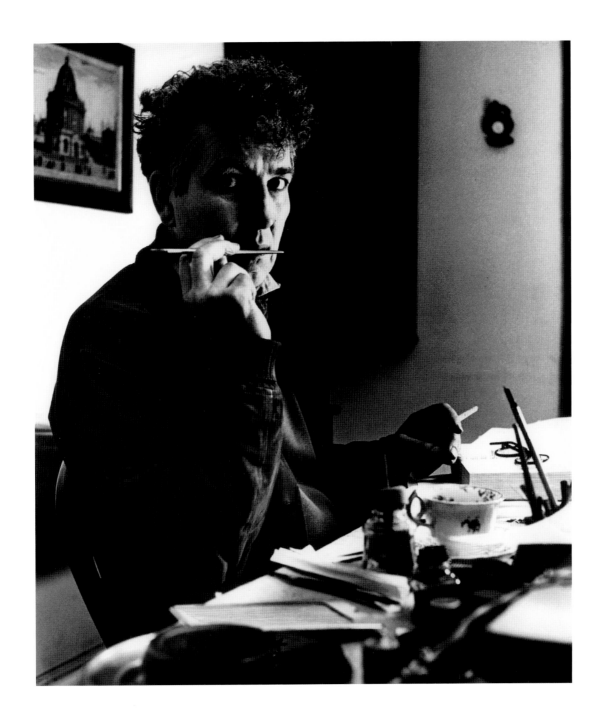

184 Cecil Beaton, **1945** 185 Robert Graves, **1941**

186 Graham Greene, **1948** 187 Henry Moore, **1946**

188 Ben Nicholson, 1956

189 Barbara Hepworth, **1956**

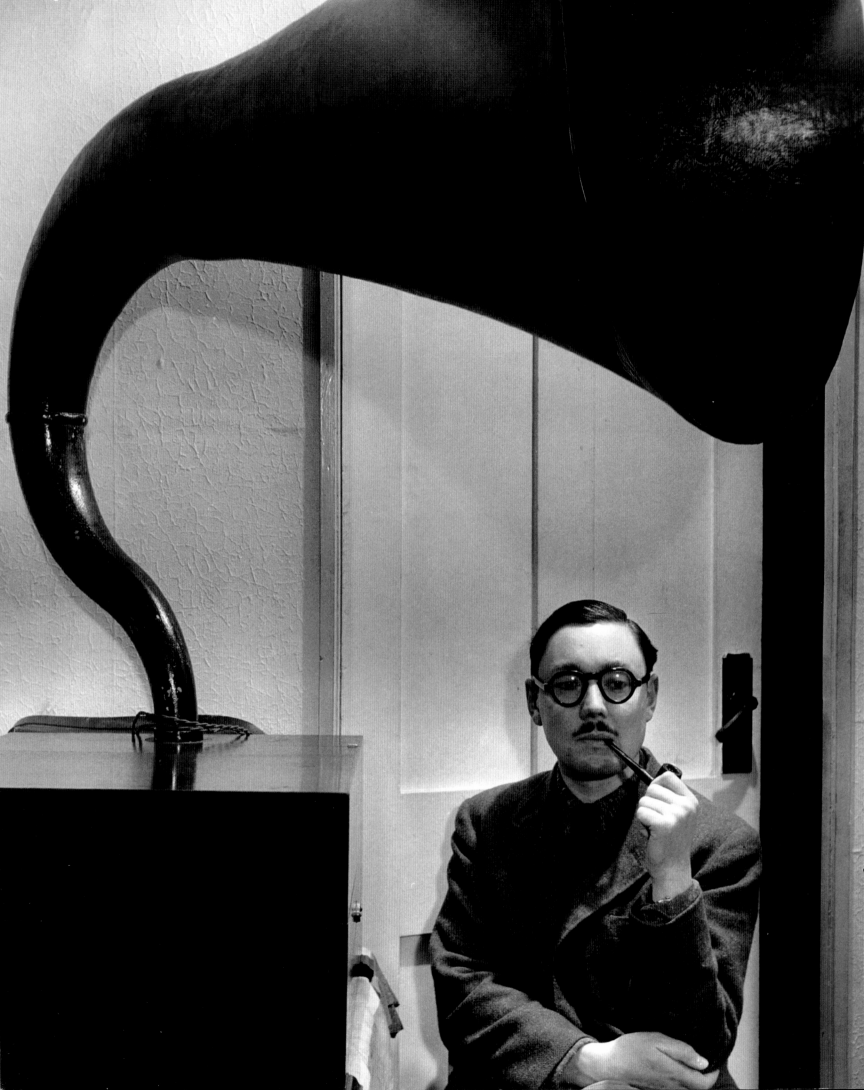

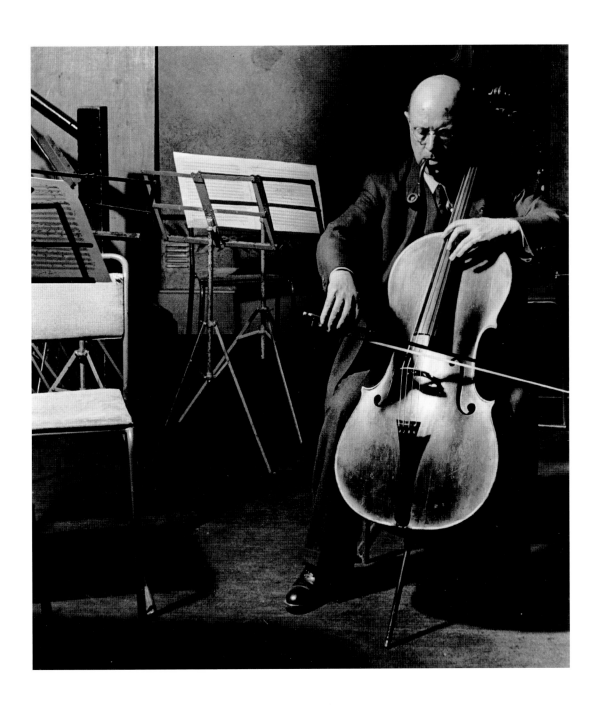

190 Bernard Stevens, **1946** 191 Pablo Casals, **1946**

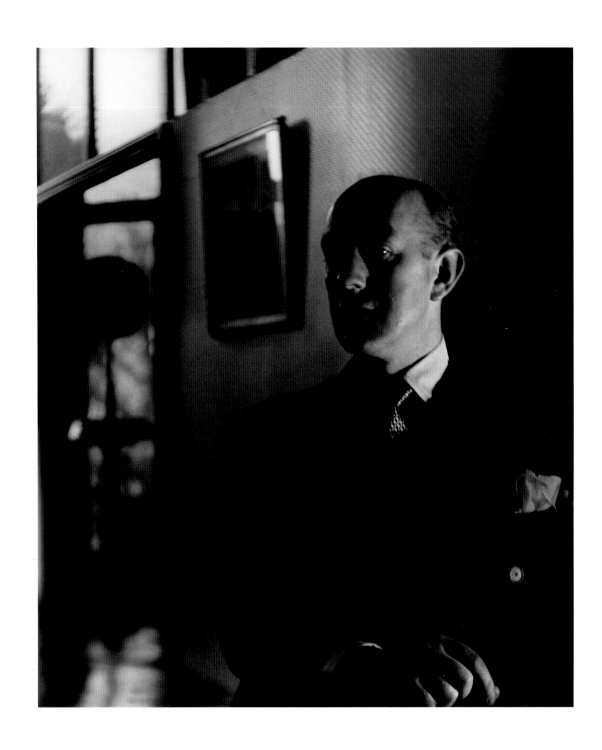

192 Alec Guinness, **1952**

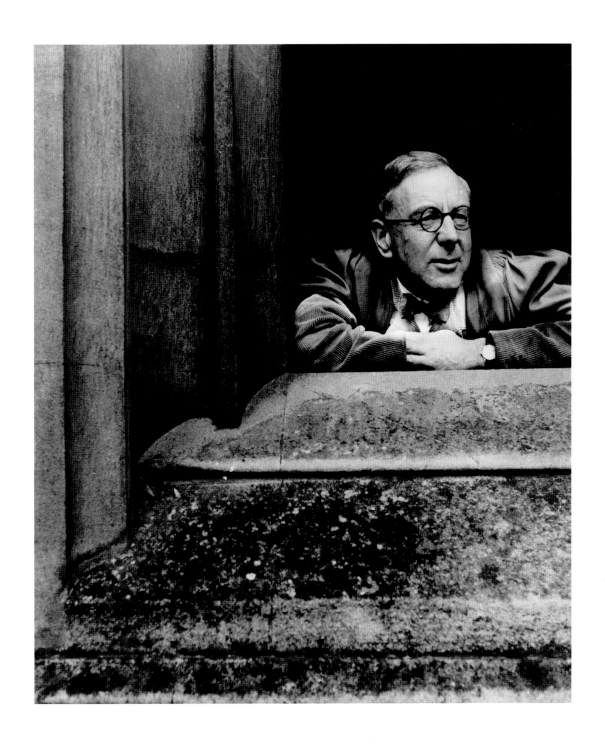

194 Bridget Riley, **1980** 195 Franco Zeffirelli, **1962**

196 René Magritte, **1966**

197 Giorgio De Chirico, **1965**

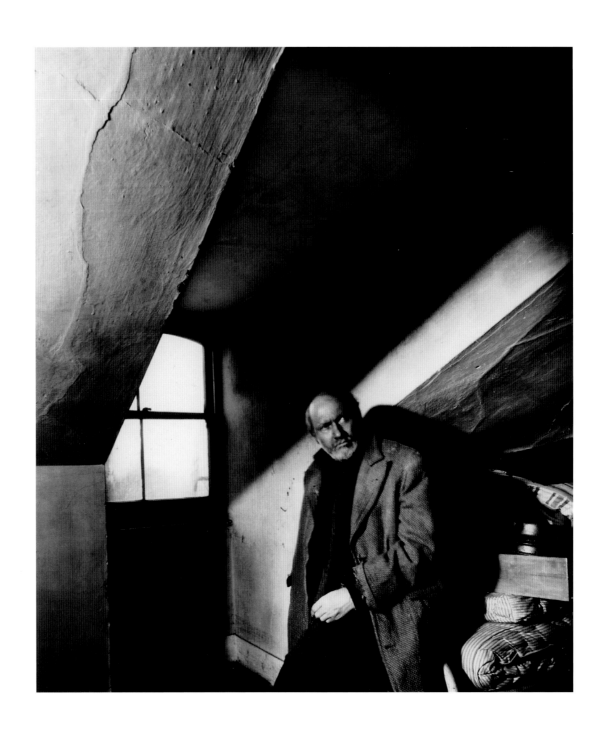

198 Donald Pleasance, **1963** 199 Bill Brandt, **1966**

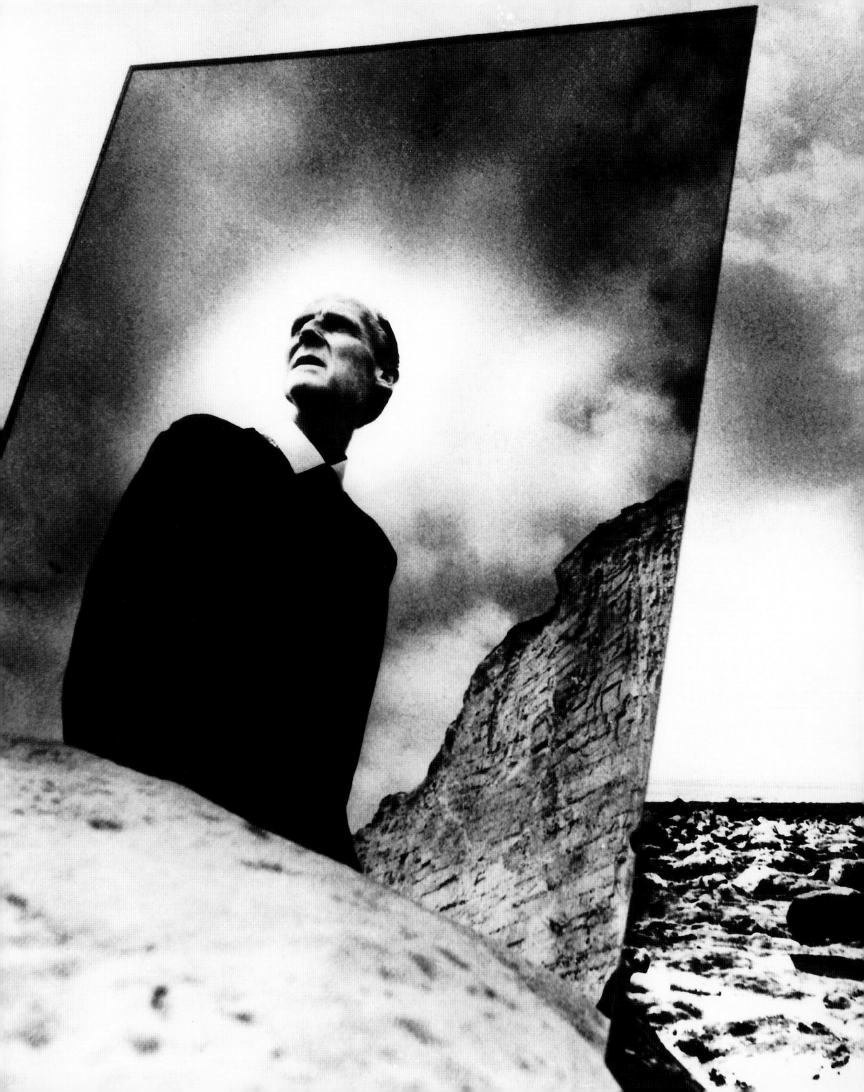

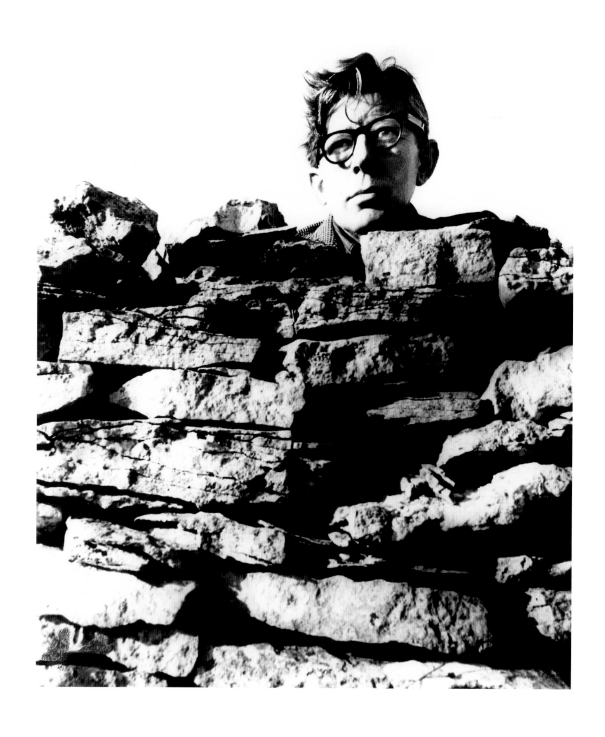

200 Laurie Lee, **1963**

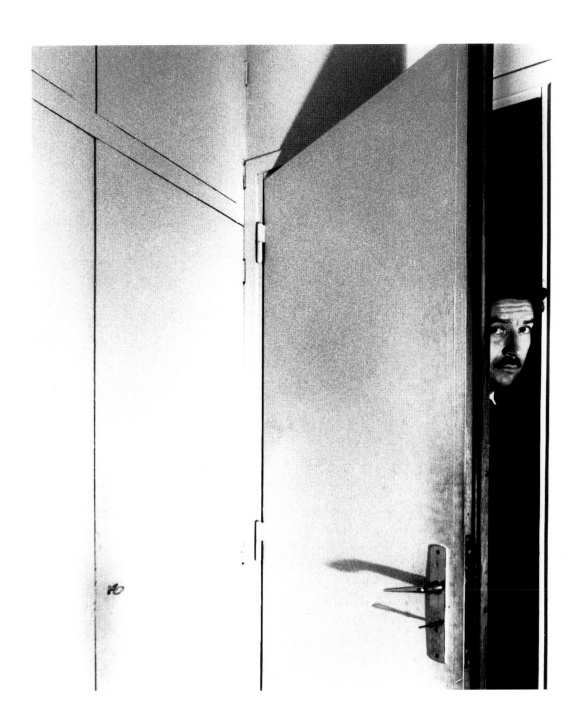

201 Alain Robbe-Grillet, 1965

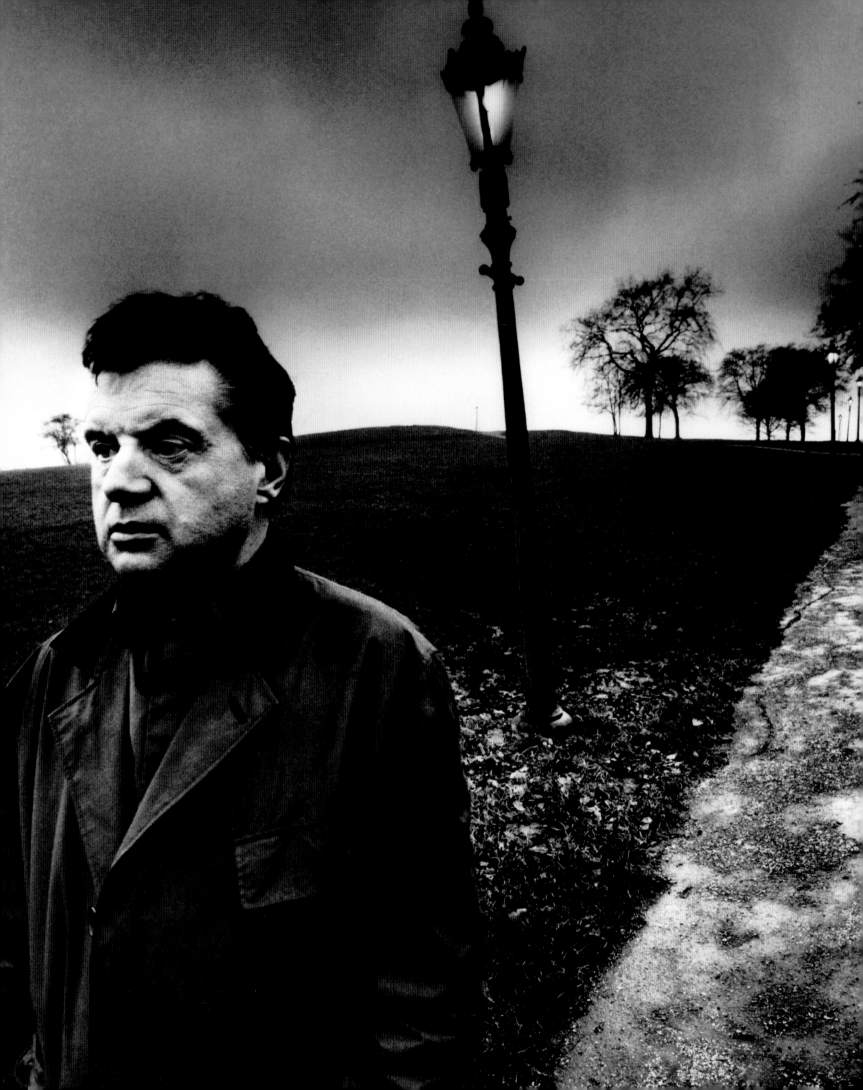

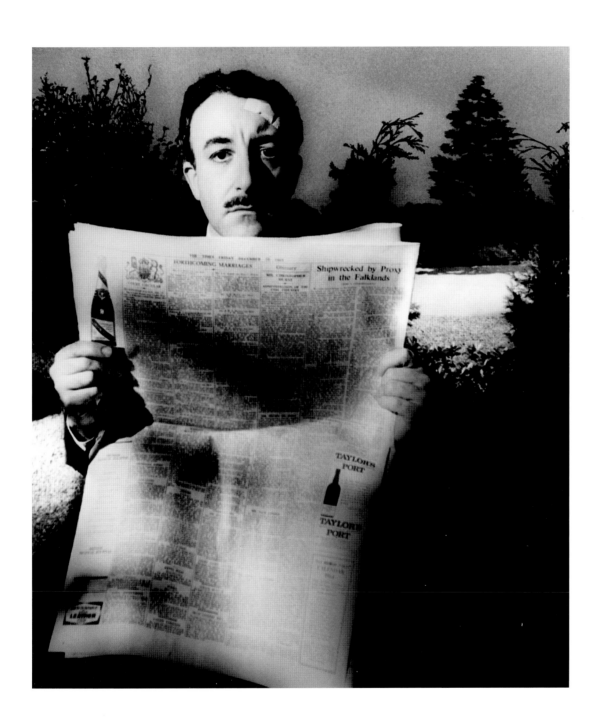

202 Francis Bacon, **1963** 203 Peter Sellers, **1963**

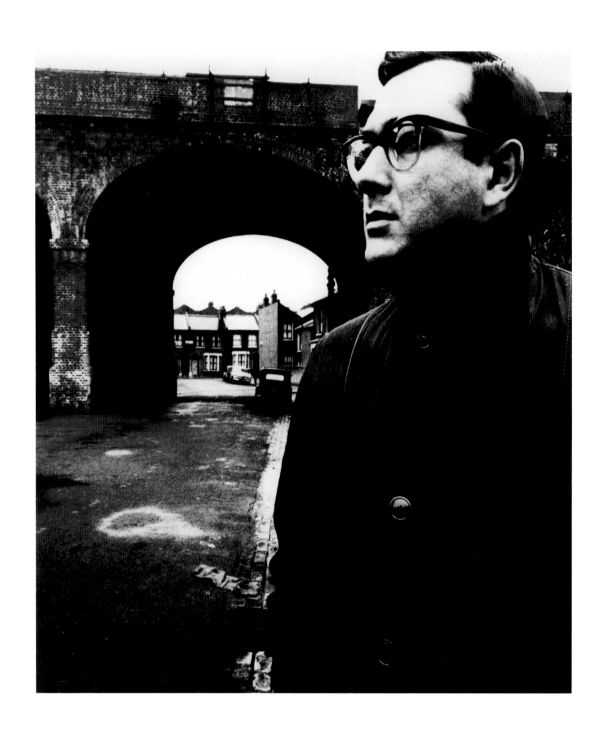

204 Harold Pinter, **1961**

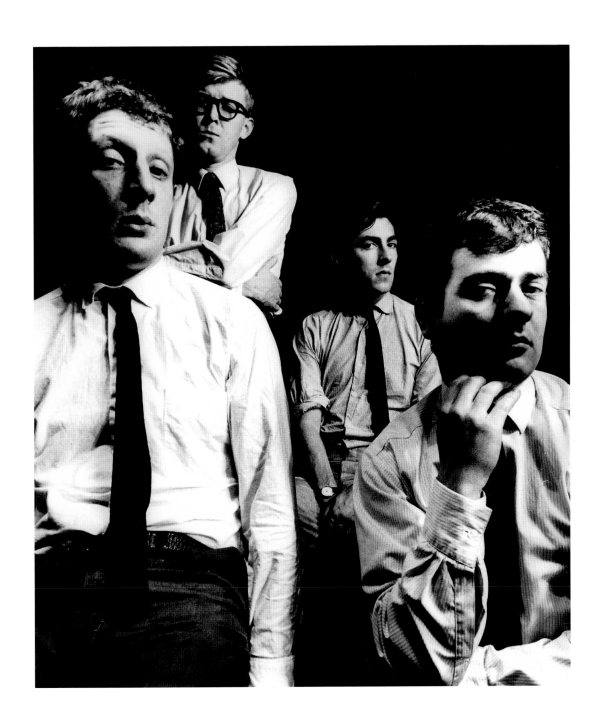

205 Jonathan Miller, Alan Bennett, Peter Cook, Dudley Moore, **1961**

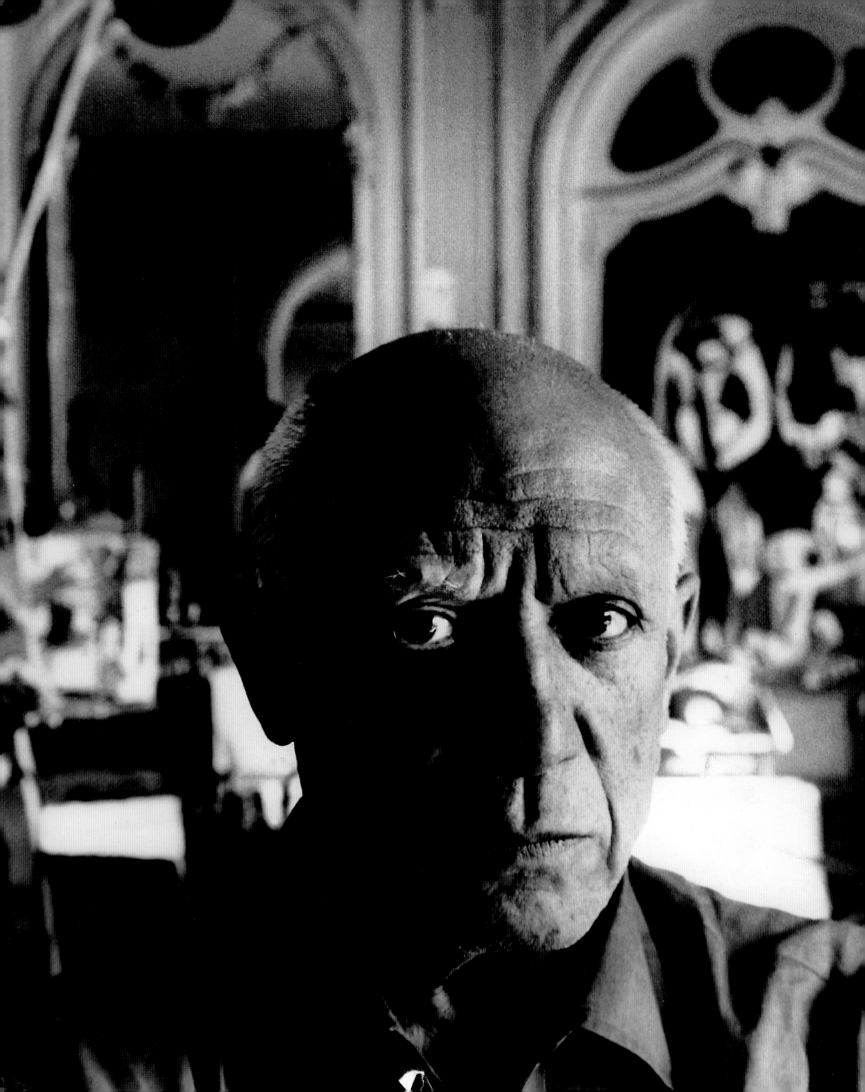

"Picasso was not yet to be seen. While waiting for him, we were introduced to Jacqueline Rocque - now Madame Picasso, and when I asked her if she would let me photograph her, she readily consented. While I was still taking her picture, Picasso appeared on the terrace. 'Who are you?' he asked me. 'Why aren't you photographing me?' He came down into the garden, was very friendly and charming and I let myself be persuaded to take his picture. He posed very well, chatted a great deal and said I could stay as long as I liked and photograph anything that took my fancy. I stayed for another hour to photograph the house and the sculptures in the garden."

206 Pablo Picasso, **1956**

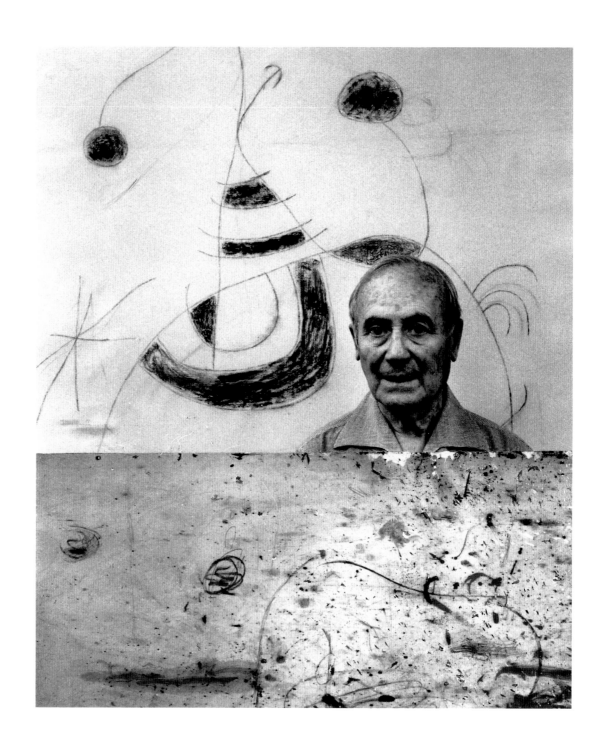

207 Joan Miró, **1968**

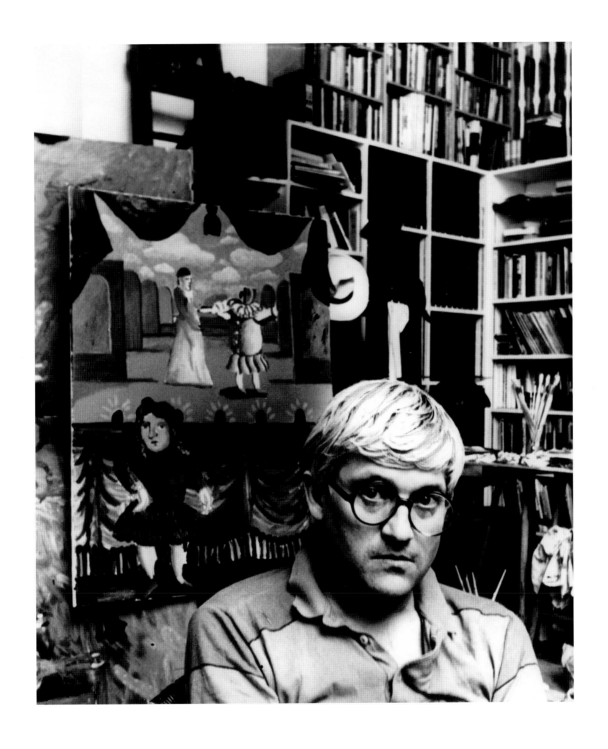

208 David Hockney, 1980

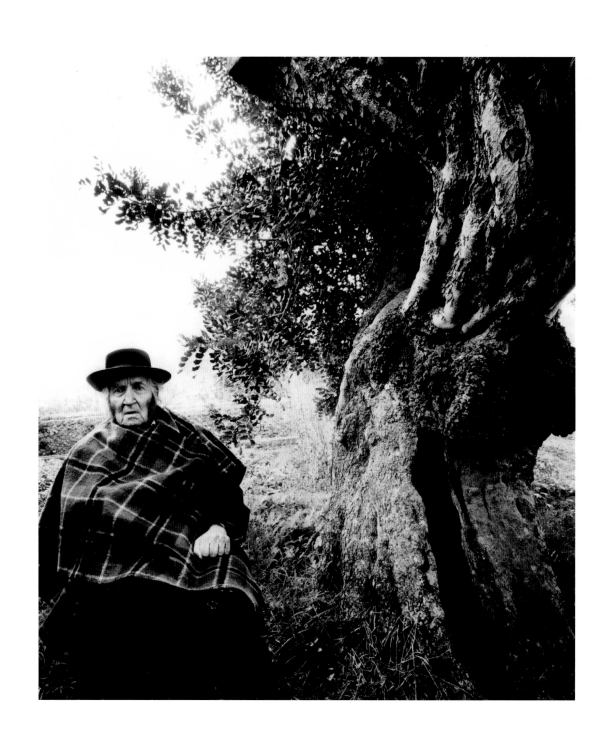

209 Robert Graves, **1979** 210 Ted Hughes, **1978**

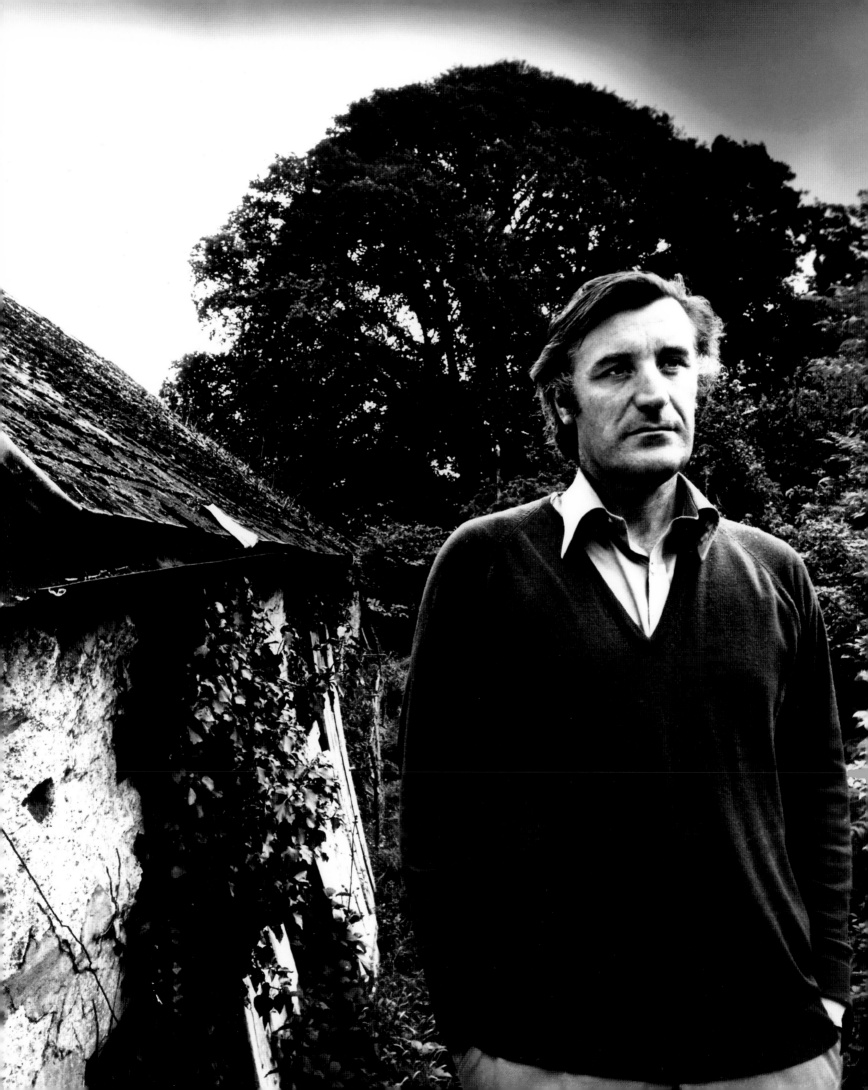

"One day in a second-hand shop, near Covent Garden, I found a 70-year-old wooden Kodak. I was delighted. Like nineteenth-century cameras it had no shutter, and the wide-angle lens, with an aperture as minute as a pin-hole, was focused on infinity. In 1926, Edward Weston wrote in his diary, 'The camera sees more than the eye, so why not make use of it?' My new camera saw more and it saw differently. It created a great illusion of space, an unrealistically steep perspective, and it distorted. When I began to photograph nudes, I let myself by guided by this camera, and instead of photographing what I saw, I photographed what the camera was seeing. I interfered very little, and the lens produced anatomical images and shapes which my eyes had never observed. I felt that I understood what Orson Welles meant when he said 'the camera is much more than a recording apparatus. It is a medium via which messages reach us from another world.'"

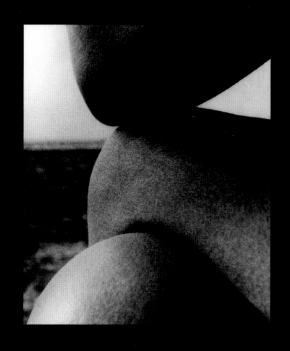

THE PERFECTION OF FORM

211 East Sussex, **1959**

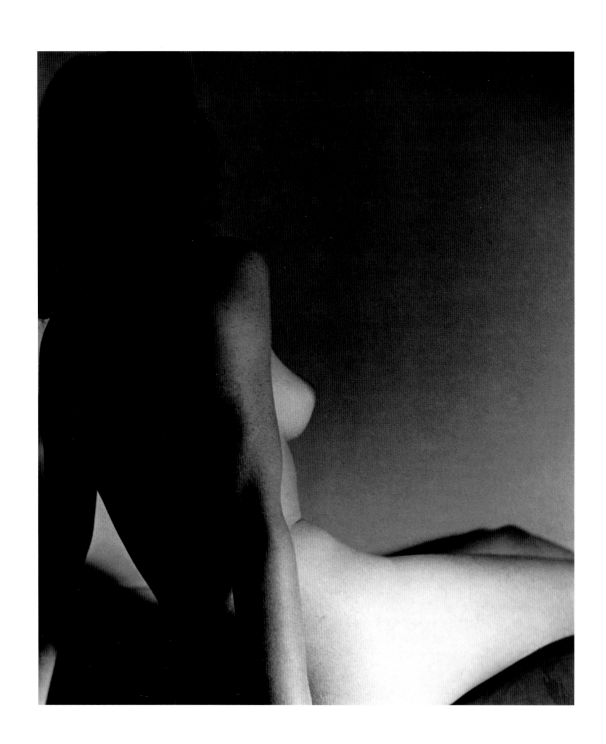

212 London, **1940s**

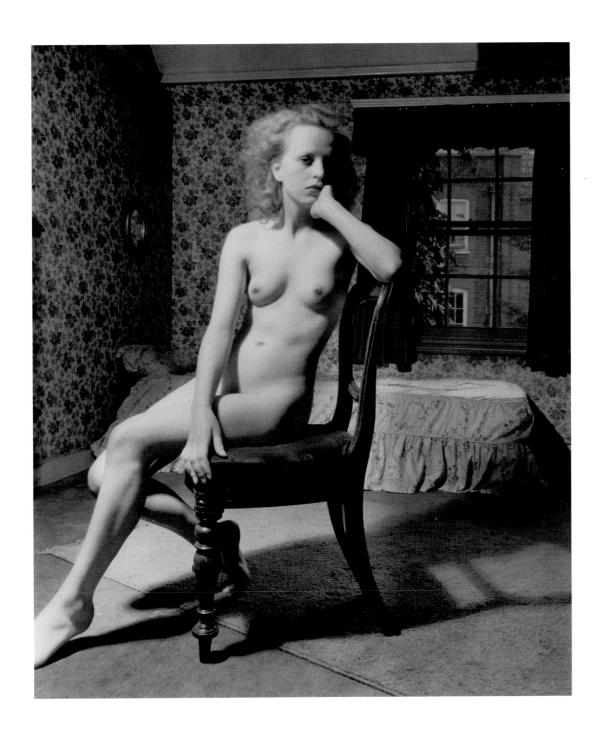

213 Hampstead, **1945**

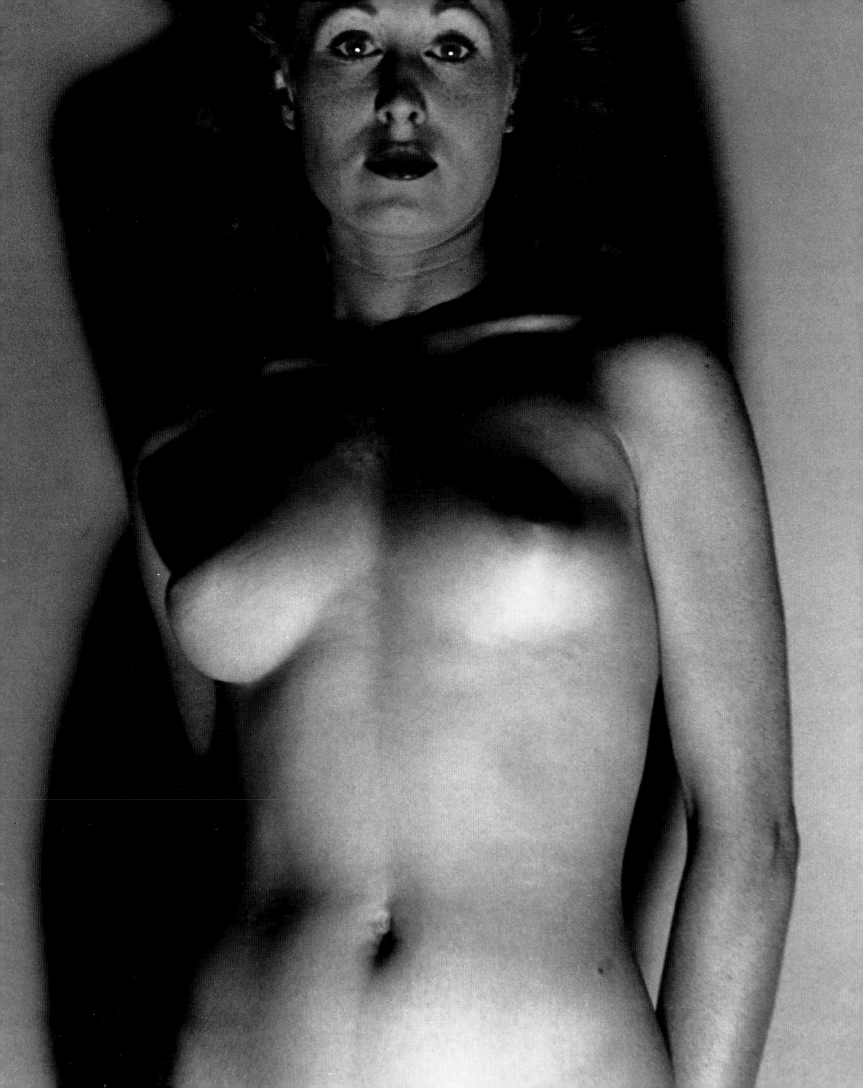

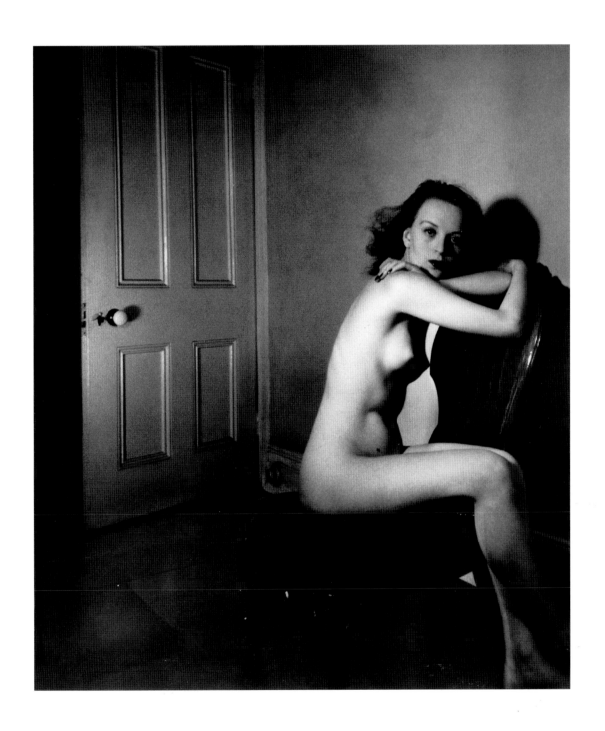

214 London, **1940s** 215 London, **1940s**

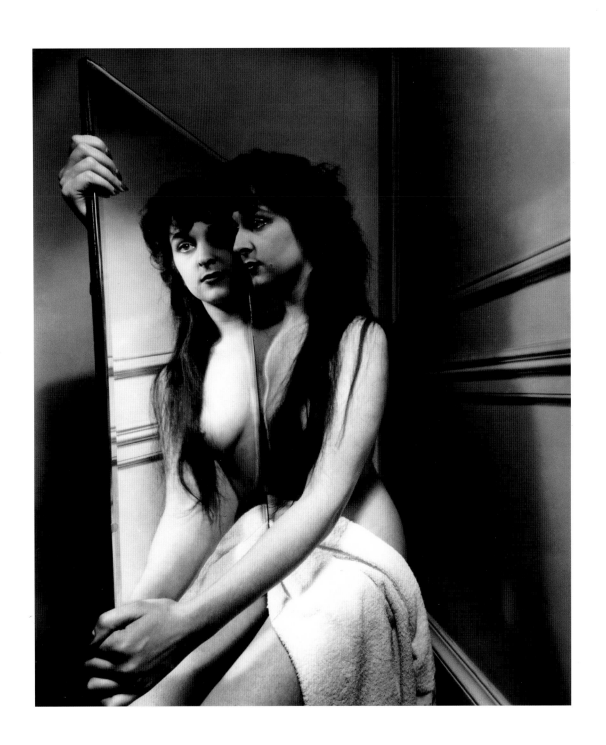

216 Belgravia, **1953**

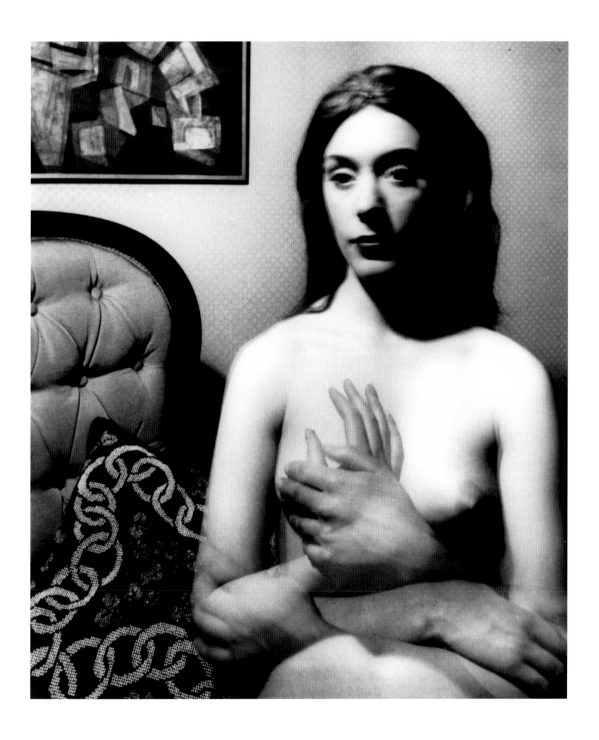

217 Campden Hill, **1956**

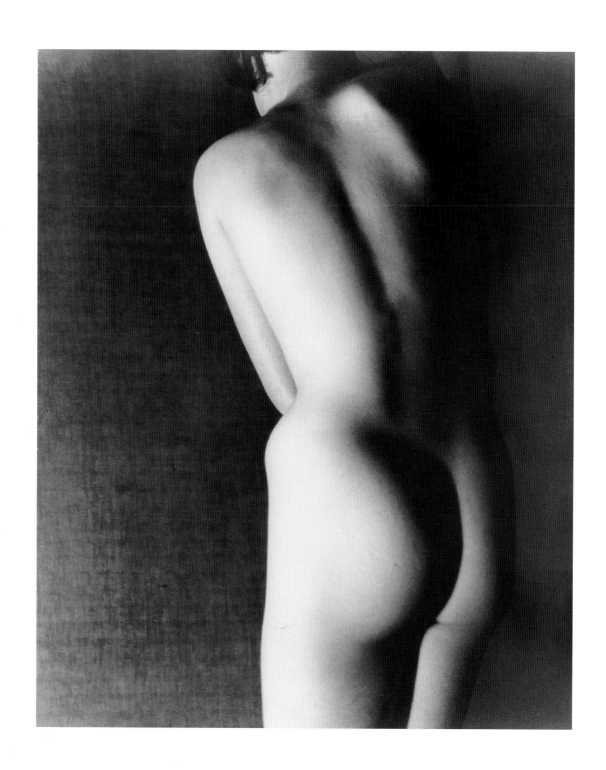

218 London, **1930s** 219 London, **1940s**

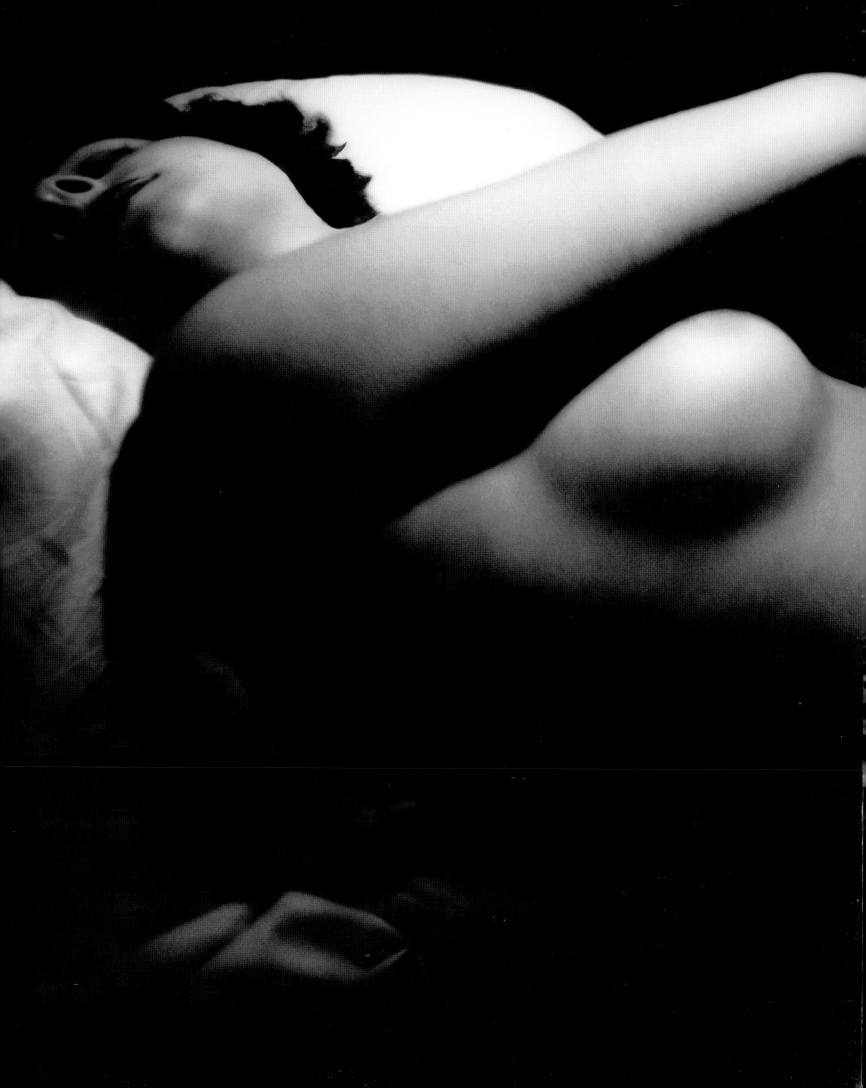

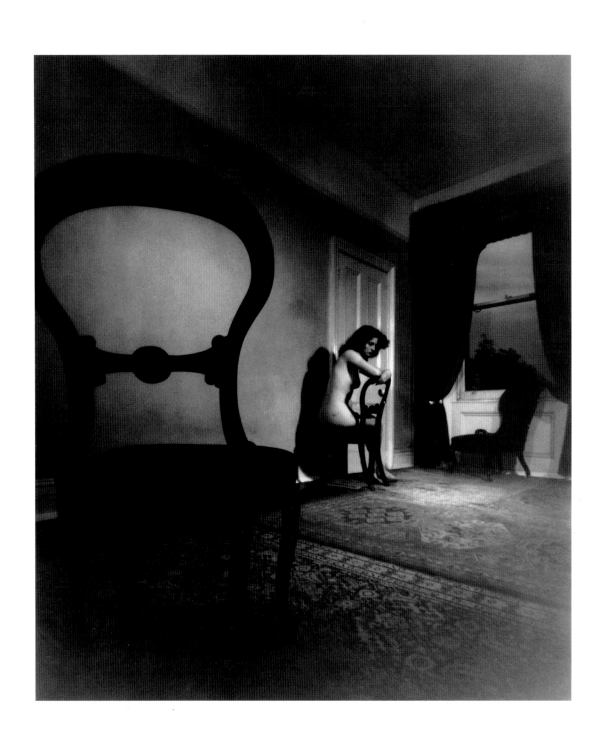

220 Campden Hill, **1947** 221 Campden Hill, **1949**

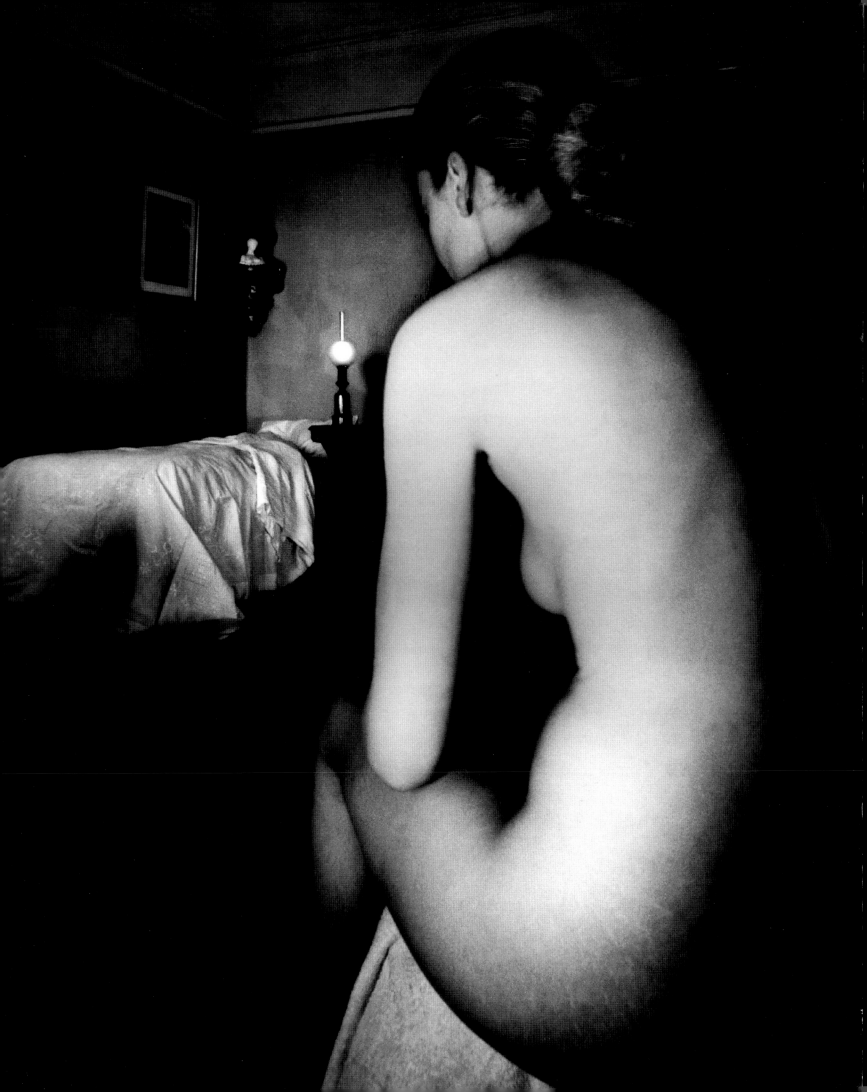

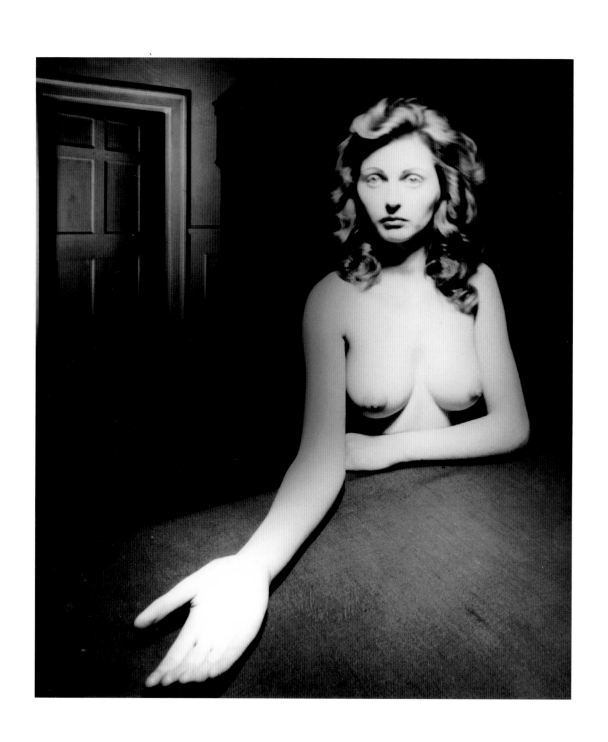

222 Micheldever, **1945**

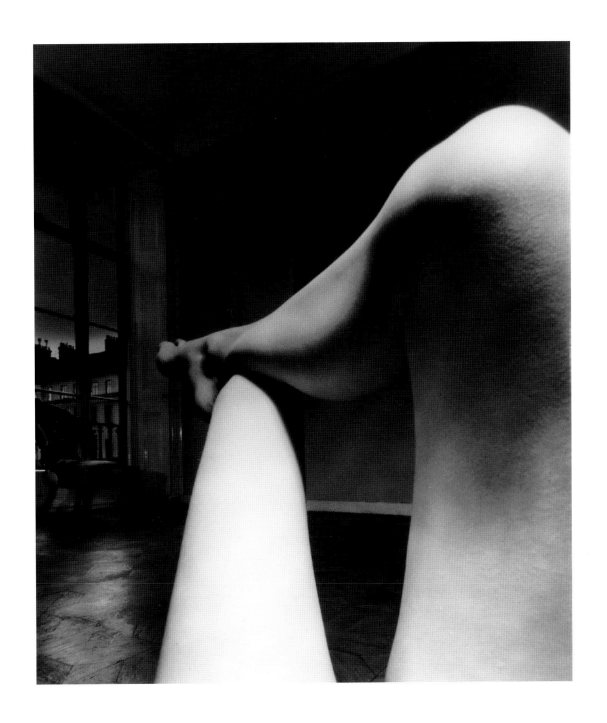

223 Belgravia, 1951

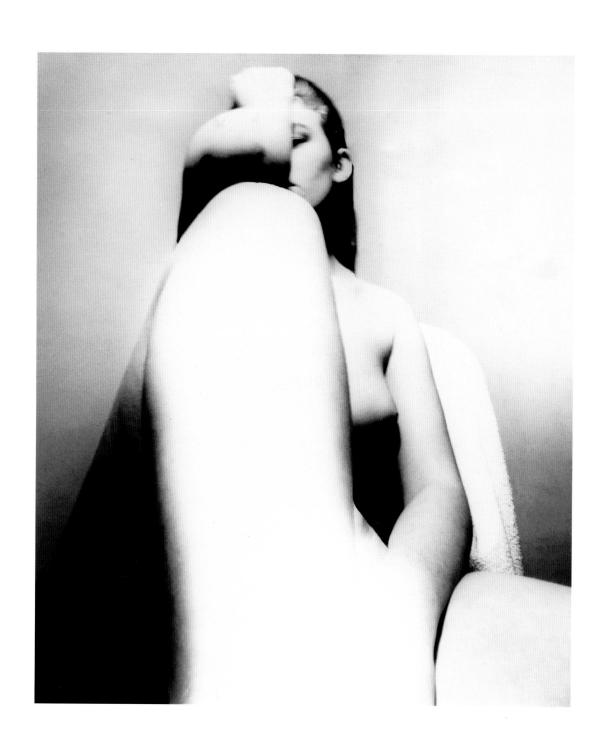

224 London, **1956** 225 London, **1953**

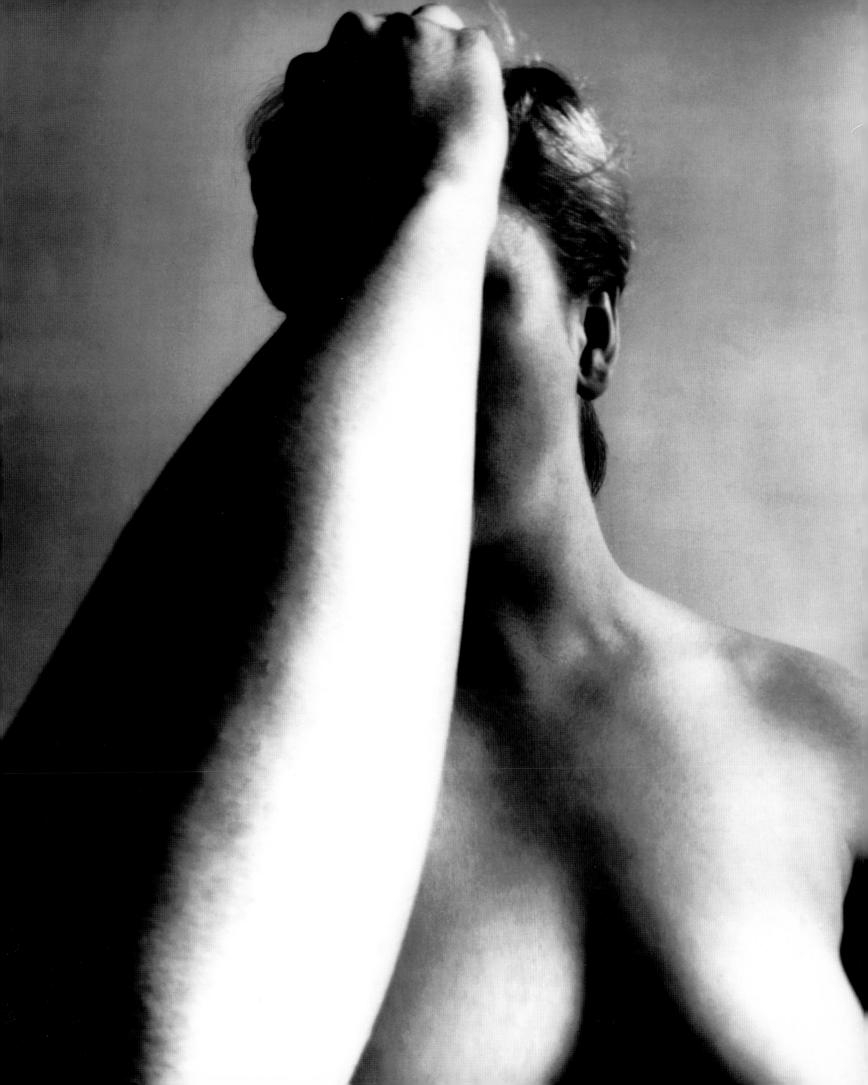

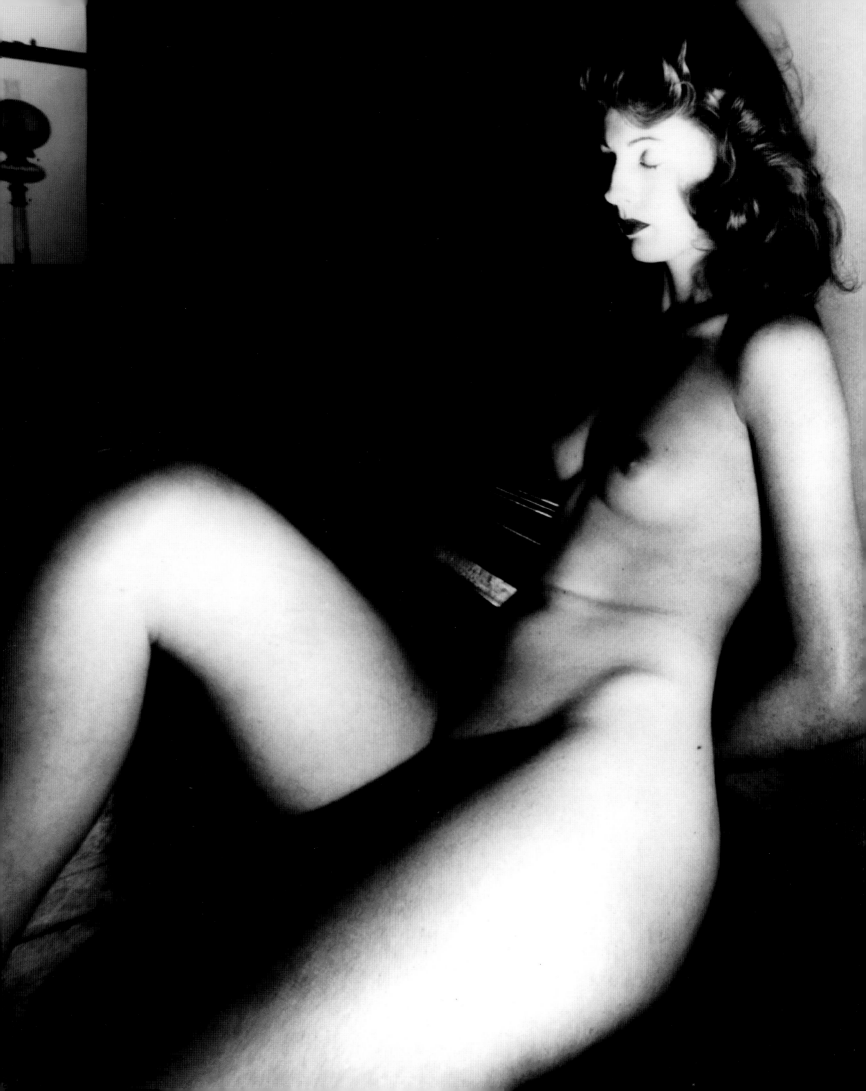

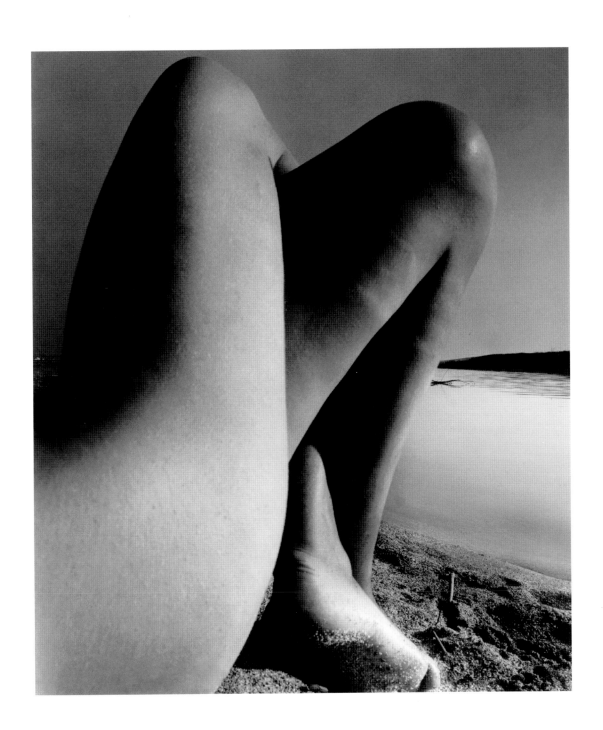

226 Campden Hill, **1949** 227 St Cyprien, **1951**

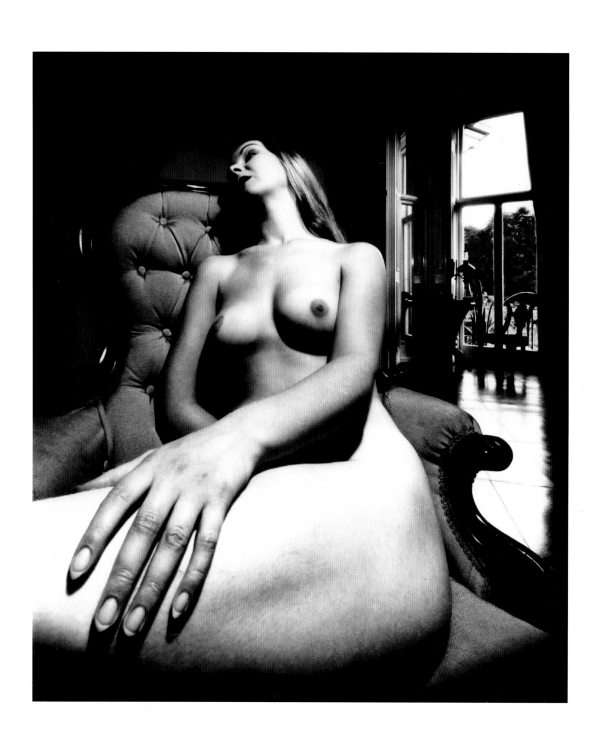

228 Campden Hill, **1953** 229 London, **1940s**

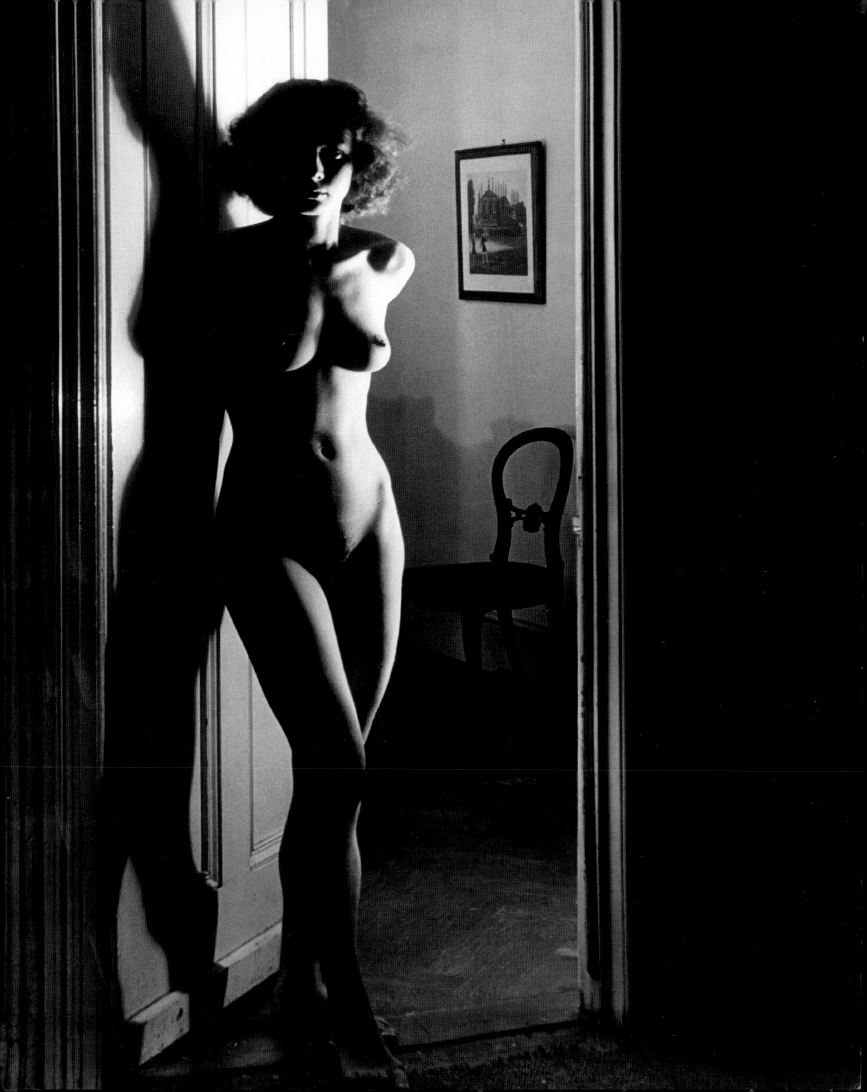

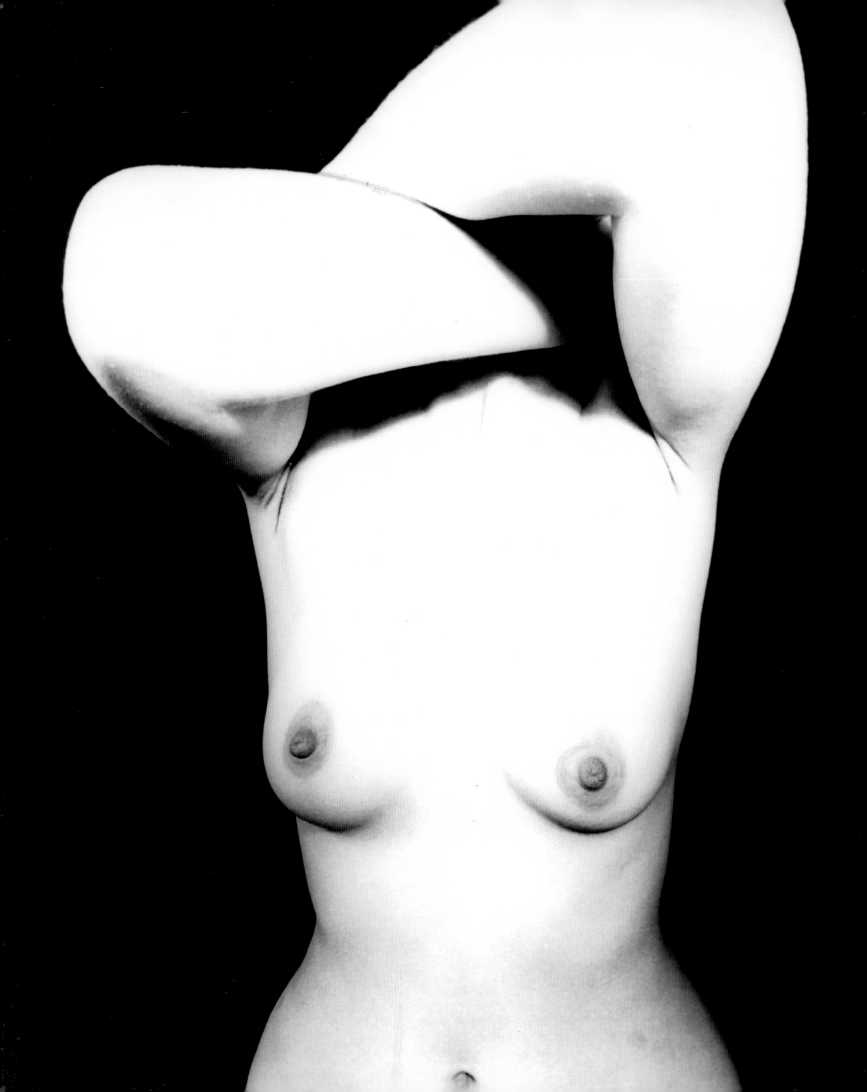

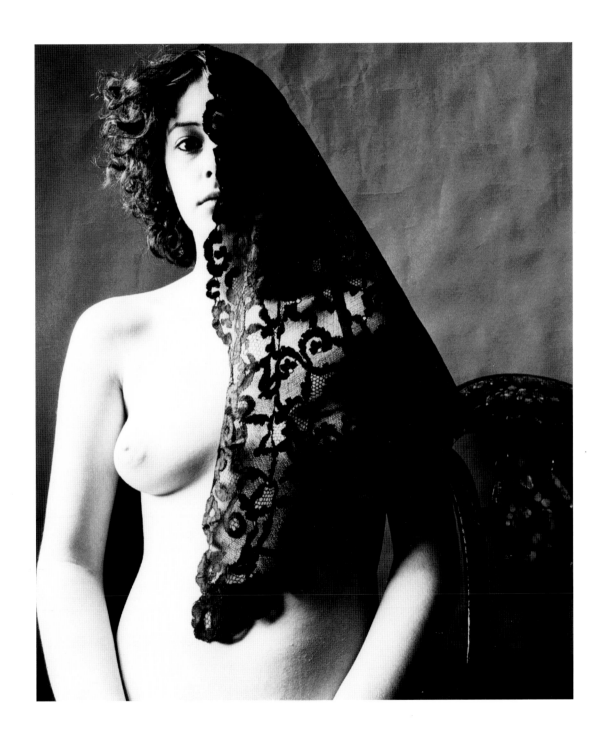

230 Campden Hill, **1978** 231 Campden Hill, **1960s**

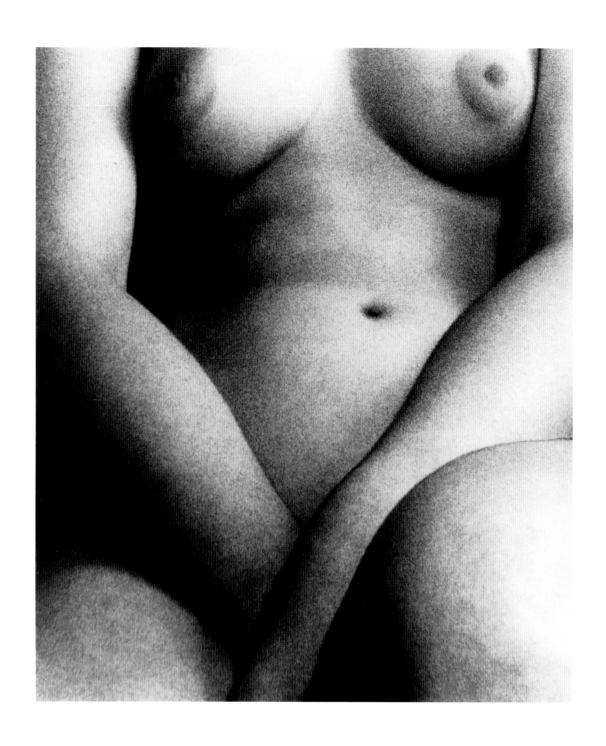

232 London, **1954**

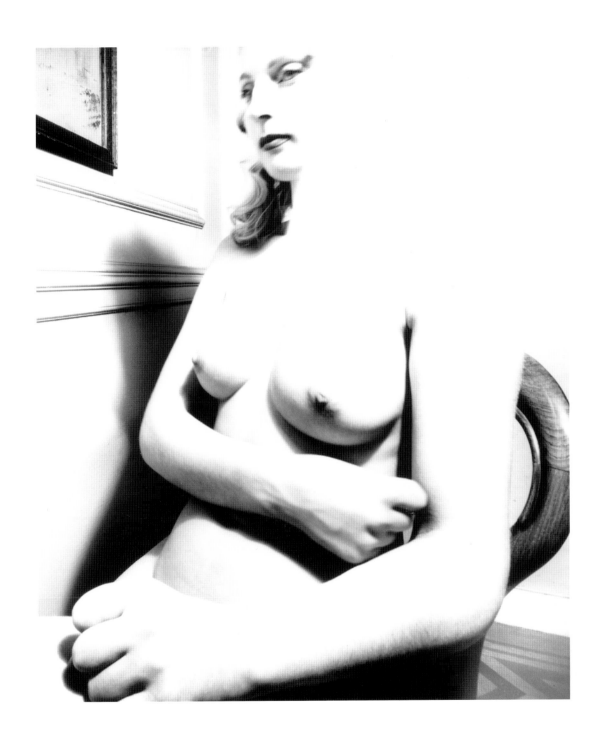

233 London, **1950s**

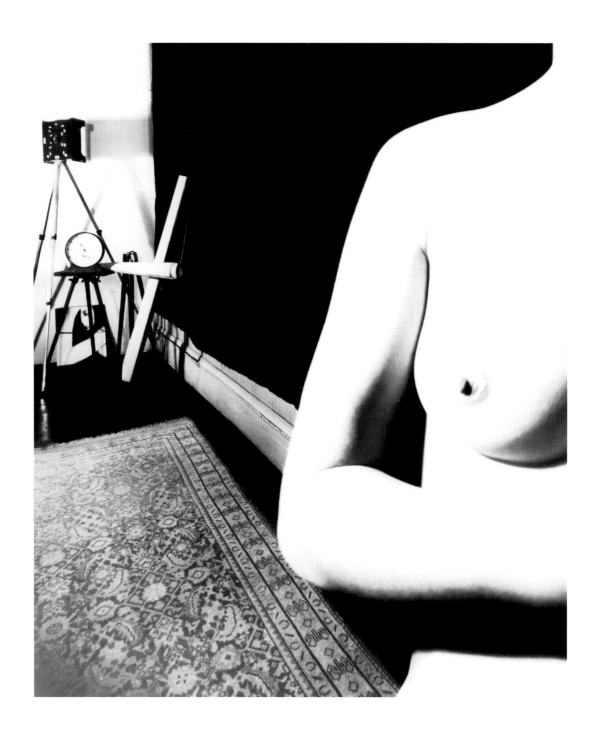

234 Campden Hill, **1956** 235 Campden Hill, **1950s**

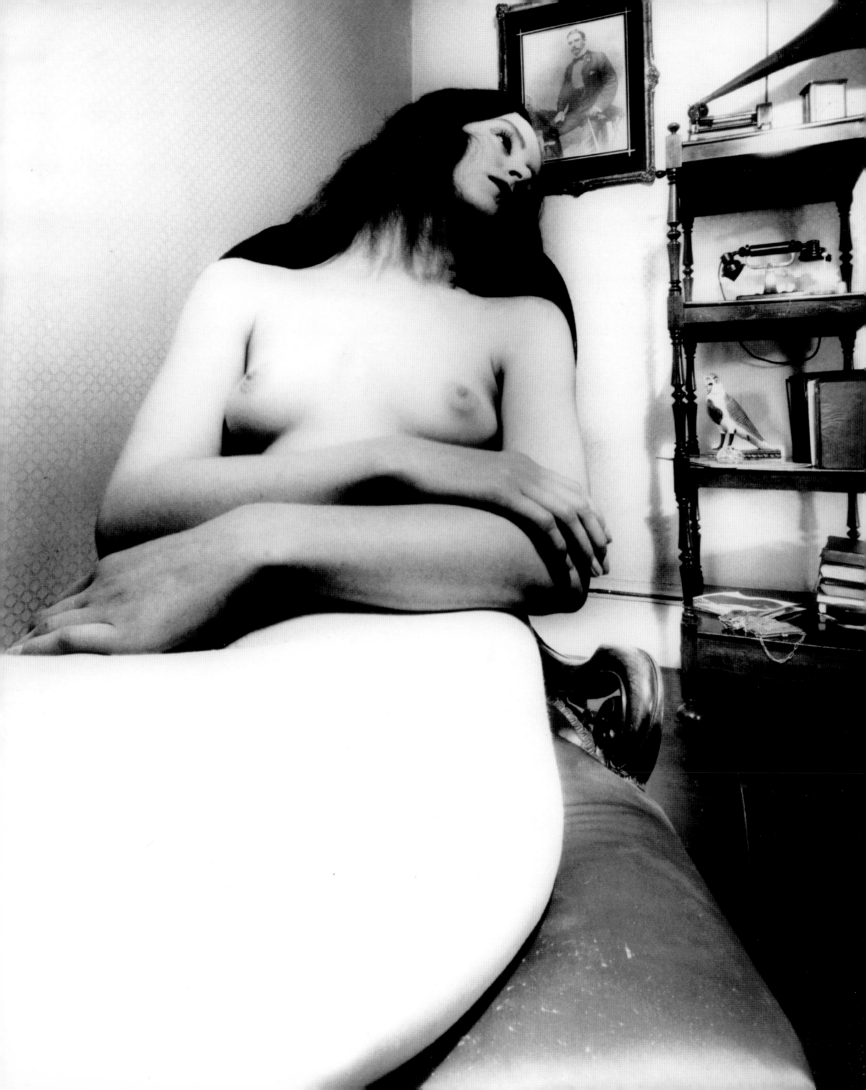

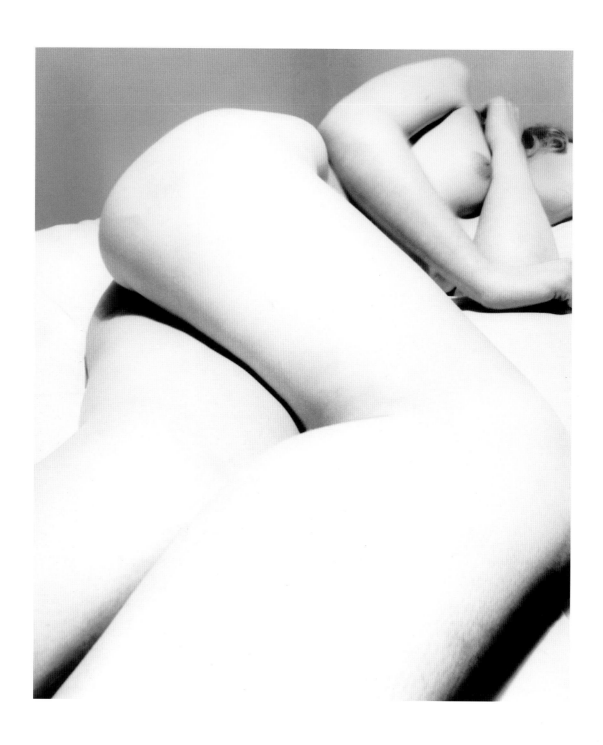

236 Campden Hill, **1950s**

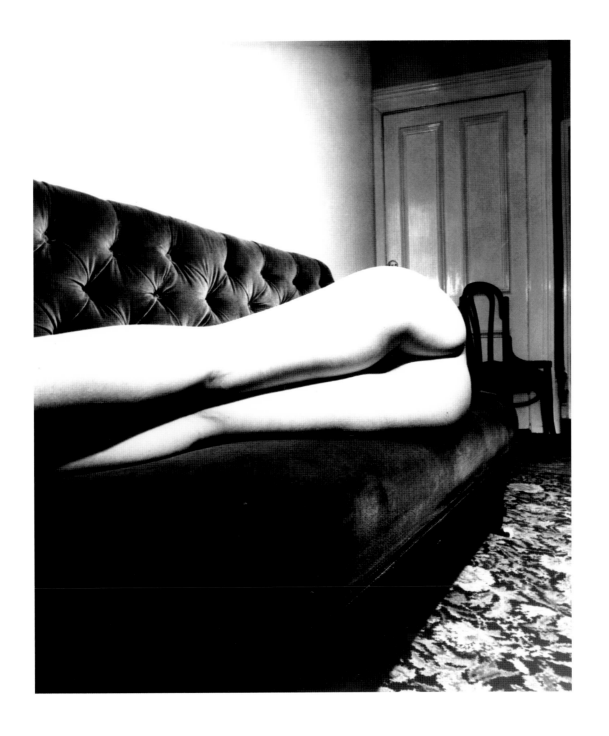

237 South Kensington, **1979**

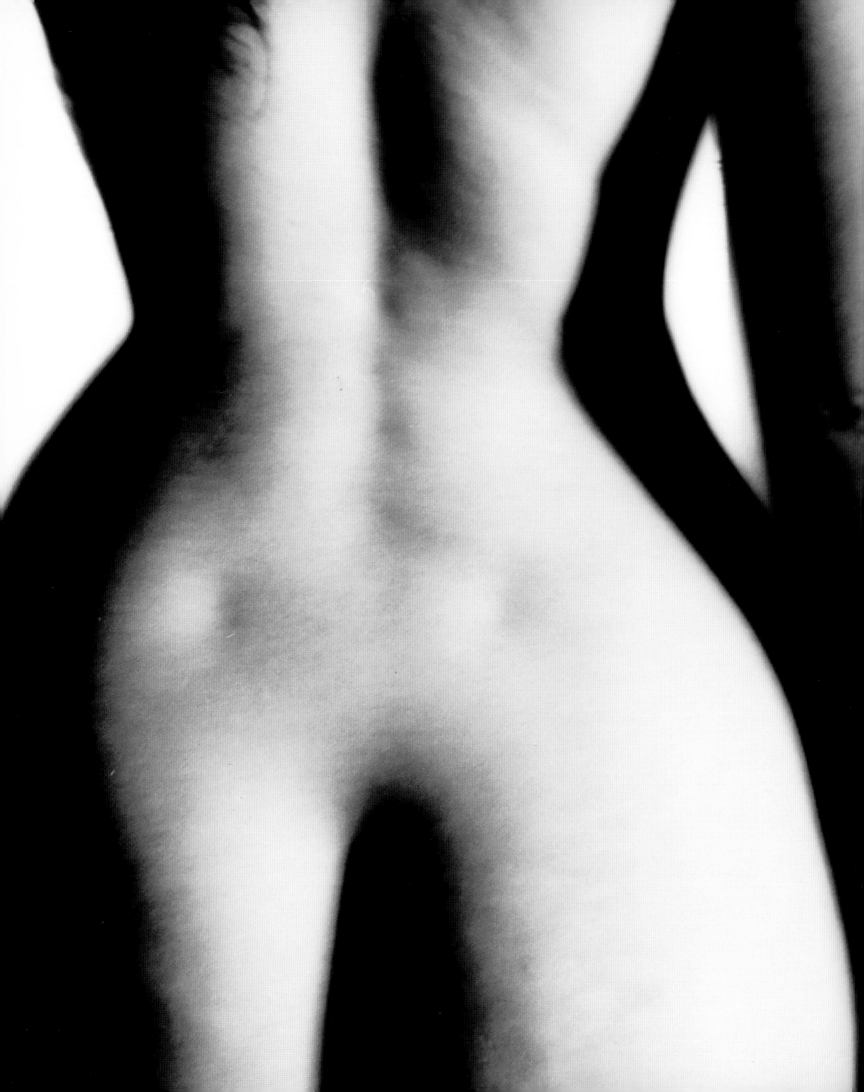

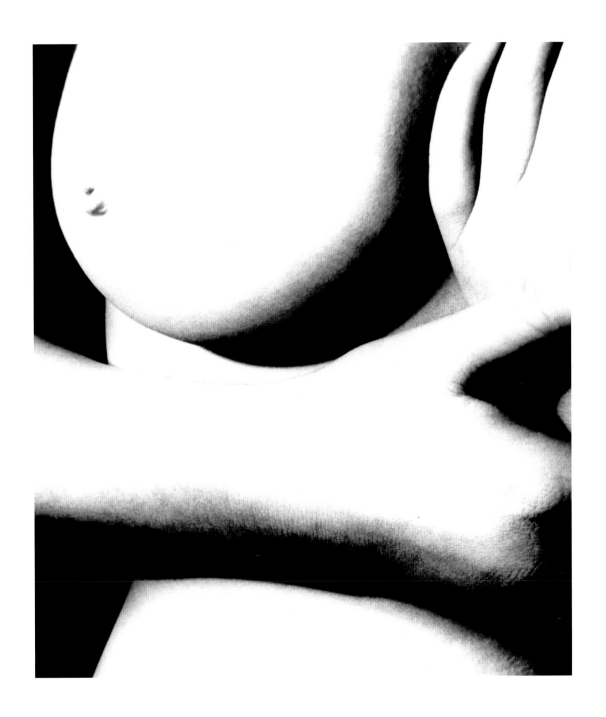

238 London, **1955** 239 London, **1957**

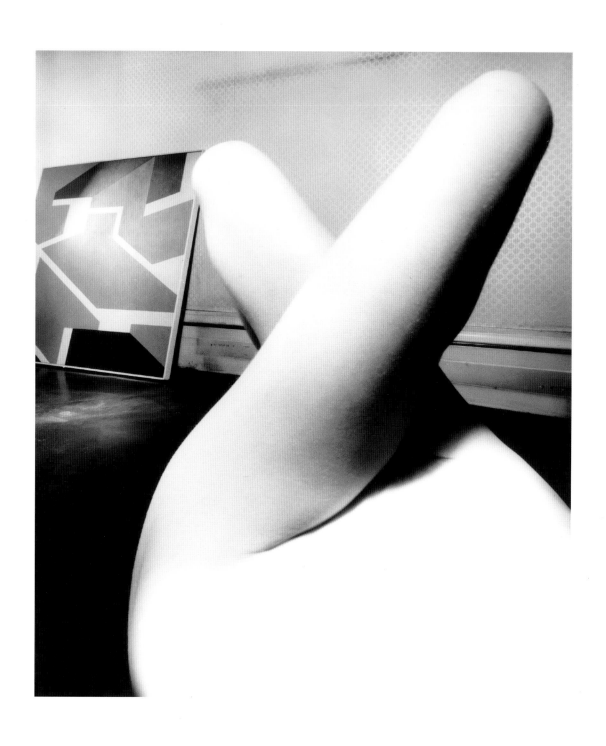

264 240 St John's Wood, **1950s**

241 St John's Wood, 1958

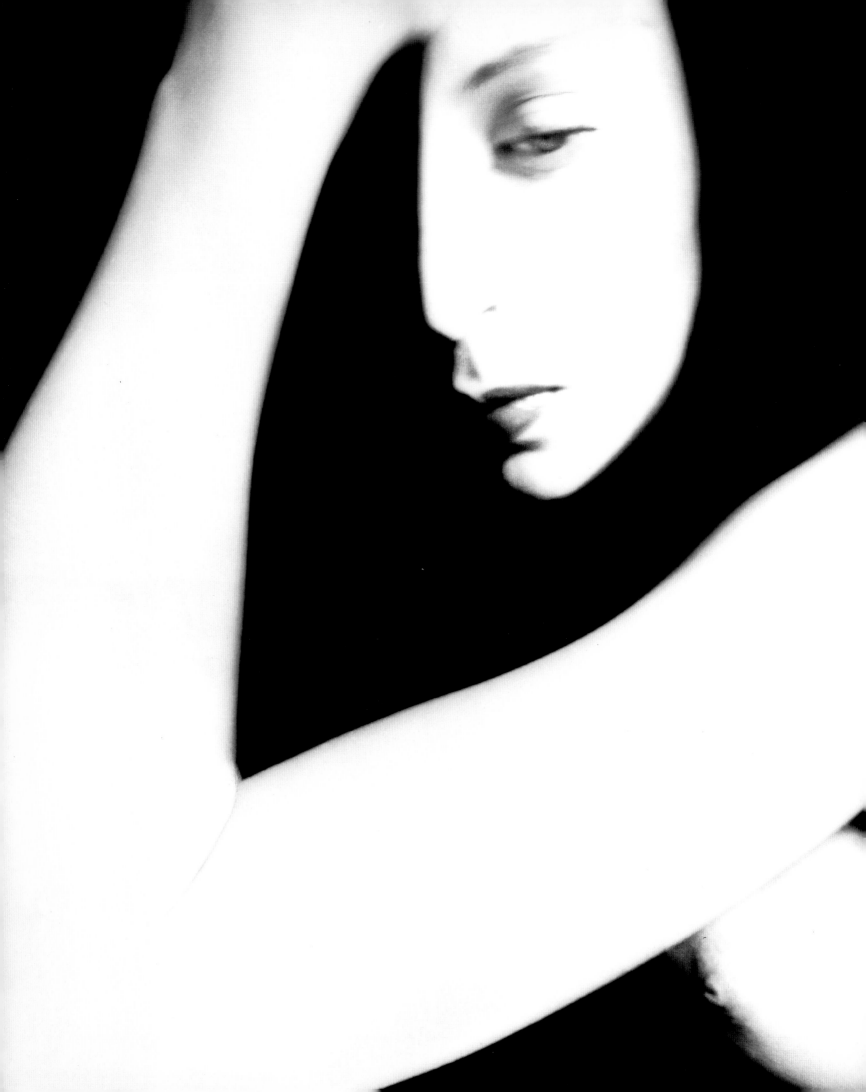

"I find the darkroom work most important, as I can finish the composition of a picture only under the enlarger. I do not understand why this is supposed to interfere with the truth. Photographers should follow their own judgement, and not the fads and dictates of others. Photography is still a very new medium and everything is allowed and everything should be tried. And there are certainly no rules about the printing of a picture. Before 1951, I liked my prints dark and muddy. Now I prefer the very contrasting black-and-white effect. It looks crisper, more dramatic and very different from colour photographs."

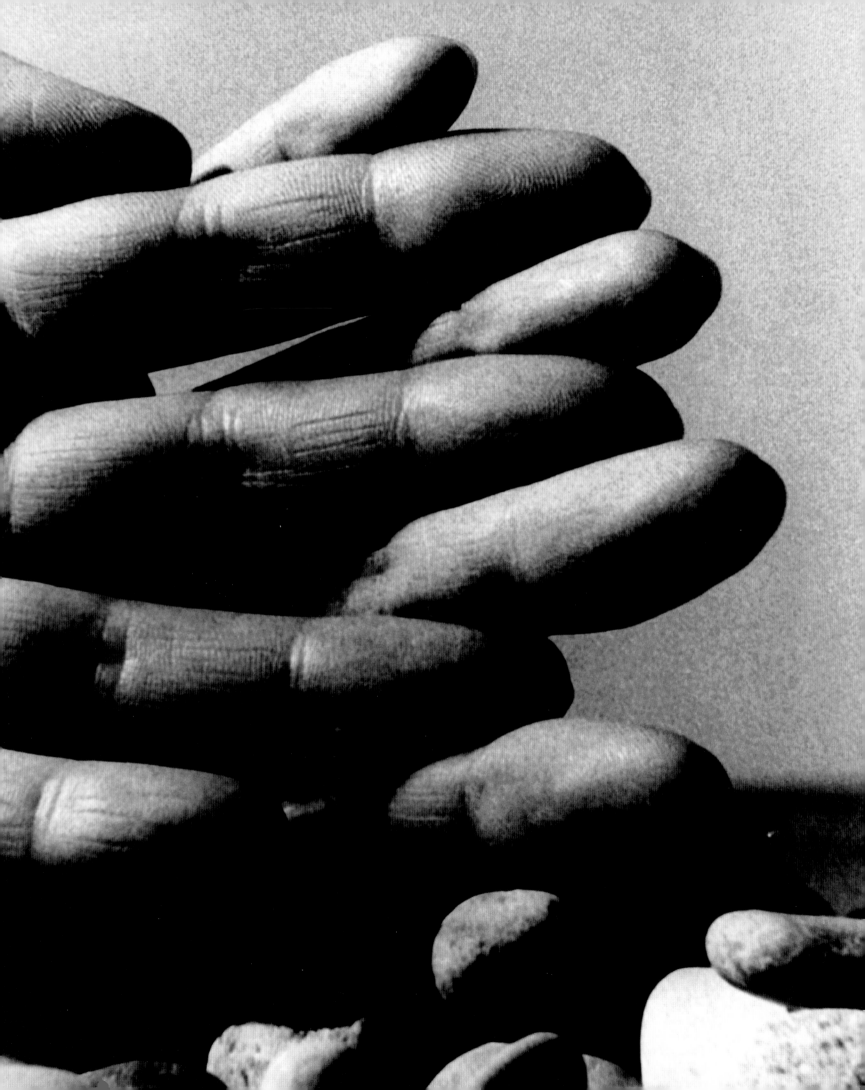

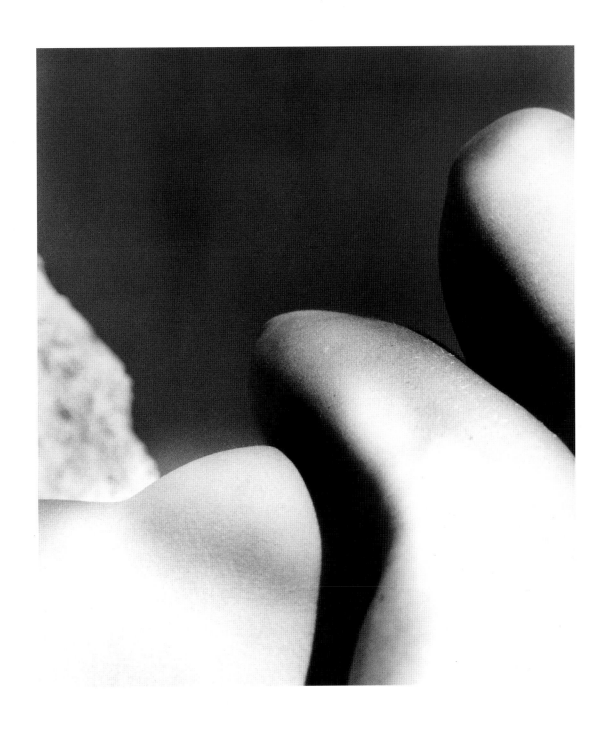

243 Baie des Anges, **1959** 244 East Sussex, **1960**

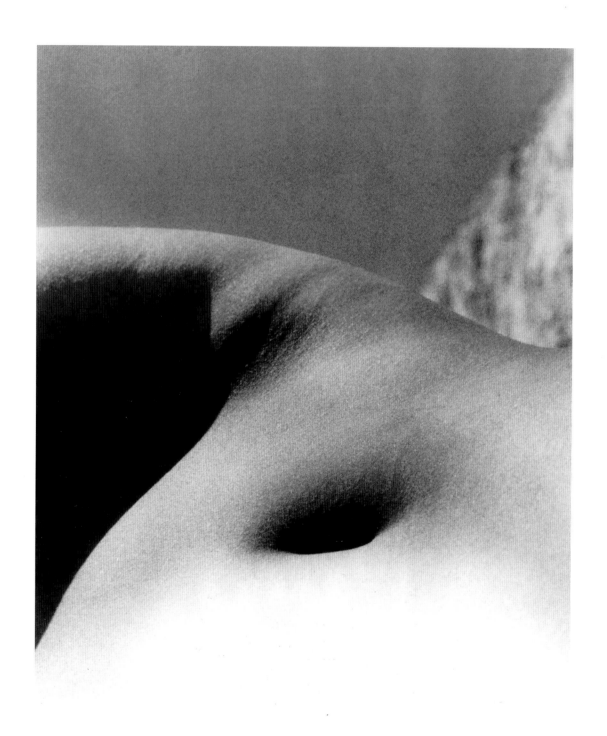

245 East Sussex, **1958**

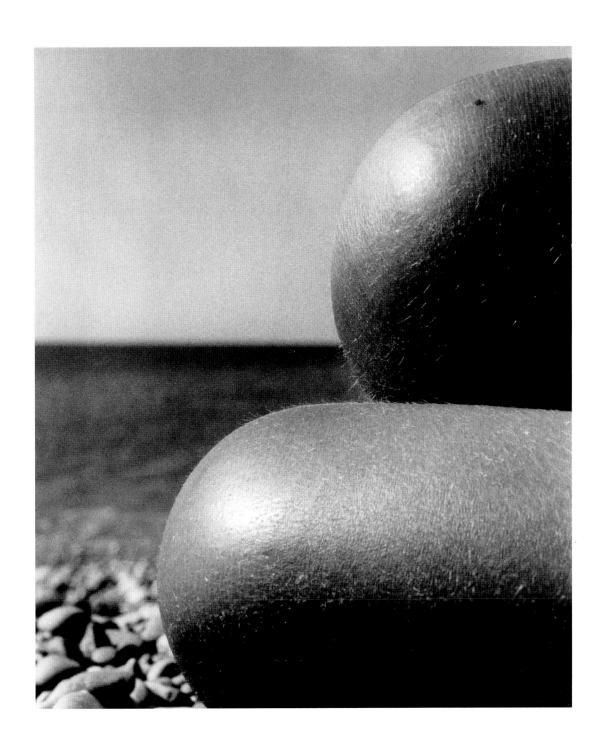

246 Baie des Anges, **1958**

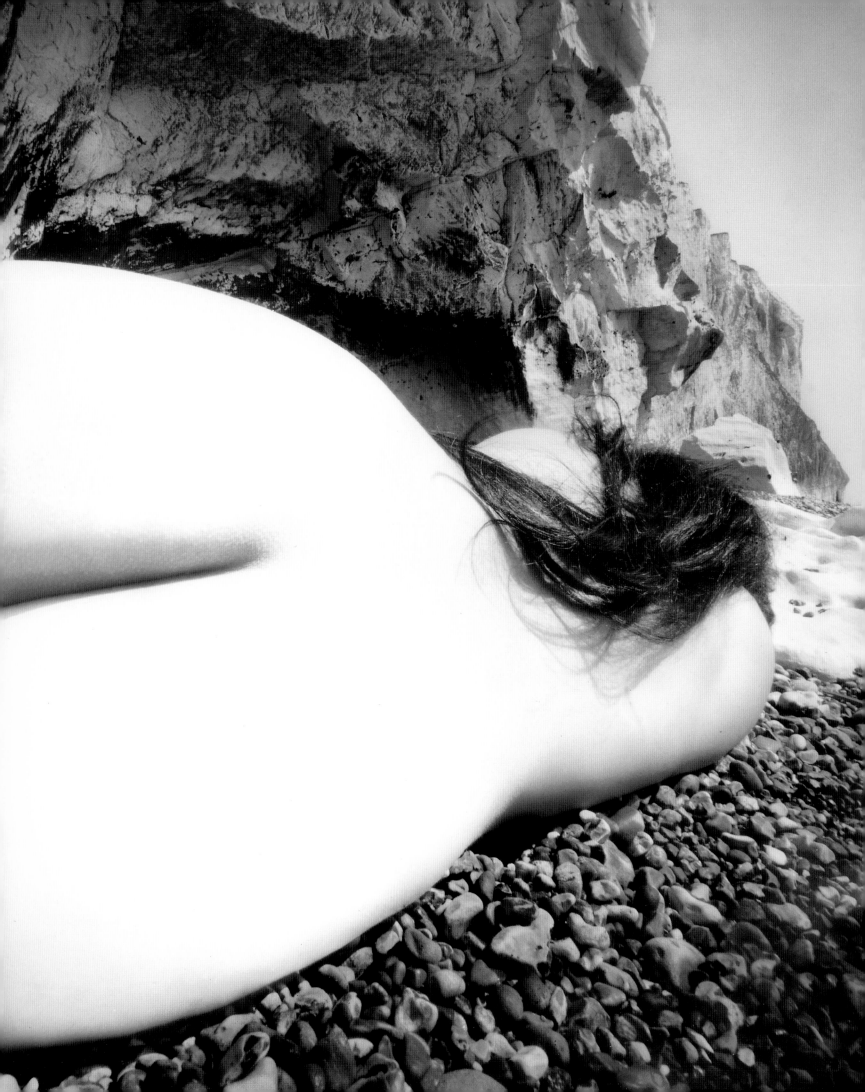

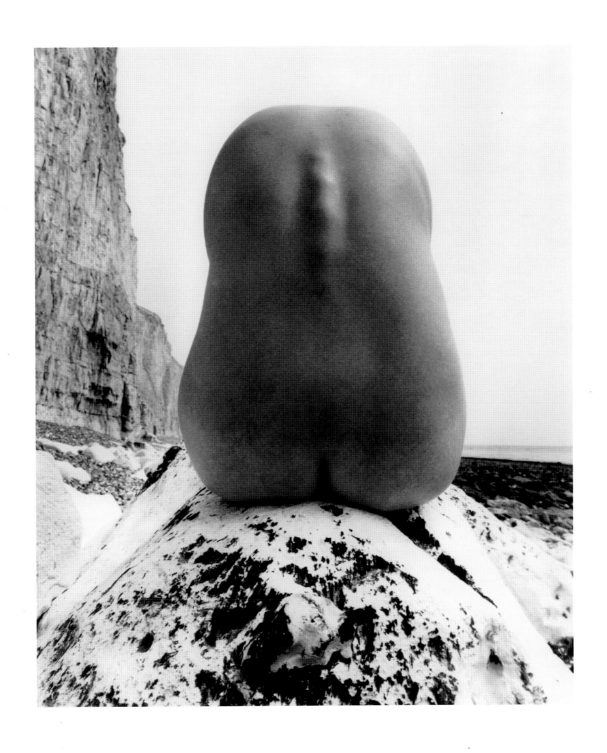

247 East Sussex, **1953** 248 East Sussex, **1977**

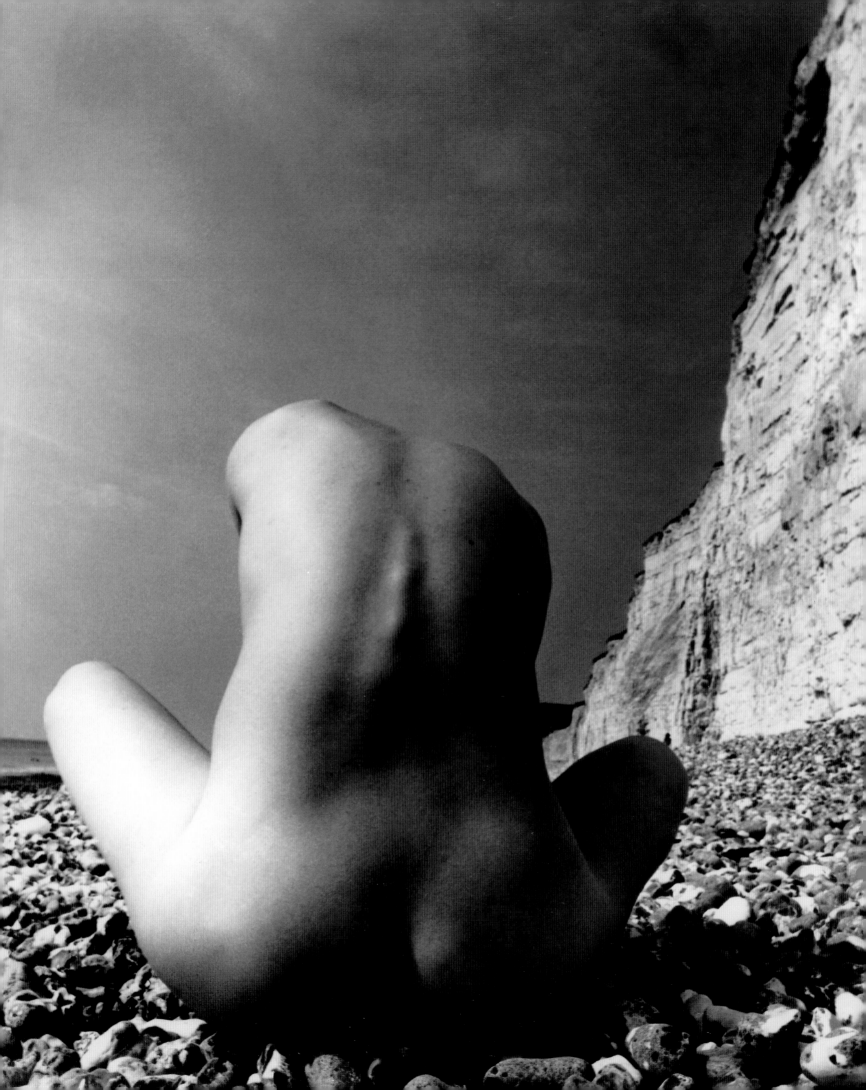

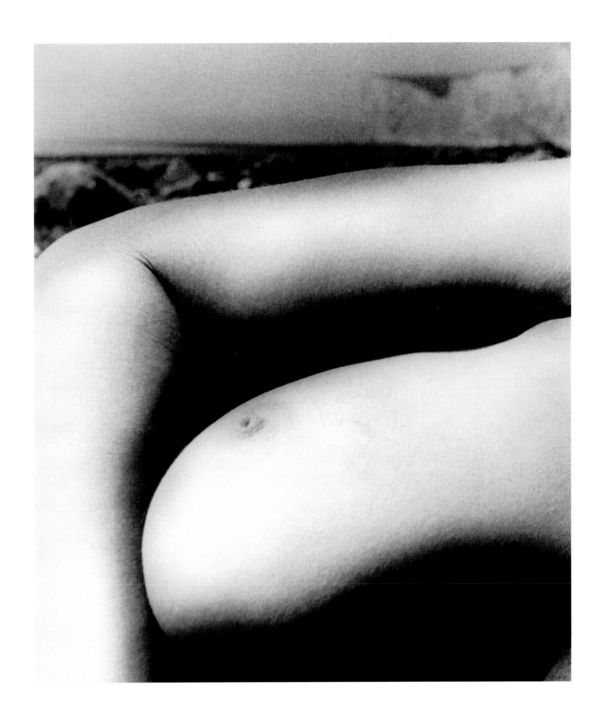

249 East Sussex, **1977** 250 East Sussex, **1950s**

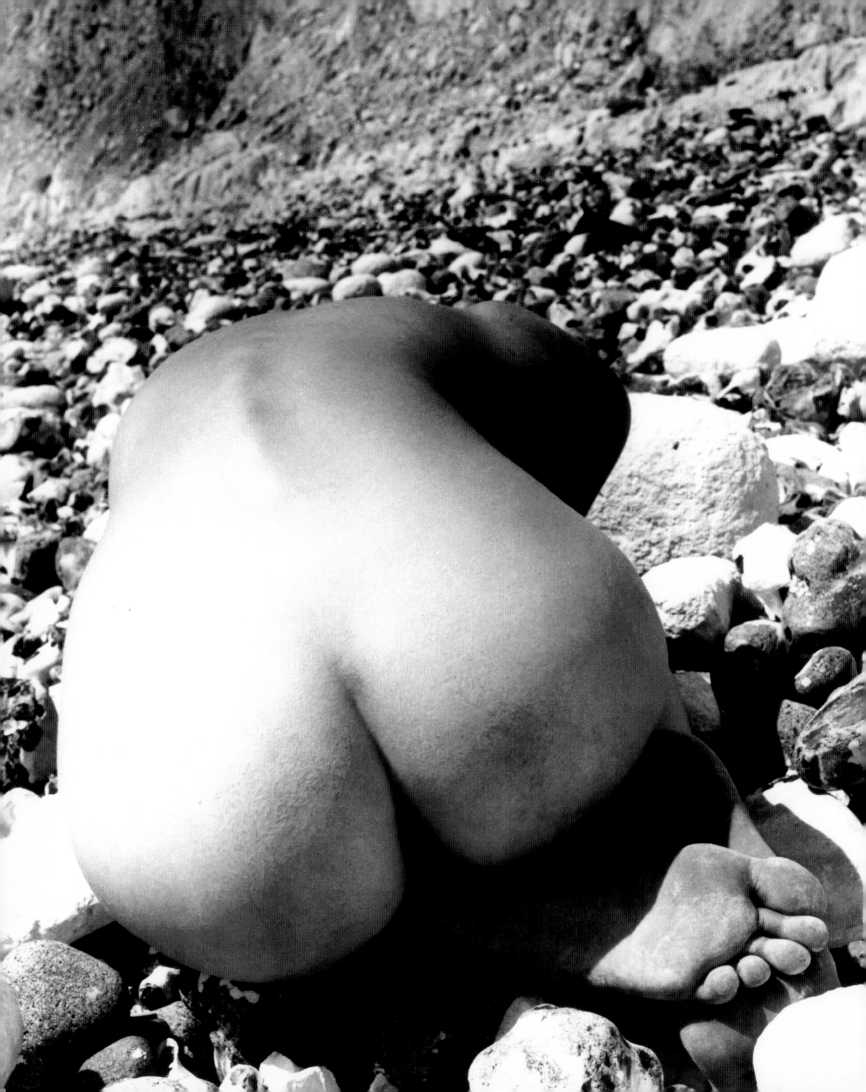

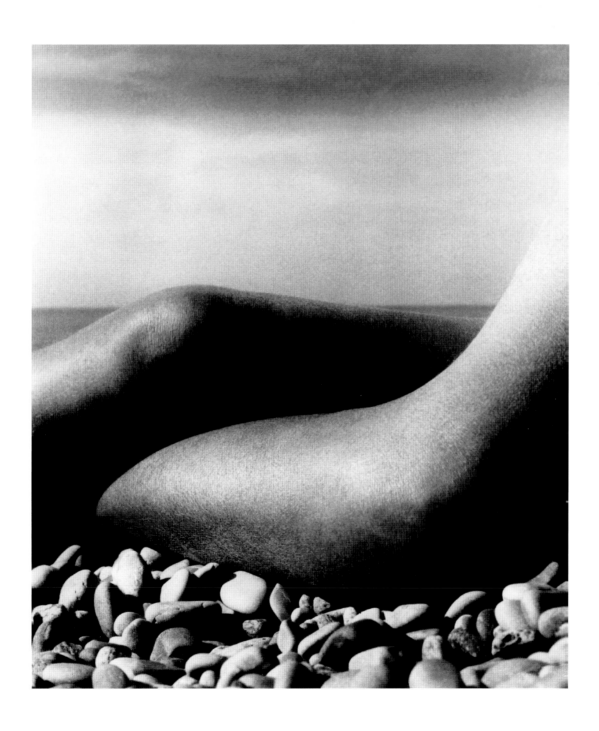

251 East Sussex, **1978** 252 Baie des Anges, **1959**

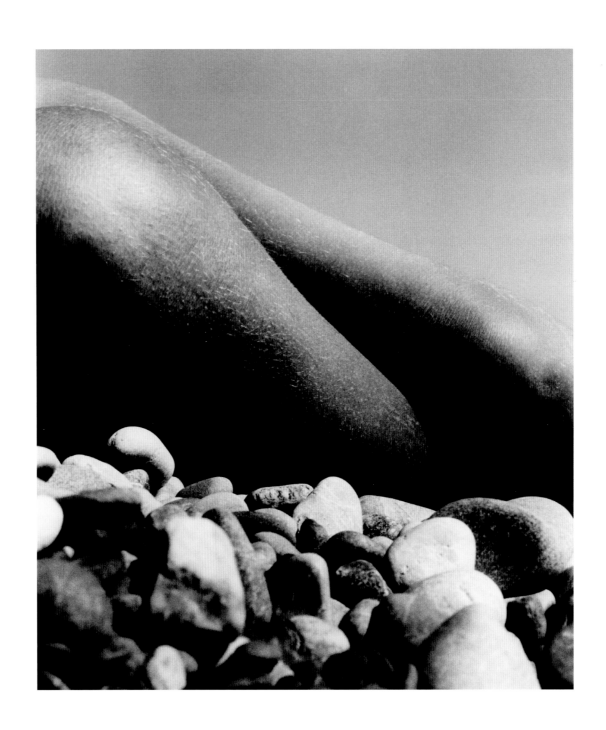

253 East Sussex, **1959**

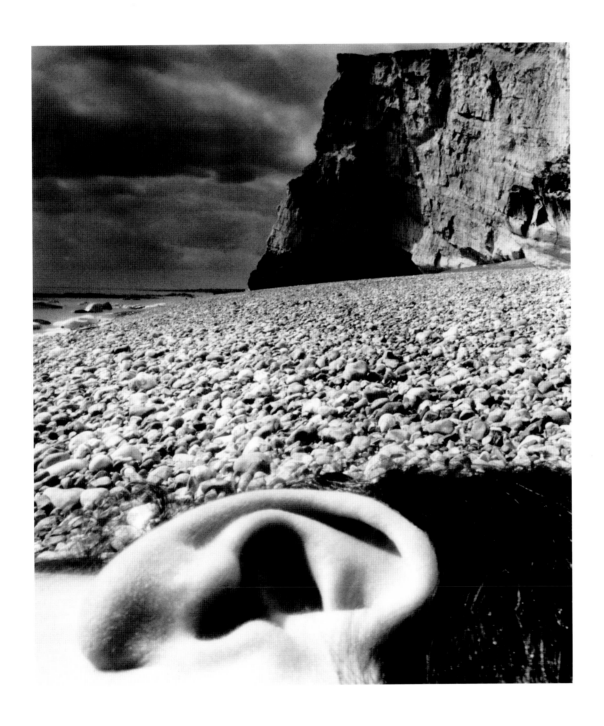

254 East Sussex, **1957**

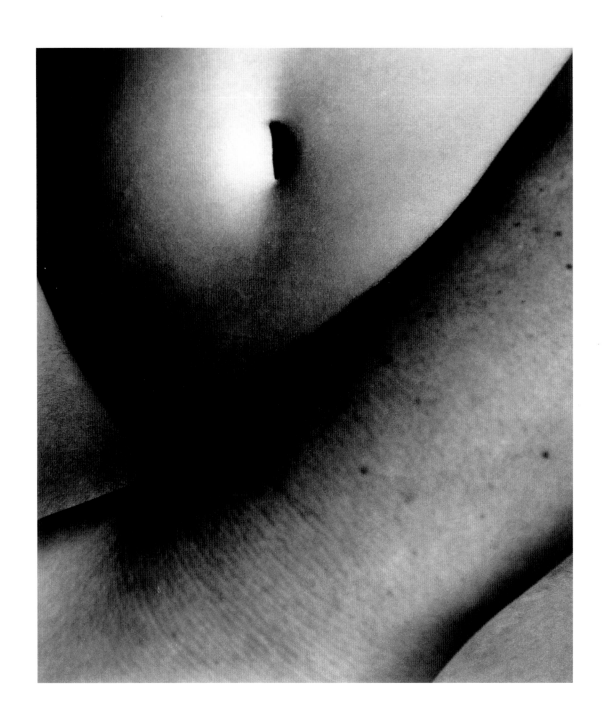

255 London, **1958**

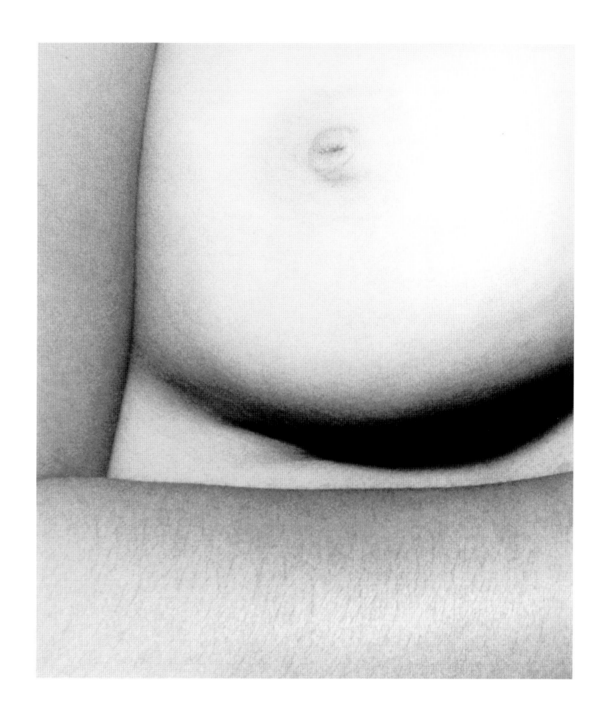

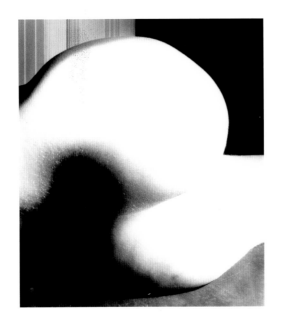 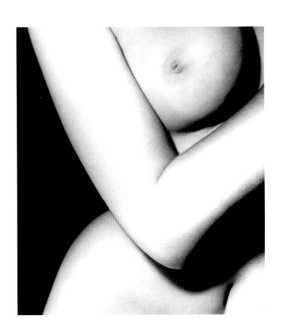

257 London, **1957** 258 London, **1959**

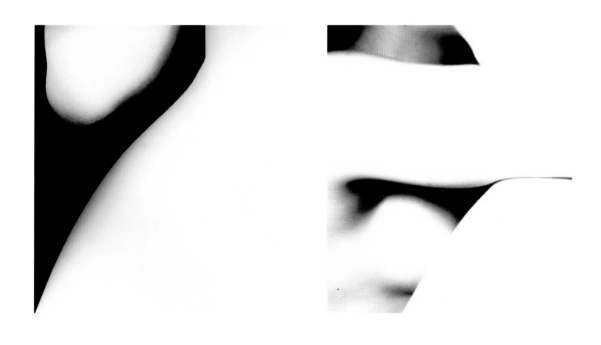

259 London, **1958** 260 London, **1958**

" If there is any method in the way I take pictures, I believe it lies in this. See the subject first. Do not try to force it to be a picture of this, that or the other thing. Stand apart from it. Then something will happen. The subject will reveal itself."

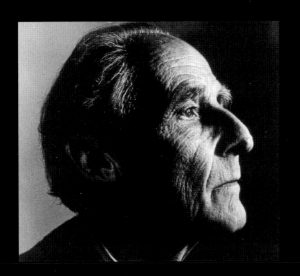

THE CAREER

Brandt by Arnold Newman

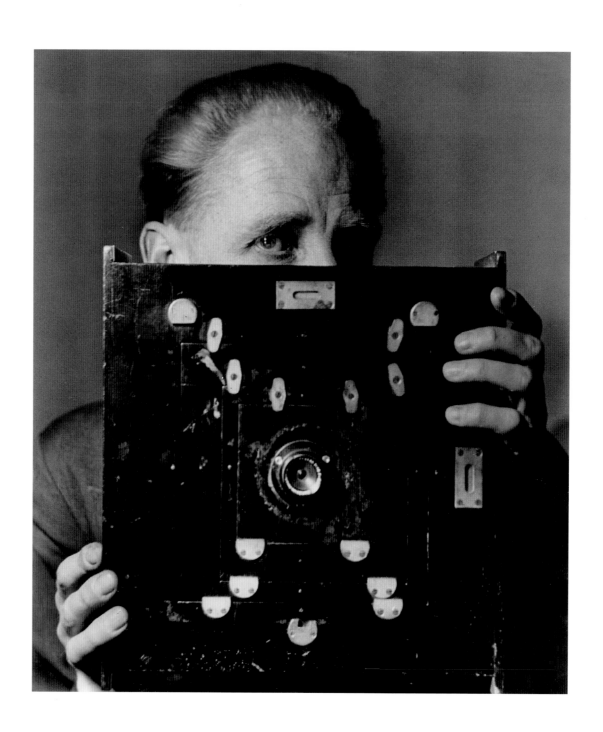

Brandt by Laelia Goehr, 1945

THE CAREER NIGEL WARBURTON

Brandt's photographic work spanned more than fifty years. For this section of the book I have selected 112 images to represent the major photographic stories, books, and series of photographs which he produced in this period. In particular I have concentrated on the photo-stories of the 1930s and '40s for the mass-circulation magazines *Picture Post* and *Lilliput*, since they are the sources of much of his best-known artistic work. With the exception of his nude photography, most of his photographs arose from assignments; and even the nude photography gained some of its impetus from a commission from *The Saturday Book* which ultimately never saw publication because of a purity campaign on the part of the publishers.

From the mid-1930s to the mid-1950s, Brandt worked extensively as a freelance photojournalist, his work appearing in magazines as diverse as *Weekly Illustrated*, *The Bystander*, *Verve*, *Coronet*, *Picture Post*, *Lilliput* and both the US and UK editions of *Harper's Bazaar*, on occasion uncredited. Early on in his career several of his photographs also appeared in the Surrealist magazine *Minotaure*. He also worked for the Black Star photographic agency, who placed some of his images. It has not been possible to record every photographic assignment that Brandt worked on - not least because of lack of conclusive evidence about Brandt's involvement on some uncredited picture stories. For example, I have only included two *Weekly Illustrated* stories, although he undoubtedly worked on many more than this, on the grounds that there is not clear evidence about precisely which photographs in other stories are Brandt's. Nor have I been able to trace all the picture stories which appeared in the US edition of *Harper's Bazaar*.

Where the image printed here was not used in the picture story, I have indicated this with the phrase 'not used'. Inverted commas around a caption indicate this was the caption used in the source. Some entries are augmented by plate numbers for further reference.

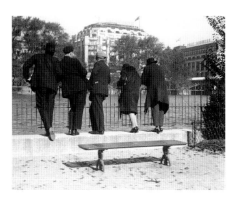

Early Portraits
Subject unknown
Vienna, 1928
Brandt spent nearly three years, from 1924 to 1927, in a sanatorium in Davos in Switzerland fighting tuberculosis. From there he moved to Vienna where he took up photography, and probably worked as an apprentice to the photographer Grete Holliner. He took a number of studio portraits at this time, including one of Ezra Pound. See plate 5.

By the Seine
Paris, c 1929
Brandt moved to Paris in around 1929, working as an assistant to Man Ray. Man Ray was rarely in his studio, but Brandt afterwards said that he learnt a great deal from looking at his work in progress. Brandt was never officially a Surrealist, but absorbed their influence. Some of his photographs were later published in the Surrealist magazine *Minotaure*: for example, the dummy in a Parisian fleamarket was published there in 1934 alongside a text by René Crevel, *'Le grande mannequin cherche et trouve sa peau.'* His work of this period includes photographs of clôchards by the Seine, and a series of pictures taken in the fleamarket. See 'A European Apprentice'.

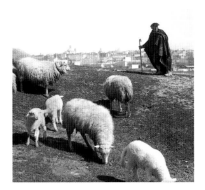

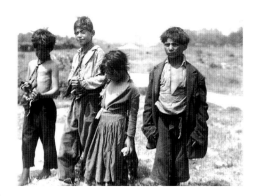

Spain, 1932
Brandt married a Hungarian, Eva Rakos, in Barcelona in 1932. They travelled widely in Europe over the next few years, visiting Madrid, Toledo, Hungary and Hamburg before settling in England where Brandt worked as a photojournalist. See 'A European Apprentice' and plate 65.

Hungarian Peasants, July 1933
Hungary
Brandt's visit to Hungary in 1933 resulted in a powerful series of photographs of peasants, several of which were later used in *Lilliput* magazine. The contrast between rich and poor was a major theme in Brandt's photography of the Thirties, so much so that his early work was sometimes taken as propaganda for socialism. See 'A European Apprentice'.

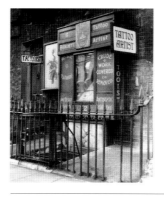

Figurehead, Scilly Isles
from 'Au Cimetière des Anciennes Galères'
Minotaure, Winter 1935
In this edition of the Surrealist magazine, four of Brandt's photographs of figureheads in a garden in the Scilly Isles appear alongside Brassaï's more overtly surrealistic 'Ciel Postiche': a composite landscape composed of two nudes. The Surrealists were drawn to effigies and dummies because they seemed to occupy the area between reality and dreams. Brandt's and Brassaï's careers overlapped significantly; they met and corresponded up until Brandt's death in 1983. Brandt's second book, *A Night in London* (1938) followed Brassaï's earlier *Paris de Nuit* (1933); Brandt's third book *Camera in London* (1948) was followed by Brassaï's *Camera in Paris* (1949); both contributed to *Lilliput* and *Picture Post*, often on quite similar subjects. See plates 76,174.

Tattooist's Window, Waterloo Road, London c 1934
Shop Windows, 1930s
Perhaps under the influence of Atget's photographs of Paris, Brandt took numerous photographs of London shop windows, few of which have been published. The picture illustrated here was used in Brandt's posthumous book, *London in the Thirties* (1984).

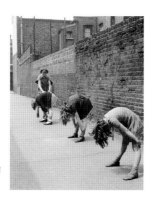

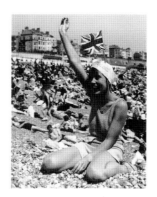

Leapfrog, London 1939
Children's Street Games, 1930s-1940s
In the early 1930s and 1940s Brandt returned again and again to the subject of city children playing in the street. They appear in several images in *The English at Home* (1936) and in magazine features such as 'These Little Children Stayed at Home' (*Weekly Illustrated*, 8 August 1936) and 'Street Play and Play Streets' (*Picture Post*, 8 April 1950).

'Brighton Belle', Spring 1936
from *The English at Home* (London: B T Batsford, 1936)
Brandt's first book provided an outsider's view of English society. Throughout he emphasised contrasts between rich and poor, so much so that an early reviewer complained that he had 'hammered his point till it is in danger of being blunted'. Brandt was amused in later life to hear of a copy of this book selling for US $500: it had originally cost five shillings, and was remaindered. The belle in the 'I'm No Angel' hat shown here is Brandt's sister-in-law, Esther Brandt, wife of Rolf Brandt, who himself appears in a number of his brother's photographs (see, for instance, 'A Day in the Life of an Artist's Model', *Picture Post*, 28 January 1939).

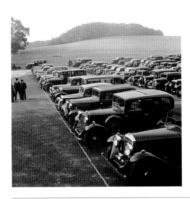

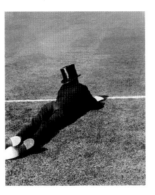

'Prelude to Glyndebourne'
from The Bystander, 3 June 1936
not used
A series of photographs very much in the spirit of *The English at Home*, showing musicians in rehearsal and the wealthy at leisure in this most English of opera houses.

'Topper versus Boater'
from *Weekly Illustrated*, 11 July 1936
Seven images accompany this short piece about the Eton versus Harrow cricket match. For an outsider few events could be more English. Brandt photographed Etonians and Harrovians a number of times: they appear, for instance, in *The English at Home* side by side as 'Harrow Strolls' and 'Eton Sprawls' (shown above). Brandt contributed extensively to *Weekly Illustrated* in the mid-Thirties (it was founded in 1934); however, relatively few stories can be attributed to him with certainty: some previous attributions are based solely on visual evidence and are unreliable. It is likely that at least some of his photographs for *Weekly Illustrated* were placed by the Black Star agency. See plate 39.

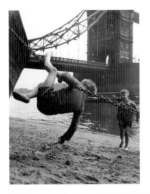

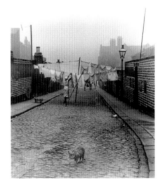

'These Little Kids Stayed at Home'
from *Weekly Illustrated*, 8 August 1936
not used
An article about places where children can play in the city in the summer illustrated with nine photographs, the most interesting of which were taken on a beach created on the Thames near Tower Bridge. Poor children playing in cities was a favourite theme for Brandt.

Backstreet, Jarrow, Tyneside 1937
Journeys North, 1937
Influenced by J B Priestley's *An English Journey* (1934), Brandt travelled to the Midlands and North of England. His images of coalminers document the conditions described in George Orwell's *The Road to Wigan Pier* which was first published in 1937; indeed the first edition of Orwell's book contained 33 photographs, many of which, such as those of coalsearchers and of a miner taking his bath, focus on the same subjects as Brandt's photographs from this series. However, none of these achieves the poetry of Brandt's images. See 'Journeys North'.

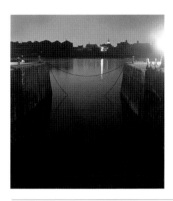

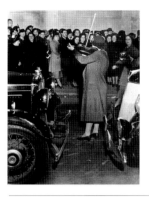

'The Thames Towards Bermondsey at Two O'Clock in the Morning'
from *A Night in London* (London: Country Life;
Paris: Arts et Métiers Graphiques, 1938)
Brandt's second book portrayed the city from twilight to dawn. The obvious precedent was Brassaï's *Paris by Night* (1933), which had also been published by Arts et Métiers Graphiques. Brandt paid great attention to the pairing of photographs. The ropes tied between the mooring posts shown above take on a symbolic significance when seen paired with lovers kissing. As in *The English at Home*, strong contrasts between the rich and poor emerge. Eight photographs from this book were used for Brandt's first *Lilliput* story, 'London Night', which appeared in the June 1938 issue of the magazine.

'Buskers of London'
from *Picture Post*, 3 December 1938
not used
Brandt's first photo-story in the newly founded *Picture Post* consisted of eleven pictures of buskers entertaining theatre queues in London's West End. *Picture Post* quickly established itself as a mass-circulation weekly; Brandt contributed extensively to the magazine from 1938 until 1951.

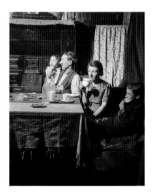

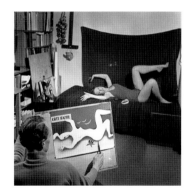

Municipal Estate, Kingstanding, Birmingham
Bourneville Village Trust, 1939 and 1943
Brandt made two visits to Birmingham - in 1939 and 1943 - working on behalf of the Bourneville Village Trust. He documented life in Birmingham's slums and corporation housing estates. An assortment of photographs and negatives, which may have been intended for the Trust's series of books entitled 'Changing Britain', only came to light in 1993 and is now in Birmingham Central Library.

'A Poster Artist Puts Her Into An Advertisement'
from 'Day in the Life of an Artist's Model'
Picture Post, 28 January 1939
Brandt shadowed artist's model Freda Walker for a *Picture Post* stock feature, the day-in-the-life story. Her day included being sketched by 'R A Brandt, surrealist commercial artist': this was Brandt's brother Rolf, a successful illustrator, who appears in several of his brother's photographs. This was the first of four *Picture Post* day-in-the-life series that Brandt photographed. The others are 'A Day in the Life of a Nippy' (4 March 1939), 'A Barmaid's Day' (8 April 1939) and 'The Perfect Parlourmaid' (29 July 1939). He used a similar approach for several other series too, such as 'A Lady of Elegant Leisure' (*Picture Post*, 2 April 1949 - see below).

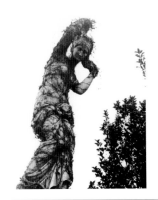

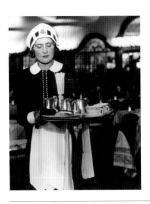

'The Entangled Lady'
from 'Daybreak at the Crystal Palace'
Picture Post, 11 February 1939
Brandt exploited the Surrealist potential of broken and overgrown statues for this series of eight photographs taken in the gardens of Crystal Palace. In his career Brandt took many pictures of effigies of various kinds. The effect of the photograph illustrated here was undermined by the addition of a light-hearted caption. Although Brandt had very little control over how his pictures appeared in *Picture Post*, he often made his own selections for *Lilliput* series, and sometimes also wrote the accompanying text; single images used in *Lilliput*, however, were frequently turned into visual puns or jokes by the editors.

From 'A Day in the Life of a Nippy'
Picture Post, 4 March 1939
not used
'Nippy' was the name coined in 1925 for waitresses in Lyons teahouses. Brandt followed a nippy in the course of her day. According to the accompanying article, there were 7,600 nippies working in Britain in 1939, and about 800-900 of them would get married each year, many to fellow employees. *Picture Post* used 18 of Brandt's photographs for this feature.

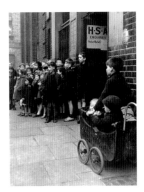

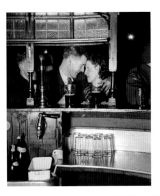

'Outside the Hoxton Market Mission: Children are Waiting for Dinner'
from 'Enough of All This!'
Picture Post, 1 April 1939
Brandt's images of children in London's East End illustrate an article about poverty and rent strikes. Although in the late Thirties Brandt's photographs of poverty and of social contrasts were frequently assumed to carry a socialist message, he remained aloof from the left-wing concerns of the day. It was, for the most part, the visual contrast between rich and poor that interested him.

Customers in 'The Crooked Billet'
from 'A Barmaid's Day'
Picture Post, 8 April 1939
not used
Alice, barmaid at 'The Crooked Billet' in Stepney close to the Tower of London, is the subject of this day-in-the-life series. The twelve photographs used by *Picture Post* show her on her way to work, behind the bar, and relaxing between shifts. Like the artist's model, the nippy and the parlourmaid, Alice is defined by her job: her day revolves around opening times with little space for an independent life. See plate 60.

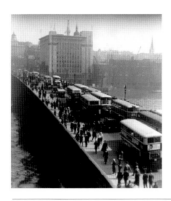

'The City as it is now'
from 'Unchanging London'
Lilliput, May 1939
Brandt's photographs of London are juxtaposed with engravings by Gustav Doré of the same scenes for this *Lilliput* feature. London Bridge in 1939, for example, is little changed from London Bridge in 1872. Brandt is described as 'a young English photographer who studied in Paris under Man Ray'. Several of Brandt's photographs had already been published alongside Doré illustrations in *Verve* (January-March 1939).

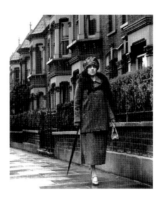

'Taking Her Afternoon Off'
from 'The Perfect Parlourmaid'
Picture Post, 29 July 1939
Brandt's uncle and aunt's head-parlourmaid, Pratt, appears in both *The English at Home* and *A Night in London*. She was a favourite subject, representing a quintessential Englishness with her stern reserve and acute sense of propriety. This *Picture Post* series of twenty-one images follows her from dawn to dusk and is the source of many of Brandt's best-known pictures of this 'general' in charge of an army of underservants. Rolf Brandt is in the final picture of the series being served cheese after dinner. Several pictures of Pratt were used in Brandt's retrospective book *Shadow of Light*, including the one illustrated, which appeared with the misleading caption 'Putney Landlady' in the first edition and 'Resident of Putney' in the second. See plates 56-9.

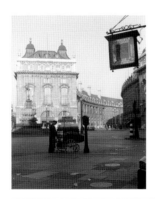

'7.30am. The day begins'
from 'Twenty-Four Hours in Piccadilly Circus'
Lilliput, September 1939
From the arrival of a hand-drawn milk cart at 7.30am to dawn the next day, Brandt tells the story of a day in the life of Piccadilly Circus in eight pictures, all taken from the same place. The captions describe him as 'Bill Brandt, the well-known London photographer'.

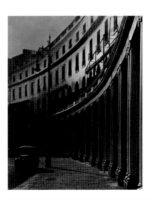

'Park Crescent, Regent's Park'
from 'Blackout in London'
Lilliput, December 1939
The enforced darkness of the wartime blackout provided an ideal subject for Brandt. However, close inspection shows that several of the photographs used in this series predate the war. 'Mayfair' is a version of 'Late Nights in Mayfair' from *A Night in London* (1938). Here the only blackout occurred in the darkroom. 'Bermondsey Warehouse' was achieved by the same method; 'Westminster' is simply a slightly darker version of 'Westminster Lies in Darkness', also from *A Night in London*. Even in his apparently documentary work Brandt was concerned with the final effect, not how it was achieved. *Lilliput* used a similar, though less successful series from Brassai in Paris (*Lilliput*, June 1940), and a later series by Brandt 'London by Moonlight' (*Lilliput*, August 1942). See plates 105, 107, 127.

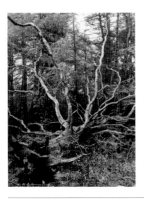

From 'Autumn in a Forgotten Wood'
Lilliput, October 1940
A poetic series of three images which prefigures Brandt's better-known landscape photography. Here the intricate shape of a fallen oak's branches is suggestive of his later collages made from driftwood and beach detritus (see page 315).

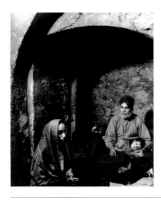

Sikh family shelter in an alcove of the crypt, Christ Church, Spitalfields
Shelter Pictures
4-12 November 1940
Brandt was asked by the Ministry of Information to record life in makeshift air-raid shelters in the London Underground and in church crypts. The project ended when Brandt contracted influenza. However the 39 photographs he produced using overhead lighting and primitive flash include some of his most remarkable work. A portfolio of these was sent to President Roosevelt to show the spirit of Londoners in the Blitz. The best images transcend their documentary function. When a selection of them was printed in *Horizon* (February 1942), Cyril Connolly wrote: ' "Elephant and Castle Station 3.45 a.m." eternalises for me the dreamlike monotony of wartime London.' Four of these images appeared alongside Henry Moore's drawings of the same subject in the December 1942 issue of *Lilliput*. See plates 114-7.

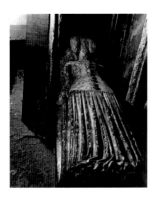

Female Effigy, Canterbury Cathedral, December 1941
National Buildings Record 1941-3
In 1941 Brandt was asked by the newly founded National Buildings Record to document the buildings and contents of various English cathedrals and churches including Canterbury, Rochester and Chichester Cathedrals, and several churches in Essex. He also photographed in Spencer House, London. He produced several hundred images, mostly of statues and monuments, as straightforward records of objects likely to be destroyed by German air raids (see 'Bath - what the Nazis Mean by A Baedeker Raid' *Picture Post*, 4 July 1942). The *Lilliput* series 'Cathedrals of England' (May 1943) probably arose directly from this work.

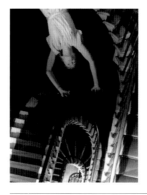

From 'Nightwalk ... a dream phantasy in photographs'
Coronet (US), January 1941
This series consists of seven photographs, mostly composite, telling the story of a young woman's dream. To create them Brandt photographed the woman spotlit on a stage and created a montage using photographs of a staircase, a street and so on. In one image he has superimposed the woman holding a small dog on to a photograph that appeared in *A Night in London* as 'Dark and Damp are the Houses in Stepney'. The photograph illustrated here seems to allude to Alice in Wonderland's fall down the rabbit hole. This was probably the only time that Brandt explicitly attempted to photograph a dream, though much of his work has a dream-like atmosphere. (As so often, Brandt reused photographs from this story - a variant on the woman sleeping appeared as 'The Sleeper - 1941' in *Lilliputt*, July 1941)

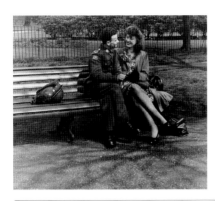

'It's a Wonderful Day to Make Plans on a Bench in the Park'
from 'Spring in the Park'
Picture Post, 10 May 1941
Twelve photographs of people, animals, statues, debris and flowers in what appears to be Hyde Park. The major caption 'Spring in the park - just the same in 1941' - is wishful thinking: it is undermined by the pictures of piles of debris from bomb-damaged buildings. As with several other stories Brandt was involved in in 1941, morale-boosting lies very close to the surface here.

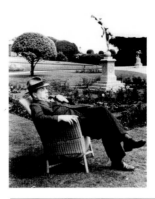

'Solitude and Safety: J B Priestley Relaxes in the Grounds of a Bournemouth Hotel'
from 'I Look at Bournemouth'
Picture Post, 21 June 1941
8 images
Brandt's photographs, including this portrait of J B Priestley relaxing in a wicker chair in the grounds of a Bournemouth hotel, illustrated a strident article by Priestley defending weary war-workers' rights to have a break in seaside resorts like Bournemouth; in particular he attacked the notion that the amenities should only be available to the rich. Brandt made several portraits of Priestley during his career (see, for example 'The Albany' *Harper's Bazaar* UK July-August 1945). It was Priestley's book, *An English Journey* (1934) which had inspired Brandt's travels to the North of England in 1937.

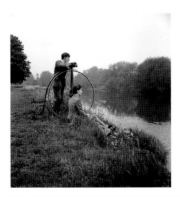

'Penny-farthing For Their Thoughts'
from 'A Day on the River'
Picture Post, 12 July 1941
Idyllic scenes of young couples idling on riverbanks at Old Windsor, Hurley and Eton provided escapism from wartime austerity. Brandt showed that he was capable of producing the sentimental images that propaganda required, as he would later in the same year for 'A Simple Story About A Girl' (*Lilliput*, September 1941 - see below).

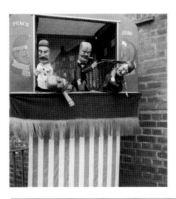

'Why, Of Course! It's a Political Punch and Judy Show'
from 'What Are All These Children Laughing At?'
Picture Post, 23 August 1941
Five photographs of children laughing. The sixth, illustrated here, shows what they were laughing at: a wartime version of a Punch and Judy show in which Churchill hangs Hitler and Mussolini is knocked out. Meanwhile Stalin acknowledges the applause. A rare photograph for Brandt in that it has an overt political message.

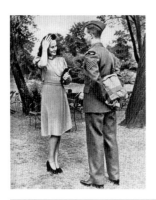

Mary meets Jack
from 'A Simple Story About A Girl'
Lilliput, September 1941
Eight photographs with captions tell a romantic story about an attractive but lonely girl called Mary who goes for a walk and meets a handsome Sergeant called Jack. 'We can't tell you whether they lived happily ever after, but it seems very likely.' A further example of morale-boosting escapism, representing a very different side of Brandt's warwork from his better known shelter pictures and images of London in the blackout.

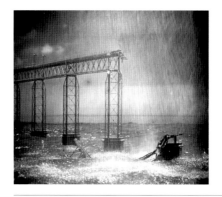

Model of Tay Bridge
from 'The Tay Bridge Disaster'
Picture Post, 20 September 1941 not used
Film and Theatre Stills, 1941-51
In December 1879 the Tay Bridge collapsed as a train was passing over it. This catastrophe was the centrepiece of a film, *Hatters Castle*. Brandt photographed Deborah Kerr as the mysterious cloaked woman in the lead role. He also photographed a model bridge set up in a thirty-foot square tank to simulate the disaster. Brandt went on to photograph on the set of Michael Powell's film *The Life and Death of Colonel Blimp* ('A Cartoonist's Joke Becomes a Film Hero' *Lilliput*, 19 December 1942), and of Cavalcanti's *Champagne Charlie* (Harper's Bazaar, UK, June 1944); he also photographed the stage production *The Madwoman of Chaillot* (*Picture Post*, 3 March 1951).

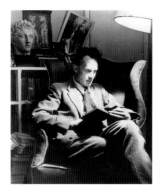

Stephen Spender
from 'Young Poets of Democracy'
Lilliput, December 1941
The poets included in this *Lilliput* series were: Stephen Spender, Cecil Day Lewis, Dylan Thomas, Louis MacNeice, Alun Lewis, Anne Ridler, Laurie Lee, and William Empson. Brandt's career as a photographer began with his 1928 portrait of the poet Ezra Pound; however, this series of portraits of poets was his first serious exploration of portraiture, which culminated in his book *Bill Brandt: Portraits* (1982). Brandt reused most of these images to illustrate an article for *Harper's Bazaar* UK 'The Common Reader and the Modern Poet' (June 1945). See plates 178, 180.

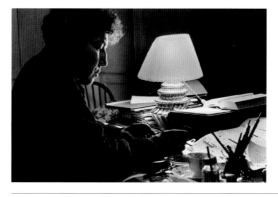

'The Article on Ghosts is Written: Robert Graves at work in his Devonshire Cottage'
from 'What I Believe About Ghosts'
Picture Post, 27 December 1941
Three photographs by Brandt, including the above portrait, accompany an article by Robert Graves in which he discourses on the nature of ghosts, bringing in the Chinese concept of *feng-shui* to help explain the phenomenon. The portrait of Robert Graves which appeared in 'An Odd Lot' (*Lilliput*, November 1949) was probably taken during this session. See plate 185.

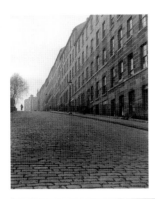

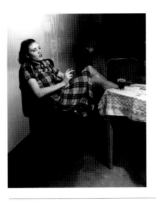

Salisbury Street, Old Town
from 'The Northern Capital in Winter'
Lilliput, February 1942
Eight photographs of Edinburgh with a text described as 'mainly by Sacheverell Sitwell'. Typically, Brandt discovered misty and dark buildings and landscapes with scarcely a human figure visible. His photographs show the castle through trees, Old Town, Princes Street, St Cuthbert's Church, Salisbury Street, the churchyard of St Cuthbert's, a view over New Town and sunrise over Arthur's Seat. All the images convey a sense of mystery and foreboding. See plates 98-9.

Soho hostess
from 'Soho in Wartime - Eight Bits of a Quarter'
Lilliput, April 1942
These eight photographs document Soho, including a Greek boarding-house keeper leaning out of a window, an Italian delicatessen, the cloakroom girl in a Soho nightclub taking a breath of fresh air, and a waiter in a bow tie carrying a glass of wine and bread across the road. The photograph illustrated here is captioned: 'In a night club off Newport Street, a hostess is waiting for her day to begin: her day that begins after midnight. Soon she will be dancing, laughing at the jokes she has heard a hundred times, smiling at the compliments that have grown flat as the beer in front of her.'

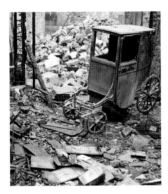

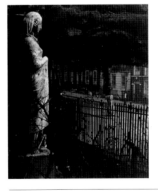

'In the Assembly Rooms the Chair Survives'
from '"Bath" - What the Nazis Mean by a "Baedeker Raid"'
Picture Post, 4 July 1942
Eight photographs document the damage caused to some of Bath's most impressive architecture by a single bombing raid. 'Baedeker' raids, named after the famous guidebooks, were retaliatory attacks deliberately targeted on English towns of historic and cultural significance. Illustrated above is the wreckage of the Assembly Rooms, built 1769-71. Brandt's wartime work for the National Buildings Commission (described above) was an attempt to record buildings and monuments of historic interest which were threatened by just such targeted raids on British heritage.

'St John's Churchyard, NW3'
from 'London by Moonlight'
Lilliput, August 1942
Photographed by moonlight, the sense of atmosphere of these London scenes is enhanced. This, his second *Lilliput* series of London in the blackout (see also *Lilliput*, December 1939), includes the silhouette of St Paul's rising from a tide of rubble, 'Street in a bombed area' and 'City water-front', all of which find beauty in the bomb-damaged city. Of the moonlit churchyard scene above Brandt commented: 'I have always loved the Beerbohm Tree Memorial in St John's Churchyard. By moonlight it looks mysterious and eerie, but by day it has roses climbing all round it.' This issue of *Lilliput* also contains an admiring profile of the photographer by *Lilliput*'s editor Tom Hopkinson who already appreciated Brandt's artistry and recognised the sense of mystery in his best work. See Plates 120, 122, 123.

'Nelumbo Nucifera'
from 'Flower Portraits by Brandt'
Lilliput, September 1942
A series of photographs of flowers. Brandt did not return to this subject matter. This series is principally of interest as an avenue not taken. Stephen Spender, whom Brandt had photographed for 'Young Poets of Democracy' (*Lilliput*, December 1941), wrote the captions. Of the flower illustrated he wrote: 'It is dancing a little dance of its own, a nymph above the plangent heavy leaves and the wet grasses. Its petals swing out, twirl gracefully in the air, whilst above these skirts, and below its tight bodice, it wears a basque made of the richest embroidered lace, hanging with minute cotton tassels.'

From 'Saving Britain's Plum Crop'
Picture Post, 12 September 1942 (cover picture)
Brandt visited Maidstone in Kent to document how surplus plums from a heavy crop were being picked, pulped and stored by the Ministry of Food using a new method of preservation. Three of Brandt's photographs illustrate an article detailing the procedure; a fourth, shown here, was used on the cover, and suggests hope and concern for the war-child's future rather than the plum crop.

'The Convoy Has Arrived - Internal Transport Takes Over'
from 'Transport: Key to Our War Effort'
Picture Post, 26 September 1942
A long article reporting on the organisation of wartime transport accompanied by ten photographs of operations rooms in the Ministry of Transport. It is surprising to think that with his German accent Brandt was admitted to and permitted to photograph so sensitive a location in wartime.

From 'Holiday Camp for War Workers'
Picture Post, 26 September 1942
not used
Brandt's second picture story in this issue of *Picture Post* presents an idyllic contrast to the stern faces of the people working in the Ministry of Transport. Here women factory workers enjoy camping and swimming in rural Cookham in a series of pictures similar to 'A Day on the River' (*Picture Post* 12 July 1941): a more humanistic side of Brandt emerges from this sort of photojournalism than is seen in his later and better known work.

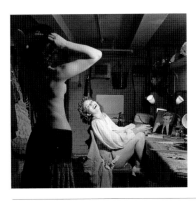

'Ten Minutes to the Show'
from 'Backstage at the Windmill'
Lilliput, October 1942
Semi-clad dancers in dressing rooms and high-kicking dancers on stage feature in this *Lilliput* picture story which was clearly a pretext for mild titillation. It bears some resemblance to the day-in-the-life stories Brandt produced for *Picture Post*.

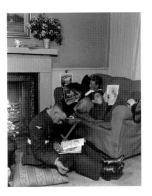

From 'A Town That Takes Care of Its Troops'
Picture Post, 3 October 1942
not used
The town in question is St Andrews in Scotland. The article, accompanied by seven photographs, describes the Number Sixty Club, a house providing a rest place for soldiers during their time off. This is Brandt providing straightforward pictures on demand as the article's subheading suggests: 'Simple, unexciting pictures. But if they became reality all over Britain, they could transform the lives of our fighting men this winter.'

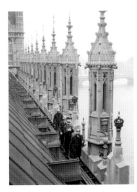

From 'Fire Guard on the House of Commons'
Picture Post, 14 November 1942
not used
The team of fire-watchers at the Palace of Westminster was, for security reasons, made up of the staff, the officials, the Press correspondents and members of the House of Commons and House of Lords. Brandt photographed the team at work both inside and on top of the buildings. In one photograph the ARP chiefs pose beneath the statue of Sir Charles Barry, architect of the Palace - a surreal touch that might have invited a humorous caption in less threatening times.

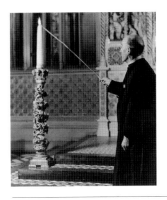

From 'The First Wartime Christmas to Bring a Vision of Peace'
Picture Post, 26 December 1942
not used
Six photographs taken in Ely Cathedral, most of choristers, accompany an optimistic article about the possibility of victory in the war: 'And victory is the gate of peace.'

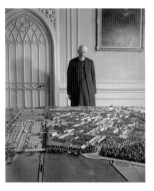

Osbert Lancaster
from 'What Our Artists Look Like'
Lilliput, March 1943
Portraits of the cartoonists who illustrated *Lilliput*: Walter Trier, Osbert Lancaster, Anthony Gilbert, David Langdon, Victoria, Mervyn Peake (better known now as the author of the *Gormenghast* books), Haro Hodson and Fix Kelly.

'The Archbishop Studies the Housing Problem: He Examines the Model of a New Town of the Future'
from 'Should the Church Keep Out?'
Picture Post, 24 April 1943
Two portraits of the Archbishop of York accompany a discussion of whether or not the Church should stay out of politics: 'Not even an Archbishop need be silent if study and experience have made him familiar with some subject under discussion.' The Archbishop is looking at a model designed for the Cadbury film *When We Build Again*.

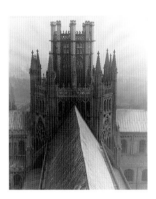

'Ely: The Octagon Tower; Nave roof in the foreground'
from 'The Cathedrals of England'
Lilliput, May 1943
Canterbury, Oxford, Salisbury, Ely, Westminster Abbey, Southwark, St Albans and Winchester Cathedrals are all included in this *Lilliput* series. These photographs, nine out of ten of which are interiors, may have been suggested by, or possibly taken during, Brandt's work for the National Buildings Record.

'Plas Newydd, Denbighshire'
from 'The Gardens of England'
Lilliput, September 1943
The gardens Brandt photographed for this series are Plas Newydd, Stonyhurst, Bowood, Garsington, Highcliffe Castle and Stowe. As with many of his pictures of English country houses, he was able to combine formal and surreal elements. See plate 64.

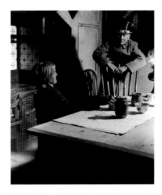

From 'The Threat to the Great Roman Wall'
Picture Post, 23 October 1943
not used
Hadrian's Wall was being destroyed by quarrying. An article by C E M Joad accompanied Brandt's bleak landscapes. Brandt returned to the theme of Roman fortifications in 'The Vanished Ports of England' (*Picture Post*, 24 September 1949). See plates 138, 149.

'The Servants of Erthig Hall Today'
from 'The Portraits in the Servants' Hall'
Picture Post, 24 December 1943
The inhabitants of the eighteenth-century mansion Erthig Hall in Denbighshire, Wales, are the subject of this feature. The servants' hall contained a series of portraits of previous servants.

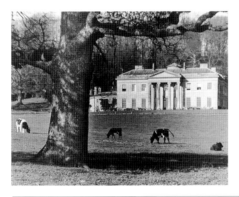

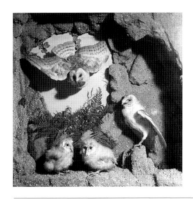

Dinton Park, Wiltshire
from 'A Year's Work by the National Trust'
Picture Post, 22 January 1944
not used
Brandt provided seventeen photographs of land and houses acquired by the National Trust for this *Picture Post* feature. These include a stretch of the Derwent Valley, Avebury, Killerton, The Court (Holt in Wiltshire), St John's (Jerusalem, Kent), Blaise Hamlet (Bristol), Woolsthorpe Manor (Lincolnshire), Dinton Park (Wiltshire), Hyde's House (Dinton), Willy Lott's Cottage (Suffolk), The Georgian colonnade at West Wycombe Park (Buckinghamshire), Selworthy (Somerset) and Alcock Tarn in Westmorland.

Stuffed Owls in the Whitechapel Museum
from 'Odd Corners of Museums'
Lilliput, February 1944
A series of eight photographs focussing on incongruous juxtapositions and tableaux in London museums. Brandt's taste for the surreal is apparent in his selection: a wooden sculpture of a tiger mauling an officer of the East India Company in the Victoria and Albert Museum; a strange collection of musical instruments including a serpent in the Donaldson Museum, Kensington; a Pre-Raphaelite painting and a dress in the De Morgan Collection; stuffed owls in the Whitechapel Museum (shown here); skeletons of a horse and a man in the Natural History Museum; a nineteenth-century model of a Japanese officer in full armour at the Victoria and Albert Museum; a pennyfarthing and the abandoned arm of a mannequin at the Science Museum; and four ships' figureheads at the National Maritime Museum.

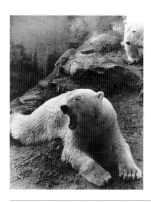

Polar Bear
from 'Animal Portraits'
Lilliput, June 1944
Eight portraits of animals taken at London Zoo. As with the flower portraits (*Lilliput*, September 1942), this series is principally of interest as a subject matter briefly explored and then set aside: a direction not taken.

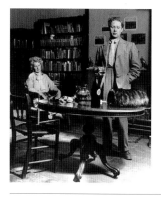

Dylan and Caitlin Thomas, Manresa Road, Chelsea
from 'Chelsea: Photographed by Bill Brandt'
Lilliput, August 1944
Ten photographs documenting the people and streets of Chelsea. This series begins with a hazy shot of a bus going over Chelsea Bridge with Battersea Power Station in the background and ends with a shot of Cheyne Row. The images in between are all of Chelsea's inhabitants, including the well-known portrait of Dylan and Caitlin Thomas in their home in Manresa Road (shown above). Other subjects include Peter Rose-Pulham painting at an easel, and two Chelsea Pensioners passing in the street.

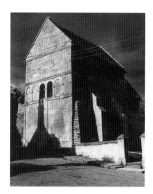

'The Saxon Church of St Lawrence'
from 'A Small Town in the Autumn Sunlight'
Lilliput, December 1944
A visit to Bradford-on-Avon in autumn produced the eight poetic images used in this *Lilliput* series. The low angle, dark sky and emphasis on shadow in the photograph of the Church of St Lawrence (shown above) produce an effect reminiscent of De Chirico. The commentary for the piece, which is for the most part prosaic, ends on a poetic note: 'Under a hurrying autumn sky, when fields are vivid green and trees are amber, the cottages and houses of Bradford turn to silver: the stone flushes warm pink at sunset, or radiant gold.' See plates 166-7.

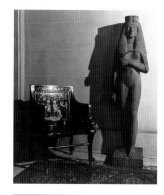

Egyptian Embassy, London
London Embassies, 1940s
Some time in the 1940s Brandt began a series of photographs of the interiors of foreign embassies in London. These include the Chinese, Dutch, Egyptian and Spanish embassies.

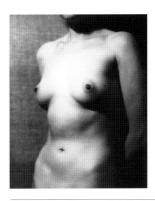

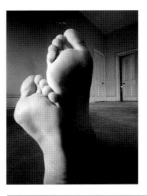

Early Nudes
1940s
Although at least one nude study from the 1930s exists, and his first published nude appeared in *Lilliput* in February 1942, Brandt only began photographing nudes seriously in the mid-1940s. After 1948 his fashion work for *Picture Post* gave him more access to models.

Nude, Hampstead, September 1952
Nudes in Rooms, 1945-83
Brandt bought an old police camera in a second-hand shop in Covent Garden. This camera had a wide-angled lens 'capable of seeing like a mouse, a fish or a fly'. After seeing *Citizen Kane*, which he described later as 'my greatest single influence', and in particular impressed by Greg Toland's cinematography, he became absorbed with the idea of photographs with a depth of focus that would take in the room in which the model was posed. He continued to experiment with nude photography until the 1980s. Many commentators have seen Brandt's nudes as his finest work. See 'The Perfection of Form'.

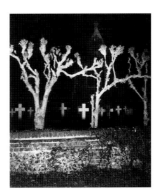

'The Waste Basket of Icing Sugar'
from 'Frosty Morning in the Park'
Picture Post, 20 January 1945
Frost-tinged statues and trees in Kew Gardens provided Brandt with the perfect mixture of surrealism and natural beauty. This series includes the well-known photograph of a sphinx surrounded by foliage and the tree study. It is similar in conception to 'Daybreak at the Crystal Palace' (*Picture Post*, 11 February 1939).

From 'The Magic Lantern of a Car's Headlights'
Picture Post, 31 March 1945
This picture story consists of ten photographs all taken at night by the light of car headlights. The subjects include a startled rabbit, a cat, a donkey, and a pair of lovers. The caption for the picture of a graveyard illustrated above reads: 'Behind the barrier of strange coral growths are the homes of those who will not notice, whether the headlights on the roads in the sixth year of war, shine bright or dim.'

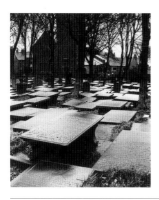

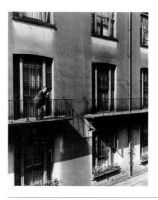

'Haworth Churchyard: View from the Sisters' Window'
from 'Bill Brandt visits the Brontë country'
Lilliput, May 1945
Brandt photographed the places associated with the Brontës, particularly
Top Withens, the building on which Wuthering Heights was based, and
Haworth. This series includes several of the images which later featured
in *Literary Britain* (1951). Charlotte Brontë described the churchyard seen
from her window as 'so filled with graves that the rank weeds and coarse
grass scarce had room to shoot up between the monuments'. See plates
136, 163.

J B Priestley
from 'The Albany'
Harper's Bazaar, UK July-August 1945
This picture story for *Harper's Bazaar* consists of six portraits of famous
inhabitants of a block of flats near Piccadilly, together with a view of
its location. The inhabitants are: J B Priestley (shown above), Clifford
Bax, Patrick Hamilton - author of *Hangover Square*, a novel which
describes the pub life captured in many of Brandt's photographs of the
1930s - G B Stern, Eric Hesketh Hubbard and Margery Sharp. Brandt
contributed regularly to both the British and American editions of
Harper's Bazaar, usually providing one or two portraits to illustrate a
feature. He also reused some images which had already been published in
Lilliput, as for example in 'The Common Reader and the Modern Poet'
(*Harper's Bazaar*, UK June 1945).

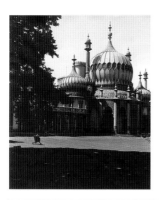

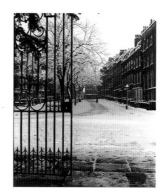

Nash's Pavilion
from 'Brighton: The Home of the English Seaside'
Lilliput, September 1945
For Brandt, Brighton seems to have been the quintessential English resort.
Lilliput used eight photographs of Regency architecture and seaside scenes
for this picture story. The belle on the beach in her 'I'm No Angel' hat used
in *The English at Home* (1936) was also photographed in Brighton.

Church Row, Hampstead
from 'Hampstead Under Snow'
Lilliput, February 1946
not used
A heavy snowfall provided the stark white/black contrasts of this series.
Lilliput printed eight photographs: St John's Chapel, a garden in South End
Road cottages in East Heath Road, Downshire Hill, a sculpture by Henry
Moore in Roland Penrose's front garden, bomb-blasted cottages in South
End Road, Burgh House, and a different view of Church Row from the one
shown above.

'Shad Thames'
from 'Below Tower Bridge'
Lilliput, March 1946
A classic Brandt picture series of London's docklands, including views of Tower Bridge from Bermondsey, Nightingale Lane, the South Bank, Shad Thames, Hermitage Stairs, Horselydown New Stairs, Charley Brown's at Limehouse, and the wharves at Wapping. See plates 48, 106.

'The Doomed East End'
Picture Post, 9 March 1946
Brandt's photographs of East End pub life appear alongside photographs by Charles H Hewitt illustrating an article about the post-war plans for development of the East End. The picture illustrated was used on the cover of the magazine.

'Salisbury Cathedral'
from 'Thomas Hardy's Wessex'
Lilliput, May 1946
This *Lilliput* picture story consists of eight images of places described in Hardy's novels: Lulworth, Shaftesbury, Egdon Heath, Stonehenge, Salisbury Cathedral, Maiden Castle, Tess's Cottages at Marnhull and Corfe Castle. Salisbury Cathedral, illustrated here, appears in *Jude the Obscure* as Melchester Cathedral. Brandt has photographed the cathedral from the same position as Constable used in painting it. Brandt's photographs of sites of literary significance eventually resulted in his book *Literary Britain* (1951). See plates 141, 148.

Benjamin Britten
from 'English Composers of Our Time'
Lilliput, September 1946
The composers Brandt photographed for this series are: Benjamin Britten, Constant Lambert, Michael Tippett, Bernard Stevens, Antony Hopkins, Alan Rawsthorne, William Alwyn and Elisabeth Lutyens. At 33 Benjamin Britten could already be described as 'one of the most spectacular stars in the English musical sky'. See plate 190.

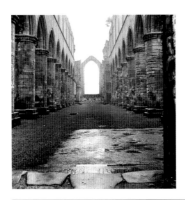

From 'Fountains Abbey: Should It Be Restored?'
Picture Post 28 September 1946
not used
John Summerson, who helped to set up the National Buildings Record, argued that Fountains Abbey near Ripon should not be restored on the grounds that it would 'kill all that is historically and artistically impressive about the Abbey'. Five of Brandt's photographs of the ruins presented a visual argument to the same conclusion. See plates 164-5.

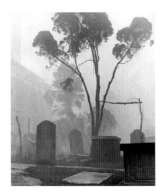

'The Londoners Who Are Quit of the Fog for Ever'
from 'The Day That Never Broke'
Picture Post, 18 January 1947
Four poetic images of London in fog: 'The Londoners Who Are Quit of the London Fog for Ever' (illustrated), 'The Man Who Found Himself Alone in London', 'The Square Where the Nightingale Died with the Fog in its Throat', and 'The Phantom Sun that Got Lost in the Yellow River'. See plates 130, 132, 133.

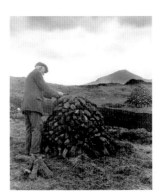

Turf Cutter, Connemara
from 'The Beauty and Sadness of Connemara'
Lilliput, March 1947
In Connemara on the Atlantic coast of Ireland, Brandt found a harsh and rocky landscape and a traditional way of life which, like his later *Lilliput* series on Skye (*Lilliput*, November 1947), produced several memorable images. Brandt wrote his own commentary. Here an old man is stacking peat - an essential fuel in Ireland during the post-war coal shortage. Brandt describes the encounter which led to the photograph of an old woman at her door: '"I have no English," said this old woman, standing with her grandchild at her cottage door overlooking Galway Bay. She is tall, proud and aristocratic in appearance, and like most Connemara women wears a long crimson petticoat and is bare-footed.' See plate 172.

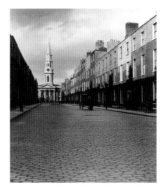

'St George's Church'
from 'A Day in Dublin'
Lilliput, August 1947
The deserted cobblestoned street on the north side of the Liffey shown here is typical of Brandt's city photographs with their strong diagonals and hint of mystery. This series of Dublin photographs includes a portrait of the poet Patrick Kavanagh.

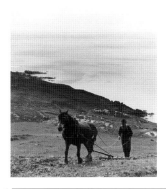

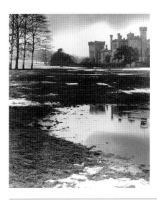

Hillside of Elgol
from 'Over the sea to Skye'
Lilliput, November 1947
A series of eight photographs, mostly poetic landscapes with a short text about the subject of each photograph written by Brandt. Six of these images are included in the main part of this book. Here a crofter on the hillside of Elgol cultivates his holding. Brandt wrote: 'Potatoes are the staple food in Skye and oats are grown for fodder. The island with its 650 sq miles has only 11,000 inhabitants. Many emigrated during the last century. An emigrant ship would come into one of the lochs by night and next morning a whole village would be empty, its inhabitants embarked for Australia.' See plates 153-8.

Ravensworth Castle
from 'The Ghost Castle of Ravensworth'
Picture Post, 20 December 1947
not used
An article about a Georgian pastiche of a medieval castle near Newcastle. The castle was falling into decay: 'Its ruins remain a memorial to the vanity of a rich man who built it for his glorification 140 years ago.' Six of Brandt's photographs illustrate the article.

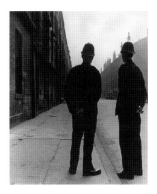

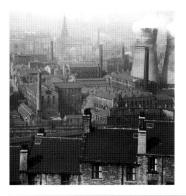

'The Sight the Sensationalists Expect to See'
from 'The Forgotten Gorbals'
Picture Post, 31 January 1948
Three of Brandt's photographs are accompanied by Bert Hardy's in this picture story recording life in an area of Glasgow notorious for poverty and crime. The contrast between Bert Hardy's sympathetic humanism and Brandt's cooler observation from a distance is notable. See plate 94.

Halifax
from 'Hail, Hell and Halifax'
Lilliput, February 1948
A classic series, this time of the Northern town of Halifax, portrayed as a grim town of dark satanic mills: 'a West Riding town charred with smoke'. It includes one of Brandt's greatest photographs, 'The Snicket', which is generally read as a metaphor for a harsh uphill existence. The title of the series comes from an old saying 'From hail, hell and Halifax Lord deliver us'. The commentary by J P W Mallalieu emphasises the starkness of Brandt's interpretation of life in the town almost to the point of parody: even the cart horses 'can barely get a foothold as they drag their loads', and the North Bridge crosses a 'stream of death' into which men and women have flung themselves in desperation. See plates 85, 86, 95, 102. The children shown in plate 95 are captioned 'Children in Sheffield' in Brandt's later books, and in this one.

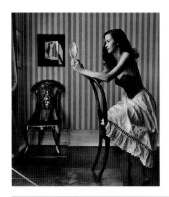

from 'Fashion in Bras', 1949
Fashion Photography, February1948-March1951
Between February 1948 and March 1951 Brandt worked on at least
a dozen fashion shoots for *Picture Post* including 'The Gibson Girl 1948'
(28 February 1948), 'Fashion-on-Sea' (24 July 1948), 'A Lady of Elegant
Leisure' (2 April 1949 - see below), 'Cottons With a Difference' (25 June
1949), 'Two for Travel' (30 July 1949), 'Fashion in Bras' (20 August 1949),
'Thoughts on Necks' (November 1949), 'Avenue Montaigne to Market
Street: How Britain Adapts Paris Fashions' (3 December 1949), 'New
Jerseys Are Made of Jersey' (31 December 1949), 'Raincoats are Promoted
to Fashion' (14 January 1950), 'Spring Goes to the Head' (24 March
1951), and 'Just a Few Lines from Paris' (31 March 1951). His second wife,
Marjorie Beckett, wrote the text for several of these features. During the
same period Brandt also produced fashion work for Rima published in
Harper's Bazaar (UK). This is one of the few photographic genres in which
he did not excel.

'8a Victoria St, Eastwood, Notts'
from 'The Poet's Crib'
Lilliput, March 1948
Geoffrey Grigson describes the eight houses photographed for this *Lilliput*
series. In each a famous writer was born. They are Coxhowe Hall, Co
Durham (Elizabeth Barrett, later to be Elizabeth Barrett-Browning); the Old
Rectory, Summersby, Lincolnshire (Alfred Lord Tennyson); 8a Victoria St,
Eastwood, Notts (D H Lawrence); 12 Aungier St, Dublin (Tom Moore);
1 Merrion Square, Dublin (Oscar Wilde); Helpston, Northamptonshire
(John Clare); Penshurst Place, Kent (Sir Philip Sidney) and Higher
Bockhampton, Dorset (Thomas Hardy). Brandt's approach here is precisely
that of his *Literary Britain* (1951), where several of these images
reappear, including a slightly different version of the one illustrated.

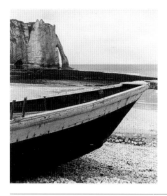

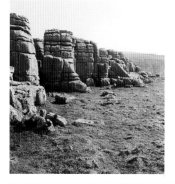

Etretat Beach, France, June 1951
Literary France, 1948-50s
At the same time as Brandt was photographing the sites of literary
significance in Britain that culminated in his book *Literary Britain*, he began
photographing similar sites in France. Brandt wrote the following on the
back of his print of the photograph illustrated: 'Much painted by the French
impressionists. When the tides are high there are dangerous currents
under the arches. In the arch of this rock Swinburne almost drowned and
a 16-year-old Maupassant was about to go to the rescue when it was
learned that some fisherman had picked him up.'

'An Outcrop Like a Giant Box of Bricks' (Malham)
from 'The Craven Fault'
Picture Post, 27 March 1948
The subject of this article is the geological phenomenon known as the
Craven Fault in Yorkshire. Brandt photographed the limestone outcrops
and ravines around Gordale Scar. His five photographs illustrated an
article about the geological processes which formed the landscape.
However, as with his later *Lilliput* series 'History in Rocks (August 1948),
Brandt's interest in the landscape was primarily formal and artistic. His father
owned a picture of Gordale Scar painted by John Piper which Brandt
admired and which may have inspired this piece. See plate 160.

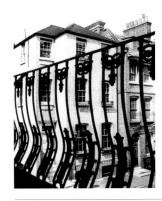

'The house beyond a Chelsea balcony', 1944
from *Camera in London* (London: The Focal Press, April 1948)
This book is a collection of Brandt's London photography, most of it from previous assignments between 1932 and 1946. It has 88 illustrations. The quality of the printing, however, does not do justice to Brandt's photographs. The book includes 'A Photographer's London', his fullest written statement on his photography where he asserts: 'It is part of the photographer's job to *see* more intensely than most people do. He must have and keep in him something of the receptiveness of the child who looks at the world for the first time or of the traveller who enters a strange country.' Brassai's *Camera in Paris* was published in the same series in 1949.

'The Night Watch on Crime'
Picture Post, 1 May 1948
not used
This is the territory of Brandt's 1938 book *A Night in London*. *Picture Post* used eight images of policemen on the night beat in East London for this picture story. The typically English bobby and night-time photography combine two of Brandt's recurrent subjects. The image shown here was used on the cover of *A Night in London*; a slightly different image of a policeman in the same pose was used ten years later in this *Picture Post* story. It is not clear whether Brandt was simply reusing photographs he had taken in the 1930s or produced a new series for this assignment.

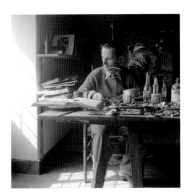

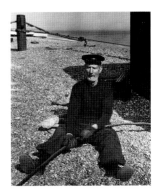

'Graham Sutherland'
from 'Six Artists'
Lilliput, June 1948
This *Lilliput* series consists of portraits of Henry Moore, James Fitton, Ivon Hitchens, John Piper, Feliks Topolski and Graham Sutherland, with a text by Geoffrey Grigson. Grigson describes Sutherland: 'Small, and neat (trousers creased), and intense, with a look of avian anguish caught in the photograph. If you wait long enough perhaps he will bite the brush in two.' Brandt's father owned pictures by Moore, Sutherland and Piper. Most of Brandt's portraits were of artists, actors and writers. See plate 187.

From 'The Borough'
Lilliput, June 1948
Brandt's photographs of Aldeburgh in Suffolk are accompanied by selections from George Crabbe's poem 'The Borough', the source of the opera libretto for *Peter Grimes*. Illustrated here is a member of that race 'skilled only in the taking of the finny tribe'; this portrait of a fisherman is an example of Brandt's fascination with social types, an interest that found its fullest expression in his book *The English at Home* (1936). See plates 171, 173.

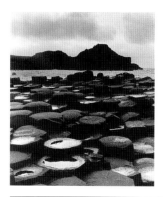

'Giant's Causeway, Antrim'
from 'History in Rocks'
Lilliput, August 1948
Lilliput used six images of coastal rock formations at Portland Bill, Lulworth Cove, and the Giant's Causeway, Antrim for this story. Although the commentary by L Dudley Stamp emphasises the geological significance of these sites, for Brandt they are a pretext for experiments in form. For a comparable picture series see 'The Craven Fault' (*Picture Post*, 27 March 1948).

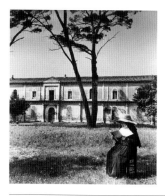

'Van Gogh's Garden at St Paul-de-Mausole'
from 'Painter's Country'
Lilliput, September 1948
Brandt both photographed and wrote the accompanying text to this series of eight photographs of van Gogh's Provence. Brandt's comments about painters might equally apply to the way his own images of particular places have transformed the way they now appear: 'It is fascinating to discover how the strong personality of a painter can impose his vision on the world. Just as the cubist-looking little mountain towns near Aix seem to have been composed by Cézanne, so the countryside around St Rémy is imbued with disquieting elements of van Gogh's dreams and hallucinations.'

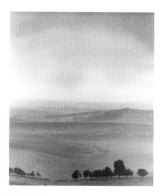

'The Dream-soft Outlines of The Country Which Set The Boundaries to Jefferies's Life and Philosophy'
from 'The Horizon of Richard Jefferies'
Picture Post, 6 November 1948
A series of Wiltshire landscapes including the well-known image of Barbury Castle, Marlborough Downs which is captioned 'The Landscape Whose Grace is Recorded in Jefferies's Novels'. The nature writer Richard Jefferies is the inspiration for the series. The following quotation accompanied the photograph illustrated: 'It is this mystery of growth and life, of beauty and sweetness and colour starting forth ... that gives the corn its power over me. Somehow I identify myself with it; I live again as I see it. Year by year it is the same, and when I see it I feel that I have once more entered a new life.' See plates 140, 143.

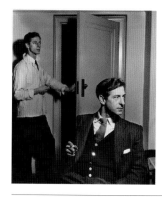

'The Boulting Twins, 35, John and Roy'
from 'British Film Directors'
Lilliput, February 1949
This series consists of portraits of David Lean, described as 'a super-sensitive, dedicated director with brilliant technical gifts that might well lead him astray', Charles Crichton, the Boulting Twins (shown here), Carol Reed, Anthony Asquith, Alberto Cavalcanti, Ronald Neame and Robert Hamer. The British film director whom Brandt most wanted to photograph was Alfred Hitchcock. In 1982 he commented: 'Ah, Hitchcock, I would love to have photographed him. It could never be arranged. I had even chosen the exact spot. It was to have been at Charing Cross Underground Station. There is an amazingly long empty corridor that looks as if it goes right under the river. That is where I wanted to photograph him.'

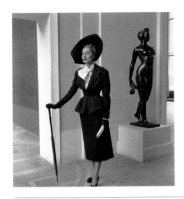

'She Wears a Formal Black Suit to Visit An Art Show'
from 'A Lady of Elegant Leisure'
Picture Post, 2 April 1949
Brandt photographed Madame de Gialluly, a beautiful and elegant Parisian. This story takes a similar approach to Brandt's earlier day-in-the-life picture stories. However, the interest here is in fashion not in social role. We see her taking her morning stroll in the Avenue Foch, having make-up applied by her *visagiste*, taking tea, visiting an art show, going to the fleamarket, at the races, on the telephone, and dancing at Maxims. Each event requires a different outfit. Brandt's second wife, Marjorie Beckett, wrote the accompanying text as she did for many of his *Picture Post* fashion assignments.

'Pevensey in Sussex: Where the Roman Britons Were Massacred by the Saxons'
from 'The Vanished Ports of England'
Picture Post, 24 September 1949
Brandt photographed the remains of Roman fortified sea ports for this *Picture Post* assignment. The ports are Reculver and Richborough (both in Kent), Burgh Castle in Suffolk, Orford in Suffolk, Portchester in Hants and Pevensey in Sussex. As with his earlier photographs of Hadrian's Wall (*Picture Post*, 23 October 1943), the combination of crumbling walls, dark shadows and open landscape produced an atmospheric series of images. In the same issue of *Picture Post* five of Brandt's photographs illustrate a fashion article by Marjorie Beckett, 'Her Hair is a Fashion Asset'.

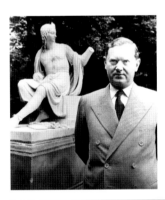

'Evelyn Waugh'
from 'An Odd Lot'
Lilliput, November 1949
The odd lot in question are all literary figures: E M Forster, Norman Douglas, Ivy Compton-Burnett, Robert Graves, Edith and Osbert Sitwell, Elizabeth Bowen, Evelyn Waugh and Graham Greene. Despite the disparaging title, this series resulted in some of Brandt's finest portraiture. The photographs of Graham Greene and E M Forster stand out as the best portraits made of either writer. See plates *177, 182, 183, 185, 186.*

'Emile Littler'
from 'Box-Office Boys'
Lilliput, December 1950
Eight theatrical impresarios were the subject of this *Lilliput* picture series: Henry Sherek, Harold Fielding, Michael Standing, Emile Littler, Tom Arnold, Val Parnell, Bernard Delfont and E P Clift. There is no evidence of sympathy between the photographer and his sitters. Most of the sharp-suited producers in this series seem to be humouring Brandt briefly and rather grudgingly before getting back to more important business. As a result the portraits lack the depth of his best work.

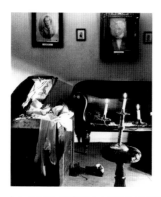

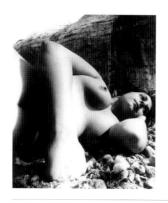

'In Haworth Parsonage'
from *Literary Britain* (London: Cassell's, 1951; 2nd revised ed, London: Gordon Fraser, 1984)
This book presents photographs of 100 sites associated with writers. In many cases Brandt reused photographs from *Lilliput* and *Picture Post* assignments: the image illustrated, for example, which shows the sofa on which Emily Brontë died, was first published in the *Lilliput* series 'Bill Brandt Visits the Brontë Country (May 1945). The second edition of *Literary Britain* (1984) contained only 75 landscapes. Tom Hopkinson, who had been Brandt's editor at *Lilliput*, wrote of the first edition: 'The book is not a collection of loosely-associated artistic products. It is the work of art itself, and out of it, long after, rise images to haunt the memory.' This book was widely reviewed and confirmed Brandt as the major photographer of his generation working in Britain.

Vastérival, Normandy, 1957
Nudes on Beaches
1951-1977
In this experimental series Brandt exploited the strange proportions wrought by his lens: parts of bodies - a foot, a leg, an elbow - are barely distinguishable in form and texture from the rocks and pebbles on the beaches of Normandy and East Sussex. In these photographs the influence of Surrealism and of Henry Moore's sculpture are both apparent. The photograph of an ear in the foreground of a pebbled beach was used on the front of the catalogue of Brandt's first major exhibition in Britain, the Arts Council travelling exhibition, 1970. More recently, in 1993, several images from this series were used in a major UK advertising campaign by the Levi Strauss company. See 'The Perfection of Form'.

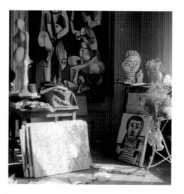

The Red Lion Brewery, Lambeth
from 'From Mud to Festival'
Picture Post, 5 May 1951
Brandt's photographs were used to illustrate an article about the transformation of London's South Bank for the Festival of Britain exhibition. Of the eleven photographs used in this series one is credited to Charles Hewitt and one to Aerofilms. The Red Lion brewery, shown here, was a well-known landmark to the north of Hungerford Bridge.

Picasso's Studio, La Californie, South of France, 1956
Artists' Studios, 1950s-1960s
In the course of his portraiture, Brandt took the opportunity of photographing the paraphernalia of artists' studios with their strange collections of work in progress, paintpots and *objets trouvés*. Artists whose studios he photographed include Arp, Braque, Hepworth, Miró, Moore and Picasso.

Jacqueline Rocque, 1956
In Picasso's Garden
One of a series of pictures taken at Picasso's house on the Côte D'Azur in October 1956. In 1955 *Harper's Bazaar* had asked Brandt to photograph Picasso. Brandt had great difficulty in getting past Picasso's gate-keeper. When he was finally admitted, a year after his first unsuccessful visit, while waiting for the great man to appear, Brandt took this portrait of Jacqueline Rocque, Mme Picasso. As he was taking the picture, Picasso appeared on the terrace and asked: 'Why aren't you photographing me?' Brandt then duly took his famous portrait of Picasso; he also took a number of photographs of the statues in Picasso's garden. Plate 206.

Vasarely's Right Eye
Artists' Eyes
1960-64
Brandt's series of photographs of artists' eyes combined Surrealism and portraiture. Amongst those photographed were Jean Arp, Jean Dubuffet, Max Ernst, Alberto Giacometti, Louise Nevelson, and Antonio Tapies. See plates 69-72.

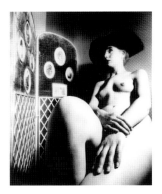

Campden Hill, London, 1953
from *Perspective of Nudes* (London: Bodley Head, 1961)
This beautifully printed book presented ninety of Brandt's nudes in chronological order from his early studies of nudes in rooms, through to the abstraction of close-ups on the beaches of East Sussex and Normandy. In his Preface to the book Lawrence Durrell wrote: 'Brandt broods over the nature of things and makes a quiet poetic transcript of them; his work is a prolonged meditation on the mystery of forms. In his best pictures one comes up against the gnomic quality which resides in poetry and sculpture; one forgets the human connotation as if one were reading a poem - even though, as I say, the subject is a human being'.

Maillol sculpture
from 'Nudes are Back'
Life (International), 20 November 1961
Life magazine published a selection of Brandt nudes which included four of Brandt's photographs of Aristide Maillol's stone and bronze sculptures of nudes taken for the Paris National Museum of Art show of Maillol's work. Brandt took numerous photographs of Maillol's work. There are strong affinities between Maillol's approach to the female nude and Brandt's.

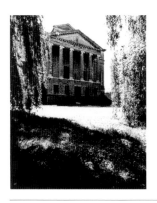

Villa Malcontenta
from 'Palladio at Vicenza'
Harper's Bazaar (US), December 1962
Brandt visited Palladio villas for this *Harper's Bazaar* feature. Brandt had originally wanted to train as an architect and kept an interest in architecture that can be traced throughout his photographic career.

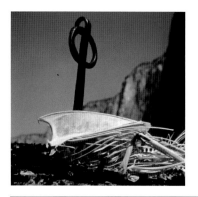

Normandy, 1965 (original in colour)
Colour Photography
1962-70
From about 1962 Brandt began experimenting with colour photography. He was not interested in realistic colours, but in intensified effects. Eight colour plates appeared in the first edition of *Shadow of Light* (1966). He concentrated on rocks and on 'that strange bottom-of-the-sea world which emerges at low tide'. By 1970 he had recognised that the experiment had not worked and he abandoned it.

Miró and Windmill, Callamayor, Majorca
Miró's World, 1964
Brandt visited Juan Miró's home in Majorca in 1964, making a series of photographs of the artist's house and gardens. The image shown here is of a windmill used to pump water to the house. Other photographs in the series show Miró's sculptures.

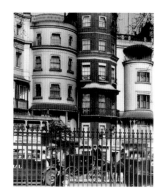

'Park Lane', 1930
from *Shadow of Light* (London: Bodley Head, 1966; 2nd ed, London: Gordon Fraser, 1977)
Brandt's second wife Marjorie Beckett came up with the apt title for this retrospective of thirty-five years' work in photography; she also wrote notes on the photographs. This was the first time that the full range of Brandt's output had been presented in a single volume. Brandt produced a revised edition in 1977, printed with starker contrasts than the earlier photogravure edition. The first edition of the book, introduced by Cyril Connolly, included eight colour images amongst the 161 plates; the second edition expanded the number of plates to 169. The image of Park Lane in London shown here was also used in *Literary Britain* (1951), the houses appear in John Galsworthy's *The Forsyte Saga*.

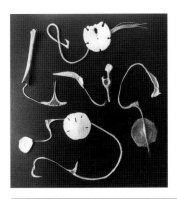

Collages
Photographs of Collages
1968-1983
Towards the end of his career, Brandt turned to a new medium, making collages from the driftwood and debris he hoarded from beaches. These were arranged on large painted boards and encased in perspex. He compared them to photographs in that they were 'made from real objects that I find as I can find a landscape'. Brandt's photographs of these collages have only been exhibited posthumously. They are reminiscent of Man Ray's rayographs which were made by placing objects directly on to light-sensitive paper.

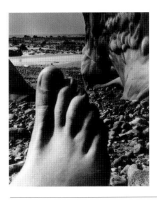

East Sussex, 1977
from *Bill Brandt: Nudes 1945-1980* (London: Gordon Fraser, 1980)
This book reproduced a hundred of Brandt's nudes in more or less chronological order. It overlapped significantly with *Perspective of Nudes* (1961), but also included his more recent experiments with nudes in rooms, some, such as a photograph of a gagged woman, with sado-masochistic elements, and his continuing series of nudes on beaches. Michael Hiley wrote in his Introduction: 'We feel as though we are about to amaze ourselves by stumbling upon some profound truth. But like sleepers awakened, we find that the meanings of these dream-like images continue to elude us, and we remain both perplexed and entranced.'

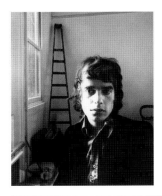

Martin Amis, 1974
from *Bill Brandt: Portraits* (London: Gordon Fraser, 1982)
This book, published in the year before Brandt's death, brought together 104 portraits spanning more than half a century. Most were taken on assignment for *Lilliput* or *Harper's Bazaar*. Typically they show a writer or artist in his or her home or studio. In most cases Brandt has achieved a sense of isolation and thoughtfulness in his sitters. As he put it: 'The photographer has to wait until something between dreaming and action occurs in the expression of a face.' He captured a kind of meditative interiority in his portraits and quoted approvingly André Breton's comment that a portrait should not only be an image 'but an oracle one questions', and that 'the photographer's aim should be a profound likeness, which physically and morally predicts the subject's entire future.'

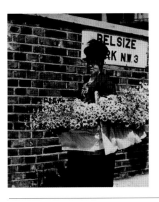

'Flower-seller near Swiss Cottage'
from *London in the Thirties* (London: Gordon Fraser, 1984)
Brandt died in 1983. However, he supervised the production of this last book which was published posthumously. It consisted of 96 photographs, many of which first appeared in *The English at Home* (1936) and *A Night in London* (1938) or had been produced on assignment for *Lilliput* or *Picture Post*. The book was printed in the harsh black/white printing style of the second edition of *Shadow of Light* (1977).

BRANDT'S PRINTING STYLES NIGEL WARBURTON

For Brandt printing was an essential part of the creative process. Working in a small one-man cupboard he composed, cropped, dodged and burnt in, coaxing atmospheric prints from often quite unpromising negatives. In 1948 he wrote:

'I consider it essential that the photographer should do his own printing and enlarging. The final effect of the finished print depends so much on these operations, and only the photographer himself knows the effect he wants.'

Although he often planned photographs in meticulous detail, cropping in the darkroom played an important part in his finished prints. Even when supplying magazines with work Brandt was adamant that the pictures should be published as he supplied them. When Kaye Webb once took the liberty of cropping a picture that Brandt had taken for *Lilliput* he gently admonished her '... if you don't like anything, ask me'.

This might suggest that he produced a definitive print of each negative as a touchstone for subsequent prints, but this was very far from his working method. Typically he would return to print the same negative many times, each print being slightly different, some substantially different. For him the process was intuitive not formulaic. He did not record detailed exposure times. Nor did the process of interpreting a negative stop in the darkroom: he often retouched prints, sometimes quite crudely. He did not produce numbered print runs: until the 1970s he was principally concerned to produce prints to be seen, not to sell. Although

Brandt is renowned for the extreme contrast of his prints, this was a relatively late phase. It was not until the 1950s, possibly in reaction to a comment made by Edward Steichen, that he began producing the high-contrast prints for which he is best known today. It should be remembered that most of the prints that Brandt was making at that time were for publication and not for exhibition. In the vagaries of the printing process, contrast was often heightened. Consequently in some cases Brandt may have been consciously anticipating the darkening effects of magazine printing.

The progression of his printing style from the greyer prints of the 1930s and '40s, through to the harsher black/white contrasts of the 1960s and 1970s can be traced in individual images. So, for example, prints Brandt made of the nude illustrated here (usually known as Nude 1, because of its plate number in *Perspective of Nudes*) range from the subtler print dating from 1945 showing a range of mid-tones, to the later print dating from the 1960s in which the model's skin is reduced almost to white. The later print emphasises form at the expense of detail. Similarly, a 1945 vintage print of Edith and Osbert Sitwell (an image used in *Lilliput* in November 1949) received a different interpretation when Brandt returned to print it in the 1960s; in this case the harsher printing style of the later print, whilst altering the expression on Osbert Sitwell's face, was balanced by an increase in detail on Edith Sitwell's clothes. Brandt had burnt in her coat to black in the earlier print. A slightly different crop in the later print also subtly changed the balance of the composition. Writing in 1970

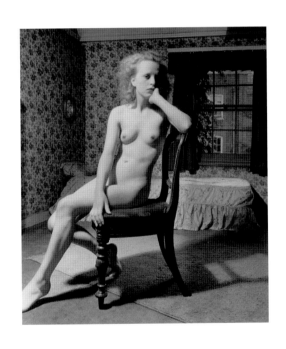 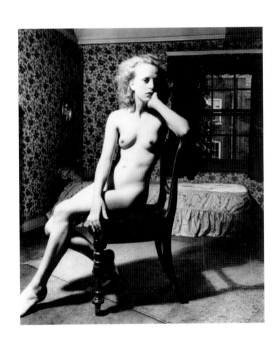

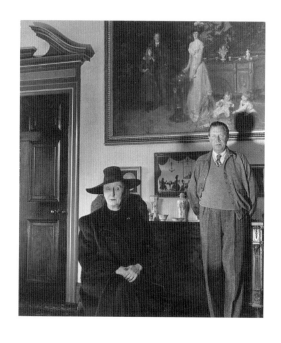 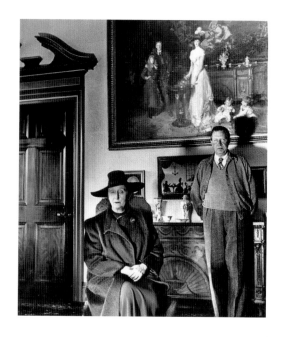

Brandt expressed a clear preference for his later printing style and identified 1951 as the turning point:

'Before 1951, I liked my prints dark and muddy. Now I prefer the very contrasting black and white effect. It looks crisper, more dramatic and very different from colour photographs.'

A further influence on his printing style may have been the printing of *Perspective of Nudes* (1961) and the first edition of *Shadow of Light* (1966). Both books were produced in photogravure, a process which compresses the tonal range to give dense blacks and sharp whites. The subsequent half-tone printing of the second edition of *Shadow of Light* in 1977 by Gordon Fraser allowed Brandt to experiment further with contrast. The galley proofs for this book are covered with Brandt's emphatic scrawl: 'more contrast', 'much more contrast'. With his growing stature and popularity among photographic collectors, he was now forced to define a style. It is with the harsh later style that he made his biggest impact on the art world.

Yet this story of a trajectory from greys to black/white contrasts is slightly misleading. It describes the *trend* of Brandt's work, particularly in his books, but is not completely reliable as a method of dating prints. Some vintage prints from the 1930s and '40s survive which experiment with the black/white contrasts for which he was to become famous. Brandt was sensitive to the requirements of individual images as well as to their subsequent use whether in magazines, books or as exhibition prints, and printed accordingly. He insisted that a photographer 'should know by instinct grounded in experience, what subjects are enhanced by hard or soft, light or dark treatment.' By the 1980s he was unhappy with his earlier printing style, and reluctant to allow his vintage prints from the 1930s and '40s to be exhibited, though he did yield to Roy Strong's cajoling for the Victoria and Albert Museum exhibition of 1984. Strong wrote:

'He disparaged the milder, fuller toned prints typical of his production in the Thirties and Forties. However, in recent years his admirers and critics found much to recommend the earlier prints.'

One such critic was Marina Vaizey who wrote:

'The vintage prints of the 1940s are much smaller, exquisitely sharply detailed, toned in silvery, iridescent muted brown. It's heresy to say so, but the latter are so much more aesthetically satisfying.'

The comparative rarity of such prints has also increased their appeal to collectors. Yet it was in large part his later printing style which allowed him to express his vision of atmosphere - 'the spirit that charged the commonplace with beauty' - through its abstraction and concentration on form. By reprinting the work of half a century he brought out and intensified its coherence and depth, most obviously in the two editions of *Shadow of Light* (1966 and 1977) and in the exhibition prints he made in the 1970s. It was with this printing style that he declared himself a photographic *artist*.

The present book mostly uses the best available print, yet when looking at these images bear in mind that for Brandt, more than for most photographers, any decision about how to print an image was analogous to a performance of a musical score - not necessarily definitive, but one of a number of possible interpretations.

BIBLIOGRAPHY

Books by Bill Brandt

The English at Home introduction by Raymond Mortimer (London: BT Batsford Ltd 1936) 63 illus.

A Night in London introduction by James Bone (London: Country Life; *Londres de Nuit,* Paris: Arts et Métiers Graphiques [introduction by André Lejard]; New York: Charles Scribner's Sons, 1938) 64 illus.

Camera in London introduction by Bill Brandt, commentary by Norah Wilson (London: The Focal Press, 1948) 59 illus.

Literary Britain introduction by John Hayward (London: Cassell and Company, 1951), 100 illus. 2nd revised edition, foreword by Sir Roy Strong, introduction by John Hayward, afterword by Mark Haworth-Booth and Tom Hopkinson, (London: Gordon Fraser; New York: Da Capo; Aperture, 1986) 79 illus.

Perspective of Nudes preface by Lawrence Durrell, introduction by Chapman Mortimer (London: Bodley Head; New York: Amphoto; *Perspectives Sur Le Nu,* Paris: Le Bélier-Prisma, 1961) 90 illus.

Shadow of Light, introduction by Cyril Connolly, notes by Marjorie Beckett (London: Bodley Head; New York: VIking Press; *Ombres d'une île,* Paris: Éditions Prisma [introduction by Michel Butor], 1966), 161 illus. 2nd revised edition, introductions by Cyril Connolly and Mark Haworth-Booth, (London: Gordon Fraser; *Ombre de Lumière,* Paris: Chêne; New York Da Capo, 1977) 169 illus.

Bill Brandt: Nudes 1945-1980 introduction by Michael Hiley (London: Gordon Fraser; Boston: New York Graphic/Little Brown, 1980) 100 illus.

Bill Brandt: Portraits introduction by Alan Ross (London: Gordon Fraser; Austin: University of Texas Press, 1982) 104 illus.

Bill Brandt: London in the Thirties (London: Gordon Fraser, 1983; New York: Pantheon, 1984) 96 illus.

Books About Bill Brandt

Mark Haworth-Booth and David Mellor *Bill Brandt: Behind the Camera, Photographs 1928-1983* (Oxford: Phaidon; New York: Aperture, 1985) 89 illus. ♦

Patrick Roegiers *Bill Brandt: Essai* [in French] (Paris: Pierre Belfond, 1990) 16 illus.

Zelda Cheatle and Adam Lowe editors *Bill Brandt: The Assemblages* (Kyoto: Kyoto Shoin, 1993) 57 illus.

Ian Jeffrey *Bill Brandt Photographs 1929-1983,* introduction by Ian Jeffrey (London: Thames and Hudson, 1993) 200 illus. ♦

Nigel Warburton editor *Bill Brandt: Selected Texts and Bibliography* introduction by Nigel Warburton (Oxford: Clio Press; New York: G K Hall, 1993) ♦

Bill Brandt introduction by Ian Jeffrey, bibliography by Nigel Warburton (Paris: Photo Poche, 1994) 61 illus.

Selected articles about Bill Brandt (in chronological order)

Tom Hopkinson 'Bill Brandt's Landscapes' *Photography* (April 1954) p.26-31.

John Berger 'Arts in Society: The Uses of Photography' *New Society* (13 October 1966), p. 582-3.

Bill Jay 'Bill Brandt - The Best from Britain' *Creative Camera Owner* (August, 1967) p.160-169, 184.

John Szarkowski 'Bill Brandt' *Album* (1970) p.12-28. 16 illus.

Peter Turner 'Bill Brandt - The Early Years' in *Bill Brandt: Early Photographs 1930-1942,* exhibition catalogue (London Arts Council, 1975).

John Taylor 'Bill Brandt and the Conversation Piece' *Afterimage* (January 1979), p.4-5.

Peter C. Bunnell and Gerry Badger *Photographer as Printmaker* exhibition catalogue (London: Arts Council, 1981). ♦♦

David Mellor 'Bill Brandt' in *Bill Brandt: A Retrospective Exhibition,* exhibition catalogue (Bath: Royal Photographic Society, 1981). ♦

John Taylor 'The Use and Abuse of Brandt' *Creative Camera* (March/April 1981), p. 17-20.

Mark Haworth-Booth 'Talking of Brandt . . .' *Creative Camera* (March/April 1981) p.20-22.

Roméo Martinez 'Bill Brandt' [in French] in *Atelier Man Ray 1920-1935* (Paris: Centre Georges Pompidou, 1982).

John Stathatos *Multiple Originals* exhibition catalogue (London: Photographers' Gallery, 1987). ♦♦

Roy Strong 'Bill Brandt: Portraits' *Creative Camera* (June 1982) p.538-45.

Charles Hagen 'Bill Brandt's Documentary Fiction' *Artforum* (September 1985), p. 11-14.

Joanne Buggins 'An Appreciation of the Shelter Photographs Taken by Bill Brandt in November 1940' *Imperial War Museum Review* (1989), p.32-42. ♦

Bill Jay 'Bill Brandt - A True But Fictional First Encounter' in Bill Jay *Occam's Razor* (Munich: Nazraeli Press, 1992), p.71-73.

Nigel Warburton 'Bill Brandt's Cathedral Interiors' *History of Photography* (Autumn 1993), p.263-76. ♦

Martin Gasser 'Bill Brandt in Switzerland and Austria: Shadows of Life *History of Photography* (1997), p.303-313. ♦

Nigel Warburton 'Authentic Photographs' *The British Journal of Aesthetics* 1998, p.129-137. ♦♦

♦ used in researching 'The Career'.
♦♦ sources for 'Brandt's Printing Style'; mostly about the issue of printmaking in photography, though all include a specific reference to Brandt.